EVERYMAN, I will go with thee,

and be thy guide,

In thy most need to go by thy side

GIORGIO VASARI

Born at Arezzo in 1511
Died in Florence 1574

GIORGIO VASARI

The Lives of the
Painters, Sculptors
and Architects

IN FOUR VOLUMES · VOLUME FOUR

TRANSLATED BY
A. B. HINDS

EDITED WITH AN INTRODUCTION BY
WILLIAM GAUNT, M.A.

DENT: LONDON
EVERYMAN'S LIBRARY
DUTTON: NEW YORK

© Introduction and editing, J. M. Dent & Sons Ltd, 1963
All rights reserved
Made in Great Britain
at the
Aldine Press · Letchworth · Herts
for
J. M. DENT & SONS LTD
Aldine House · Bedford Street · London
First included in Everyman's Library 1927
Revised edition 1963
Last reprinted 1970

NO. 787

ISBN: 0 460 00787 4

CONTENTS

PART III—*continued*

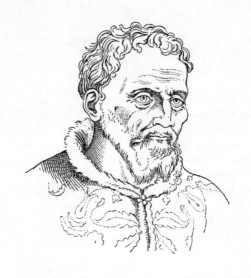

MICHELAGNOLO

VASARI'S LIVES

PART III—*continued*

RIDOLFO, DAVID and BENEDETTO GHIRLANDAI, Painters of Florence

(1483–1561; 1452–1525; 1458–1497)

ALTHOUGH it does not seem possible that one who imitates and follows in the footsteps of a great artist should not become like him, yet we often see that the brothers and sons of famous men do not follow them but, strange to say, they take a different line. I do not think this arises because they do not possess the hereditary genius, but from another cause, namely greater ease and wealth, which prevent them from being industrious. But the rule is not absolute, and the contrary is sometimes seen.

David and Benedetto Ghirlandai, although clever and possessing great possibilities, did not follow their brother Domenico in art, because after his death they deviated from good work, as Benedetto was a wanderer for a good while, and the other uselessly bothered himself over mosaics. David, who had been much beloved by Domenico, and returned his affection, finished many of his brother's works, aided by Benedetto, notably the high-altar picture of S. Maria Novella, that is the part towards the choir, and some of Domenico's pupils finished the predella, Niccolaio doing a dispute of St. Stephen under the saint's figure, and Francesco Granacci, Jacopo del Tedesco, and Benedetto doing St. Anthony, archbishop of Florence, and St. Catherine of Siena. They also did the head of a friar near the middle of the church, a St. Lucy, and many other pictures for private houses. After remaining several years in France, where he earned much money, Benedetto returned to Florence, having received many gifts and privileges from the king as a tribute to his talent. At length, after practising arms as well as painting, he died, aged fifty. David, although he designed and worked hard, did not

much excel Benedetto, possibly because he was too well off
and did not keep his attention fixed on art, which is only
found by those who seek it, and when found it flies away if
neglected. There are two figures in fresco at the foot of a
crucifix by David, at the top of an alley in the garden of
the monks of the Angeli at Florence, namely St. Benedict and
St. Romuald, and some similar things unworthy of mention.
But if David did not cultivate art, he made Domenico's son
Ridolfo do so, because the boy was his ward and showed ability,
so that his uncle supplied him with every convenience for
study, repenting himself of not having studied instead of
wasting his time on mosaics.

David did a much-admired Madonna with angels, in mosaic,
in a thick piece of walnut wood, to be sent to the King of
France.[1] While staying at Montaione in Valdelsa, where he was
well supplied with glass, wood and furnaces, he did many
mosaics and glasswork, notably some vases presented to
Lorenzo de' Medici the elder, and heads of St. Peter, St. Laurence
and Giuliano de' Medici on a sheet of copper, now in the
duke's wardrobe.

Ridolfo meanwhile studied the cartoon of Michelagnolo, and
was considered one of the best draughtsmen there. This won
him the affection of all, and especially of Raphael, who was
then staying in Florence to learn art. After having studied the
cartoon, and practised under Frà Bartolommeo, Ridolfo already
knew so much that, when Raphael was summoned to Rome by
Pope Julius II., he left Ridolfo to finish the blue robe and some
of the details of a Madonna which he had done for some noble
Sienese. That done, Ridolfo sent it to Siena, and Raphael had
not long been in Rome before he wanted Ridolfo to go there.
But Ridolfo never lost sight of the cupola, as the saying goes,
and could not bear to live away from Florence, so that he
would never leave the city.

In the convent of the nuns of Ripoli, Ridolfo did a Coronation
of the Virgin [2] and a Madonna and saints in oils. In the church
of S. Gallo he did Christ bearing the Cross,[3] with a number of
soldiers, the Virgin, and the other Maries weeping with St. John,
while Veronica offers her handkerchief, with movement and
vivacity. This work, containing many fine portraits, brought
Ridolfo a great reputation. He then drew his father and some of
his apprentices, and among his friends, Poggino, Scheggia and

Nunziata, the last exceedingly life-like. This Nunziata, although a painter of puppets, was in some respects a clever man, especially in making fireworks and the *girandole* for the feast of St. John prepared every year. As he was a jest-loving and witty man, everyone enjoyed his conversation. When a citizen once confessed to him that certain painters displeased him because they only treated lascivious subjects, and said that he wanted a Madonna which should be modest and not an incitement to desire, Nunziata painted him one with a beard. Another man wanted him to do a crucifix for a country house where he lived in summer time, but he expressed himself, "I want a Crucifix for the summer," and Nunziata, seeing he was a simpleton, did him one in breeches.

But to return to Ridolfo. Being employed to do a Nativity for the monastery of Cestello, he took the utmost pains in order to surpass his rivals, and, displaying extraordinary diligence, he made a Virgin adoring the Christ-child, with St. Joseph, and St. Jerome kneeling.[1] It contains a beautiful landscape like the Sasso della Vernia, where St. Francis received the stigmata, and above the hut are angels singing, all beautifully coloured and in good relief. Having done a panel for Pistoia, he began two others [2] for the company of S. Zanobi, next the canonry of S. Maria del Fiore, on either side of the Annunciation of Mariotto Albertinelli. He completed them to the great satisfaction of the men of the company, one being St. Zanobius raising a child, in the Borgo degli at Florence, a very vigorous scene, many heads being portraits, and some women making lively demonstrations of joy at seeing the child returning to life. The other is the translation of St. Zanobius, borne by six bishops from S. Lorenzo, where he was first buried, to S. Maria del Fiore, and on touching a withered elm, when passing through the piazza S. Giovanni, the tree immediately put forth leaves, the site being marked to-day by a marble column surmounted by a cross, the work being of the same excellence as the other paintings. David was still alive, and was much gratified at his nephew's success, who inherited the talent of Domenico, and he thanked God for being permitted to live to see it. However, at the age of seventy-four, as he was preparing to go to Rome for the Jubilee, he fell sick and died, in 1525, and was buried by Ridolfo in S. Maria Novella, with the other Ghirlandai. In the Camaldolite house of the Angeli at Florence Ridolfo had a brother called Don Bartolommeo, a

[1] Probably the Nativity of the Hermitage, Leningrad.
[2] In 1510; now in the Uffizi.

friar of holy life. Ridolfo, who loved him dearly, painted in the loggia opening on to the garden, and containing the life of St. Benedict done in *verdaccio* by Paolo Uccello, a representation of the saint seated at table with two angels awaiting the bread sent him by Romano, and the devil cutting the cord with stones, as well as the saint putting the habit on a youth. But the best figure of all in this arch is a portrait of a dwarf who used to stand at the door of the monastery. Above the holy-water vessel at the entrance to the church Ridolfo painted a Virgin and Child surrounded by beautiful angels. Over the door of a chapel in the cloister before the chapterhouse, he painted in a lunette St. Romuald holding the church of Camaldoli, and not long after he did a fine Last Supper [1] at the end of the refectory for the same monks for Don Andrea Doffi the abbot, who had been a monk there, and whose portrait was introduced in a lower corner. In the church of the Misericordia, on the piazza of S. Giovanni, Ridolfo painted a predella of three subjects from the life of the Virgin like miniatures.[2] For Mattio Cini, at a corner of his house near the piazza of S. Maria Novella, he painted a tabernacle with the Virgin, St. Matthias, St. Dominic, and two small children of Mattio kneeling, a work of great beauty and grace. For the bare-footed Franciscan nuns of S. Girolamo, on the hill of S. Giorgio, he painted two panels, one of St. Jerome in penitence with a Nativity in a lunette above, and the other an Annunciation with the communion of the Magdalene above. In the duke's present palace he did the chapel where Mass is celebrated,[3] representing the Trinity on the vaulting with cherubs holding the mysteries of the Passion, and the heads of the twelve Apostles in the other compartments. At the four corners he did full-length Evangelists, and at the end an Annunciation with a representation of the piazza of the Nunziata at Florence, as far as the church of S Marco, a finely executed work with many ornaments. That done, he painted the Virgin giving her girdle to St. Thomas,[4] who is with the other Apostles, for the Pieve of Prato. In Ognissanti he did a panel of the Virgin, St. John the Baptist and St. Romuald for Monsignor de' Bonafe, master of the hospital of S. Maria Nuova, and some other works which I need not mention. He then copied the three labours of Hercules, painted in the Medici palace by Anton Pollaiolo, for Giovanbattista dalla Palla, who sent them to France. After these and many other works, Ridolfo, finding in his house all the machinery for doing mosaics

[1] In 1543.　　[2] In 1515.　　[3] In 1514.　　[4] Also in 1514.

of David his uncle and Domenico his father, and having himself learned something of the work, determined to make an attempt in mosaic as an experiment. Finding this succeeded, he undertook to do the tympanum of a door of the Nunziata, where he made an Annunciation.[1] But not having the patience to fit together the little pieces, he never did anything else. For the company of the wool-combers he did an Assumption at the top of the churchyard, with a choir of angels and the Apostles about the tomb. But the room where it was being unfortunately full of young birches for making fascines, in the siege year, the damp affected the intonaco, so that Ridolfo had to restore it, when he introduced his own portrait. In a tabernacle in the Pieve of Giogoli in the street he did a Virgin with two angels,[2] and opposite a mill of the Camaldolites, beyond the Certosa on the Ema, he painted several figures in fresco in another tabernacle. Seeing himself in sufficient employment with a good income, Ridolfo would not trouble to accomplish what he might have achieved in painting, and made up his mind to live at ease and take what came. When Pope Leo came to Florence he did almost all the decoration of the Medici palace, aided by his men and apprentices, adorning the Pope's hall and other apartments, and getting Pontormo to paint the chapel. He also did the decorations for the weddings of Duke Giuliano and Duke Lorenzo, and scenery for comedies. Those lords valued his ability, obtaining many offices for him, and he was admitted to the college as an honoured citizen.

Ridolfo did not disdain to do standards, cloths, and other similar things, and I have heard that he thrice did the banners of the Potenze,[3] which arm and hold festival in the city every year. In fine, he produced everything in his shop, so that he kept many youths there, who learned what pleased them most. Thus Antonio del Ceraiolo, having been with Lorenzo di Credi and then with Ridolfo, did many works and portraits when by himself. In S. Jacopo tra' Fossi there is a panel by him of St. Francis and the Magdalene at the foot of the Cross,[4] and behind the high altar of the Servites a St. Michael copied from one by Ghirlandaio in the Ossa of S. Maria Nuova.

Another successful pupil, Mariano da Pescia, did a Virgin and Child, St. Elizabeth and St. John,[5] of great excellence, in the chapel of the palace, where Ridolfo had already painted for the Signoria.

[1] In 1509. [2] In 1519.
[3] The name given to certain associations or clubs at Florence.
[4] Now in the Accademia, Florence. [5] Now in the Uffizi Gallery.

Mariano also painted in grisaille all the house of Carlo Ginori in the via Ginori, with the acts of Samson done in good style. If he had lived longer he would have become excellent. Another pupil, Toto del Nunziata, did a panel in conjunction with Ridolfo in S. Piero Scheraggio of the Virgin and Child and two saints. But the dearest of all to Ridolfo was a pupil of Lorenzo di Credi called Michele, who had also been with Antonio del Ceraiolo, for he was a youth of the highest character, and executed his works with spirit and without effort. He followed Ridolfo's style, and succeeded so well that, whereas it was at first arranged that he should have a third of the profit, they afterwards agreed to do the work together and share the proceeds. Michele always considered Ridolfo as a father, and was so beloved by him that he has never been known except as Michele di Ridolfo. They did countless works together; to begin with, a panel for the Camaldolite church of S. Felice in Piazza of Christ and the Virgin in the air, praying to God for the people below, where saints are kneeling. In S. Felicità they did two chapels in fresco, one with a Dead Christ and the Maries, and the other an Assumption with some saints. In the church of the nuns of S. Jacopo dalle Murate they did a panel for the Bishop de' Bonafe of Cortona,[1] and another in the nunnery of Ripoli of a Virgin and saints. For the Segni Chapel under the organ in S. Spirito they did a panel of the Virgin, St. Anne and many other saints. For the company of the Neri they did a Beheading of St. John the Baptist and an Annunciation; for the little nuns in Borgo S. Friano and S. Rocco at Prato they painted the Virgin between St. Roch and St. Sebastian. In the company of S. Bastiano, next to S. Jacopo sopr' Arno, they did a panel of the Virgin, St. Sebastian and St. James, and another panel at S. Martino dalla Palma. For Sig. Alessandro Vitelli they did a St. Anne, which was sent to Città di Castello, and placed in his chapel in S. Fiordo. But as the works which issued from Ridolfo's shop are countless, with numerous portraits, I will only say that he made a portrait of Sig. Cosimo de' Medici, as a youth, a fine work and a very good likeness, now in the duke's wardrobe. Ridolfo painted some things with great speed, especially for feasts. Thus when Charles V. came to Florence Ridolfo did an arch at the Cuculia corner in ten days, and another at the Prato gate on the coming of Duchess Leonora, in a very short time, as will be related in the Life of Battista Franco. For the Camaldolite monastery of the Madonna di Vertigli, outside Monte S. Savino, he did the life of Joseph in grisaille

[1] Now in the Accademia, Florence.

in a small cloister, the high-altar picture, and a Visitation, among his finest works in fresco, aided by Battista and Michele. Most beautiful of all is the venerable aspect of St. Romuald at the high altar. He did other paintings there, but let these suffice. In the green chamber in the palace of Duke Cosimo Ridolfo decorated the vaulting with arabesques and the walls with landscapes, which greatly pleased the duke.

Ridolfo enjoyed a happy old age, having married his daughters and seeing his sons successfully engaged in business in France and Ferrara, and although he suffered from the gout, and remained indoors or was carried in a chair, he supported this malady and some misfortunes of his sons with patience. He remained very fond of art, and wanted to hear about and some- times see the buildings and paintings and such things produced daily which he heard highly praised. One day, when the duke was absent from Florence, Ridolfo had himself carried to the palace in his chair and dined there, spending the whole day in seeing the building, so altered from what he had known that he did not recognise it. On leaving in the evening he said: "I shall die content if I can carry the news to our artists that I have seen the dead raised, the ugly made beautiful, and the old rejuvenated." Ridolfo lived to the age of seventy-five, and died in 1560, being buried with his ancestors in S. Maria Novella. His pupil Michele, who is always known as Michele di Ridolfo, did three large arches in fresco over the gates of Florence, after Ridolfo gave up art; a Virgin at S. Gallo with the Baptist and St. Cosimo, executed with great skill; at the Prato gate, similar figures; and at the Croce gate the Virgin, the Baptist and St. Ambrose, as well as numberless pictures skilfully executed. Owing to his excellence I have often employed him on the works of the palace, to my own and the general satisfaction. What I like best about him, besides his being an excellent and God- fearing man, is that he always keeps a number of youths in his shop, whom he teaches with incredible pains.

Another pupil of Ridolfo, Carlo Portelli of Loro di Valdarno, did some panels in Florence, and numerous pictures in S. Maria Maggiore, in S. Felicità, for the nuns of Monticelli, and the picture in the Baldesi Chapel in Cestello on the right on entering the church, of the martyrdom of St. Romolo, bishop of Fiesole.

Giovanni da Udine, Painter
(1494 – 1564)

In Udine in Friuli a citizen called Giovanni of the Nani family was the first to practise embroidery (*ricamare*), in which his descendants became so excellent that they became known no longer as de' Nani, but as de' Ricamatori. One Francesco, an honoured citizen of the family, who loved the chase and other exercises, had a son in 1494 whom he called Giovanni. While still a boy the child showed a marvellous aptitude for design, as while hunting and fowling with his father he would draw the dogs, hares, goats, and all the animals and birds which he could get hold of, arousing the admiration of everyone. When Francesco remarked this he took the boy to Venice, and put him with Giorgione to learn art. While there Giovanni heard such praises of Michelagnolo and Raphael that he determined he would go to Rome. Armed with a letter of introduction from Domenico Grimano, a friend of his father, to Baldassarre Castiglioni, secretary of the Duke of Mantua and a great friend of Raphael, Giovanni set out, and being provided by Castiglioni with a place in Raphael's school, he thoroughly learned the principles of art, which is of great importance. For when men acquire a bad style at the beginning, they are rarely able to abandon it for a better without difficulty. Thus, after a very short stay at Venice under Giorgione, Giovanni was seized with a great desire to acquire the suave and graceful style of Raphael. His ability corresponding with his intentions, he made such progress that he was soon able to design and colour with grace and ease, and, in a word, could excellently imitate animals, cloth, instruments, vases, landscapes, buildings and verdure, so that none of the students surpassed him. He was most fond of drawing all manner of birds, and in a short time filled a book with them, so varied and beautiful that it became a pastime and relaxation for Raphael. A Fleming with Raphael named John, an excellent master of fruits, foliage and flowers, though with a somewhat dry and laboured style, taught Giovanni da Udine to do them like a master in a rich tone, and he introduced them successfully into some things, as I shall relate. He also learned to make landscapes with ruins, and fragments of antiquities, colouring them in a style since adopted by Italians as well as Flemings. Thus Raphael, who thought highly of Giovanni's skill, employed him to do the organ for his St. Cecilia at Bologna, done so well that it

seems in relief, and all the musical instruments at the saint's feet. What is more, he made his painting so like Raphael's that it seems by the same hand. Not long after, in digging near S. Pier ad Vincola among the ruins of the palace of Titus, they found some rooms roofed in, covered with grotesques, small figures and scenes in stucco. Giovanni and Raphael, who were taken to see them, were amazed at their beauty, freshness and excellence, which had been preserved so long; but it is not remarkable, because they had been protected from the destructive influence of the air. These grotesques, so called from being found in grottoes, executed with design, variety and fancy, and with stucco ornaments traversed by delicate colours, with their light and beautiful scenes, so captivated Giovanni that he set himself to study them, and he drew them over and over again until he could do them with ease and grace, and he lacked nothing except the knowledge how to make the groundwork of stucco. Although many had puzzled themselves about this previously without discovering how to make a stucco at the fire with gypsum, lime, Greek pitch, wax and brick-dust, and to gild it, they had not found the right way to make this stucco like that discovered. But when the interior arches and tribune of S. Pietro were being constructed of lime and puzzolana, as related in the Life of Bramante, all the carving of foliage, ovals and other members being cast in clay moulds, Giovanni examined the composition of the lime and gravel, to try if he could make figures in bas-relief. After various experiments he achieved success, except in rendering the outer skin as smooth, delicate and white as did the ancients. He therefore tried the effect of mixing with the lime of white travertine something white instead of puzzolana. After some experiments with fragments of travertine, he obtained a livid colour and an uneven surface. But after pounding fragments of the whitest marble which he could find, and mixing it with white travertine lime, he obtained what was doubtless the true ancient stucco with all the requisite properties. Greatly delighted, he showed Raphael what he had done, and the master, who was then engaged upon the loggias of the papal palace for Leo X., employed Giovanni to cover the vaulting with stucco, with rich ornaments surrounded by grotesques similar to those of the ancients, full of the charming inventions and the most varied and curious things imaginable. He did the entire decoration in bas- and half-relief, introducing therein scenes, landscapes, foliage, and various friezes, endeavouring to achieve the utmost of which that art is capable. He not only equalled the ancients

but surpassed them, as far as can be judged, for these are incomparably finer in design, invention and colouring than those of the Coliseum, the baths of Diocletian, and other places. Where else can we see birds so painted, with their plumage and other parts so truthfully depicted? They are varied like nature, and placed on branches and twigs, with the corn, vegetables and fruits necessary for their nourishment. It is the same with the fish and other animals done by Giovanni there, but as I cannot hope to describe them adequately I will say no more. What can I say of the variety of the fruits and flowers there resembling nature, and the most natural musical instruments? It is well known that at the end of the loggia Giovanni painted some balusters in continuation of the real ones, with a carpet flung over them, the Pope not having decided what to have done there. One day, when the Pope was going in haste to the Belvedere, a groom who did not know this ran from some distance to remove one of the painted carpets. In fact, with all respect to the other artists, we may say that this is the finest painting ever seen by mortal eye. I will venture to assert that it has led to Rome, and every other part of the world, being filled with such paintings. For besides the fact that Giovanni rediscovered this stucco and the other grotesques, others have followed his example, whilst his numerous apprentices learned under him, and then scattered through the provinces.

Giovanni continued the work of the loggia, doing the stucco compartments, the wall-paintings and vaulting of the other loggias, lovely for their fine invention of the vine-stems laden with bunches of grapes, the briony, jessamine, roses, and various kinds of animals and birds. Pope Leo, wishing to have the hall of his guard painted, on the level of the loggia, Giovanni did some compartments of variegated stones, like the ancient incrustations of the Romans in their baths, temples and other places, as we see by the Rotonda and the portico of S. Pietro, and he also did a frieze of infants, lions, the papal arms, and arabesques. In a hall next this, where the chamberlains are, Raphael did apostles in tabernacles of life-size and great beauty in grisaille. Over the cornices Giovanni drew parrots of various colours, then in the Pope's possession, with baboons, apes, civets, and other curious animals. But Paul IV. destroyed all to make some retiring-rooms, depriving the palace of a remarkable work, which he would not have done had he possessed any taste for art. Giovanni painted the cartoons for the chamber hangings, which were afterwards woven in Flanders in silk

and gold. They represent infants playing about festoons, with the device of Pope Leo and various animals drawn from life. These remarkable hangings are now in the palace. He also made the cartoons, full of arabesques, for the arras in the first rooms of the consistory. While thus engaged Giovanni did the greater part of the façade of the palace of M. Giovanni Battista dall' Aquila, then building at the top of the Borgo Nuovo, near the piazza of S. Piero, considered a remarkable work. He executed and painted all the stucco for the loggia of Cardinal Giulio de' Medici's villa under Monte Mario, with animals, arabesques, festoons and friezes of such beauty that he seems to have determined to surpass himself; and the cardinal, who admired his ability, besides doing much for his relations, gave him a canonry of Civitale in Friuli, which Giovanni gave to a brother. For the same villa Giovanni did a fountain, the spout of which was an elephant's head. He imitated in everything the temple of Neptune recently discovered among the ruins of the principal palace, and richly adorned with marine objects and various stucco ornaments. He far surpassed his model with his beautiful animals, shells, and similar accessories. He then did another fountain in the hollow of a ditch surrounded by a wood, making the water-spouts issue ingeniously from among the stones so as to appear really natural. At the top of the cavern he made a lion's head of spungite, surrounded with a garland of maiden-hair and other plants most gracefully adorning the whole, and forming an incredibly delightful spot. That done, the cardinal created Giovanni a knight of St. Peter, and sent him to Florence to decorate a chamber in the Medici palace, on the site where Cosmo the elder had made a loggia for the citizens to meet, as the most noble families then used to do, to paint it with arabesques and stucco. The loggia had been made enclosed, following the design of Michelagnolo, and in the form of the chamber with two barred windows, the first of the kind erected outside palaces. Giovanni decorated the whole of the vaulting with stucco and painting, introducing the six balls, the Medici arms, into a circle, supported by cherubs in relief, in graceful attitudes. He also introduced some fine animals and the devices of the illustrious men of the house with some stucco scenes in half-relief, and did the background in white and black like cameos, of the utmost beauty. Four arches under the vaulting, twelve braccia by six, were not then painted, but many years afterwards Giorgio Vasari, a youth of eighteen, did them when in the service of Duke Alessandro de' Medici, his first patron, in 1535, representing

the acts of Julius Cæsar, in allusion to Cardinal Giulio. In a small barrel vault next this chamber Giovanni did some things in stucco and some fine paintings. Although these pleased the Florentine painters of the day for their vigour, skill, invention and fancy, yet being accustomed to their slow method of drawing everything from life for their works, they did not praise them unreservedly, perhaps because they had not the courage to imitate them.

On returning to Rome Giovanni did a border of rich festoons about the loggia of Agostino Chigi, painted by Raphael, making all manner of fruits, flowers and foliage, for each season, with such art that everything seems to stand out from the walls. The fruits and grain are so varied that they seem to comprise every variety known to Nature. Above a flying Mercury he has represented a pumpkin for Priapus, enveloped in its tendrils, and near the flowers he made a bunch of large figs, one of them bursting, a fancy expressed with inconceivable grace. But what more can I say? To conclude, I venture to affirm that in this branch Giovanni has surpassed all those who have best imitated Nature, as his elder-tree flowers, fennel, and other small things are stupendous. We also see here a great quantity of animals in the lunettes, surrounded by these festoons, and infants holding the attributes of the gods. Among them a lion and a sea-horse are highly esteemed for their fine foreshortening. On finishing this remarkable work Giovanni did a fine study in the castle of St. Angelo, and many small things in the Pope's palace, which I omit for the sake of brevity.

When Raphael died, causing Giovanni great sorrow, and Pope Leo also, the arts of design no longer had a place in Rome, and Giovanni spent many months at the villa of the Cardinal de' Medici, on some unimportant works. When Pope Adrian came to Rome he only did the lesser banners of the castle, which he had twice restored under Leo, together with the great standard on the top of the last tower. He also did four square banners when Pope Adrian canonised Antonino, archbishop of Florence, and Hubert, bishop of some city in Flanders. One of these, with the figure of St. Antonino, was presented to the church of S. Marco in Florence, where the saint's body rests[1]; a second, with St. Hubert, was placed in S. Maria *de Anima*, the German church at Rome; and the other two were sent to Flanders. On the election of Clement VII., whom Giovanni had often served, he at once returned to Rome from Udine, whither

[1] In 1522.

he had fled to avoid the plague. For the coronation of the Pope he was employed to make a rich decoration above the steps of S. Pietro, and it was then arranged that he and Perino del Vaga should do some paintings on the vaulting of the old hall before the lower rooms leading from the loggias, which he had already painted to the rooms of the Borgio tower. Giovanni therefore did some fine stucco with arabesques and various animals, and Perino painted the chariots of the seven Planets. They also had to paint the façade of the same hall where Giotto painted, as Platina says in his *Lives of the Popes*, representing popes who suffered for the faith, so that the room was called the Hall of the Martyrs. But hardly was the vaulting finished when the unhappy sack of Rome took place, and Giovanni, having suffered both in person and property, returned to Udine, intending to make a long stay. But when Pope Clement returned to Rome after crowning Charles V. at Bologna, Giovanni also went back, and after having made new standards for the castle of St. Angelo, he was employed to do the ceiling of the principal chapel of S. Pietro. Frà Mariano of the Piombo dying at that time, the office was conferred on Bastiano Viniziano, the celebrated painter, while Giovanni was accorded a pension of eighty ducats of the chamber upon it. The troubles of the Pope being then nearly at an end, and Rome quieted, Clement sent Giovanni with many promises to Florence to decorate the tribune of the new sacristy of S. Lorenzo, adorned by the magnificent sculptures of Michelagnolo. With the aid of many of his men Giovanni here did some beautiful foliage, bosses, and other ornaments of stucco and gold, diminishing gradually towards the central point. But in one thing he lacked judgment, as on the flat friezes forming the ribs of the vaulting he made foliage, birds, masks and figures which cannot be seen from the ground owing to the distance, and because they are made on a coloured ground, although they are very beautiful. If he had coloured them they would be visible, and the work would be much lightened and enriched. He only needed fifteen days to finish this work when the news came of Clement's death, and he lost all hope, especially of the reward which he expected from the Pope. Perceiving, though late, how fallacious are the hopes of those who depend on the lives of princes, he returned to Rome. Although he might have lived on his offices and income, and served Cardinal Ippolito de' Medici and the new Pope Paul III., he resolved to return to Udine. Accordingly he went back to live with the brother to whom he had given the canonry, intending never to take up the

brush again. However, he married and had children, and was forced by instinct to take up work again in order to support his family and leave them well provided. At the request of the father of Giovan Francesco di Spilimbergo, knight, he painted a frieze of a hall full of festoons, infants, fruits, and other fancies; he then decorated the chapel of S. Maria at Civitale with charming stuccoes and paintings. For the canons of the duomo there he did two fine standards, and for the brotherhood of S. Maria di Castello at Udine he painted a rich banner of the Virgin and Child, and a graceful angel offering him the castle, which is on a hill in the midst of the city. In the palace of Grimani, Patriarch of Aquilea, at Venice, he decorated a fine chamber with stucco and painting. It contains some beautiful little scenes by Francesco Salviati.

In 1550 Giovanni went on foot to Rome to celebrate the Jubilee, clothed as a poor pilgrim, in the company of common people, and he remained unrecognised there for several days. But one day, on going to S. Paolo, he was recognised by Giorgio Vasari, who was on his way thither in a coach with M. Bindo Altoviti his friend. Giovanni at first denied his identity, but was at length forced to disclose himself, and to say that he was in great need of Giorgio's assistance with the Pope, because his pension on the Piombo had been refused him by Frà Guglielmo, a Genoese sculptor,[1] the holder of the office after Frà Bastiano. Giorgio mentioned the matter to the Pope, and it was put right, and subsequently exchanged for a canonry in Udine for a son of Giovanni. But being again annoyed by Frà Guglielmo, Giovanni came from Udine to Florence on the creation of Pope Pius, to obtain the Pope's aid and favour by means of Vasari. He was there introduced by Giorgio to the duke,[2] as they were going to Siena *en route* to Rome, whither the Duchess Leonora also went, and his highness not only satisfied his requirements, but the Pope set him to finish the last loggia above the one done by Pope Leo. He then retouched the whole of the first loggia. This was a mistake, because by retouching it *a secco* he destroyed the masterly strokes of his better age and lost its original vigour and freshness. On completing this work Giovanni also ended his life, at the age of seventy, in 1564, expiring at Rome, where he had lived for so many years in such repute. He was always God-fearing and a good Christian, but especially so in his last years, and in his youth took few pleasures except hunting and

[1] Guglielmo della Porta, but he was a native of Milan.
[2] In 1560.

fowling. He used to go out on feast days with his hunting-horn about ten miles from Rome, and as he shot very well with the gun and crossbow, he rarely returned without being laden with wild geese, pigeons, wild ducks and other animals found in those marshes. Many declare that Giovanni invented the painted canvas ox, behind which one can fire without being seen by the game, and he always kept dogs for his hunting which he trained himself. He must be enumerated among the chief men of his profession. He desired to be buried in the Rotonda near his master Raphael, in order not to be separated from him in death whom he had never left when alive, and as they were both good Christians, we may believe that they are now enjoying the eternal blessedness together.

BATTISTA FRANCO, Painter of Venice
(1498–1561)

BATTISTA FRANCO having studied design in his early childhood, went at the age of twenty to Rome, where, after having devoted himself to various styles for some time, he resolved to imitate nothing but the designs, paintings and sculptures of Michelagnolo. Accordingly there was nothing of that master which he did not copy, and before long he became one of the first draughtsmen frequenting Michelagnolo's chapel, and for some time he did nothing but draw without caring to paint. However, when in 1536 Antonio da San Gallo was preparing a magnificent trophy for the coming of Charles V., on which all artists good and bad were employed, Raffaello da Montelupo, who was to decorate the Ponte S. Angelo and make the ten statues for it, contrived that Battista should have something to do, for he recognised in him a fine draughtsman and an intelligent youth. Accordingly he spoke to San Gallo, and Battista obtained four large scenes to be done in grisaille on the façade of the Capena gate, now called S. Bastiano, by which the emperor was to enter. Although he had never touched colours, Battista did the arms of Paul III. and the emperor over the gate with a Romulus holding the papal and imperial crowns above them, a figure of five braccia, clothed in the ancient style, wearing a crown, with Numa Pompilius on his right, and on his left Tullius Hostilius, and the letters QVIRINVS PATER above. One of the

scenes on the façades of the round towers on either side of the gate was Scipio the Great triumphing over Carthage, and the other the triumph of Scipio the Less after the destruction of Carthage. One of the two pictures outside the large tower contained Hannibal repulsed by a tempest under the walls of Rome, the other on the left represented Flaccus entering the gate to relieve Rome against Hannibal. All these scenes were of considerable merit, and much praised as being Battista's earliest works, and by comparison with those of the others. If Battista had first begun to paint and learned the use of colours and the brush he would doubtless have surpassed several of the competitors, but he persisted in an opinion held by many, that a painter need only know drawing, to his great prejudice. However, he did much better than some who decorated the arch of S. Marco containing four scenes on either side, the best being those by Francesco Salviati and Martin[1] with other German youths who had come to Rome to learn.

I must not omit to say that Martin, who excelled in grisaille, did some battle-scenes with the utmost vigour and with fine invention, of conflicts between Christians and Turks. The quickness and carefulness of Martin and his men were marvellous, as they finished the work in time, never leaving it, and as they had a continual supply of drink they were always drunk, but warmed by the good Greek wine and the enthusiasm of work they performed wonders. When Salviati, Battista and Calavrese saw what they had produced they admitted that a painter must begin to use the brush early. Battista therefore ceased to devote so much time to design, and sometimes coloured.

When Montelupo arrived in Florence great preparations were being made to receive the emperor. Battista accompanied him, and found work well advanced. However, he was given a pedestal to do with figures and trophies for the statue of Frà Giovanni Antonio Montorsoli at the corner of the Carnesecchi. From this the artists recognised his merits, and he was again employed on the coming of Margaret of Austria, wife of Duke Alessandro, especially on the apparatus made by Giorgio Vasari in the palace of M. Ottaviano de' Medici, where the lady was to dwell. When these festivities were over, Battista began carefully to draw Michelagnolo's statues in the sacristy of S. Lorenzo, frequented then by all the sculptors and painters of Florence, among whom Battista acquitted himself well, but his mistake in not drawing from life or using colours became manifest, as

[1] Martin van Heemskerk, 1458–1573.

drawing statues only rendered his style hard and dry, of which faults he could never rid himself, as we see by a painting on canvas of Lucretia violated by Tarquin, very carefully finished. While frequenting the sacristy Battista made the friendship of Bartolommeo Ammannati, the sculptor, who, together with many others, was studying the things of Buonarotti. Ammannati received into his house Battista and Genga of Urbino, and they all lived together for some time, studying art with great success.

When Duke Alessandro perished in 1536 and Duke Cosimo succeeded him, many of the late duke's servants continued in the service of his successor. Among those who did not was Giorgio Vasari, who returned to Arezzo, determined never to follow courts again, for he had lost his first master, Cardinal Ippolito de' Medici, and then Duke Alessandro. This led to Battista being employed to work in the duke's wardrobe, where he painted a large square picture after Frà Bastiano and Titian of Pope Clement and Cardinal Ippolito, with Duke Alessandro, copied from Pontormo. Although this work did not realise expectations, he began to make a cartoon like that of Michelagnolo which he had seen in that wardrobe, coloured by Pontormo, of a *Noli me tangere*, but with larger figures, and no colouring, and then painted a picture from it. This he did far better, his cartoon being excellent, and drawn with great patience.

After the affair of Montemurlo, where the rebels against the duke were routed and taken, Battista depicted the battle intermingled with poetical fancies of his own, which was much admired, although in the deeds of arms and the actions of the prisoners he evidently borrowed largely from Michelagnolo. The battle was in the background, while in the foreground were the huntsmen of Ganymede standing to admire Jove's bird carrying the youth in the sky, copied from Michelagnolo's design. It was intended to be a representation of the young duke in the midst of his friends transported to heaven by God, or something similar. Battista first made the cartoon and then painted the picture with extreme care, and it is now among his other works in the upper rooms of the Pitti palace, lately completed by the duke.

Battista, having thus served the duke, was employed on the apparatus for his marriage with Leonora of Toledo to do a triumphal arch for the Prato gate, where Ridolfo Ghirlandaio painted some scenes of the duke's father Sig. Giovanni; one

representing his passage of the Po and Adda in the presence
of Cardinal Giulio de' Medici, afterwards Clement VII., Pros-
pero Colonna and others; and above it the redemption of
St. Secundus. Opposite this Battista did Milan surrounded by
the camp of the League, which departed leaving Sig. Giovanni
there. On one side of the arch he did a Chance with dishevelled
hair offering her hand to the Signor, and on the other Mars present-
ing a sword. In another scene under the arch Battista represented
Sig. Giovanni defending the Ponte Rozzo between the Tesino
and Biegrassa, like another Horatius, with incredible bravery.
Opposite was the taking of Caravaggio, with Sig. Giovanni in
the thick of the battle passing fearlessly through the midst of
the enemy with fire and sword. In an oval between the columns
he did the capture of Garlasso by a single company, and oppo-
site, between the other two columns, the taking of a bastion of
Milan from the enemy. On the front he did Sig. Giovanni on
horseback under the walls of Milan, in single combat with a
knight whom he transfixes with his lance. Over the principal
cornice, meeting the end of the one on which the frontispiece
rests, he did another large scene of Charles V. seated on a rock
crowned with laurel and holding the sceptre, and at his feet
the River Betis with a vase pouring water from two mouths,
and the Danube beside it with its seven mouths. I will not
mention the numberless statues on the arch, as for the present
I am only dealing with Battista Franco, and it would be
superfluous to speak of the statues, as they no longer exist
to be seen and examined, and the apparatus for the marriage
has been described at length by others.

To return to Battista. The best thing he did for the wedding
was one of the ten pictures for the great court of the Medici
palace, representing Duke Cosimo in grisaille, dressed in all the
ducal insignia. But in spite of his diligence he was surpassed
by Bronzino and the others, who were inferior to him in design
but who excelled him in invention, vigour and the treatment
of grisaille, for, as I have elsewhere remarked, paintings must
be executed with ease and the things disposed with judgment,
too much effort making them appear hard and crude. Too great
a strain often spoils a work, destroying the facility, grace and
vigour which are usually natural gifts, though they may to a
great extent be acquired by study and art.

When Ridolfo Ghirlandaio took Battista to the Camaldolite
monastery of the Madonna di Vertigli in Valdichiana, a member
of the monastery of the Angeli at Florence, and now a head

Benedictine monastery, which, being outside the Pinti gate, was ruined during the siege of Florence, he did the scenes in the cloister, while Ridolfo was engaged upon the picture and decoration of the high altar. That done, they did other paintings for that holy place so celebrated for the miracles wrought by the Virgin there. Returning to Rome about the time when Michelagnolo's Last Judgment was uncovered, Battista, as an admirer of that style, hastened to see the marvel. Resolving to stay in Rome, he painted a loggia facing the piazza for Cardinal Francesco Cornaro, who had restored his palace beside S. Pietro communicating with the portico towards Campo Santo, representing arabesques full of small scenes and figures, a work executed with great diligence, and considered very fine.

About the same time, in 1538, Francesco Salviati, having done a fresco in the company of the Misericordia, and being about to begin the decoration, stayed his hand owing to his rivalry with Jacopo del Conte. On hearing this, Battista sought an opportunity of showing himself a better master than Francesco, and the first in Rome. By means of his friends he induced Monsignor della Casa to give him the work, after showing his design. He then did a St. John the Baptist cast into prison by Herod. But although executed with great labour, it was not considered nearly equal to Salviati's, being too laboured and executed in a crude and melancholy style, destitute of order or composition, and altogether lacking the grace and charm of Francesco's colouring. We may thus judge that those who think they do better in studying the torso, an arm, leg, or other member, making good muscles and understanding them all, are in error, for this is a part and not the whole, and those who do the part well ought to make everything correspond, and produce a composition which renders their conception without confusion. It is necessary above all to have vivacious and graceful heads, not crude ones, and so much black in the nudes that they stand in relief and fade into the distance, as may be required, to say nothing of the perspective, landscapes, and other parts of a good painting, in which the things borrowed from others should be so treated as not to be easily recognised. Battista therefore perceived too late that he had lost too much time upon the details of muscles and careful designing, without taking account of the other branches of art.

On completing this unsuccessful work he entered the service of the Duke of Urbino, by means of Bartolommeo Genga, being employed to paint a large vault in the church and chapel

adjoining the palace of Urbino. He set to work immediately to make the designs and, imitating Buonarotto's Last Judgment, he represented the saints in glory upon clouds and a choir of angels about the Virgin, who is standing to be crowned by Christ, while the patriarchs, prophets, sibyls, apostles, martyrs, confessors and virgins stand about in various groups and attitudes, rejoicing at the coming of the Virgin. This work afforded a great opportunity for Battista to show his skill, if he had adopted a better way, not only by learning to colour in fresco, but in employing better order and judgment. But he retained his old style, making the same figures, the same draperies, and the same members. Moreover, his colouring lacked charm, and everything was laboured. The Duke Guidobaldo was not pleased, nor Genga nor the others, who had expected great things corresponding to the fine design which he had shown them at the outset. Indeed, in the making of designs Battista had no peer.

The duke recognized this, and thought he would have his designs executed by some who made beautiful earthenware vessels at Castel Durante, who had made great use of Raphael's numerous engravings and those of other great artists. The duke then got Battista to do countless designs which, when executed in that earthenware, proved marvellously successful. Great quantities of these vases were made, sufficient for a royal treasure, and the paintings on them might have been done in oils by the greatest masters. Duke Guidobaldo sent a double set of these vases, which resembled in the quality of the ware the ancient ones of Arezzo made in the time of King Porsenna of Tuscany, to the Emperor Charles V. and another to Cardinal Farnese, brother of Signora Vettoria, his consort. So far as we are aware, the Romans did not know of this method of painting on vases. The ones found containing the ashes of their dead or other things have the figures hatched, with only black, red or white colouring, and never glazed or containing the modern charm and variety of painting. It is not possible that the examples have been lost, since ours resist bad weather and everything, and even a burial of four thousand years would not destroy the painting. Although such vases were produced in all Italy, the best and the finest ware came from Castel Durante in the state of Urbino, and from Faenza, the finest being very white with few paintings, and those in the middle or round them charmingly coloured.

But to return to Battista. For the wedding of the Duke of Urbino to Signora Vettoria Farnese he did all the paintings

for the arches made by Genga, who was head of the apparatus, assisted by his young men. But as the duke feared that Battista would not finish such a great task in time, he sent for Giorgio Vasari, then engaged in painting a large chapel and the high-altar picture for the white monks of Scolca Olivetani at Arimini, to come and help Genga and Battista. But feeling indisposed at the time Vasari excused himself, writing that he felt sure that the skill and knowledge of Battista would enable him to finish everything in time, as indeed he did. On completing the work at Arimini, Giorgio came to make his excuses in person, and the duke showed him the chapel painted by Battista, wishing to hear his opinion. Vasari praised it greatly and extolled the ability of the artist, who was liberally rewarded by the duke. Battista, indeed, was then at Rome designing the statues and all the antiquities there for a large book, which was an admirable work.

Meanwhile M. Giovanni Andrea dall' Anguillara, a rare poet in some branches of his art, had collected a number of fine spirits, and in the great hall of S. Apostolo he prepared a rich scene for the performance of the comedies of various authors before nobles and great personages, with different places for the spectators, and rooms for the cardinals and other great prelates where they could see and hear without being seen. The company included painters, sculptors, architects, as well as the players, and Battista and Ammannato, who were also members, were charged to do the scenery and decorations. Battista designed these from statues by Ammannato so excellently that he won the greatest praise. But as the great expenses exceeded the receipts, M. Giovanni Andrea and the others were forced to remove these things from S. Apostolo and take them to the new church of S. Biagio, in Strada Giulia. There Battista rearranged everything, and many comedies were performed, to the great delight of the people and courtiers of Rome. This was the origin of the travelling comedians called the Zanni.

In 1550 Battista, aided by Girolamo Sicciolante of Sermonata, did the arms of the new Pope Julius III., with three figures and some infants, which were much admired, for the Cardinal di Cesio on the façade of his palace. In a chapel of the Minerva, built by a canon of S. Pietro and decorated with stucco surrounding stories of the Virgin and Christ, he painted a compartment of the vaulting, one of the best things he ever did. On one of the two walls he painted a Nativity with shepherds

and angels singing above the cottage; and on the other he did a Resurrection with soldiers surrounding the tomb in various attitudes. In the lunettes over these he made some large prophets; on the altar-wall he did Christ on the cross, the Virgin, St. John, St. Dominic and other saints in niches, comporting himself like a great master. But as his gains were small, and Rome is an expensive place to live in, he went to his native Venice, after doing some small things on canvas, hoping to change his fortune with his country. His fine design made his reputation there, and in a few days he was employed to do a panel in oils for the chapel of Monsignor Barbaro, patriarch-elect of Aquilea, in S. Francesco della Vigna; he represented St. John baptising Christ, with God the Father above and two cherubs below holding Christ's raiment. The angels contain the Annunciation, and at the feet of the figures he designed a canvas containing a number of small nude figures of angels, demons and souls in Purgatory, with the legend *In nomine Jesu omne genuflectatur.* This work, which was considered very good, brought him a great reputation, so that the bare-footed friars who have charge of the church of S. Jobbe, in Canareio, employed him to do a Virgin and Child between St. Mark and another saint, with angels scattering flowers, in the Chapel of ca Foscari in that church. At the tomb of Christopher Fugger, a German merchant, in S. Bartolommeo, he did a panel of Abundance, Mercury and Fame. For M. Antonio della Vecchia of Venice he painted, in life-size figures of great beauty, Christ crowned with thorns mocked by Pharisees.

The building of the flight of steps leading up from the first floor of the palace of S. Marco having been executed from the design of Jacopo Sansovino, as will be related, and adorned with stucco by Alessandro the sculptor, Sansovino's pupil, Battista painted small arabesques for the whole and a number of figures in larger spaces, which have been much praised by artists, and then did the ceiling of the staircase. Not long after, when three pictures for the library of S. Marco were to be done by one of the best painters of Venice, the senators to be the judges and the prize a gold collar in addition to the ordinary reward, Battista painted three scenes, with two philosophers between the windows, and succeeded excellently, although he did not win the prize. In S. Francesco della Vigna the first chapel on the left on entering the church was allotted to him by the Patriarch Grimani, where he decorated the vaulting with rich divisions in stucco and paintings in fresco, executed with extraordinary diligence. But,

whether through his carelessness, or through having done some things in fresco in the villas of some nobles upon new walls, he died before he finished this chapel, though it was afterwards completed by Federigo Zuccaro of S. Agnolo in Vado, an excellent youth, considered one of the best painters in Rome. On the side walls Federigo did a Magdalene converted by the preaching of Christ and the Resurrection of her brother Lazarus, very graceful paintings. He then did an Adoration of the Magi for the high altar, which was admired. Battista died in 1561, and his numerous printed designs, which are truly admirable, have given him a great reputation.

In the same city of Venice and about the same time there flourished a painter called Jacopo Tintoretto,[1] who loved all the arts, especially music, and was an agreeable person in all his actions. In painting, however, he showed himself eccentric, fanciful, quick and resolute. He possessed the most stupendous brain that painting has ever known, as we see in all his works and compositions, which differ widely from those of other artists, and he surpassed himself with new and extraordinary inventions, the creations of his intellect, and worked at hazard, without design, as if to show that this art is a trifle. He sometimes left his finished sketches so gross that the pencil-strokes possess more vigour than design and judgment, and seem to have been made by chance. He has painted practically every kind of picture in fresco and portraits in oils at every price, and in this way he has done and is still doing most of his painting in Venice. In his youth he showed great judgment in many beautiful works, and if he had realised his natural gifts and aided them by study, as did those who followed the fine style of his predecessors, and had not abandoned the beaten track, he would have become one of the greatest painters ever seen in Venice, although he is a good and vigorous artist, possessing an alert, fanciful and cultivated mind.

It being ordained by the senate that he and Paolo Veronese, then youths of great promise, should each do a scene for the Hall of the Council, while Titian's son Orazio should do another, Tintoretto did Frederick Barbarossa crowned by the Pope, with a fine building and a great number of cardinals and Venetian nobles about the Pope, all portraits, and below them the Pope's band of music.[2] This picture may bear comparison with any others, not excepting Orazio's. This was a fight at Rome between the Germans of Frederick and the Romans, near the castle of

[1] Jacopo Robusti, 1518–94. [2] About 1556; destroyed by fire in 1577.

St. Angelo and the Tiber. It contains, among other things, a fine foreshortened horse jumping over a soldier. Some say that Orazio was here helped by his father. Near these Paolo Veronese did Frederick Barbarossa kissing the hand of Pope Octavius before his court to the prejudice of Alexander III., and four large figures above a window: Time, Concord with a bundle of rods, Patience and Faith, of unequalled merit. Not long after Tintoretto did a scene which was lacking in this hall, through the intervention of his friends, executing it in a marvellous manner, so that it is among the best things he ever did, so great was the incitement to equal if not surpass the work of his rivals there. It represents Pope Alexander excommunicating Barbarossa and the emperor forbidding his followers to obey the Pope. Among other fancies in it, where the Pope and cardinals are throwing down the torches and candles as is done at an excommunication, there is a group of nude figures below disputing for these torches and candles, of the utmost beauty and charm. Some pedestals, antiquities and portraits of nobles scattered about this scene are very well done and brought him fame and general favour. In the principal chapel of S. Rocco, under the work of Pordenone, he did two oil-paintings,[1] occupying the entire width of the chapel, namely twelve braccia each. In one he represented a hospital full of beds and sick people in various attitudes, who are tended by St. Roch, and among them are some finely managed nudes, and a remarkable dead body foreshortened. The next scene, also of St. Roch, is full of beautiful and graceful figures, indeed it is considered one of his best works. In a scene of the same size in the middle of the church he did the Pool of Bethesda, a work of considerable merit. In S. Maria dell' Orto, where the Brescian painters Cristofano and his brother [2] decorated the ceiling, Tintoretto painted the two walls of the principal chapel in oils on canvas, twenty-two braccia high from the vaulting to the top of the seats. The one on the right represents Moses returning from the Mount and finding the people adoring the golden calf, and opposite is the Last Judgment, an extraordinary invention, really tremendous for the variety of the figures of every age and sex, with the blessed and damned in the distance and foreground. We see also the barque of Charon, but so different from the usual representations that it is both curious and beautiful. If this fanciful invention had been executed with correct and regular design, and had the painter displayed as much care in the details

[1] In 1559. [2] Cristofano and Stefano Rosa.

as he has upon the general effect, expressing the confusion and terror of that day, it would be a stupendous work, and at a first glance one is astounded, but on careful examination it looks as if it was painted as a jest. On the organ-shutters of the same church he painted in oils a Virgin mounting the Temple steps, the best-executed and happiest painting in that place. He also painted the organ-shutters of S. Maria Zebenigo with a Conversion of St. Paul, but not very carefully. In La Carità he did a Deposition from the Cross, and in the sacristy of S. Sebastiano, in competition with Paolo Veronese, who decorated the ceiling and walls there with many paintings, he did Moses in the Desert and other scenes, continued by Natalino, painter of Venice, and others. At the altar of the Pietà in S. Jobbe Tintoretto next did the three Maries, St. Francis, St. Sebastian, St. John, and a piece of landscape. On the organ-doors of the Servites' church he did St. Augustine and St. Philip, and beneath Cain killing Abel. At the altar of the Sacrament of S. Felice, namely in the vault of the tribune, he painted the four Evangelists, an Annunciation in one lunette, and Christ on the Mount of Olives in another, with the Last Supper on the wall. A fainting Virgin with the other Maries and some prophets by his hand may be seen at the altar of the Deposition from the Cross in S. Francesco della Vigna. In the Scuola of St. Marco by S. Giovanni e Paolo there are four large scenes, one of St. Mark in the air delivering a devotee from many torments prepared for him,[1] the instruments breaking in the hands of the executioner. It contains a quantity of figures, foreshortenings, armour, buildings, portraits, and other similar adornments. Another represents a storm, and St. Mark in the air releasing another devotee, but this is not so carefully finished as the first. The third represents a heavy rain and the soul of another devotee ascending to heaven, with a good composition of figures. The fourth, in which a devil is cast out, contains a large loggia in perspective, illuminated by a fire at the end which casts many reflections.[2] Besides these, Jacopo did a St. Mark for the altar, a picture of merit. These pictures, and many others, for I have only mentioned the best, were executed with such speed that he had finished before others thought he had begun.

In addition to these extraordinary traits, Tintoretto contrived

[1] Painted in 1548; now in the Accademia, Venice.
[2] The second and third are in the Palazzo Reale, Venice, the last in the Brera, Milan.

never to be without work, and when he could not obtain commissions through his own efforts and those of his friends, even for a small price, he would force his paintings on people as a gift. It is not long since, after he had done a large canvas in oils of the Passion of Christ in the Scuola of St. Rocco,[1] the men of the company resolved to have something magnificent painted on the ceiling, and to allot the work to the painter in Venice who should prepare the best design. They therefore invited Josef Salviati, Federigo Zucchero, who was then in Venice, Paolo of Verona and Jacopo Tintoretto to prepare designs, promising the work to the one who should acquit himself the best. While the others were preparing their designs, Tintoretto took measurements of the place, and then painted a large canvas with his usual quickness,[2] and put it in position, without anyone knowing. Then when the company met one morning to consider the designs and make their decision, they found Tintoretto's finished work already there. They remonstrated with him, saying that they had asked for designs and had not given him the work. He replied that this was his way of designing and he knew no other, and that designs and models ought to be done thus in order to avoid deception. If they did not wish to pay him for his labour he would give it to them, and in this way he so contrived that the work is still there, although many objected. It represents God descending with angels to embrace St. Roch, with many figures below emblematical of the other Scuole of Venice, La Carità, S. Giovanni Evangelistà, La Misericordia, S. Marco and S. Teodoro, done in his usual style. But it would take too long to recite all the paintings of Tintoretto, and this must suffice for this truly able man and admirable painter.

At the same time Venice possessed a painter called Bazzacco, a dependant of the Grimani house, who had spent many years in Rome, and was by favour employed to paint the ceiling of the great hall of the Council of Ten. But perceiving that he could not do it by himself, he took as companions Paolo of Verona and Battista Zelotti, and they divided between them the nine oil-paintings for that place, namely four ovals at the corners, four oblong panels, and a large oval in the middle. This, with three panels, was given to Paolo, who did Jove fulminating the Vices and other figures. Bazzacco did two of the smaller ovals and a panel, and gave two to Battista. One contains Neptune, and each of the others has two figures representing the greatness

<hr />

[1] In 1565. [2] About 1560.

and peacefulness of Venice. Although all three did well, Paolo proved himself the best, and so the Signory gave him the ceiling of the hall next this. Helped by Battista, he did St. Mark in the air supported by angels, and below Venice with Faith, Hope and Charity, not equal in excellence to the first, although good. In the Umiltà, Paolo did unaided a large oval of a ceiling representing an Assumption with other figures, a joyous, beautiful and well-conceived picture.

Another good painter of our day in Venice is Andrea Schiavone[1]; I say good because he has sometimes happened to produce good works, and has always imitated the good style so far as he was able. But the greater part of his works are pictures for private houses, and I only propose to mention the public ones. In the Pellegrini Chapel in S. Sebastiano he did a St. James with two pilgrims. In the vaulting of a choir in the Carmine he did an Assumption with many angels and saints, and in the chapel of the Presentation, a Presentation in the Temple containing many portraits. But the best figure there is a woman suckling a child and wearing a yellow dress. This is done in a style practised at Venice, in dabs or lumps, left unfinished. In 1540 Giorgio Vasari employed him to do a large canvas of the battle which had taken place just before, between Charles V. and Barbarossa,[2] one of the best works Andrea ever produced, and of great beauty. It is now in Florence in the house of the heirs of M. Ottaviano de' Medici, to whom Vasari presented it.

GIOVAN FRANCESCO RUSTICO, Sculptor and Architect of Florence

(1474 – 1554)

IT is remarkable that all who belonged to the school of the garden of the Medici under the patronage of Lorenzo the elder became excellent, a circumstance due to the extraordinary judgment of that veritable Mæcenas who was able to recognise and reward men of ability. Giovan Francesco Rustico, citizen of Florence, distinguished himself in designing and clay modelling, and Lorenzo, perceiving the youth's ability, put him to

[1] Andrea Meldolla, 1522–82.
[2] The defeat of the famous Barbary Corsair at Tunis on 21 July, 1535.

learn of Andrea del Verocchio, who was then teaching that rare genius Lionardo da Vinci. The style and methods of Lionardo so pleased Rustico, who thought the air of his heads and the motions of his figures the most graceful and vigorous he had ever seen, that he joined him after he had learnt to cast bronze, draw in perspective and carve marble, Andrea having gone to Venice to work. While they were thus associated Lionardo became very fond of Rustico, whose excellence and diligence in art he recognised, and he would do anything that Rustico desired. The latter, being of a noble family and possessing a competence, took to art rather as a pastime than for gain. Indeed, those artists who work chiefly for gain and not for glory rarely become excellent, whatever their talents. Besides, the toil for necessities aggravated by poverty and a family, and the doing things because it is necessary for the daily requirements and not when one is in the mood, is the work of a manual labourer, not of one who toils for glory, for good works are only produced after long consideration. Thus Rustico used to say in his riper years that it was first necessary to reflect, then to make sketches, then designs, to leave them for weeks and months without seeing them, and then to select the best and execute them. Everyone could not do this, certainly not those who work for gain alone. He also said that works ought not to be exhibited before they are finished, to allow of their being changed as often and in as many ways as one pleases without ulterior considerations.

Rustico learned much from Lionardo, especially in making horses, of which he was very fond, producing them in clay, in wax, in full and in bas-relief, and every imaginable way. Some in our book are so well designed as to show the ability and knowledge of Rustico. He could also paint, and did some meritorious pictures, though sculpture was his principal profession. As he lived a while in the via de' Martelli, he was very friendly with the family, which has never lacked great minds, especially with Piero, for whom, as a bosom friend, he made some small figures, including a Virgin and Child, seated upon clouds full of cherubin, resembling an oil-painting which he did afterwards with the cherubim forming a diadem about the Virgin's head.

When the Medici returned to Florence, Rustico introduced himself to the Cardinal Giovanni as a dependant of his father Lorenzo, and was well received. But as the ways of the court did not please him, being contrary to his sincere and quiet

nature, averse to envy and ambition, he preferred to live the life of a philosopher in solitude, enjoying peace and quiet. When he wished to recreate himself he would visit his artist friends or other intimates, though he did not cease to work when he wished or when opportunity arose. Thus, when Pope Leo came to Florence in 1515, he did some statues at the request of his friend Andrea del Sarto considered very beautiful. They so pleased Cardinal Giulio de' Medici that he employed Rustico to do in bronze the nude Mercury, about a braccia high, in the act of flight, standing on a ball, on the top of the fountain in the great court of the Medici palace. He put in his hands an instrument with four metal blades, which is turned by the water it spouts. A rod passes through the body of the figure to the mouth, the water from which strikes the instrument with its delicately balanced blades resembling a butterfly, and makes it turn. This figure was much admired for a small work.

Not long after Rustico prepared a model for a bronze David for the same cardinal, like that of Donato done for Cosimo the elder, to be placed in the first court, whence Donato's had been removed. This model gave considerable pleasure, but it was never cast in bronze, owing to Rustico's slowness. Thus Bandinello's marble Orpheus was placed there, and Rustico's clay David suffered neglect, which was a great pity. In a large medallion Rustico did an Annunciation in half-relief, with a fine perspective, assisted by Raffaello Bello the painter and Niccolo Soggi. Cast in bronze, it proved of unsurpassable beauty, and was sent to the King of Spain. He did a similar medallion in marble of the Virgin and Child and a little St. John the Baptist, placed in the first hall of the consuls of the art of Por S. Maria.

By this work Rustico won great credit, so that the consuls of the art of the merchants, having removed some clumsy marble figures over the three doors of the church of S. Giovanni, made in 1240, and having allotted to Contucci Sansovino the task of replacing those for the door facing the Misericordia, employed Rustico to do those for the door facing the Canonicate, to make three bronze figures each of four braccia like the old ones, namely St. John preaching between a Pharisee and a Levite.[1] This work exactly suited Rustico because the place was so important, and also because he was competing with Contucci. He at once made a small model, which he surpassed in the excellence of the finished work, employing all the consideration

[1] He was at work on this between 1506 and 1511.

and diligence requisite, and when done it was considered the best example of its kind yet produced, the figures being perfect in their graceful and vigorous aspect. The bare arms and legs are also good and excellently joined, not to speak of the hands and feet, and the gracious pose and heroic gravity of the heads. While engaged upon it Rustico would allow no one near save Lionardo da Vinci,[1] who never left him while he was moulding and casting until the work was complete. Many therefore believe, though nothing definite is known, that Lionardo worked at them himself, or at least helped Rustico with his advice and judgment. These bronze statues, the best ever executed by a modern master, were cast in three turns, and polished in Rustico's house in the via de' Martelli, and he also did the marble decoration about S. Giovanni with two columns, cornices, and the device of the art of the merchants. Beside the vigorous St. John, there is a fine, stout, bald-headed man with his arm at his side and his shoulder partly bared, holding a paper before him, his left leg over his right, and listening attentively to St. John to answer him. He wears two robes, a light one which plays about the naked part of the figure, and a thicker overmantle with graceful folds. The Pharisee is similar, holding his beard with his right hand, in a serious attitude; he draws somewhat back in his wonder at the words of St. John.

While engaged upon this, Rustico became tired of being obliged to ask money of the consuls or their ministers every day, as they were not always the same persons and are generally men who have little esteem for ability, and he sold a farm of his at S. Marco Vecchio, outside Florence, in order to finish the work. But in spite of his labour and expense he was but ill rewarded by the consuls and his fellow-citizens, as one of the Ridolfi, head of the office, always opposed him for some special reason; perhaps Rustico had not honoured him enough, or allowed him to see the figures at his ease. Thus what should have brought Rustico honour turned to his prejudice, and whereas he should have been esteemed at once as a noble citizen and a man of genius, his skill as an artist prejudiced his nobility in the eyes of the ignorant and foolish.

Rustico called in Michelagnolo to value the work for him, and the magistrates, persuaded by Ridolfi, called in Baccio d' Agnolo. Rustico complained, telling the magistrates that it was strange to call in a wood-carver to value the work of a sculptor, intimating that they were a herd of oxen, but Ridolfi

[1] But Leonardo was in Milan at the time.

replied it was quite right, and that Rustico was proud and arrogant. But, worse still, a work which did not deserve less than two thousand crowns was valued by the magistrates at five hundred, and only four hundred of them were paid, through the intervention of Cardinal Giulio de' Medici. In despair at such malignity Rustico determined never again to work for the magistrates, but only for individuals. He thus lived a solitary life in the rooms of the Sapienza, next the house of the Servite friars, doing some things to occupy his time, and wasting his money in seeking to solidify mercury in company with another hot-head called Raffaello Baglioni. Rustico painted in oils a Conversion of St. Paul on a panel three braccia by two, full of different kinds of horses ridden by the soldiers, in various attitudes and foreshortenings. This, with many other things by the same hand, is in the possession of the heirs of Piero Martelli, to whom he gave it. In a small picture he painted a charming and curious Chace full of small animals, now owned and valued by Lorenzo Borghini, who loves the arts. For the nuns of St. Lucia in the via di S. Gallo he did a *Noli me tangere*, done in clay in half-relief, afterwards glazed by Giovanni della Robbia and placed on an altar in the church in a macigno frame. For his friend Jacopo Salviati the elder he did a fine marble medallion for his palace at the Ponte alla Badia of the Virgin, and many others about the court of terra cotta, full of figures and other beautiful ornaments, mostly destroyed by the soldiers during the siege, the palace being fired by the party hostile to the Medici.

As Rustico loved the place, he would sometimes leave Florence dressed as he was, to go and stay there. Once outside the city he put his gown over his shoulder and sauntered slowly on, dreaming, until he arrived. On one occasion it happened to be warm, and he hid his gown in a sloe-bush, and had been two days at the palace before he remembered it. He then sent a man to look for it, and when it was found he exclaimed, "The world is too good; it will not last."

Rustico was a man of the utmost good nature and a friend of the poor, never allowing any to go away unsatisfied; for this he kept money in a basket, and gave according to his powers to all who asked. Once a person who often asked alms of him said to himself, not thinking he was heard: "Oh God, if I had in my room what is inside that basket, I could arrange my affairs." Rustico overheard, and after looking at him steadily, said, "Come here, I will satisfy you," and so saying emptied the basket into his cap, saying, "Go, and may God bless you!"

Soon after he sent for money to his friend Niccolo Buoni, who managed all his affairs. Niccolo, who kept account of his crops and invested money and sold his goods when the time came, used to give Rustico so much a week, in accordance with Rustico's desire. Rustico kept his money in the drawer of his inkstand without keys, and took out what he required for his household expenses.

But to return to his works. He did a beautiful wooden crucifix of life-size, to send to France; but it came to Niccolo Buoni, together with other bas-reliefs and designs now in his possession, when he proposed to leave Florence, hoping to change his fortune. For Duke Giuliano, who always favoured him, he did his profile in half-relief, and cast it in bronze, a fine work, now in the house of M. Alessandro, son of M. Ottaviano de' Medici. To Ruberto di Filippo Lippi the painter, his pupil, Rustico gave many of his bas-reliefs, models and designs, among them Leda, Europa, Neptune, and a fine Vulcan, and another bas-relief of a nude figure on horseback, of great beauty, now in the scriptorium of Don Silvano Razzi in the Angeli. He did a beautiful bronze female Grace, two braccia high, pressing her breast, but I do not know what happened to it or who has it. Of his clay horses, with men upon or beneath them, like those already mentioned, many are in private houses, for being most courteous, and not avaricious like the majority of such men, he gave them to his friends. Dionigi da Diacceto, a rich noble who, like Niccolo Buoni, kept Rustico's accounts, received several bas-reliefs from him.

There was never a more pleasant and fanciful man than Rustico, nor one fonder of animals. He so tamed a porcupine that it remained under the table like a dog, and sometimes pricked people's legs so that they drew them in quickly. He had an eagle, and a raven which spoke like a human being. He also studied necromancy, and I understand that he often frightened his apprentices and family thereby, and thus he passed his time free from care. Having made a fish-pond in which he kept snakes which could not escape, he delighted to watch their gambols and see their spirit, especially in summer. In his rooms at the Sapienza he gathered together a number of choice spirits, who called themselves the company of the Cauldron, not more than twelve in number, namely Rustico, Andrea del Sarto, Spillo the painter, Domenico Puligo, Robetta the goldsmith, Aristotile da Sangallo, Francesco di Pellegrino, Niccolo Buoni, Domenico Baccelli who played and sang delightfully, Solosmeo the sculptor,

Lorenzo called Guazzetto,[1] and Ruberto di Filippo Lippi, who
was their steward. Each of them might bring four guests, and
no more, to certain of their banquets and entertainments.

The order of their banquets, now quite gone out of use, was
thus: everyone brought something to eat, made with some
clever invention, which he presented to the president, who was
always a member, and he gave it to whom he pleased, so that
each one exchanged his dish for another's. At table the dishes
were passed round, and if two people brought the same thing
they were fined. One evening, when Rustico gave the feast, he
arranged an enormous cauldron to serve for the table, made
of a vat, in which they all stood seemingly in boiling water,
from the middle of which the dishes circulated. A bright light
was placed in the middle of the handle of the cauldron, illumi-
nating them all as they sat round. When all were comfortably
seated round the table inside the cauldron, a tree with many
branches issued from the pot with the viands hanging from its
branches, and when these were taken it descended below, where
musicians were playing. The same occurred with the second
and third courses, and so on, while the servants poured out
choice wines. This invention, finely decorated with canvas and
paintings, was much praised by the men of the company. In
this turn the present of Rustico was a cauldron made of pastry,
in which Ulysses was roasting his father to rejuvenate him, the
two figures being capons shaped like men, with well-disposed
members, every part being good to eat. Andrea del Sarto pre-
sented an octagonal church like S. Giovanni, but resting on
columns. The pavement was formed of jelly, resembling a vari-
ously coloured mosaic; the columns, which looked like porphyry,
were large sausages; the bases and capitals parmesan cheese;
the cornices were made of pastry and sugar, and the tribune
of quarters of marchpane. In the middle was a choir-desk made
of cold veal, with a book made of pastry, the letters and notes
being formed of peppercorns. The singers were roast thrushes
with open beaks, wearing surplices of slender pig's caul, and
behind these were two large pigeons for the basses, with six larks
for the sopranos. Spillo brought a tinker, made of a large goose
or similar bird, with all the necessary tools for repairing the
cauldron if necessary. Domenico Puligo of a sucking-pig made
a maidservant with her distaff watching a brood of chickens;
she was brought to wash the cauldron. Robetta made an
anvil out of a calf's head, with all the implements to keep

[1] Lorenzo Naldini.

the cauldron in repair. This was very fine and good, as were the other presents at that banquet as well as those at others which they gave.

The similar company of the Trowel, to which Rustico belonged, was founded thus: In 1512 a banquet was given one evening in the garden of Feo d'Agnolo in Campaccio; a player of the pipes and a pleasant man, he himself, Ser Bastiano Sagginati, Ser Raffaello de Beccaio, Ser Cecchino de' Profumi, Girolamo del Giocondo and Il Baia [1] being present, as they were eating their cream cheese Il Baia saw a heap of mortar with a trowel in it, left there the day before by a builder. He took some of the mortar with the trowel and stuffed it in Feo's mouth, as he was about to take a huge spoonful of cream, at which the others called out, "Trowel! trowel!" The company was then organised of twenty-four persons, twelve, who in the phraseology of the time had passed for the greater,[2] and twelve for the minor. Their device was a trowel, to which they afterwards added the little black vessels with large heads and a tail called *cazzuola* (trowel) in Tuscany. Their patron was St. Andrew, whose day they celebrated with a fine banquet.

The first members of the greater part were Jacopo Bottegai, Francesco Rucellai, Domenico his brother, Gio. Battista Ginori, Girolamo del Giocondo, Giovanni Miniati, Niccolo del Barbigia, Mezzabotte his brother, Cosimo da Panzano, Matteo his brother, Marco Jacopi, Pieraccino Bartoli; and of the lesser Ser Bastiano Sagginnotti, Ser Raffaello del Beccaio, Ser Cecchino de' Profumi, Giuliano Bugiardini the painter, Francesco Granacci the painter, Giovan Francesco Rustico, Feo Gobbo, Il Talina the player, his partner, Pierino the piper, Giovanni the trombone, and Il Baia the bombardier. The associates were Bernardino di Giordano, Il Talano, Il Caiano, Maestro Jacopo del Bientina, and M. Gio. Battista di Cristofano, coppersmith, both heralds of the Signoria, Buon Pocci and Domenico Barlucchi. Before many years, the reputation of the company increasing, it was joined by Sig. Giuliano de' Medici, Ottangolo Benvenuti, Giovanni Canigiani, Giovanni Serrestori, Giovanni Gaddi, Giovanni Bandini, Luigi Martelli, Paolo da Romena and Filippo Pandolfini Gobbo, with Andrea del Sarto, Bartolommeo Tromboni the musician, Ser Bernardo Pisanello, Piero the cloth-shearer, Il Gemma, mercer, and Maestro Manente da S. Giovanni, physician, as associates. They made countless feasts, but I shall only

[1] Jacopo di Corso di Giovanni.
[2] That is matriculated in one of the greater Arts or Guilds.

mention a few, for the sake of those who do not know the ways of such companies, which have now practically died out.

The first repast of the Trowel, arranged by Giuliano Bugiardini, was held in a place called Luia da S. Maria Nuova, where the bronze doors of S. Giovanni were cast. The president of the company commanded that everyone should dress as he pleased; but those who were dressed alike should be fined. At the appointed time they appeared in the most extraordinary costumes imaginable. At the banquet they were ranged according to their costumes, those dressed as princes first, the wealthy and nobles next, and then the poorer ones. But I cannot attempt to describe the revels which succeeded. At one feast, arranged by Bugiardini and Rustico, all the members came dressed as builders and labourers, with their trowels and hammers, and the minor members with hods and a trowel in their girdle. When they reached the first room, the host showed them the plan of a building to be erected by the company; and when the masters were seated about it the labourers began to bring materials for laying the foundation, namely vessels full of cream cheese for mortar, pastry sugared over, spices and pepper mixed with cheese for sand, and coarse sugar, plums and slices of cake for gravel. The bricks and tiles brought in baskets on hand-barrows were bread and cake. A pedestal being brought in, and judged unsatisfactory by the masons, it was resolved to break it in pieces, and they found the interior full of tarts and such things on which they fell to, being waited on by the labourers. They then brought a great column wound round with calf's tripe. Pulling this to pieces they ate the boiled veal, capons and other things of which it was composed. They next attacked its base of parmesan cheese, and its marvellous capital of roast capon and slices of veal with mouldings of tongue. But why should I relate all these particulars? A very ingenious architrave next entered on a car, with frieze and cornice, composed of too many viands to relate. When it was time to go, there came up mimic rain and thunder, and all left their work and fled back home.

Another time, when Matteo da Panzano was president, the banquet was arranged as follows: Ceres seeking her daughter Proserpine stolen by Pluto enters and asks the guests to follow her to Hell. After a discussion they agree, and enter a somewhat dark room, the door of which is a huge serpent's mouth, whose head covers the whole space. Ceres asks the barking Cerberus if her lost daughter has entered, and adds that she

desires to have her back again. The reply is that Pluto will not give her up, but invites Ceres and all the company to the wedding. They accept and enter through the serpent's mouth full of teeth, which being hinged opens and closes on each pair, and find themselves in a round room illuminated by one small light in the middle, so that they can scarcely recognise each other. They are shown into their places at the black-draped table by a hideous devil holding a fork, and Pluto commands that the pains of hell shall cease so long as they remain there, in honour of the wedding. The holes of the damned were all painted, and their torments, and on a light being applied flames sprang up which showed the nature of the torment. The viands were all animals of the most repulsive appearance but with delicate meats of various kinds underneath. The exteriors were serpents, toads, lizards, newts, spiders, frogs, scorpions, bats, and such things, with the most delicious viands inside. These were placed before each guest with a fire-shovel, and a devil poured choice wines from an ugly glass horn into ladles such as are used for melting glass, which served as drinking-cups. Instead of fruits, dead men's bones followed, pretending that the banquet, though hardly begun, was at an end, but they were of sugar. Then Pluto said he would retire with Prosperine, and that the damned should be tormented again; the lights all went out, horrible cries were heard, and in the midst of the darkness appeared the figure of Baia, one of the guests, condemned by Pluto to hell because in his fire-works he had always represented the seven mortal sins and the things of hell. While all were looking at this and hearing the cries the melancholy apparatus was removed, lights were brought and a regal scene took its place, decent servants bringing the remainder of a magnificent banquet. At the end there came a ship full of various confections, the masters of which, pretending to remove their wares, gradually led the guests into the upper rooms, where there was a rich scene and a much-admired comedy called *Filogenia* was performed. At dawn all returned light-heartedly to their homes.

After two years some of the company, having suffered very severely from the expenses of such feasts, being eaten alive so to speak, a banquet was arranged thus. The front door of their meeting-place was painted with figures such as are usually made on the doors of hospitals, namely a master receiving the poor and pilgrims. The guests were received in this manner and conducted into a ward with beds and other things, and in the

middle, round a great fire, were Bientina, Battista dell' Ottonaio, Il Barlacchi, Il Baia, and others of the same humorous disposition, dressed like tramps or beggars, who, pretending not to recognise the others, said the hardest things of those who had thrown away their money on such feasts. After this and when all had arrived, there came their patron St. Andrew, who led them from the hospital to a magnificent room where they sat at table and feasted joyfully, and the saint pléasantly exhorted them not to indulge in excessive expenses and to keep themselves out of the hospital, to be content with one chief feast a year, and so departed. They obeyed him, and for many years they had a fine banquet and a comedy, often performing *la Calandra*, by M. Bernardo, cardinal of Bibbiena, *i Suppositi* and *Cassaria* of Ariosto, *la Clizia* and *Mandragola* of Machiavelli, and many others.

Francesco and Domenico Rucellai at their turn did the *Harpies* of Fineo and later a dispute of philosophers upon the Trinity, showing St. Andrew in heaven with a choir of angels, a very fine thing. Giovanni Gaddi, with the help of Jacopo Sansovino, Andrea del Sarto, and Giovanfrancesco Rustico, represented Tantalus in Hell, who distributed the meats to the members dressed as gods, with many fanciful inventions of gardens, paradises, fireworks, and other things, a full description of which would occupy too much space for this story. Luigi Martelli when president gave his banquet in the house of Giuliano Scali at the Pinti gate, represented a blood-stained Mars in a room full of bloody human limbs, and in another room Mars and Venus in bed, and nearby Vulcan, who has covered them with his nets, calling the gods to see the outrage done him by Mars and his disreputable wife.

But after this somewhat lengthy digression, which however I do not think out of place, I return to Rustico. Being discontented after the expulsion of the Medici in 1528, he departed from Florence, leaving his affairs in charge of Niccolo Buoni and Lorenzo Naldini, called Guazzetto, his apprentice, and went to France. Introduced to King Francis by Giovambattista della Palla, who was then there, and by his friend Francesco di Pellegrino, who had just arrived, he was well received and obtained a provision of five hundred crowns a year from the king, for whom he did some things about which there is no exact information. He was finally commissioned to do a bronze horse, double life-size, to carry a statue of the king. After preparing a model which pleased the king, he made ready to cast it in a

great palace which the king had devoted to his use. But the king died before the work was finished. At the beginning of the reign of Henry the provisions of many were cut off, and the expenses of the court curtailed, and it is said that Rustico, being old and not very well off, lived on the hire of the house given him by King Francis. But fortune inflicted yet another shock upon him, for King Henry gave the palace to Sig. Piero Strozzi, and Rustico would have been in difficulties but that worthy signor, grieving at the bad fortune of Rustico, sent him to an abbey of a brother where he could be cared for and spend the remainder of his days as his talents deserved.

Rustico died at the age of eighty, and most of his things went to Sig. Pietro Strozzi. I must mention that while Antonio Mini, a pupil of Buonarotto, was staying in France, being entertained at Paris by Rustico, some of Michelagnolo's cartoons, designs and models came into Rustico's hands, part of which Benvenuto Cellini had while in France, and he brought them to Florence. Rustico was not only unequalled in casting, but a man of excellent character, most kind to the poor, so that it was but right that Sig. Piero should help him in his need, as it is most true that God even in this life renders the double of what we do for our neighbours. Rustico designed excellently, as may be seen by our book and by the book of designs of Don Vincenzio Borghini. Lorenzo Naldini, called Guazzetto, has done some excellent sculptures in France, but I have not been able to obtain particulars of these or of all his master's work, though I cannot believe that he remained idle during all the years spent in France, only engaged on his horse. Lorenzo had some houses outside the S. Gallo gate, which were destroyed during the siege with others. This so grieved him that, when he returned to Florence in 1540, he drew his hood over his eyes as he approached the city in order not to see the ruins. The guards at the gate laughed when told why he was so muffled up. After staying a few months in Florence he returned to France, taking his mother with him, and he is still living and working there.

FRA GIOVANN' AGNOLO MONTORSOLI, Sculptor
(1507-1563)

MICHELE D' AGNOLO of Poggibonsi had a son born to him at Montorsoli, three miles from Florence on the Bologna road, where he owned a large and good property, to whom he gave his father's name of Angelo. As the child grew up he showed an inclination for design, and so, by the advice of some friends, his father put him to learn stone-cutting with some masters then at the quarries of Fiesole almost opposite Montorsoli. Before many months Angelo, who was with Francesco del Tadda [1] and other youths, learned to use his tools skilfully, and produced many works. Through Tadda he formed a friendship with Maestro Andrea, a sculptor of Fiesole, and the boy's intelligence pleased Andrea so much that he began to teach him, and so kept him for three years. Michele being dead, Angelo then went to Rome with other youthful stone-cutters, where they carved some of the bosses on the principal cornice of S. Pietro, receiving good pay. Leaving Rome for some reason, Angelo joined a master stone-cutter at Perugia, who in a year gave him the charge of all his work. But Agnolo, recognising that he could learn nothing there, went to Volterra to work on the tomb of M. Raffaello Maffei, called Il Volaterrano, where he showed promise of future success. He then learned that Michelagnolo was employing the best carvers to be found on the new sacristy and library of S. Lorenzo. He went to Florence, and from his first things there Michelagnolo recognised his talent and vigour, and that he could do more in one day than more skilled and elder masters accomplished in two, so that he gave this child the same salary as mature men drew. When this work was stopped in 1527 by the plague and other circumstances, Agnolo, not knowing what else to do, went to Poggibonsi, the home of his father and grandfather, and stayed a while with his uncle M. Giovanni Norchiati, a religious and learned man, designing and studying. Finding the world upside down, he resolved to attend to the salvation of his soul, and went to Camaldoli. But not liking the discomfort and abstinence he did not stay there. However, the fathers were glad to have him because he was of a good disposition, and he paid for his keep by carving with heads of men and animals the tops of the sticks which the friars carry

[1] Francesco Ferrucci.

when they go from Camaldoli to the desert or through the wood, when silence is ordained. Leaving the hermitage with the consent of the superior, Agnolo went to la Vernia, and remained there a while associating with the friars, for he was still drawn to the life. But the life there did not please him any better, and after inquiring concerning many orders in Florence and Arezzo, where he next went, and finding he could not easily study design and see to his salvation, he finally joined the Jesuits outside the Pinti gate at Florence, who received him gladly, hoping that he would help them with their stained-glass windows. But as those fathers do not say Mass by their rule, they keep a priest for this, their chaplain at that time being Frà Martino, a Servite, a man of good judgment and character. He recognised Agnolo's ability, and seeing how little he could exercise it among the friars who do nothing but say the paternosters, make windows, distil waters, till gardens and such things, and do not study letters, he succeeded in taking the youth from the Jesuits, and Agnolo became a Servite friar of the Nunziata at Florence on 7 October, 1530, as Frà Giovann' Agnolo. While attending to the ceremonies of the order, he studied the works of Andrea del Sarto there in 1531. In the following year he sang his first Mass with much pomp and ceremony to the great satisfaction of the fathers and his relations.

When the waxen images of Leo, Clement and other famous Medici were destroyed,[1] on the expulsion of the house, by youths who showed more folly than valour, the friars had them replaced by Agnolo and another of the brethren, who made new images of Leo and Clement, and soon after those of the King of Bossina and the old lord of Piombino, works which brought Agnolo considerable fame.

Michelagnolo being then at Rome with Pope Clement, who wished the work of S. Lorenzo to be continued, the Pope, who had sent for him about this, asked for a youth to restore some broken antiques of the Belvedere. Michelagnolo suggested Agnolo, and the Pope wrote to the general of the Servites, who reluctantly granted what he could not refuse. Agnolo therefore went to Rome and restored the left arm of the Apollo and the right arm of the Laocoon in the Belvedere, where the Pope gave him rooms, and prepared to deal similarly with the Hercules. As the Pope went almost every morning to the Belvedere for his pleasure and to say the office, the friar made an admirable portrait of him in marble which won him the Pope's

[1] In 1527.

affection, especially as he was a most industrious artist who designed all night to have something new to show His Holiness in the morning. Meanwhile a canonry became vacant in S. Lorenzo at Florence, a church built and endowed by the Medici, and the friar obtained it for M. Giovanni Norchiati, his uncle, chaplain in the church.

Pope Clement having at length decided that Michelagnolo Buonarotti should return to Florence and finish the sacristy and library of S. Lorenzo, instructed him to employ the best men whom he could find, especially the friar, as many statues were wanting, observing the same methods as those employed by Sangallo to finish the work of the Madonna of Loreto. Accordingly Michelagnolo took the friar with him to Florence and employed him a great deal on the statues of Duke Lorenzo and Giuliano and in finishing and attacking some of the difficulties of the perforated work. Agnolo learned much from the great artist by watching him work and observing every detail. Among the statues required there were the saints Cosmo and Damian on either side of the Virgin. Michelagnolo gave the St. Damian to Raffaello Montelupo and the St. Cosmo to the friar, directing them to work in the same room as himself. Agnolo with great diligence made a full-sized model, retouched by Michelagnolo, the head and arms by him in clay being among the choicest possessions of Vasari at Arezzo. Many blamed Michelagnolo, saying that he had made a bad choice, but the results prove the contrary.

After having finished the statues of Lorenzo and Giuliano, with the friar's aid, and then set them up, Michelagnolo was summoned to Rome by Pope Clement, who wished to make a marble façade for S. Lorenzo; but before he had been there long the death of Clement interrupted everything. However, the statue of the friar and the other works, though unfinished, were uncovered at Florence and much admired. Indeed, whether owing to his own diligence or the help of Michelagnolo, it proved the best figure he ever did in his life, and was truly worthy of its position.

Being released from the work of S. Lorenzo by the death of Clement, Michelagnolo turned his attention to the tomb of Julius II., and needing help he sent for the friar. Before leaving Florence Agnolo completed an extraordinary handsome figure of Duke Alessandro, in the Annunziata, in armour, kneeling, wearing a Burgundian helmet, his hand to his breast, recommending himself to the Virgin. On completing this he went to

Rome, where he proved of great assistance to Michelagnolo in the tomb.

Cardinal Ippolito de' Medici, learning that the cardinal Tournon wanted a sculptor to take to France to serve the king, sent him the friar, who accompanied the cardinal to Paris, he being prevailed upon to do this by Michelagnolo. The king received him graciously, and assigned him a new provision, commissioning him to make four large statues. The friar had not finished the models when, owing to the absence of the king on the confines of the realm in a war with the English, he was neglected by the treasurers and could not draw his provision or have what he required. Accordingly he departed in a rage, although the treasurers, on learning of his anger, paid him his arrears to the last farthing. It is true that before leaving he made known his intention to the king and the cardinal. From Paris he proceeded to Lyons, and thence by Provence to Genoa. After a short stay he went with friends to Venice, Padua, Verona and Mantua, seeing and occasionally designing buildings, sculptures and paintings with great delight. He was most pleased with the paintings by Giulio Romano at Mantua, and drew them with great care. Learning at Ferrara and Bologna that the Servites were holding a chapter-general at Budrione, he went thither to visit his friends, especially Maestro Zaccheria of Florence, at whose request he made two life-size clay figures of Faith and Charity in a day and a night. These being made to resemble white marble, were placed at a large fountain with a copper basin, and spouted water all day in honour of the newly elected general. Agnolo went with Zaccheria from Budrione to the Servite convent at Florence, and there did two much-admired clay figures of Moses and St. Paul, larger than life, in two niches of the chapter-house. Being sent to Arezzo by Maestro Dionisio, general of the Servites, afterwards made a cardinal by Pope Paul III., and who felt under an obligation to the general Angelo of Arezzo, who had reared and taught him, Agnolo did a fine tomb for that general of macigno, in S. Piero, with much carving and some statues, comprising an effigy of the general on the sarcophagus with two weeping infants extinguishing the torches of human life, and other ornaments, forming a most beautiful work. It was not quite finished when he was summoned to Florence by the proveditori of the apparatus made by Duke Alessandro for the reception of the Emperor Charles V., then returning victorious from Tunis. At the S. Trinità bridge at Florence he made

a beautiful recumbent figure of the Arno, eight braccia high, on a large pedestal, who is rejoicing with the Rhine, Danube, Biagrada and Ebro, made by others, at the coming of the emperor. At the corner of the Carnesecchi he did a figure of Jason, twelve braccia high, but not of equal excellence, owing to its great size and the short time, and this remark applies to a Hilarity at the corner of la Cuculia. But considering the shortness of the time, he won great honour among artists and the people generally. On finishing the work at Arezzo, and learning that Girolamo Genga was engaged upon a marble work at Urbino, the friar went thither, but as nothing came of it he proceeded to Rome, and thence in a short while to Naples, hoping to obtain the tomb of Jacopo Sannazzaro, a Neapolitan noble and a rare poet.[1] At Margoglino, a pleasant place with a fine view, Sannazzaro had built a magnificent and convenient house on the sea at the end of the Chaia, and left this place on his death to the Servites as a convent, with a fine church, directing Sig. Cesare Mormerio and the Count of Lif,[2] his executors, to have a tomb set up to him in the church. The friars recommended Agnolo to the executors, and the tomb was finally allotted to him for 1000 crowns, his models being considered much better than the others submitted by various sculptors. Agnolo sent Francesco del Tadda of Fiesole to get his marble, entrusting him with all the carved work, for the sake of speed. While he was thus engaged the Turks invaded Apulia, and the people of Naples, in their alarm, gave orders for the fortification of the city, and appointed four men of judgment to have charge of this. These men, in looking out for skilful architects, thought of the friar. The latter heard of this, and not thinking it well that he should be employed on matters of war, he sent word to the executors that he would do the tomb in Carrera or Florence, and that it should be finished at the appointed time. So he travelled from Naples to Florence, where Donna Maria, mother of Duke Cosimo, forthwith required him to finish the St. Cosimo which he had begun for the tomb of Lorenzo the elder. He did this, and then, as the duke had carried out a great part of the conduits for the villa at Castello, and desired a Hercules crushing Antæus for the top, the friar prepared a model. This so pleased the duke that he was com-

[1] Born at Naples in 1458. His most famous work, the *Arcadia*, afforded a model to similar compositions by other authors, of whom Sir Philip Sidney is perhaps the best known. He died on 27 April, 1530. The church containing his tomb is called S. Mario del Parto.

[2] Count d' Aliffe.

missioned to make it, and he went to Carrara to obtain the marble. He was glad to seize the opportunity of advancing the tomb of Sannazzaro, especially a half-relief. While he was there, Cardinal Doria wrote from Genoa asking for some skilful sculptor to finish the statue of Prince Doria, which Bandinello had never completed. Cibo, who received this letter, and had long known the friar, tried every means to induce him to go to Genoa. But Agnolo declared he neither could nor would serve the prince before he had fulfilled his promises to Duke Cosimo. Meanwhile he had advanced the Sannazzaro tomb and sketched the Hercules, with which he returned to Florence. There he worked with such speed that he would soon have finished; but a report spread that the marble would not be so perfect as the model, and that the friar would have difficulties in joining the legs of Hercules to the torso, so that M. Pier Francesco Riccio, major-domo, held back the provision, putting too much faith in Bandinello, who tried every means to avenge the injury he thought had been done him by Agnolo by promising to do the Doria statue when he had been released by the duke. It seemed that the favour of Tribolo, who did the decorations of Castello, was of no assistance to the friar, who, being a choleric man, left for Genoa, where he finished the Doria statue,[1] to the delight of the prince and the Genoese, though he did not abandon the Sannazzaro work, Tadda being engaged upon the remainder of the carving at Carrara. Although the statue was intended for the Piazza Doria, the Genoese placed it on the Piazza della Signoria, despite the protests of the friar, who said that since he had made it to stand isolated on a pedestal it would not look well against a wall. Indeed, it is impossible to do worse than set up in one place a work intended for another, for an artist adapts a painting or a sculpture to its site, taking into consideration the light and the points of view. The Genoese being pleased with this, and with the scenes and other figures made for the Sannazzaro tomb, desired the friar to do a St. John the Evangelist for their cathedral, which when finished filled them with amazement. On leaving Genoa Agnolo went to Naples and set up the Sannazzaro tomb. At the lower corners are two pedestals carved with the Sannazzaro arms, and in the middle a stone tablet of 1½ braccia, supported by two infants, containing the epitaph written by Jacopo himself. On each pedestal is a marble seated figure, four braccia high, one representing Minerva and the other Apollo, and between them are fauns,

[1] 1539.

satyrs, nymphs and other figures in bas-relief, playing and singing as described in the poet's *Arcadia*. Over this scene is a fine round urn richly carved containing Sannazzaro's remains, and above it is his bust with the words ACTIVS SINCERVS on the base, accompanied by two winged cupids surrounded by books. Two niches on the other walls of the chapel contain marble figures of St. James and St. Nazzaro of three braccia or more, on pedestals. When the work was finished the executors and all Naples were much pleased.

The friar, remembering that he had promised Prince Doria that he would return to Genoa to make his tomb in S. Matteo[1] and decorate the church, departed for Genoa, where he prepared models which greatly pleased the prince. Agnolo received a good provision of money, and employed several assistants. While thus engaged the friar made many friends among the lords and men of ability at Genoa, especially with some physicians who helped him with anatomy, and by this means, and by studying architecture and perspective, the friar became excellent.

The prince would often visit him at work, and became very fond of him, delighting in his conversation. At the same time, Angelo, one of his two nephews, whom he had left in charge of Maestro Zaccheria, a good and intelligent youth, was sent to him, and another youth came soon after, called Martino, son of one Bartolommeo, a tailor. The friar taught both these boys as if they had been his own sons, and made use of them on the works he had in hand. These he at length completed, finishing the chapel, the tomb and the decoration of the church, which forms a single cross at the upper end of the nave and three crosses at the lower end, the high altar in the middle standing isolated. The chapel is supported at the corners by five large pilasters which carry the cornice, and above it, resting immediately on the pilasters, are four half-circle arches, three of which have windows of no great size. Above these arches is a round cornice forming four angles at the corners between arch and arch, with a tribune above like a basin. The friar having made many marble ornaments about the altar at all four sides, placed a rich vase above for the Sacrament, between two marble angels of life-size. About it is an ornament of variegated and precious stones, such as serpentine, porphyry and jasper, set in the marble, and at the top in front of the principal chapel he made another course on a level with the pavement to the height of

[1] He worked at S. Matteo from 1543 to 1547.

the altar, forming a basement to four marble pilasters enclosing three spaces. In the middle one, which is larger than the others, is the body of some saint in a sepulchral urn, and in the side ones are two marble statues of evangelists. Above these is a cornice, and over the cornice four lesser pilasters bearing another cornice, and forming three more spaces corresponding to the lower ones. The middle one contains a Resurrection in full relief and larger than life. The same arrangement is followed on the side walls, a Pietà in half-relief being in the middle space over the tomb, the Virgin between David and the Baptist and St. Andrew and Jeremiah. The arches over the principal cornice, where the windows are, are of stucco and surrounded by infants. The angles under the tribune contain four sibyls also of stucco, as are the grotesques of the vaulting in various styles. Below the chapel is a room underground, approached by marble steps, and containing a marble sacrophagus with two cherubs above, made for the body of Sig. Andrea Doria, and I think it has been deposited there. Opposite on the altar is a handsome bronze vase containing some of the wood of the True Cross, given to Prince Doria by the Duke of Savoy. The walls of the tomb are incrusted with marble, and the vault decorated with stucco and gold with scenes representing the exploits of the Doria. The pavement is composed of variegated stones corresponding to the vaulting. Against the walls at the crossing above these are two marble tombs with panels in half-relief, one of Count Filippino Doria and the other of Sig. Giannettino of the same family. On the pilasters at the beginning of the nave are two handsome marble pulpits, and along the walls of the side aisles there are chapels decorated with columns and other ornaments, which render the church truly magnificent.

On the completion of the church Prince Doria began his palace, adding new buildings and fine gardens under the friar's direction. After making a lake before the palace, Agnolo did a sea-monster spouting water into it, resembling another which was sent to the Cardinal Granvella in Spain. He did a large stucco Neptune, which was placed on a pedestal in the prince's garden. He did two portraits of the prince in marble, and two of the Emperor Charles V., which were brought from Coves in Spain.

The friar had many friends during his stay at Genoa, including M. Cipriano Pallavicino, who, being a man of good judgment in art, has always been fond of associating with the best artists, the abbot Negro, M. Giovanni da Montepulciano,

the prior of S. Matteo, and, indeed, all the first nobles of the city where he won fame and wealth.

On finishing these works Agnolo went to Rome[1] to visit Buonarotto, whom he had not seen for many years, and to endeavour to resume his relations with the Duke of Florence, and finish his Hercules. But at Rome, where he bought a knight-hood of St. Peter, he learned that Bandinello, pretending that he needed marble and that the Hercules was spoiled marble, had broken it to pieces by permission of the major-domo Riccio, and used it for the cornices of the tomb of Signor Giovanni. The friar was so enraged at this that he refused to revisit Florence, considering that the presumption and insolence of Bandinello were insupportable.

While the friar was in Rome the Messinese decided to have a fountain on the piazza of their duomo, decorated with statues, and sent men to Rome to look for a good sculptor. They engaged Raffaello da Montelupo, but as he fell ill just as he was about to set out with them, they took the friar, who was anxious to have the work. Having placed his nephew Angelo with a wood-carver in Rome, where he showed unexpected talent, the friar took Martino with him to Messina, and arrived there in September 1547. After securing rooms, they began to bring the water from a distance, and sent to Carrara for marble, and with the aid of many sculptors and masons speedily completed the fountain. It has eight sides, four large and four smaller; two of the larger project outwards, forming an angle, and two lean inwards forming a plane with another surface on the other side of the smaller faces. The four outside faces project and make room for the four planes inside. The space contains a basin of considerable size which receives water from four marble rivers which surround the space. The fountain rests on four steps forming twelve faces, eight large ones forming an angle and four smaller ones, on which vases are placed. Under the four rivers are balusters, five palms high, and in each of the twenty angles there is a caryatid as an ornament. The circumference of the first octagonal space is 102 palms, and the diameter thirty-four, and on each of the twenty sides is carved a marble bas-relief, the subjects being appropriate to fountains and water, such as Pegasus forming the Castalian fountain, Europa crossing the sea, Icarus falling into the sea, Arethusa changed into a fountain, Jason crossing the sea with the golden fleece, Narcissus changed into a fountain, Diana at the spring converting Actæon

[1] In 1547.

into a stag, and so forth. At the eight angles divided by the projections of the steps of the fountain which rises two steps towards the basin and rivers and four to the rim are eight marine monsters of various forms, lying on socles, with their fore-paws in front resting on masks, which spout water into vessels. The rivers, which rest inside on a socle, so high that they seem to be seated in the water, are the Nile with seven infants, the Tiber surrounded by countless palms and trophies, the Ebro with numerous victories of Charles V., and the Cumano near Messina, from which the water of the fountain flows, and some reliefs and nymphs made with good judgment. Sixteen large jets of water discharge from this plane of ten palms, eight from the masks, four from the rivers, and four from some fish standing upright in the basin, seven palms high, throwing water from their mouths. On a socle four palms high in the middle of the octagon a winged and armless siren sits at each corner, and above these are four tritons, eight palms high, their tails intertwined and bearing a great cup, into which four superbly carved masks spout water. From the middle of the cup issue two hideous masks of Scylla and Charybdis, held by three nude nymphs, each six palms high, who hold the last cup, at the base of which are four dolphins, whose upturned tails support a ball from which water flows from four heads, as it does from the dolphins, which are ridden by four naked infants. At the very top is an armed figure of Orion, bearing the arms of Messina on his shield, of which town he is the fabled founder. Such is the fountain of Messina, which I could describe better by a design than by words. As it greatly pleased the Messinese they employed Agnolo to make another on the shore where the customs house is, which is also rich and beautiful, and although octagonal it differs from the first, having four faces of three steps and four lesser ones, and the edges of the great fountain have a carved pedestal and another inside. By the round steps is a marble cistern, oval in shape, which receives water from two masks on the parapet below the carved edge. In the middle of the basin is a pedestal of proportionate height, with the arms of Charles V., and at the angles are sea-horses which spout water between their hoofs. On the frieze under the upper cornice are eight masks spouting water, and at the top a Neptune, five braccia high, holding a trident, and a dolphin resting beside his right foot. On two side pedestals are Scylla and Charybdis as two monsters with dogs' heads surrounded by furies, very well made. This also greatly delighted the Messinese, who, having

found a man to please them, set him to begin the façade of the duomo, and they afterwards gave him a commission to do twelve marble Apostles, five braccia each, for the twelve chapels of Corinthian work, six on each side. But the friar only finished four himself, doing St. Peter and St. Paul, very good figures. At the top of the principal chapel there was to be a marble Christ surrounded by a rich ornament, and a bas-relief under each of the twelve Apostles, but he did nothing then. On the piazza of the duomo he designed the church of S. Lorenzo in fine architecture, which excited much admiration. The light-house tower was done from his design, and in the meantime he had a chapel done in S. Domenico for the captain Cicala, for which he did a marble Virgin of life-size, and he made a marble bas-relief, carefully finished and considered very fine, for the chapel of Sig. Agnolo Borsa in the cloister of the same church. By the wall of S. Agnolo he brought water for a fountain, and made a large marble infant pouring water from a handsome vase. At the wall of the Virgin he made another fountain, with a Virgin pouring water into a basin. For the fountain at the palace of Sig. don Filippo Laroca he made an infant of more than life-size, of a stone used in Messina, surrounded by sea-monsters and pouring water into a vase. He made a fine marble statue, of four braccia, of St. Catherine the Martyr, which was sent to Taurmina, twenty-four miles from Messina.

While at Messina Agnolo made friends with Don Filippo Laroca and Don Francesco of the same family, M. Bardo Corsi, Giovanfrancesco Scali and M. Lorenzo Borghini, all three Florentine nobles, Serafino da Fermo, and the grand master of Rhodes, who made several attempts to bring him to Malta and make him a knight. But the friar said that he did not wish to shut himself up in that island, and knowing that he did ill to remain without his habit, he thought of returning to the cloister. Indeed, I know that even if he had not been almost compelled he would have returned and lived like a good religious friar. When in 1557, under Paul V., all the apostate friars were compelled to return to their orders under severe penalties, Agnolo left his works in charge of his pupil Martino, and reached Naples in May on his way back to the Servites at Florence. But before devoting himself entirely to God he wished to dispose suitably of his numerous gains. After marrying his poor nieces and other relatives of his home at Montorsoli, he gave his nephew Angelo one thousand crowns and bought him a knighthood of the lily. To two hospitals at Naples he gave large sums of money; to his convent of the

Servites he left one thousand crowns to buy a property; and he gave his ancestral property of Montorsoli, charged with twenty-five crowns yearly, to each of his nephews, friars of the order, for life, and some other charges mentioned below. He then appeared in Rome and resumed the habit, to the joy of himself and the friars, especially of Maestro Zaccheria. On reaching Florence he was received with great joy by his friends and relations.

But in spite of his resolution to spend the remainder of his life quietly in the service of God, he did not succeed in this so soon, for he was pressed to go to Bologna by Maestro Giulio Bovio, uncle of Il Vascone Bovio, to make the marble high altar in the Servite church,[1] and a tomb with figures and rich ornaments of variegated stones and marbles. He could not refuse, especially as it was a church of his order. He went to Bologna, therefore, and executed the work in twenty-eight months, making the altar, which shuts off the choir of the friars, of marble both within and without, with a nude Christ in the middle of $2\frac{1}{2}$ braccia, and other statues at the sides. The architecture and construction are unsurpassable. The pavement also where the Bovio tomb stands is well arranged, as are the marble candelabra, some reliefs and small figures, everything being richly carved. But the figures do not compare with the architecture, as they are small owing to the difficulty of taking large blocks of marble to Bologna.

While thus engaged, the friar reflected how he might best spend his last years, a point upon which he had not quite made up his mind. But his friend Maestro Zaccheria, then prior of the Nunziata at Florence, wishing to keep him there, spoke with Duke Cosimo, recalling his talents, and begged the duke to employ him. The duke promised to give the friar work on his return, and Zaccheria wrote telling him all, and then sent him a letter of Cardinal Giulio de' Medici, in which the cardinal advised him to return to produce some distinguished work in his native place. On receiving these letters, the friar, remembering that his old enemies M. Pier Francesco Ricci and Bandinello were dead, the former having been mad for many years, replied that he would return as soon as possible to serve the duke on sacred, not profane works, as he had turned his mind to the service of God and the saints. Reaching Florence in 1561, he accompanied Zaccheria to Pisa, the duke and cardinal being there, to pay his respects. He was graciously received, and the duke

[1] S. Maria dei Servi, done in 1561.

promised to give him a work of importance on his return to Florence. He went back, and having obtained the permission of the friars of the Nunziata, he made a handsome tomb in the chapter-house there,[1] where many years before he had done the Moses and St. Paul in stucco, for all the painters, sculptors and architects who had no proper place of burial. He intended to leave property for the friars to say Mass on feast days in this chapter-house, and hold a solemn feast at Trinity, and on the following day repeat the office of the dead for the souls of those buried there. He and Maestro Zaccheria disclosed this plan to Giorgio Vasari their friend, and after they had discussed the affairs of the company of design founded in Giotto's time,[2] with its quarters in S. Maria Nuova at Florence, the memory of which is still preserved at the high altar of that hospital, they thought the time suitable to revive it. As the company had been removed from that high altar to the corner of the via della Pergola, as will be related in the Life of Jacopo di Casentino, and removed thence by Don Isidoro Montaguti, master of the hospital, it had not met since and was practically broken up. The friar next spoke of the matter with Bronzino, Francesco Sangallo, Ammannati, Vincenzio de' Rossi, Michel di Ridolfo, and many others of the foremost painters and sculptors, and on the morning of Holy Trinity day all the best artists, to the number of forty-eight, met in the chapter-house, where they kept festival, the tomb being finished, and the altar only lacking some marble figures. After Mass one of the friars delivered an oration in praise of Agnolo and his liberality to the company in giving them the chapter-house, tomb and chapel, in which they were to inter Pontormo first, who had been laid in the first cloister of the Nunziata. They then went into the church where Pontormo's remains lay on a bier, and the youngest taking it up they marched round the piazza bearing torches, and brought it to the chapter-house, which in place of its previous decoration of cloth of gold was now draped in black and painted with death's heads and similar things, and then they laid Pontormo's body in the new tomb. It was arranged that the company should meet on the following Sunday to make a selection of the best artists, and create an academy to teach those who wished to learn, and to improve the skilled masters by honourable competition. Giorgio, after speaking to the duke on these matters, asking him to favour the study of these noble arts, as

[1] In 1565.
[2] It was not founded till 1349, twelve years after Giotto's death.

he had done that of letters, by reopening the university of Pisa and founding the Florentine academy, found him most favourable and ready to assist the project. The Servites, after considering the matter, informed the company that they would only allow the chapter-house to be used for festivals, offices and burials, and for no other meetings. Giorgio told the duke of this, who said he had thought of giving them a place where they could build a company, and at the same time have an ample field for displaying their talents. He wrote soon after to the prior and monks of the Angeli, directing them through M. Lelio Torelli to accommodate the company in the temple begun in their monastery by Filippo Scolari called lo Spano. The friars obeyed, and the company obtained the use of some apartments in which they met several times by the favour of the fathers, who frequently received them courteously in their own chapter-house. But the duke learning that some of the monks did not want the company to establish itself there, or to decorate the church in their own way, informed the academy, who had already celebrated the feast of St. Luke there, that he would provide them with another place. He added, like a magnanimous prince, that he himself would be the president and protector of the company, and would appoint a deputy every year to take part in all the functions, the first being Don Vincenzio Borghini, master of the Innocents. For these favours the duke received the thanks of ten of the oldest and ablest members. But I will say no more, as the re-forming of the company and the rules of the academy are treated at large in the report made by the men deputed for this, namely Fra Giovann' Agnolo, Francesco da Sangallo, Agnolo Bronzino, Giorgio Vasari, Michele di Ridolfo and Pier Francesco di Jacopo di Sandro, with the intervention of the deputy and the duke's confirmation. As the old seal and arms of the company, the winged ox of St. Luke, did not please many, it was decided that every man should prepare a design and give his opinion. This gave rise to many beautiful and extraordinary fancies, though they have not been able to decide which to adopt.

Meanwhile the friar's pupil, Martino, having come from Messina to Florence, died in a few days, and was buried in the tomb made by his master, who soon after, in 1564, was laid there himself, his eulogy being pronounced in the Nunziata by the learned Maestro Michelagnolo. Our arts are indebted to Frà Giovann' Agnolo for many reasons, for he always loved them, and artists too. The academy also, which he may be said to

have founded, is of great assistance. It is now under the patronage of Duke Cosimo, and meets, by his order, in the new sacristy of S. Lorenzo containing the sculptures of Michelagnolo, whose obsequies were royally celebrated by the artists with the assistance of the duke, as I shall relate in his Life. Competition also led to the production of marvellous works, especially at the marriage of Don Francesco Medici, prince of Florence and Siena, to Queen Joan of Austria, which has been fully described by others, and which will be repeated by us in a more suitable place. The example of this good friar and of others previously mentioned are useful to the world and render service to the arts and nobler exercises, as well as to letters, public studies and sacred councils, and that they have no cause to fear comparison with others. There may not be much truth after all in the contention of some inspired more by passion and private resentment than by reason and a love for truth that they take up that life out of cowardice and to avoid fending for themselves like other men. May God pardon the thought. Frà Giovann' Agnolo lived fifty-six years, and died on 31 August, 1563.

FRANCESCO, called DE' SALVIATI,[1] Painter of Florence
(1510 – 1563)

THE father of Francesco, who was born in 1510, was a worthy manufacturer of velvet called Michelagnolo de' Rossi, who had many other children, and needing assistance had always intended that Francesco should follow his own trade. But the boy disliked the work, though it had anciently been practised by many wealthy men, if not noble, for his mind was turned to other things. At their house in the via de' Servi, next to that of the children of Domenico Naldini, his neighbour and an honoured citizen, he showed great inclination for design and polite manners, being much helped by his cousin Diaceto, a goldsmith, who was a very skilful draughtsman. Diaceto not only taught Francesco the little he knew, but supplied him with many designs of various skilled men, which Francesco studied day and night, unknown to his father. However, Domenico Naldini found it out, and after examining the boy, persuaded

[1] Francesco Rossi.

his father to put him in his uncle's shop, to learn the gold-smith's art. With this opportunity of designing, Francesco made such progress in a few months that all marvelled.

At that time a band of young goldsmiths and painters used to meet, and go on feast days to design the best works in Florence. None of them took more pains or pleasure in this than Francesco. The youths were Nanni di Prospero delle Corniuole, Francesco di Girolamo dal Prato, goldsmith, Nan-noccio da S. Giorgio, and many others, who afterwards became distinguished in their professions. At the same time Francesco and Giorgio Vasari, then both children, became fast friends. It came about in this way. In 1523 Silvio Passerini, cardinal of Cortona, passed through Arezzo as legate of Clement VII., and Antonio Vasari, his kinsman, took Giorgio his eldest son to pay his respects to the cardinal. On seeing the boy, not then more than nine, who, by the care of M. Antonio da Saccone and M. Giovanni Pollastra, a distinguished Aretine poet, had already so much acquaintance with letters that he knew by heart a great part of Virgil's *Æneid,* which he was to recite to the cardinal, and had learned to draw from Guglielmo da Marcilla, the French painter, the cardinal arranged that Antonio should himself take the boy to Florence. There Giorgio stayed in the house of M. Niccolo Vespucci, knight of Rhodes, on the Ponte Vecchio above the church del Sepolcro, and was sent to study under Michelagnolo Buonarotto. Francesco heard of this, and he was then in the alley of Monte Bivigliano, where his father had a large gabled house with a front in Vacchereccia, and employed many workmen. As like seeks like, Francesco en-deavoured to make Giorgio's acquaintance through M. Marco da Lodi, a gentleman of the cardinal, who showed Giorgio a portrait painted by Francesco, who had just taken up painting with Giuliano Bugiardini, a work which greatly pleased him. Vasari, by the cardinal's instructions, without abandoning letters, spent two hours a day with Ippolito and Alessandro de' Medici under their worthy tutor Pierio. The friendship con-tracted between Vasari and Francesco endured unaltered, although some thought it was strained by competition and a somewhat haughty manner of speaking in the latter.

Vasari spent some months with Michelagnolo, who, on being summoned to Rome by Pope Clement to arrange for the com-mencement of the library of S. Lorenzo, put the boy with Andrea del Sarto, under whom he studied design, secretly supplying his master's drawings to Francesco, who desired

nothing better than to study them, as he did day and night. Giorgio was then placed by the Magnificent Ippolito with Baccio Bandinelli, who was glad to have the boy to teach, and succeeded in getting Francesco also, to the great benefit of both, for together they learned more in a month than they had done in two years apart, and so did another youth then with Bandinello, called Nannoccio dalla Costa S. Giorgio.

When the Medici were expelled from Florence in 1527, a bench was thrown down from the palace of the Signoria on those who were attacking the gate. Unfortunately this struck an arm of Michelagnolo's David, which is beside the gate, and broke it into three pieces. There they remained lying for three days, when Francesco called on Giorgio, and, children as they were, they went to the piazza and picked up the pieces fearlessly in the midst of the guard, carrying them to the house of Francesco's father. Duke Cosimo received these pieces afterwards, and caused them to be replaced with copper rivets.

While the Medici were in exile together with the Cardinal of Cortona, Antonio Vasari took his son back to Arezzo, to the grief of Giorgio and Francesco, who were like brothers. They did not long remain separated, however, for in the following August Giorgio's father and his chief kinsmen died of the plague, and moved by Francesco's letters, for he also came near to dying of the plague, Giorgio returned to Florence, where, after two years of hard study, impelled by his necessities and the desire to learn, he made marvellous progress, and with Francesco and Nannoccio entered the shop of Raffaello del Brescia the painter, where Francesco, impelled by his necessities, produced many small pictures. In 1529 Francesco, finding he was not making great progress with Brescia, went with Nannoccio to Andrea del Sarto, remaining with him during the siege, but in such discomfort that they repented not having followed Giorgio, who spent the year in Pisa with Manno the goldsmith, studying that trade for four months. When Vasari went to Bologna at the coronation of Charles V., Francesco remained in Florence, and did a votive picture for a soldier who had been attacked while in bed during the siege, executed with great perfection. It fell into Vasari's hands not many years ago, and he gave it to Don Vincenzio Borghini, master of the Innocents, who values it highly. For the black monks of the Badia Francesco did three small scenes in a tabernacle of the Sacrament made by Tasso the carver like a triumphal arch, namely the Sacrifice of Abraham, the Manna, and

the Hebrews eating the Paschal Lamb on leaving Egypt, show-
ing promise of his future progress. For Francesco Sertini he did
Delilah cutting Samson's hair, and in the background his pull-
ing down the temple, a work which showed him to be the best
of the young painters then in Florence, and which was sent by
Francesco to France.

Not long after Cardinal Salviati the elder asked Benvenuto
dalla Volpaia, a master clockmaker, then in Rome, to send him
a young painter to stay with him and paint some pictures for
him. Benvenuto recommended Francesco, as his friend, for he
knew him to be the best, and he was the more glad to do so
because the cardinal promised to afford the youth every oppor-
tunity for study. Being pleased with the youth's qualities, the
cardinal told Benvenuto to send for him, and gave him money.
When Francesco reached Rome his bearing pleased the cardinal,
who gave him rooms in the Borgo Vecchio, four crowns a month,
and a mess at the table of the gentlemen.

Francesco considered himself very fortunate. His first works
for the cardinal were a Virgin, considered very beautiful, and
a French noble hunting a hind, which takes refuge in the temple
of Diana, done on canvas. I keep the design for this in my
book in memory of him. The cardinal then made him paint
in a beautiful picture of the Virgin his niece and her husband,
Sig. Cagnino Gonzaga.

While Francesco was in Rome fortune favoured his desire,
and the greater longing of Vasari, to meet again; for Cardinal
Ippolito, having quarrelled with Pope Clement, left Rome,
accompanied by Baccio Valori, and found the fatherless Giorgio
at Arezzo, who was managing as best he could. The cardinal,
wishing the boy to make progress in art and desiring to keep
Giorgio near him, directed the commissary, Tommaso de' Nerli,
to send him to Rome immediately he had finished a chapel he
was doing in fresco for the monks of St. Bernardo of the order
of Monte Oliveto in that city, and this Nerli immediately did.
On reaching Rome Giorgio at once went to find Francesco, who
joyfully told him of the cardinal's favours, and how he was
allowed to study, adding, "I not only rejoice in my present
prosperity, but hope for more, for besides being able to talk
over art with you here, I hope to serve Cardinal Ippolito, from
whose liberality and the Pope's favour I can look for greater
things than these, and shall do if a youth who is expected does
not come." Giorgio knew that he was that youth, but said
nothing, for he thought that perhaps the cardinal had other

things in hand. Giorgio brought a letter from Nerli to the cardinal, which he had not presented during the five days he stayed in Rome. At length he and Francesco went to the Hall of the Kings in the palace and found M. Marco da Lodi, who had been in the service of the cardinal of Cortona, and was now serving the Medici. Giorgio told him of the letter, and asked him to give it to the cardinal. M. Marco promised, and behold the cardinal appeared on the scene. Giorgio therefore presented the letter when kissing his hand, and was graciously received, while Jacopone da Bibbiena, steward of the household, was ordered to give him rooms and a place at the pages' table. Francesco thought it strange that Giorgio should not have told him, though Giorgio had acted as he thought best. When Jacopone had given some rooms to Giorgio behind S. Spirito, and near Francesco, they spent the winter together with great profit, leaving nothing in Rome of importance which they did not copy. As they could not design when the Pope was in the palace, they gained admission to his apartments by means of friends immediately he rode off to Magliana, as he frequently did, and remained there from morning to night with nothing to eat but a morsel of bread, and where they were almost benumbed with cold.

When Cardinal Salviati directed that Francesco should paint the life of John the Baptist in fresco in the chapel where he heard Mass every morning, Francesco devoted himself to study the nude from life, and so did Giorgio in a studio hard-by, and they afterwards did some anatomy in the cemetery.

In the spring, when the Pope sent Cardinal Ippolito to Hungary, he directed that Giorgio should go to Florence to do some pictures and portraits for Rome. But in July Giorgio fell sick from the labours of the winter and the heat of the summer, and was taken to Arezzo, to the grief of Francesco, who also fell ill, and was like to die. However, he recovered, and by the influence of Antonio Labacco, a master wood-carver, Maestro Filippo da Siena employed him to paint in a niche over the inside of the door of S. Maria della Pace Christ speaking with St. Philip, and an Annunciation in two angles, paintings which greatly pleased Filippo, and led to Francesco doing a large Assumption in a place which had not been previously decorated.

Francesco being thus employed in a place containing the works of such masters as Raphael, Rosso, Baldassarre of Siena and others, determined to employ all study and diligence in the painting, and succeeded well. A very good figure is the

portrait of Maestro Filippo himself with his hands clasped. As Francesco was known to be the *protégé* of Cardinal Salviati, he came to be called Cecchino Salviati, a name he retained until his death.

When Paul III. succeeded Clement VII., M. Bindo Altoviti had the new Pope's arms painted by Francesco on the façade of his house on the Ponte S. Agnolo with some large nude figures, which gave great pleasure. At the same time he made M. Bindo's portrait very successfully; it is now in his villa of S. Mizzano in Valdarno. Francesco next did a beautiful Annunciation in oils for the church of S. Francesco a Ripa, very carefully finished. When Charles V. came to Rome in 1535, Francesco did some scenes in grisaille for Antonio da San Gallo, which were placed in the arch made at S. Marco, and were the best in all the apparatus. When Sig. Pier Luigi Farnese was created Lord of Nepi, he wished to adorn that city with new buildings and paintings, and took Francesco into his service, giving him rooms in the Belvedere, where he did large water-colour scenes on cloth of the deeds of Alexander the Great, afterwards executed as arras in Flanders. For the same signor he decorated a handsome study with scenes and figures in fresco. When the lord was made Duke of Castro, Francesco devised a rich apparatus for his entry into the city, and an arch at the gate full of scenes, figures and statues executed with great judgment by Alessandro, called Scherano of Settignano, and other skilled artists. Another arch was made at Petrone, and a third at the piazza, the woodwork being by Battista Botticelli. In addition to these Francesco made some beautiful scenery for a comedy.

At this time Giulio Cammillo, then in Rome, had made a book of his compositions to send to King Francis in France, illustrated by Francesco, who displayed the utmost possible diligence. Cardinal Salviati, desiring a marquetry panel by Frà Damiano of Bergamo, a lay brother of S. Domenico at Bologna, sent him a design by Francesco in red chalk representing David anointed by Samuel, the best drawing he ever did.

When Giovanni da Cepperello and Battista Gobbo of Sangallo had caused the young Jacopo del Conte of Florence to paint the appearance of the angel to Zacharias in the company of the Misericordia of the Florentines in S. Giovanni Decollato below the Capitol at Rome, where the company meets, they employed Francesco to do a Visitation under it. This was finished in 1538, and is among the most graceful and skilful of Francesco's works, remarkable for its invention, composition, regular diminution

of the figures, perspective, architecture, nudes, draperies, graceful heads, and indeed every part, so that Rome was amazed. About the window he painted a curious imitation marble decoration, and some marvellously graceful little scenes. Meantime he was not idle, doing several other things, and colouring a design of Michelagnolo of Phaëton and the horses of the Sun. Salviati showed all these things to Giorgio, who had gone to Rome for two months, on the death of Duke Alessandro, saying that he had done a youthful St. John for Cardinal Salviati, a Passion of Christ on canvas for Spain, and a Madonna for Raffaello Acciaiuoli, and he wished to see his native Florence, his relations and friends, his parents being still alive, whom he greatly assisted, especially in settling his two sisters, one being married, and the other becoming a nun at Monte Domini.

At Florence his relations and friends welcomed him with delight, and he was at once engaged upon the apparatus for the wedding of Duke Cosimo and Leonora of Toledo, doing one of the scenes for the court, where the Emperor is investing Cosimo with the ducal crown. But before finishing it he wanted to go to Venice, and handed it over to Carlo Portelli of Loro. Francesco's design for it is in our book, with many others by him.

At Bologna Francesco found Vasari, who had arrived two days before from Camaldoli, where he had finished two panels on the screen of the church, begun that of the high altar, and arranged to do three large ones for the refectory of S. Michele in Bosco. He stayed two days with Francesco, while some of his friends tried to obtain for him the painting of a panel for the Hospital of la Morte. But although Salviati prepared a fine design, those men lost, through ignorance, the opportunity which God had given them in sending a man of genius to Bologna. Francesco therefore departed in disgust, leaving some fine designs with Girolamo Fagiuoli to be engraved on copper. At Venice Francesco was courteously received by the Patriarch Grimani and his brother M. Vettor, for whom, in an octagon, he did a Psyche receiving incense and vows as a goddess. It was placed in a salon of the Patriarch's house, containing a ceiling with festoons by Cammillo Mantovano, an excellent painter of landscapes, flowers, fruits, and such things. It was placed in the middle of four pictures of Psyche, $2\frac{1}{2}$ braccia square, done by Francesco da Furli, than which it is incomparably more beautiful, and indeed it is the finest painting in all Venice. In a chamber decorated with stucco by Giovanni Ricamatore of Udine Francesco did some graceful figures in fresco, both nude and

draped. He also executed, with great diligence, for the nuns of
Corpus Domini at Venice, a Dead Christ and the Maries with an
angel in the air, holding the mysteries of the Passion. He did
a portrait of M. Pietro Aretino, which that poet sent to King
Francis, together with some verses in praise of the artist. For
the church of the nuns of St. Cristina of the Camaldolite order,
at Bologna, he did a beautiful panel with many figures, at the
request of Don Giovanfrancesco da Bagno, their confessor. Be-
coming tired of Venice, which he did not think suited to artists,
and recalling his life at Rome, he set out thither. Visiting Verona
and Mantua for the antiquities of the former and the paintings by
Giulio Romano in the latter, he passed through Romagna and
reached Rome in 1541. His first works there, after a short rest,
were portraits of his friends M. Giovanni Gaddi and M. Annibale
Caro, and a panel of the chapel of the clerks in the Pope's palace.
In the German church he began a chapel in fresco for a merchant
of that nation, representing a Descent of the Holy Spirit in the
vaulting, and half-way up a Resurrection, the heavily sleeping
soldiers in various attitudes about the tomb being admirably
foreshortened. In two niches at the sides he did St. Stephen and
St. George, and beneath them St. John the almoner giving alms
to a poor naked man, with Charity and St. Albert the Carmelite
between Logic and Prudence. For the altarpiece he did a Dead
Christ and the Maries in fresco. Becoming friendly with Piero di
Marcone, goldsmith of Florence, Francesco made a handsome
design as a present to his wife and mother-in-law, to be painted
on one of those round platters used by women lying-in, for their
food. It represented the life of man, each scene surrounded by an
appropriate festoon, the sun and moon being in two ellipses,
and in the middle Isais, a city of Egypt, with Pallas before the
temple asking for wisdom, to show that wisdom and goodness are
the first requisites for new-born children. This design was rightly
valued by Piero as a most precious jewel. Not long after Piero
and other friends wrote that Francesco would do well to return
home, for they felt sure he would be employed by Duke Cosimo,
who only had slow and irresolute masters about him. Trusting
in the favour of M. Alamanno, the cardinal's brother and the
duke's uncle, Francesco resolved to return to Florence. On his
arrival, and before anything else, he there did a beautiful Madon-
na for M. Alamanno Salviati in a room which Francesco di Prato,
goldsmith and marquetry worker, kept in the opera of S. Maria
del Fiore, for casting bronze and painting, which he occupied
as head of the woodwork of the opera. Here Salviati portrayed

his friends Piero di Marcone and Avveduto del Cegia, the fur-
dresser, who possesses a most natural portrait of the artist by
himself, with many others of Francesco's works. The Madonna,
when in the shop of the wood-carver Tasso, then architect of
the palace, was seen by many and much admired. But what
was most remarkable, Tasso, who usually blamed everything,
praised it ceaselessly, and even said to Pierfrancesco, major-
domo, that the duke would have done well to give Salviati
something of importance. Thus M. Pierfrancesco and Cristofano
Rinieri, who had the ear of the duke, succeeded so well that,
when M. Alamanno told his excellency that Francesco would
like to paint the audience-chamber before the chapel of the ducal
palace, without caring about the payment, the duke granted
him this. Francesco thereupon designed the triumph and other
stories of Furius Camillus, and followed the openings of the
windows and doors, which are irregular, and make it hard not
to spoil the scenes. On the wall of the entrance-door there were
two large spaces on either side. Opposite are the three windows
looking on the piazza, leaving four spaces not more than three
braccia broad each. At the top, on the right-hand on entering,
with two windows looking on the piazza from another side,
were three similar spaces, and on the left, where there are the
marble door leading into the chapel and a window with a bronze
grating, there was only one large space for anything of im-
portance. On the wall of the chapel was a framework of Corinthian
pilasters, bearing an architrave with hanging festoons, and a
naked infant above holding the Medici and Toledo arms. Fran-
cesco did Camillus commanding the school-master to be handed
to his scholars on the right, and on the left his routing the Gauls
while the camp is burning. Beside this, with a continuation of
the ornamentation, he did Chance seizing Fortune by the hair,
and some devices of the duke with many ornaments of marvellous
grace. On the principal wall he did two large and handsome
scenes, the Gauls weighing the money and throwing in a sword,
and the arrival of Camillus, a scene full of figures, landscapes,
antiquities and handsome gold and silver vases. Next this is
Camillus in a triumphal car drawn by four horses with Fame
crowning him. Before the car march priests, bearing the statue
of Juno and rich vessels, trophies and spoils. About the car are
countless prisoners in various attitudes, and soldiers follow,
among whom Francesco introduced a speaking likeness of him-
self. In the distance is a beautiful Rome, and above the door a
Peace, in grisaille, with prisoners engaged in burning arms. The

whole is executed with skill and diligence, and no finer work can be seen. On the wall facing west he did an armed Mars in the middle space, and below it a nude figure of a Gaul with a cock's-comb. In another niche is Diana dressed in skins drawing an arrow from her quiver, with a dog. At the angles are two figures of Time, one adjusting weights on the scales, the other emptying water from one vase into another. On the north wall, opposite the chapel, is a Sun, represented in the Egyptian style, and on the other side the Moon in the same manner. In the middle is Favour as a naked youth on a wheel, with Envy, Hatred and Slander on one side, and Honours, Delights and all the other things described by Lucian on the other. Over the windows is a handsome frieze, life-size, of nudes, with stories of Camillus. Opposite the Peace is the Arno with a cornucopia, raising her mantle and discovering Florence and the greatness of her popes and the heroes of the Medici family. He decorated the basement and niches with female busts holding festoons, and ovals in the middle with people decorating a sphynx, and the River Arno. Francesco devoted all his skill and diligence to this work in order to leave something worthy of himself to his country and his prince, although he suffered many vexations. He was of a melancholy temperament, and usually preferred to be alone when working. However, in this work he made an effort to be sociable, allowing Tasso and his other friends to see him, and welcoming them in the warmest manner possible. They say that after he had won favour at court he returned to his angry and morbid nature, and blamed the works of others with biting words, exalting his own to the skies. This brought him so much dislike that Tasso and many others who had been his friends became his enemies, and began to give him cause for anxiety. Thus, although they praised his excellence, facility and quickness in art, they did not withold their blame, and they even began to annoy him, because if he had been allowed to get a footing he would have passed out of their reach. Accordingly they united to spread abroad slanders, saying that the work in the salon was not a success, and that Francesco did not devote study to the things which he executed. In this they were wrong, for although he did not labour as they did, there is no doubt he studied, and both possessed and exhibited infinite invention and grace. But his adversaries, not being able to surpass the genius of his works, wished to undermine them by such words and slanders. But ability and truth have too much power in the end. Francesco at first mocked at such reports, but finding them increase he

frequently complained to the duke. However that prince did not seem to care, and did not display great favour. Francesco's adversaries took courage to report that his scenes in the hall were to be pulled down, as they did not give satisfaction and possessed no excellence. All these things brought Francesco to such a state that, had it not been for the kindness of M. Lelio Torelli, M. Pasquino Bertini and other friends, he would have abandoned the field to his adversaries, which was just what they wanted. But these friends and others outside Florence to whom he wrote about his persecution encouraged him to continue the hall. Giorgio Vasari, in answering a letter of his, exhorted him to have patience, because persecution refined ability as the fire does gold, adding that time would prove his ability and genius, and that he had no one to blame but himself for not knowing the humour and nature of men and of the artists of his own country. Thus, in spite of these vexations, Francesco finished the hall, namely the frescoes on the walls, because it was not necessary to do anything on the ceiling, which was most richly carved and gilded. The duke also had two new stained-glass windows done with his device and that of Charles V. executed by Battista dal Borro, painter of Arezzo, rare in this profession.

Francesco next did the ceiling of the winter dining-hall for the duke, with many devices and figures in tempera, and a handsome study opening into the green room. He also made portraits of some of the duke's children, and one carnival year he did the scenery for a comedy, judged superior to any made in Florence up to that time. Indeed in everything Francesco displayed great judgment, a varied and copious invention, a design superior to any other master in Florence, and managed his colours with great skill and charm. He drew a head of Sig. Giovanni de' Medici, father of Duke Cosimo, of great beauty, and now in the duke's wardrobe. For his friend Cristofano Rinieri he did a beautiful Madonna, now in the audience-chamber of the Decima. For Ridolfo Landi he did a Charity of unsurpassed beauty, and a Madonna for Simon Corsi which was much admired. For M. Donato Acciaiuoli, knight of Rhodes, with whom he was remarkably intimate, he did some beautiful pictures. He also did a Christ showing His wounds to St. Thomas; this panel was taken to France by Tommaso Guadagni, and placed in the Florentine chapel of a church at Lyons.[1] At the request of Cristofano Rinieri and John Rost, a Flemish tapestry-weaver, Francesco did the story of Tarquinius and Lucretia in

[1] It is now in the Louvre.

many cartoons, which made a marvellous arras. When the duke
heard of it he got John to do similar ones for the hall of the Two
Hundred, from cartoons by Bronzino and Pontormo on the
history of Joseph. He also desired Francesco to do a cartoon of
the seven kine, to which he devoted the greatest diligence neces-
sary for such work which is to be woven. Ingenious inventions
and varied compositions require the figures to stand out from
each other, so that they may have relief and bright colouring
with rich vestments. As this proved a success, the duke resolved
to establish the art at Florence, and had it taught to some boys,
who now they are grown produce excellent work for the duke.
Francesco also did a beautiful Madonna in oils, now in the
chamber of M. Alessandro, son of M. Ottaviano de' Medici. For
M. Pasquino Bertini he did on canvas a Virgin and Child with
the little St. John playing with a parrot, a charming work; and
for the same person he did a crucifix about a braccia high, with
the Magdalene embracing Christ's feet, a marvellous work
in a new and charming style. M. Salvestro Bertini lent this
design to his friend Girolamo Razzi, now Don Silvano, and
two copies were coloured by Carlo da Loro, who did several
others for Florence.

Giovanni and Piero d'Agostino Dini having erected a rich
chapel of macigno on the right on entering the middle door of
S. Croce, and a tomb of Agostino and others of their house,
gave the panel to Francesco. He painted a Deposition from
the Cross with Joseph of Arimathea and Nicodemus, the Virgin
fainting, the Magdalene, St. John and the other Maries, executed
with such art and study that the nude Christ is most beautiful,
and all the other figures are well-disposed and coloured with
vigour and relief. Although it was at first blamed by Fran-
cesco's enemies, yet it brought him a great name, and those
who have since rivalled it have not surpassed it. Before leaving
Florence Francesco did a portrait of M. Lelio Torelli, and some
other things of slight importance of which I do not know the
particulars. But he finished a beautiful cartoon of the Conversion
of St. Paul, which he had drawn at Rome long before, and had
it engraved at Florence by Enea Vico of Parma, the duke grant-
ing him his customary stipend and provision until it was done.

Giorgio Vasari being then, in 1548, engaged at Arimini upon
works in fresco and oils, mentioned elsewhere, Francesco wrote
him a long letter giving full particulars of his affairs in Florence,
and especially describing a design for the principal chapel of
S. Lorenzo which the duke wished to have painted; but adding

that some evil influence had been at work, and he felt sure that M. Pierfrancesco, the major-domo, had not shown his design, as the work was allotted to Pontormo, and he was therefore returning to Rome disgusted with the men and artists of his native city. At Rome he bought a house near the palace of Cardinal Farnese, and while he was occupying himself with some unimportant things the cardinal, by means of M. Annibale Caro and Don Giulio Clovio, gave him the chapel of the palace of St. Giorgio to paint. He made beautiful stucco compartments, and decorated the vaulting in fresco, with scenes of St. Laurence, and did a Nativity in oils on a stone panel, comprising a portrait of the cardinal. Being allotted some work in the company of the Misericordia,[1] where Jacopo del Conte had already done the Preaching and Baptism of St. John, of great excellence, though not better than the work of Francesco, and where Battista Franco of Venice and Pirro Ligorio had done some other things, Francesco painted a Nativity of St. John beside his Visitation, though not equal to it, in spite of its excellence. At the top of the chapel he did St. Andrew and St. Bartholomew in fresco for M. Bartolommeo Bussotti; on either side of the altar-picture a Deposition from the Cross, by Jacopo del Conte, and one of the best works he had then produced.

On the election of Julius III., in 1550, Francesco did some fine scenes in grisaille for an arch on the steps of S. Pietro for the coronation. That same year a tomb was erected by the company of the Sacrament in the Minerva, with columns, for which Francesco did reliefs and figures in clay, which were considered very beautiful. In a chapel of St. Lorenzo in Damaso he did two angels in fresco holding a canopy, the design for one being in our book. On the principal wall of the refectory of St. Salvatore del Lauro at Monte Giordano he painted the Marriage at Cana in Galilee, with a large number of figures, and at the sides some saints, and Eugenius IV., who belonged to the order, and other founders. Over the door he did St. George killing the serpent, executed in oils with great skill and charming colouring. About the same time he sent to M. Alamanno Salviato at Florence a large picture of Adam and Eve eating the forbidden fruit, a very beautiful work. For Sig. Ranuccio, cardinal S. Agnolo of the Farnese house, he did two walls with pleasant fancies in the principal hall of the Farnese palace. One represented Sig. Ranuccio Farnese receiving the baton of

[1] i.e. S. Giovanni Decollato.

Captain of the Church from Eugenius IV., with Virtues, and the other the Farnese Pope, Paul III., giving the baton of the Church to Sig. Pier Luigi, with Charles V. in the distance, accompanied by Cardinal Alessandro Farnese and other lords, all portraits. Besides many other things he painted an excellent Fame here. However, Taddeo Zucchero of St. Agnolo finished this for him, as I shall relate. Francesco completed the chapel of the Popolo, begun by Frà Bastiano of Venice for Agostino Chigi. For Cardinal Riccio da Montepulciano he painted a beautiful hall in his palace in the Strada Giulia, with scenes from the life of David, including a fine composition of David watching Bathsheba at the bath, with many other women, as graceful and full of invention as anything that is to be seen. Another represents the death of Uriah; and a third the Ark, preceded by many people playing; and finally there is a battle between David and his enemies, very well composed. In short, the work in this hall is full of grace and fancy and the most ingenious inventions, the division being made with judgment, and the colouring charming. Francesco would have always preferred large works, for he knew he was bold and prolific in invention, with a hand obedient to his mind. He behaved strangely to his friends, owing to a certain instability, loving one day and hating the next, and he did few things of importance without haggling over the price, a matter which caused many to avoid him.

Andrea Tassini, having to send a painter to the King of France, and as Vasari, when approached in 1554, declared that he would not leave the service of Duke Cosimo, however great the provision and promises that might be made to him, finally came to an agreement with Francesco, and took him to France, on the understanding that he should be paid in Rome. Before leaving Rome Francesco sold his house and all his possessions except the offices, as if he never expected to return. But on reaching Paris, where he was kindly received by M. Francesco Primaticcio, abbot of St. Martino and painter and architect to the king, his character immediately appeared by his blaming everything he saw of Rosso and the other masters. Everyone therefore expected something great from him, and the cardinal of Lorraine employed him to do some paintings in his palace at Dampierre. After making several designs, Francesco set to work doing scenes in fresco above cornices of chimneypieces, and decorating the whole of one room with scenes, said to be very charming. But whatever the cause, they were not much admired. Neither was Francesco much loved, his nature being

antipathetic to that of the men of the country, who prefer jovial characters, fond of company and giving banquets, and who are much less attracted by melancholy, reserved, unhealthy and solitary men like Francesco. But he must be excused, for if his health had allowed him to eat and drink freely he might have been more sociable and conformed more to the habits of the country, when he would have been courted by everybody. The king and cardinal being occupied in war, and Francesco's provisions and promises being neglected, he resolved to return to Italy, after an absence of twenty months. Arrived in Milan, he was courteously received at the house of the knight Lione of Arezzo, which is full of ancient and modern statues and plaster casts. He stayed there a fortnight, and then came to Florence, meeting Giorgio Vasari and congratulating him on not having gone to France, telling him enough to prevent anyone from wishing to go there. From Florence Francesco went to Rome, and there brought an action against the stewards of the cardinal of Lorraine, for his provisions, compelling them to pay him everything. With the money he bought the offices on which he proposed to live, on account of his bad health. However, he would have liked employment upon some great work, but not obtaining any, busied himself a while at pictures and portraits.

Pius IV., who succeeded Paul IV., took great delight in building, and employed Pirro Ligorio as his architect. He directed that Cardinals Alessandro Farnese and Emulio should get Daniello da Volterra to finish the great Hall of the Kings, which he had begun. Farnese made every effort to obtain a half for Francesco, and a long contest took place between him and Daniello, and as Buonarotto favoured the latter, it was not settled for some time. On Vasari going to Rome with Cardinal Giovanni de' Medici, Duke Cosimo's son, he heard of Francesco's misfortunes from his own lips. Giorgio, who admired his ability, pointed out to him his lack of tact, and told him to leave the matter to him, and he would succeed in obtaining half the work for him, as Daniello, being slow and irresolute, and perhaps not so gifted or versatile as Francesco, could never do it alone. Not many days after the Pope sent for Giorgio to do a part of the hall; but he answered that he had to do three larger vaults in the palace of Duke Cosimo, and he had been so badly treated by Pope Julius III., for whose villa at Monte he had done many things, that he did not know whom to trust. He added that he had done a picture of Christ calling Peter and Andrew

*C 751

from their nets for the palace, for which he had never been paid. It had been removed by Paul IV. from a chapel made by Julius above the corridor of Belvedere, and was to be sent to Milan, and he prayed the Pope either to restore the picture to him or pay him for it. The Pope said he knew nothing of the picture, whether truly or falsely, and would like to see it. He sent for it, and after seeing it in a bad light, decided that it should be given back. The conversation then turned on the hall, and Giorgio told the Pope frankly that Francesco was the best painter in Rome, and no one could serve him better; and that though Buonarotto and the Cardinal di Carpi favoured Daniello, they did it rather from friendship and perhaps prejudice than any other cause. Immediately Giorgio had left the Pope, who had sent his picture to Francesco's house, the latter had it taken to Arezzo, where it was set up by Vasari in the Pieve at great expense.

While this affair of the King's Hall stood thus, Vasari, who had accompanied Duke Cosimo from Siena towards Rome, warmly recommended Salviati to him, for the Pope's favour, and he wrote telling Francesco what to do when the duke arrived. Francesco followed the directions implicitly, and was graciously received by the duke, who induced the Pope to allot the hall to him. Before beginning he destroyed a scene begun by Daniello, and this gave rise to many disputes between them. As already related, the Pope employed Pirro Ligorio in architecture, who had from the first greatly favoured Francesco. But his friendship was turned to enmity because Francesco took no account of him or of others. Pirro began to tell the Pope that Rome possessed many young and skilful painters, and it would have been well to give them a scene each, and get the hall finished once and for all. The Pope consented, and Francesco in disgust threw up the work and the contest, and mounting his horse rode away to Florence without saying a word to anyone. Without considering his friends, he stayed in an inn as if he knew nobody. The duke, however, welcomed him so kindly that he might have expected something if his nature had been different, and if he had followed Giorgio's advice to sell his offices at Rome and to go and enjoy Florence and his friends, without risking the loss of his labours and life itself. But guided by his anger and vindictiveness, Francesco determined to return to Rome in a few days. At the prayers of his friends he left the inn for the house of M. Marco Finale, prior of St. Apostolo, and there as a pastime did a lovely Pietà with the Maries on cloth

of silver for M. Jacopo Salviati. He recoloured for the same the
ducal scutcheon placed over the door of M. Alamanno which
he had done before. For M. Jacopo he did a book of curious
habits and dresses of men and horses for masques, for which
he received great courtesies from that lord, who complained
of his eccentricities, for Francesco refused to stay in his house
as he had done before. When Francesco at length left for Rome,
Giorgio as a friend advised him to live quietly, avoiding con-
tention, as he was rich, elderly, in bad health, and unfit for
fatigue. He might easily have done so, for he had acquired
enough property and honour, but he was too greedy of gain.
Giorgio also advised him to sell his offices and so arrange his
affairs, that he might remember his friends and those who had
faithfully and lovingly served him, in any difficulty or emer-
gency that might arise. Francesco promised to act and speak
discreetly, and admitted that Giorgio spoke the truth, but,
like most men who wait for things to turn up, he did not
mend his ways.

On reaching Rome Francesco found that Cardinal Emulio
had given two scenes in the hall to Taddeo Zucchero of S. Agnolo,
one to Livio da Forli, one to Orazio da Bologna, one to Giro-
lamo Sermoneta, and the rest to others. Francesco told Giorgio
of this, who wrote back that he would do well to finish what
he had begun after he had made so many little designs and large
cartoons, and that he should endeavour to approach as nearly
as possible to the paintings of the Sistine Chapel by Buonarotto
and those of la Paulina, as when the excellence of his work
was seen, that of the other artists would be destroyed, and he
would obtain the whole to his great glory. Giorgio moreover
warned him not to think of money or the affronts of those who
directed the work, as honour is more important than all else.
The copies and originals of these letters and replies are kept
by me in memory of our friendship, and my letters ought to
be among his things. After these events Francesco remained in
an angry mood, irresolute and afflicted both in body and mind;
at length he fell ill, sick unto death, and was in extremis
before he had had time to dispose entirely of his property.
To a pupil called Annibale, son of Nanni di Baccio Bigio, he
left sixty crowns a year on the Monte of Corn,[1] fourteen pictures,
and all his designs and other things of art. He left the rest of
his things to his sister Gabriella the nun, though I understand
that she did not even receive the cord of the sack, as the saying

[1] A bank.

is. However, she ought to have received a picture painted on cloth of silver with a border of embroidery, done for the King of Portugal or Poland, and left to her in memory of him. All the offices which Francesco had bought at the expense of so much labour were lost. Francesco died at Martinmas 1563, and was buried in S. Jeronimo near his house.

His death was a great loss to art, for although he was fifty-four and in bad health, he studied and worked ceaselessly. He had at the end practised mosaic, being a restless man anxious to be accomplished in many things. Rich and copious in invention and universal in every branch of pictorial art, he would have produced marvellous things if he had found a prince to humour him. He endowed all his heads with grace, and was more thoroughly master of the nude than any painter of his day. His draperies were graceful and gentle, and arranged to display the nude where it is seemly. He tried new ways of clothing his figures, made curious and various head-dresses, shoes and other ornaments. His colouring in oils, tempera and fresco proved him one of the most skilful, speedy, vigorous and careful artists of our age, as I can testify from my experience of so many years. Although there was always an honest rivalry between us, owing to the desire of good artists to surpass each other, yet our mutual affection never failed, although we have competed and worked in the most famous places in Italy, as may be seen by the countless letters of Francesco in my possession.

Salviati was naturally amiable, but suspicious, credulous, sharp, subtle and penetrating. When he spoke on art, whether in jest or from duty, he would sometimes offend and sometimes cut to the quick. He loved the society of the learned and great, and always disliked plebeian artists even if they possessed talent. He avoided those who always speak evil, and when they were mentioned he always attacked them. But he most of all disliked the trickeries sometimes practised among artists, of which he had learned too much when in France. Though naturally melancholy, he would sometimes force himself to be merry among friends. But his irresolute, suspicious and solitary character did most harm to himself. His closest friend was Manno, a rare Florentine goldsmith at Rome, of excellent character. As he had a family, Francesco would have left him much of his property if he had not devoted his labours to acquiring offices to be left to the Pope. Another friend, Avveduto dell' Avveduto, was the most faithful and loving of all, and if he had been in Rome when Francesco died, his affairs might

have been better managed. Roviale the Spaniard, a pupil, did many works with Francesco, and a Conversion of St. Paul in S. Spirito at Rome.

Salviati was very fond of Francesco di Girolamo of Prato, with whom he studied design as a child, and who possessed a fine intelligence and designed better than any goldsmith of his day, not being inferior to his father Girolamo, a man capable of making anything out of a sheet of silver. Some say that he achieved his results with ease, as he beat out the silver, put it on brass, with wax and pitch beneath, making a hard material ready for anything he desired, for votive offerings hung about sacred images, put there for prayers answered. This Francesco not only made such offerings like his father, but also inlaid gold and silver on steel, making foliage, figures, and anything else required. In this way he made beautiful armour for a foot-soldier for Duke Alessandro de' Medici. Among numerous medals by him, some of great beauty with that duke's head were placed in the foundations of the fortress of the Faenza gate, with others containing the head of Clement VII., and on the reverse Christ scourged. He delighted in sculpture, and cast some very graceful bronze figures which were in the possession of Duke Alessandro. He also cleaned and finished four similar figures made by Bandinelli, of Leda, Venus, Hercules and Apollo, which were given to the same duke. Becoming tired of goldsmith's work, and not being able to study sculpture, which demands considerable resources, he took up painting, as he was a good designer, doing many things by himself, though he did not feel anxious that any should know more than the mere fact that he was painting. Meanwhile Francesco Salviati came to Florence and did the picture of M. Alamanno in the rooms in the opera of S. Maria del Fiore. The other Francesco, having this opportunity of seeing Salviati's methods, devoted more study to painting than he had hitherto done, and did a fine Conversion of St. Paul, now in the possession of Guglielmo del Tovaglia. In another picture of the same size he did the serpents raining on the Hebrews; and in another Christ releasing the patriarchs from Limbo, the last two being very beautiful. They are now in the possession of Filippo Spini, a noble who is very fond of the arts. Besides many other small things, Francesco dal Prato drew well, as is shown by some designs of his in our book. He died in 1562, his death being a great loss to our Academy, for, besides being a clever artist, a better man never lived.

A pupil of Salviati, Giuseppo Porta of Castelnuovo della

Garafagna, was also known as Giuseppo Salviati, after his master. Being taken to Rome in 1535, when quite young, by his uncle, secretary of Onofrio Bartolini, Archbishop of Pisa, he was placed with Salviati, with whom he soon learned to colour beautifully as well as to draw well. Accompanying his master to Venice, he succeeded so well with the nobles that he resolved to make the city his home, took a wife, and has remained there ever since, doing little elsewhere. In the Campo S. Stefano he painted the façade of the Loredano house with beautifully coloured frescoes in good style. He also painted that of the Bernardi at S. Polo, and another behind S. Rocco, of great excellence. He did three other façades in grisaille, one at S. Moisè, one at S. Cassiano, and the third at S. Maria Zebenigo. He also painted in fresco all the Priuli palace at Treville near Trevisi, a very rich structure, described at length in the Life of Sansovino. At Pieve di Sacco he did a beautiful façade, and painted a panel in oils at Bagnuolo, a house of the friars of S. Spirito at Venice. For this convent of S. Spirito he did the ceiling of the refectory, filling the panels with paintings and doing a Last Supper at the end. In the Doge's Hall in the palace of S. Marco he painted sibyls, prophets, the cardinal virtues, and Christ with the Maries, which have been much admired. In the library of S. Marco he did two large scenes in competition with other Venetian artists, as related above. Being summoned to Rome by Cardinal Emulio after the death of Francesco, he finished one of the principal scenes in the King's Hall and began another. On the death of Pius IV. he returned to Venice, where the Signoria employed him to decorate a ceiling in the palace at the top of the new staircase. He also painted six beautiful panels in oils, one in S. Francesco della Vigna at the altar of the Madonna, one at the high altar of the Servites' church, one for the Minorites, one in the Madonna dell' Orto, one in S. Zaccaria, and the sixth in S. Moisè. He also did two fine ones at Murano with great diligence and in a good style. He is still living and working, so that I will say no more except that he studies geometry as well as painting, and did the volute of the Ionic capital, which has been recently printed to show the ancient proportion, and he will shortly publish a work on geometry. Domenico Romano, another pupil of Francesco, proved of great assistance to his master in the hall which he did in Florence, and in other works. In 1550 Domenico was with Sig. Giuliano Cesarino, and he does not work on his own account.

DANIELLO RICCIARELLI of Volterra, Painter
and Sculptor

(c. 1509–1566)

WHILE young, Daniello had learned something of design from
Sodoma, who was working in that city at the time, but after
he left, Daniello made far greater progress under Baldasarre
Peruzzi. But indeed he did not do much although he studied
hard, impelled by his earnest desire to learn, for this is of little
use without the help of the mind and hand. Thus his first works
at Volterra give evidence of great pains, but give no promise of
the style, grace or invention of born painters who display ease,
vigour and the promise of a good style in their earliest efforts.
They seem the work of a melancholy man, produced with toil
and patience in a long time. But to come to his works, passing
over those of no account. In his youth he did the façade of
Monsignor Mario Maffei in grisaille, which brought him much
credit. Then, finding himself without opposition, with few
opportunities of improvement in a city possessing no ancient
or modern works from which he could learn much, he resolved
to go to Rome, having heard that there were not many practising
painting there at the time, without counting Perino del Vaga.
Before leaving he thought he would take something to prove
his worth. Accordingly he did a Christ at the Column and a
number of figures in oils on canvas, with the utmost diligence,
using living models. He had not been long in Rome when, by
means of friends, he showed this to the Cardinal Triulzi, who
was greatly pleased, and not only bought it but showed Daniello
great favour and sent him to a building he was erecting outside
Rome, called Salone, which he was decorating with fountains,
stucco and painting, and where Gianmaria da Milano and others
were doing some rooms with stucco and arabesques. There
Daniello did many rooms and loggias with the rest, executing
many arabesques full of female figures, moved by emulation
and a desire to serve the cardinal, from whom he might hope
for much honour and profit. But he did best of all the story of
Phaëton in life-size figures in fresco, and a colossal river, an ex-
cellent figure. The cardinal often came to see these works, bring-
ing one or another of his colleagues, so that Daniello obtained
the favour of many of them and gained further employment.

Perino del Vaga needing assistance in the chapel of M. Agnolo

de' Massimi in la Trinità, Daniello joined him, attracted by his
promises, and helped him to do some things there with great
diligence. Before the sack of Rome, Perino had decorated the
vaulting of the chapel of the Crucified in S. Marcello with the
creation of Adam and Eve, St. John and St. Mark, the former
figure only half-finished. The men of the company decided that
he should finish it after tranquillity had been restored; but, as
he was otherwise employed, he made the cartoons and gave it
to Daniello, who finished the St. John and did St. Luke and
St. Matthew, with two infants holding a candelabrum in the
middle, and on the arch of the window-wall two flying angels
holding the mysteries of the Passion, decorating the arch with
arabesques and many fine nude figures, doing extraordinarily
well, although he spent a great deal of time over it. Piero then
gave him a frieze in the hall of the palace of M. Agnolo Massimi
to decorate with stucco and other ornaments and scenes of
Fabius Maximus. He did so well that Signora Elena Orsina, on
seeing it and hearing loud praises of his talent, gave him her
chapel in the church of the Trinità at Rome where the friars of
S. Francesco di Paula are. To this Daniello prepared to devote
many years, using every effort to produce a rare work and show
himself an excellent painter. He chose the story of St. Helena,
in honour of his patron, the chapel being dedicated to the Holy
Cross. He first did a Deposition from the Cross, displaying great
judgment in the richness of the composition and the finely
foreshortened Christ with the feet foremost and the rest of the
body farther back. Very fine also are the figures of those who
are on the ladders lowering the body, showing the nude in many
many places and executed with much grace. About the picture
he made a stucco ornament, with two figures supporting the
front with their heads, holding the capital with one hand and
the column with the other. This work is executed with incredible
diligence. In the arch above he painted two sibyls, the best
figures of all, with a window between them which lights the
whole chapel. The vault is divided into four parts, with a
curious decoration of stucco and arabesques and new fancies
in masks and festoons, containing stories of the Cross and St.
Helena. In the first the three crosses are being made; in the
second St. Helena is commanding the Jews to show her the
crosses; in the third she puts one of them in a well on their
refusal; in the fourth the three crosses are dug up, all scenes of
incredible beauty, executed with much study. The side walls
contain four other scenes, separated by the cornice forming the

impost of the arch on which the crossing of the vaulting rests. One contains St. Helena causing the three crosses to be dug up; the second shows the cross of Christ healing a sick man; in the third, on the right-hand, it raises a dead man, the nude body displaying a close study of the muscles and parts of the body, as do the bystanders who stand amazed at the miracle. He has also executed with great diligence a coffin containing bones. In the fourth he did the Emperor Heraclius, bare-footed and in his shirt, taking the cross to the gate of Jerusalem, with women, men and children kneeling in adoration, many barons, and a squire holding the horse. Underneath and bearing the scenes are two beautiful women painted like marble in grisaille. Under the arch in front he made two excellent life-size figures, St. Francesco di Paola, founder of the order, and St. Jerome as a cardinal. He finished this work in seven years of extraordinary labour. But as works thus produced are always hard, it lacks the light ease which charms. He himself admitted the effort, and fearing what actually happened, that he might be blamed, he did two bas-reliefs in stucco below the feet of the saints, out of caprice or as a sort of defence, as if to show that Michelagnolo Buonarotto and Frà Bastiano del Piombo, whose works he imitated and whose principles he followed, were his friends and his imitation of such friends should suffice to protect him from attack by the envious and malignant even if he was slow and laboured. In one of these scenes he represented a number of satyrs weighing legs, arms and other members to pass the good ones of correct weight and give the bad to Michelagnolo and Frà Bastiano, who are judging them; in the other Michelagnolo is looking at himself in a mirror, the meaning of which is apparent. Daniello also did two nudes in grisaille in the angles on the outside of the arch, of the same excellence as the other figures, which were much admired on being uncovered after so long a time. At a corner under one of the rich ceilings done by Antonio da Sangallo in the palace of Cardinal Alessandro Farnese, Daniello did a beautiful frieze of paintings with figures on each wall representing a triumph of Bacchus, a chase, and such things, which greatly pleased the cardinal, who made him do a unicorn on the lap of a virgin, the device of his family, on several parts of the frieze. From this time the cardinal always favoured him, for he always delighted in men of ability. He would have done more if Daniello had not worked so slowly, though it was not his fault, but his nature, and he preferred to do a little well rather than produce inferior work. Besides the cardinal, Sig. Annibale Caro assisted

him with the Farnese, who always aided him. For Margaret of Austria, daughter of Charles V., in her study in the Medici palace at Navona, mentioned in the life of Indaco, he did eight scenes, in as many spaces, of the deeds of Charles V., with unsurpassed diligence so that better work of the kind can hardly be seen.

On the death of Perino del Vaga in 1547, Daniello was appointed to finish the painting in the Hall of the Kings by Pope Paul III. through the influence of his friends, chiefly Michelagnolo, with the same provision. He was directed to begin the decoration of the façade in stucco with many nudes. The hall being entered by six large doors, three on each side, only one wall presenting an unbroken surface, Daniello made a fine stucco tabernacle over each door, intending to fill each with a painting of one of the kings who defended the Apostolic Church, occupying the walls with stories of the kings who have benefited the church by tribute or victories. There were to be six scenes and six niches, and Daniello made the latter with rich stucco decoration, assisted by many, while he thought over the cartoons for the paintings. He then began one of the scenes, but only painted about two braccia and two of the kings, because of the requirements of Cardinal Farnese and the Pope, who did not reflect that death frequently interrupts man's plans. Thus only so much was completed in 1549 on the death of the Pope, and as the conclave had to be held in that hall, the scaffolding was pulled down and the work uncovered. The stucco-work thus disclosed was greatly and deservedly praised, though the kings were less admired because they did not seem so good as the work of the Trinità, and he seemed to have gone back rather than progressed in spite of his advantages and stipends. On the election of Julius III. in 1550, Daniello by means of his friends secured the same provision and the continuation of his work in the hall. But the Pope not having turned his attention to it, kept putting it off, and sent for Giorgio Vasari, who had served him in all questions of design when he was archbishop of Sipontino. However, the Pope desiring to have a fountain at the end of the corridor of Belvedere, and not liking the design of Michelagnolo, which was a Moses striking the rock, because it would take a long time, since Buonarotto wished to do it in marble, gave Daniello the task of making a grotto for the divine Cleopatra made by the Greeks to be put in that place, as Giorgio advised, Michelagnolo recommending him. Daniello, however, worked so slowly that he only finished the stuccoes and paintings of the room, and as the

Pope wished to have many other things done, and had not expected this to take so long, it was left as it now stands. In a chapel in S. Agostino Daniello did St. Helena finding the Cross, in life-size figures, with St. Cecilia and St. Lucy in niches at the sides, partly coloured by himself and partly by his pupils from his designs, so that it did not reach the perfection of his other works. At the same time Signora Lucrezia della Rovere allotted to him a chapel in la Trinità opposite that of Signora Elena Orsini. He decorated it with stucco, and paintings of the life of the Virgin were done on the vaulting from his designs by Marco da Siena and Pellegrino da Bologna, while Bizzera the Spaniard did a Nativity of the Virgin on one of the walls, and Giovan Paolo Rossetti of Volterra, his pupil, did Christ presented to Simeon on the other. The same pupil did two scenes on the arches above, an Annunciation and Nativity. In the angles outside he did two large figures, and two prophets on the pilasters below. On the altar-front Daniello himself painted the Virgin ascending the steps of the Temple, and an Assumption above with many beautiful cherubs and the Apostles watching the Virgin ascend. As the place was not large enough for so many figures, he introduced a novelty, making the altar represent the tomb, arranging the Apostles about it on the plane of the chapel. This pleased some, but not the majority or the most judicious. But though Daniello laboured for fourteen years over this, he made it no better than the first. On the other wall he made the cartoons for a Massacre of the Innocents, entrusting all this work to his pupil, Michele Alberti of Florence.

M. Giovanni della Casa, a learned Florentine, as his graceful and learned works in the Latin and vulgar tongues prove, having begun a treatise on painting, and wishing to be instructed upon some details by professional artists, employed Daniello to make a clay David with the utmost diligence, and then to paint it so as to show every side. The painting, which is very beautiful, is now owned by M. Annibale Rucellai. For the same M. Giovanni Daniello did a Dead Christ with the Maries on canvas, to be sent to France, and Æneas undressing himself to go to Dido when Mercury arrives as described by Virgil. For the same he did another fine oil-painting of St. John in penitence, of life-size, which was greatly valued by its owner, and a marvellously fine St. Jerome. When Paul IV. succeeded Julius III. the Cardinal de' Carpi sought to induce the Pope to get Daniello to finish the Hall of the Kings, but Paul did not care for painting, and said the money would be much better spent in fortifying Rome. So

the Castello gate was begun from designs by Salustio, son of Baldassare Peruzzi, being made entirely of travertine, like a magnificent triumphal arch, and it was ordained that four statues, each 4½ braccia high, should be placed in the niches. Of these a St. Michael was allotted to Daniello, the remainder being given to others.

Giovanni Riccio, cardinal of Montepulciano, having resolved to erect a chapel in S. Piero a Montorio opposite the Pope's done by Giorgio Vasari, allotted the altarpiece, frescoes and marble statues to Daniello, who had decided to abandon painting for sculpture. He therefore went to Carrara for marble for his Michael and the statues of the chapel. This gave him an opportunity of visiting Florence, and seeing the works of Vasari in the palace of Duke Cosimo and the other things in the city. His numerous friends then welcomed him warmly, especially Vasari, who had received a letter of introduction from Buonarotto. While in Florence Daniello perceived the duke's fondness for art, and desired to enter his service. After he had tried many means the duke replied that Vasari might introduce him, and this was done. So when Daniello offered his service he was graciously accepted after he had fulfilled the works he had to do in Rome. Daniello remained all that summer in Florence in the house of Vasari's friend, Simon Botti. Here he made plaster casts of nearly all Michelagnolo's figures in the new sacristy of S. Lorenzo, and did a fine Leda for Michael Fugger, a Fleming. Proceeding to Carrara he sent the marble he required to Rome and returned to Florence again, for this reason. When he first came thither he had brought an apprentice named Orazio Pianetti, a youth of ability and breeding, who died as soon as he reached Florence. This caused Daniello great sorrow, for he loved the youth, and having no other means of showing his affection he made a marble bust of him on his second visit to Florence, modelling it from a death-mask. He put it when finished in S. Michele Bertelli on the Piazza degli Altinori. By this loving office Daniello showed himself a man of rare character, for in friendship there are few who seek anything but their own advantage.

It was long since Daniello had been at his native Volterra, and he went there before proceeding to Rome, being welcomed by his friends and relations. When asked to do something, he painted a Massacre of the Innocents[1] in small figures, considered very beautiful, and placed it in S. Piero. As he did not

[1] Now in the Uffizi Gallery.

expect to return, he sold his little patrimony to Lionardo Ricciarelli, his nephew, who having been with him in Rome where he learned to do stucco, served Giorgio Vasari for three years with many others on the works of the duke's palace.

On returning to Rome Daniello found that Paul IV. proposed to destroy Michelagnolo's Last Judgment on account of the nudes, but the cardinals and men of judgment had remonstrated, and succeeded in getting Daniello employed to clothe them with light draperies. This was done, and St. Catherine and St. Blaise were repainted for a like reason. Meanwhile Daniello began the statues for the chapel of the cardinal of Montepulciano and the St. Michael, but did not proceed so quickly as he might or should, as he was always changing his plans.

On the death of King Henry of France at a tournament,[1] Sig. Ruberto Strozzi came to Italy and Rome, and Queen Catherine de' Medici the regent sent him to arrange with Buonarotto for some memorial to her husband. After Ruberto had held a long conference with the master, Michelagnolo would not undertake the work, being too old, and advised him to go to Daniello, whom he would aid and advise as much as possible. Strozzi accepted this offer gladly, and after mature consideration it was decided that Daniello should make a bronze horse of one piece, twenty palms from the head to the feet, and about forty long, surmounted by a bronze statue of King Henry in armour. Daniello prepared a clay model with the help of Michelagnolo which greatly pleased Ruberto, and after communication with France the terms were finally settled. Daniello therefore made a clay horse with great care, of the requisite size, and prepared to cast it, taking the opinion of many founders in order to ensure success. But on Pius IV. succeeding Paul, the new Pope sent word to Daniello that he desired to have the Hall of the Kings finished, and that he should leave everything else. Daniello replied that he was under obligations to the Queen of France, but would prepare cartoons and set his apprentices to work, and would also do his share. As this reply did not please the Pope he thought of giving the whole to Salviati. This aroused Daniello's jealousy, and by means of the Cardinal di Carpi and Michelagnolo he succeeded in obtaining one half, while Salviati had the other, although he endeavoured to get the whole, to enable him to work at his ease without competition. But it ultimately fell out that he did no more than what he had already made great progress on, and Salviati did

[1] Henry II., in 1559.

not finish the little he had begun, while some was destroyed
by malice. At length, after four years, Daniello cast his horse,
but many months were still required before it was completed,
as he lacked the necessary metal and other materials which
Ruberto should have supplied. Daniello finally buried his mould
between two furnaces in a convenient place of his at Monte-
cavallo. The metal flowed fairly well for a while, but the weight
of metal in the body caused the whole material to take a
different course, to his infinite chagrin; however, he found a
remedy. Casting again after two months, his skill triumphed
over fortune, and he produced a perfect cast, a sixth or more
larger than that of the Antoninus[1] in the Capitol; this is a
great thing, considering that it weighs not less than twenty
miglaia. But the misfortunes and labours joined to his poor
health and melancholy nature brought on a severe catarrh.
Thus, when he ought to have been rejoicing at his success,
Daniello seems never to have tasted happiness again, and died
in two days, on 4 April, 1566. He confessed very devoutly and
took the sacraments. By his will he provided that his body
should be buried in the new church begun at the Terme by
Pius IV. for the Carthusian monks, directing that the angel
he had done for the Castello gate should be placed there. He
appointed Michele degli Alberti of Florence and Feliciano da
S. Vito of Rome his executors, leaving them two hundred
crowns, and they both fulfilled his wishes with affection and
diligence. He left them all his artistic property, casts, models,
designs and tools, so that they offered to finish the horse and
figure of the king for the ambassador of France. They both
studied many years under Daniello, and so great things may
be expected of them. Biagio da Carigliano of Pistoia, and Gio-
vampaulo Rossetti of Volterra, a diligent and intelligent man,
were both pupils of Daniello. The latter, who withdrew to
Volterra many years ago, has produced works worthy of great
praise. Marco da Siena also worked with Daniello, with great
profit. He has made Naples his home. Another pupil, Giulio
Mazzoni of Piacenza, began under Giorgio Vasari on the panel
M. Biagio Mei sent to Lucca and placed in S. Piero Cigoli, and
on the high-altar picture done by Giorgio in Monte Oliveto of
Naples, a large work in the refectory, the sacristy of Giovanni
Carbonero, the organ-shutters of the Piscopio, and other panels
and works. Learning stucco from Daniello, he equalled his
master, and has decorated the interior of the palace of Cardinal

[1] Marcus Aurelius.

Capodiferro, doing marvellous works not only in stucco but scenes in fresco and oils which have brought him well-deserved praise. He has done a fine marble bust of Francesco del Nero which cannot, I think, be bettered, so that the greatest results may be anticipated from him.

Daniello was a man of good character, but neglected everything from his devotion to art, and was a melancholy and solitary man. He died aged about fifty-seven. His portrait was promised to me by his pupils, who made it in plaster, when I was in Rome last year, but they have not sent it, in spite of my messages and letters, thus showing little affection for their dead master. However, as Daniello was my friend, I have inserted this one, not being willing to be baulked by their ingratitude, and if the portrait is not a good likeness, I must plead the neglect of Michele degli Alberti and Feliciano da S. Vito as my excuse.

TADDEO ZUCCHERO, Painter of S. Agnolo in Vado
(1529 – 1566)

WHEN Francesco Maria was duke of Urbino, Ottaviano Zucchero, the painter, had a son on 1 September, 1529, at S. Agnolo in Vado in that state, whom he called Taddeo. The boy having learned to read and write fairly, his father began to teach him something of design at the age of ten. But perceiving that his son might become a better painter than himself, he put him with his friend Pompeo da Fano, a mediocre artist. But as Taddeo liked neither the works nor the manners of his new master, he returned to S. Agnolo, and helped his father as much as he could. Having grown in years and judgment, Taddeo perceived that his father, burdened with seven boys and a girl, could not teach him much, and that he did not know enough to help him. So, at the age of fourteen, he went alone to Rome, where, as he knew no one, he suffered some hardships, and those who did know him treated him worse than the others. Accordingly he went to Francesco, called Il Sant' Agnolo, who did arabesques by the day for Perino del Vaga, and recommended himself with all humility, hoping that he would obtain help from a kinsman. But Francesco helped him with neither word nor deed, and scolded him severely, after the manner of some relations. Nevertheless, he did not lose heart, and contrived to exist for

several months in Rome, grinding colours in various shops for a pittance, and occasionally designing as best he could.

Although he became the apprentice of Giovampiero Calavrese, he did not make much progress, because his master and his exacting wife made him grind colours day and night, and fed him on nothing but bread, and in order that he might not have enough they kept it in a basket hung from the ceiling with bells, which rang whenever he touched it. But Taddeo would have endured all this had he been allowed to copy some sheets of Raphael owned by his master. However, Taddeo left Giovampiero on account of his treatment, and resolved to go about the shops where he was known, spending one part of the week on working for a living, and the other in designing chiefly the works of Raphael in the house of Agostino Chigi, and elsewhere in Rome. He would often pass the night in the loggias of Chigi and in similar places, having nowhere else to go. These hardships ruined his health, and but for his youth they would have killed him. Falling sick, and receiving no help from his kinsman Francesco, he returned to his father, not wanting to die in such misery.

This is sufficient to show what hardships Taddeo had to encounter, and I will not waste more time on these relatively unimportant details. He returned to Rome as soon as he was recovered and resumed his studies, but with more care than before. Under one Jacopone he made such progress that his kinsman Francesco, seeing his skill, took him into his house, and they worked together, Taddeo's good nature causing him to forget past injuries. So Taddeo made designs, and they both executed many friezes for chambers and loggias.

Daniello of Parma, who had stayed many years with Antonio da Correggio and had worked with Parmigiano, having undertaken to decorate a church at Vitto, in the Abruzzi, for the chapel of S. Maria, took Taddeo to help him. Thus, although Daniello was not a great painter, yet he had observed the methods of Correggio and Parmigiano and their charm and skill, and so taught Taddeo, assisting him as much by advice as others might by example. Taddeo here did the evangelists, two sybils, two prophets and four small scenes of Christ and the Virgin on the vaulting. On his returning to Rome M. Jacopo Matteo, a Roman noble, consulted Francesco Sant' Agnolo about painting the façade of his house. Francesco suggested Taddeo, but as the boy seemed too young to the noble, Francesco suggested that he should do two scenes, and if these were not

approved they should be destroyed, but if they were he should continue. Taddeo therefore did two scenes, which not only satisfied but amazed M. Jacopo, and when he completed the work in 1548 all Rome united in his praise, with good cause. For, since Polidoro, Maturino, Vincenzio da S. Gimignano and Baldassare of Siena, no one had produced work of the kind equal to this production of a lad of eighteen. The scenes, which relate to the deeds of Camillus, may be understood from the inscription under each:

The first is, *Tusculani pace constanti vim Romanam arcent.*
The second, *M.F.C. Signiferum secum in hostem rapit.*
The third, *M.F.C. auctore incensa urbs restituitur.*
The fourth, *M.F.C. pactionibus turbatis praelium Gallis nunciat.*
The fifth, *M.F.C. proditorem vinctum Falerio reducendum tradit.*
The sixth, *Matronalis auri collatione votum Apollini solvitur.*
The seventh, *M.F.C. Junoni Reginæ templum in Aventino dedicat.*
The eighth, *Signum Junonis reginæ a Veiis Romam transferitur.*
The ninth, *M.F.C. . . . anlius dict. decem . . . socios capit.*

From that time to the election of Julius III. in 1550 Taddeo was engaged upon unimportant works, though he made fair progress. That year his father, mother and a brother came to Rome to celebrate the Jubilee, and to see him. After a stay of some weeks they left the brother called Federigo with Taddeo to study letters. But as Taddeo judged him better fitted for painting, as appeared by his subsequent success, he began to teach him design after he had done his first letters, so that his brother enjoyed better fortune than he had himself. Behind the high altar of the Milanese church of S. Ambrogio Taddeo did four scenes of that saint in fresco, with a frieze of boys and girls as termini. That done, he did a wall with five stories of Alexander the Great, next to S. Lucia della Tinta near the Orso, which were much admired, although they had to stand comparison with a wall by Polidoro close by.

Guido Baldo, duke of Urbino, having heard the fame of his young subject, and desiring to finish the walls of the chapel in the duomo of Urbino, where Battista Franco had painted the vaulting, sent for Taddeo. He therefore left Federigo learning at Rome, and another brother put with a goldsmith, and proceeded to Urbino, where he was welcomed by the duke. While he was designing the things for the chapel, the duke, as general of the Venetians, had to go to Verona to inspect the fortifications, and took Taddeo with him, who copied for him Raphael's picture in the house of the Counts of Canossa. He then began

a large canvas for the duke of the Conversion of St. Paul, which is still unfinished and in the possession of Ottaviano, his father, at S. Agnolo. Returning to Urbino, Taddeo continued the designs for the chapel of the life of the Virgin, as we see by a portion in grisaille in the possession of his brother Federigo. But whether the duke thought him too young, or for some other cause, during the two years Taddeo remained with him he did no more than some pictures in a study at Pesaro, a large scutcheon in fresco on the façade of the palace and a life-size portrait of the duke, all fine works. The duke having to go to Rome to receive his baton as general of the Church from Julius III., left Taddeo to continue the chapel, providing him with everything necessary. But the duke's ministers, after their kind, delayed everything, so that after wasting two years Taddeo went to Rome and, finding the duke, dexterously excused himself without blaming anyone, promising that he would finish the chapel in due time.

The following year, 1551, Stefano Veltroni of Monte Sansavino, directed by the Pope and Vasari, had adorned with grotesques the Pope's villa outside the Popolo gate, which had belonged to the Cardinal Poggio. He called in Taddeo, who painted a Chance about to shear off the locks of Fortune, the Pope's device, executed very well. Vasari, having designed the court and fountain under the new palace, continued by Vignola and Ammannato and executed by Baronino, employed Taddeo in painting many things. This proved of great advantage to him, for the Pope liked his style, and got him to colour some small figures as a frieze in rooms above the Belvedere corridor, and to do the labours of Hercules in grisaille, and of life-size, in an open loggia facing Rome, destroyed under Paul IV. to make other rooms and a chapel. In the first room of Pope Julius's villa he coloured some scenes in the middle of the vaulting, notably Mount Parnassus, and did two stories of the Sabines in the court in grisaille, on either side of the principal door to the loggia, at the place where the descent to the fountain of Acqua Vergine begins, works which were much praised.

While Taddeo was at Rome with the duke, Federigo had returned to Urbino, and stayed some while both there and at Pesaro. But Taddeo recalled him to Rome to help him with a long frieze in a hall, and some in other rooms of the Giambeccari house on the piazza of S. Apostolo, and yet others in the house of M. Antonio Portatore, by S. Mauro, full of figures

and other things considered very beautiful. Mattiuolo, master
of the post under Pope Julius, having built a convenient house
on a site he had bought in Campo Marzio, employed Taddeo to
paint the façade in grisaille. Taddeo did three scenes of Mercury,
messenger of the gods, of great beauty, and the rest was done
by others from his designs. M. Jacopo Mattei, having built a
chapel in the church of the Consolation under the Capitol, gave
it to Taddeo to paint, of whose skill he was already aware. He
took it willingly, and for a small price, in order to show that
he could do façades in other things besides grisaille, which some
denied. But he only worked when he felt in the mood, devoting
the rest of his time to things in which his reputation was not
so closely concerned, and he took four years to finish it. In the
vaulting he did four scenes of the Passion, surpassing himself
in invention, design and colouring. The scenes are the Last
Supper, the Washing of the Feet, the Agony in the Garden
and the Betrayal. On one of the side walls he did a Christ at
the Column, and on the other an *Ecce Homo*, with Pilate
washing his hands in the lunette above, and opposite, Christ
brought before Annas. On the altar-front he did the Crucifixion,
with the Maries and the Virgin fainting, and two prophets at
the sides. In the arch he did two sibyls above the stucco orna-
ment, all four figures relating to the Passion. The vaulting con-
tains four half-length Evangelists of great beauty, surrounded
by a stucco ornament. This was uncovered in 1556, Taddeo
being only twenty-six, and already considered a master. M.
Mario Frangipani then allotted to him his chapel in S. Marcello,
where Taddeo employed, as in many other works, those young
artists from distant parts who do journeyman's work in Rome
for gain and instruction, but did not complete it at the time.
In the time of Paul IV. he painted in fresco some room in the
Pope's palace, occupied by the Cardinal Caraffa, in the tower
over the guard-chamber. He also did some small pictures in oils
of a Nativity and a Flight into Egypt, both sent to Portugal
by the ambassador of the king.

The Cardinal of Mantua, wishing to have the interior of his
palace next the Portuguese arch painted with all speed, allotted
the work to Taddeo for a reasonable price. Aided by numerous
assistants he soon finished it, showing great judgment in his
employment of so many brains on so great a work, in such a
way that it seems to be by one hand. In fine, he satisfied the
cardinal and everyone, though some said he would not succeed
in such a large work. For M. Alessandro Mattei he painted some

nooks in rooms of his palace, and caused others to be executed
by his brother Federigo, who, being encouraged by this, did a
Mount Parnassus by himself in the house of Stefano Margani,
a Roman noble, under the steps leading to Araceli. Taddeo
seeing him thus working unaided from his own designs, induced
the men of S. Maria dell' Orto a Ripa in Rome to allot a chapel
to him, though they objected that he was too young. To satisfy
them Taddeo himself did a Nativity, but Federigo painted all
the rest, showing the first signs of his present excellence.

The Duke of Guise being then in Rome, and desiring a skilful
artist to paint his palace in France, he was introduced to Taddeo,
whose style pleased him, and he agreed to give Taddeo 600
crowns a year, while the painter promised to go to France to
serve the duke when he had finished what he had in hand.
He would have done so, the money being left in a bank, but for
the wars which broke out in France and the duke's death soon
after.[1] Returning to the work in S. Marcello, Taddeo did not do
much before he was interrupted, as he had to prepare numerous
trophies and other ornaments in pasteboard for the obsequies
of Charles V. in Rome. For these, which he completed in twenty-
five days, he received 600 gold crowns for his own labours and
those of Federigo and his other assistants. He next did two
large rooms decorated in stucco for Signor Paolo Giordano Orsini
in Bracciano, one of Cupid and Psyche, the other with scenes of
Alexander the Great, in which he was helped by Federigo, who
acquitted himself excellently. For M. Stefano del Bufalo's garden
at the fountain of Trevi he did the Muses about the Castalian
fount and a Mount Parnassus, of great beauty.

The wardens of the Madonna at Orvieto having made some
chapels in the aisles, adorned with marble and stucco, giving
some panels to Girolamo Mosciano of Brescia, employed Taddeo
also, whose fame they had heard from his friends, and so he
took Federigo there. On the front of one of the chapels he did
two large figures representing the Active and the Contemplative
life in a bold, easy style, such as he adopted where he did not
devote much study. Meanwhile Federigo did three stories of
St. Paul in a niche of the chapel, but as they both fell ill they
departed, promising to return in September, Taddeo going to
Rome and Federigo to S. Agnolo. After two months Federigo
also went to Rome, and in Holy Week they both painted in four
days the scenes of the Passion on the vaulting and in a niche
of the oratory of St. Agata of the Florentines, behind the Banchi,

[1] On 12 April, 1550.

for an apparatus, with prophets and other paintings, which excited universal wonder.

Cardinal Alessandro Farnese, having well advanced his palace of Capraola, under Vignola the architect, gave all the painting to Taddeo, on condition, as Taddeo did not wish to abandon his other works, that he should make all the designs, cartoons and arrangements for the painting and stucco; that his assistants should be selected by him but paid by the cardinal, that he should himself work for two or three months in the year, and go when necessary to see how things were progressing and do the retouching, for all which the cardinal granted a provision of 200 crowns a year. With such a salary and such a patron Taddeo resolved that he would take no more mean work at Rome, to avoid the blame of many who said that he accepted everything greedily, depriving others of the means to enable them to study, as he himself had done in his boyhood. Taddeo defended himself by saying that he did it for the sake of Federigo and another brother. Having decided to devote himself to the service of Farnese, Taddeo induced M. Tizio da Spoleti, master of the cardinal's house, to give Federigo the façade of his house on the piazza of the Dogana near S. Eustachio. Federigo desired nothing better, and painted the legend of St. Eustace, comprising the saint's baptism with his wife and children, a very good work, and his seeing the crucifix between the horns of a stag while hunting. But as Federigo was not then more than twenty, Taddeo sometimes went to retouch things, for the situation was a public one, and Federigo's honour was at stake. After enduring this for a while Federigo lost all patience, and taking a hammer destroyed something which Taddeo had done, remaining away from home for some days. On hearing of this their friends reconciled them, on the terms that Taddeo should correct Federigo's designs and cartoons, but not his work in fresco or oils. On finishing the house Federigo was recognised as a master and won great praise. Taddeo being afterwards directed to restore the Apostles painted by Raphael in the hall of the Palafrenieri, removed by Paul IV., did one and left the rest to Federigo, who acquitted himself admirably. They then did together a coloured frieze in fresco in a hall of the Araceli palace.

About this time Taddeo was commissioned to paint the portrait of Verginia, daughter of Duke Guido Baldo of Urbino, whom it was proposed to marry to Sig. Federigo Borromeo, and did so with admirable success. Before leaving Urbino Taddeo prepared all the designs for a service which the duke had

executed in majolica at Castel Durante, to be sent to King Philip of Spain. On returning to Rome Taddeo presented the portrait to the Pope, who was well pleased. But such was the discourtesy of the Pope or his ministers that they did not even pay the poor painter's expenses. In 1560, when the Pope expected Duke Cosimo and the Duchess Leonora in Rome, he proposed to lodge them in the rooms built by Innocent VIII. in the first court of the palace, with loggias in front on the piazza where the benediction is given. Taddeo was charged to do the painting and friezes and to gild the new ceilings, the old ones being worn out. In this important work Federigo showed great excellence, being charged with almost everything by his brother, but he was nearly killed through a serious fall from a scaffold while painting arabesques there. Cardinal Emulio, who was charged with the work by the Pope, in order to have it finished quickly, employed many youths to paint the little palace in the wood of Belvedere, begun under Paul IV., with a handsome fountain and many ancient statues, Pirro Ligorio being architect. The youths were Federigo Barocci of Urbino, a youth of great promise, Lionardo Cungi, Durante del Nero, both of Borgo S. Sepolcro, who did the first-floor rooms. Santi Titi of Florence painted the first room at the top of the spiral staircase with great success, and the large room beside it was done by Federigo, Taddeo's brother. A room out of this was by Giovanni del Carso, a Sclavonian, and a good master of arabesques. But though all did well, Federigo surpassed them in a Transfiguration, a Marriage at Cana, the Centurion, and other scenes from the life of Christ; of the two remaining, Orazio Sammachini of Bologna did one and Lorenzo Costa of Mantua another. Federigo also did the loggia overlooking the lake, and a frieze in the principal hall of the Belvedere, approached by the spiral staircase, with stories of Moses and Pharaoh of great beauty. Not long since Federigo gave the coloured design for this to Don Vincenzio Borghini, who values it highly. In the same place Federigo, assisted by many apprentices to get done more quickly, painted the Angel slaying the first-born. But the labours of Federigo and the others did not obtain the recognition they deserved, for some of the artists of Rome, Florence and elsewhere are very malignant and, being blinded by envy, will not recognise merits in others or defects in themselves, and this often discourages young men of genius.

In the office of the Ruota, Federigo painted Justice and Equity supporting the arms of Paul IV., larger than life-size, which were

much admired, Taddeo being meanwhile engaged upon the work
at Caprarola and the chapel of St. Marcello. The Pope, being
anxious to have the Hall of the Kings finished, after the dis-
putes between Daniello and Salviati, sent orders for this to the
bishop of Furli. Accordingly, on 3 September, 1561, the bishop
wrote to Vasari, saying that the Pope wanted men to finish it,
and begged him, for their old friendship's sake, to obtain the
duke's permission to come to Rome to do this work, for it
would benefit him and please the Pope. Vasari answered that
he was very contented in the duke's service, who rewarded him
better than the popes had done, and that he was engaged upon
a much larger hall than that of the Kings, while Rome did
not lack men for the work. On receiving this reply the bishop
consulted the Pope, and they decided that the Cardinal Emulio
should divide the work among many young men, some of whom
were already at Rome, while others were to be invited from
other parts. Salviati's pupil, Giuseppe Porta, had the two
largest scenes, Girolamo Sicciolante of Sermoneta had one
large and one small scene, Orazio Sommachini of Bologna had
a small scene, and Livio da Furli another, and Gio. Battista
Fiorini of Bologna had a small one. Taddeo, finding himself
excluded, because the cardinal had been told that he thought
more of gain than glory, made every effort with Cardinal Far-
nese to obtain a share of the work. But the cardinal, not wishing
to interfere, answered that the work at Caprarola ought to
content him, and that he did not want his things neglected
because of rivalry between artists, adding that works bring
reputation to places, not places to works. Nevertheless, by
approaching Emulio, Taddeo at length obtained one of the
smaller scenes over a door, though he could not get a larger
one. Indeed, they say that Emulio hoped that Giuseppe Sal-
viati would surpass all and would get the rest of the work,
perhaps destroying what had been done by others. On the com-
pletion of the painting the Pope wished to see it, and all the
cardinals and best artists were agreed that Taddeo had acquitted
himself best, though all had done fairly. The Pope, therefore,
directed Cardinal Emulio to give him one of the larger scenes,
and he received the end with the door of the Paolina Chapel.
He did not finish this, as the Pope died and everything was
uncovered for the conclave, so that many of the scenes there
were not completed. However, we have Taddeo's design in our
book. At the same time, besides some small things, Taddeo
did a beautiful Christ to be sent to Cardinal Farnese at Caprarola,

and now owned by Federigo his brother, who says he wants it for himself. The light is given by torches held by weeping angels. But I will say no more of Taddeo's work at Caprarola, as it is described at length in the discourse on Vignola, who built the place.[1] Federigo being summoned to Venice, agreed with the Patriarch Grimani to finish the chapel of S. Francesco della Vigna, interrupted by the death of Battista Franco. But before beginning he decorated the steps of the patriarch's palace with small figures gracefully placed in stucco ornaments, and then did two scenes of Lazarus and the Conversion of the Magdalene in the chapel, the design for which is in our book. For the picture of the chapel Federigo did an Adoration of the Magi in oils. At the villa of M. Gio. Battista Pellegrini, between Chioggia and Monselice, decorated with many things by Andrea Schiavone and the Flemings Lambert and Walter, he did several admirable paintings in a loggia.

After Federigo's departure Taddeo spent all the summer working in the chapel of St. Marcello, where he finished a picture of the Conversion of St. Paul; the saint has fallen from his horse, and is dazed by the splendour and the voice of Christ, who is represented in a glory of angels. The men with Paul are as much dazed and amazed as their master. In the vaulting Taddeo painted Paul landing at Malta, and shaking the viper into the fire, with half-naked mariners standing about the boat, his raising a youth who had fallen out of the window, and his decollation. At the base he did two large scenes, St. Paul healing a lame man and his rendering a sorcerer blind, both of great beauty. This work, being interrupted by his death, was finished by Federigo in the present year, and excited much admiration when uncovered. At the same time Taddeo did some oil-paintings which were sent to the king of France by his ambassador.

The hall of the Farnese palace being left unfinished by the death of Salviati, lacking two scenes at the entrance opposite the great window, the Cardinal St. Agnolo Farnese gave it to Taddeo, who completed it successfully, but did not attain to the excellence of Francesco, as some malignant people went about saying in Rome, seeking to dim Salviati's glory. Taddeo defended himself by saying that he had left everything to his apprentices, and that only the designs and a few other things were his. The excuses were not considered valid, because in competition a man ought not to trust his reputation to weak hands, since he will in such case inevitably lose ground. Cardinal

[1] See pp. 93–106.

S. Agnolo, being a man of excellent judgment, realised how much he had lost by the death of Salviati, who, despite his proud and crabbed nature was an excellent painter. But there being no better painters in Rome, the best having gone, the cardinal decided to entrust the principal hall of the palace to Taddeo. That artist readily accepted, hoping to show the extent of his ability and knowledge. Lorenzo Pucci of Florence, Cardinal Santi Quattro, had built a chapel in the Trinità, and had the vaulting painted by Perino del Vaga, and the exterior with prophets and two infants supporting his arms. But three walls being left undone at the cardinal's death, the fathers, without regard to judgment or reason, sold the chapel to the archbishop of Corfu, who gave it to Taddeo to paint. But respect for the Church ought to have prevented them from consenting to the removal of the cardinal's arms in favour of those of the archbishop, which might have gone elsewhere without wronging the cardinal. Taddeo, being so busy, kept urging Federigo to return from Venice. After finishing the patriarch's chapel, Federigo was hoping to paint the principal wall of the Great Hall of the Council, where Antonio Viniziano had worked. But his quarrels and disputes with the Venetian painters prevented both him and them from getting it.

Meanwhile Taddeo wished to see Florence, and the numerous works which he understood that Duke Cosimo intended to have done, including the great hall in the charge of his friend Vasari, hoping to go to Caprarola for the work there. One St. John's day he arrived in Florence with Tiberio Calcagni, a young sculptor and architect of Florence. The city, as well as its numerous art treasures, both ancient and modern, greatly delighted him, and if he had not had so many works in hand he would have liked to spend some months there. He saw Vasari's preparations for the great hall, namely forty-four large pictures of four, six, seven and ten braccia each, all executed in less than a year, with the help of Giovanni Strada, a Fleming, and Jacopo Zucchi his pupils, and Battista Naldini, and they afforded him great pleasure and inspired him with fresh courage. On returning to Rome Taddeo began the chapel of la Trinità, intending to surpass himself in the life of the Virgin there. Although Federigo had been urged to return from Venice he could not resist remaining for the carnival with Andrea Palladio the architect, who had made a wooden colosseum for the performance of a tragedy for the company of la Calza, and gave Federigo twelve scenes, $7\frac{1}{2}$ feet square for the mounting, representing the deeds of Hyrcanus,

King of Jerusalem, the subject of the tragedy. The excellence
and the speed with which Federigo executed this work brought
him considerable fame. When Palladio went to lay the founda-
tions of the palace of Civitale in Friuli, of which he had made the
model, Federigo accompanied him to see the country, and drew
many things which pleased him. After seeing Verona and several
other Lombard cities he at length reached Florence, at the time
of the preparations for the reception of Queen Joan of Austria.
Accordingly he did a large canvas for the duke at the top of the
hall, of a hunting scene, and some scenes in grisaille for an arch,
which gave great delight. Passing through S. Agnolo to visit his
friends and relations, he reached Rome on 16 January. But he
was then of little use to Taddeo, for the death of Pius IV. and of
the Cardinal S. Agnolo interrupted the work in the Kings' Hall
and in the Farnese palace. Accordingly Taddeo, who had finished
a suite of rooms at Caprarola and almost completed the chapel
of St. Marcello, went quietly on with the work of la Trinità, doing
an Assumption and the Apostles about the bier. Meanwhile
Federigo undertook a chapel in the church of the reformed
Jesuits at the obelisk of S. Mauro. Taddeo, being angry at
Federigo's delay, pretended to be indifferent about his brother's
return, though he was really very glad, as appeared afterwards.
For he disliked household cares, of which Federigo used to free
him, as well as of the charge of their brother with the goldsmith.
Thus Federigo's return released him from many annoyances and
left him free to work. At this time Taddeo's friends wanted him
to marry, but he preferred his liberty, and feared the thousand
worries which usually come to those who take a wife. For the
principal wall of la Trinità he did a cartoon for an Assumption,
while Federigo did a St. Peter in Prison [1] for the Duke of Urbino,
and a Virgin in Heaven surrounded by angels, to be sent to Milan.
He did a Chance for Perugia.

The Cardinal of Ferrara,[2] having employed many painters
and stucco masters to decorate his beautiful villa at Tigoli, at
length sent Federigo thither to paint two rooms dedicated
respectively to Nobility and Glory. Federigo did very well,
showing good invention, and then returned to Rome and com-
pleted his chapel, representing a choir of angels with God send-
ing the Holy Spirit upon the Madonna, and the Angel Gabriel
making the annunciation, placed between six prophets, larger
than life-size and of great beauty.

[1] Now in the Pitti Gallery.
[2] Ippolito d'Este, 1479–1520, made cardinal in 1493.

Taddeo meanwhile continued his Assumption, straining every nerve. It was his last work, for he fell ill, and though the disorder seemed slight and occasioned by the great warmth of the year, he grew worse, and died in September 1566, after receiving the sacraments like a good Christian and having seen most of his friends. He left behind him Federigo, who was also sick. Thus in a short while the world lost Buonarotto, Salviati, Daniello and Taddeo, to the great detriment of the arts, especially of painting.

Taddeo's works display great vigour, and he possessed a smooth style without a trace of crudeness. His compositions were abundant, and he excelled in heads, hands and nudes, avoiding the crudeness of some who have studied anatomy, who are like the man who was recognised by a woman of the people not to be an Athenian, from his efforts to speak too much like an Athenian. Taddeo naturally possessed a charming and easy style, but sometimes relied too much upon this. He was too greedy, and for a while took everything for the sake of gain, producing much, though countless works of his are admirable. He was obliged to retain numerous assistants, for otherwise he could not have completed his undertakings. He was of a quick and choleric temper, besides being given to amours, but in this he was temperate, and knew how to act secretly. He loved his friends, and was always anxious to help them whenever he could. At his death the work of the Trinità was still veiled, and the great hall of the Farnese palace and the works of Caprarola were unfinished; however, they were entrusted to Federigo to complete. Indeed, Federigo is as much the heir of Taddeo's genius as of his property. Taddeo was buried by Federigo in the Rotonda of Rome, near the tabernacle where his fellow-countryman Raphael lies. It is right that it should be so, because as Raphael died at thirty-seven on Good Friday, his birthday, so Taddeo, born on 1 September, 1529, died on the 2nd of that month in 1566. Federigo proposes to restore the tabernacle and make some memorial there to his brother, to whom he owes so much.

Jacopo Barozzi of Vignola has been mentioned above as the architect of the Cardinal Farnese's rich and royal villa of Caprarola. He is a painter and architect of Bologna, now aged fifty-eight. In his boyhood he was apprenticed to painting in Bologna, but did not profit much, because he was not well taught, and also, to tell the truth, because he had more natural ability for architecture, as is shown by his designs and his few paintings.

However, Nature inclined him so powerfully to architecture and perspective that he learned the elements almost unaided, and speedily mastered the difficulties. Thus almost before he became known we saw fanciful designs by him, mostly done at the request of M. Francesco Guicciardini, then governor of Bologna,[1] and of some other friends. These designs were afterwards executed in marquetry of coloured woods by Frà Damiano, a Dominican of Bologna. Proceeding to Rome, to study painting and help his poor family, Vignola first went to the Belvedere with Jacopo Melighini of Ferrara, architect of Paul III., designing some architectural things for him.

At that time Rome possessed an academy of nobles for the study of Vitruvius, among them being M. Marcello Cervini, afterwards pope, Monsignor Maffei, and M. Alessandro Manzuoli. Vignola served there in taking measurements of all the antiquities of Rome and doing things after their fancy, which greatly assisted both his studies and his purse. When Francesco Primaticcio, the Bolognese painter mentioned elsewhere, reached Rome, he employed Vignola in modelling a great part of the antiquities of Rome to be sent to France, and in casting bronze copies of the ancient statues. When Primaticcio went to France he took Vignola with him to employ him in architecture, and to help in casting the statues, in both of which Vignola showed great diligence and judgment. After two years he returned to Bologna to attend to the fabric of S. Petronio, as he had promised Count Filippo Pepoli. There he spent several years in disputes with those who competed with him in that work, without doing anything except having a canal constructed from his designs, to bring boats right up to Bologna when previously they had not approached within three miles, and no better or more useful work was ever accomplished, though the inventor was badly recompensed.

On the election of Julius III., in 1550, Vignola was appointed the Pope's architect through Vasari's influence, and especially charged with the Acqua Vergine, and to superintend the works of the Pope's villa. Julius was glad to employ him, for he had known Vignola when he was legate at Bologna. Vignola worked very hard for the Pope in these and other things, but was badly rewarded. At length Cardinal Alessandro Farnese recognised the ability of Vignola, and in building his palace of Caprarola placed implicit confidence in his fancy, design and invention. Indeed the cardinal showed as much judgment in selecting his

[1] From 1529 to 1532.

architect as in undertaking such a noble work, which, though situated in a place where it can give but little pleasure to the generality, is marvellously situated for one who wishes occasionally to withdraw from the worries and tumult of the city. The building is pentagonal and divided into four parts, excluding the front containing the principal door and a loggia 40 palms broad by 80 long. On one side is a spiral staircase 10 palms in width, with a light of 20 palms in the middle. It ascends to the third floor and rests upon double columns with cornices following the steps, both rich and varied in the Doric, Ionic, Corinthian and Composite orders, with rich balusters, niches and other fancies, rendering it most beautiful. Opposite, on the other side of the loggia, is a suite of rooms, beginning with a round hall of the width of the staircase, and leading to a large room 80 palms long and 40 broad decorated with stucco and paintings of the birth of Jupiter, his nursing by the goat Amaltea, her coronation, and two other scenes, one of her being placed in heaven among the forty-eight images and the second also relating to the same goat (*capra*), all alluding to the name Caprarola. The walls contain perspectives of buildings drawn by Vignola, coloured by his son-in-law, of great beauty, and they make the room appear larger. Next this is a hall of 40 palms, exactly in the following angle, containing paintings of Spring. Following this, to the beginning of a tower, three rooms, 40 palms by 30, are entered. The first is decorated with stucco and painting representing Summer, the second for Autumn, and the third, towards the north, for Winter. Hitherto I have only spoken of half the pentagon on the right above the cellars containing the kitchen, buttery, larders and offices. On the left are an equal number of rooms of the same size. Within the five angles of the pentagon Vignola formed a round court with doors to each room opening into a round loggia, running round the court, 18 palms broad. The diameter of the court is 95 palms 5 inches. The pilasters of the loggia, separated by niches supporting the arches and vaulting, are in pairs and 15 braccia across, and so are the spans of the arches. In the angles formed about the loggia are four spiral staircases mounting to the top of the palace, for the rooms, with cisterns for rain-water and a large and handsome basin in the middle. With the windows and other conveniences this forms a beautiful structure. It is like a fortress, with a newel staircase outside and a moat and drawbridge, in a new style and fine invention. The gardens are filled with rich and varied fountains, graceful shrubberies and

lawns, and every requisite for such a royal villa. On mounting the spiral staircase to the first floor one finds as many rooms as those mentioned above and a chapel in addition, opposite the principal staircase. In the hall above that of Jupiter, Taddeo and his assistants made rich decorations in stucco of the acts of illustrious members of the Farnese house. The vaulting contains six scenes, four square and two round, with a cornice, and three ovals in the middle, corresponding with the smaller squares, a Fame being painted in one and Bellona in the other. The first oval contains Peace, the middle one the old Farnese arms with the casque and a unicorn, and the third Religion. The first of the scenes is round, and represents Guido Farnese surrounded by a multitude, with this legend:

Guido Farnesius urbis veteris principatum civibus ipsis deferentibus adeptus, laboranti intestinis discordiis civitati seditiosa factione ejecta, pacem et tranquillitatem restituit, anno 1323.

In an oblong is Pietro Niccolo Farnese liberating Bologna, with the legend:

Petrus Nicolaus sedis romanae potentissimis hostibus memorabili praelio superatis, imminenti obsidionis periculo Bononiam liberat, anno salutis 1361.

In the next square Piero Farnese is made captain of the Florentines, with the legend:

Petrus Farnesius reip. florentinae imperator magnis Pisanorum copiis capto duce obsidionis occisis urbem Florentiam triumphans ingreditur, anno 1362.

In the circle opposite the first Pietro Farnese routs the enemies of the Church at Orbatello, with its inscription. One of the two other squares has Raineri Farnese created general of the Florentines in place of his brother Piero, with the legend:

Rainerius Farnesius a Florentinis difficili reip. tempore, in Petri fratris mortui locum copiarum omnium dux delegitur, anno 1362.

The other represents Ranuccio Farnese appointed general of the Church by Eugenius IV., with the legend:

Ranutius Fanesius Pauli III. papæ avus Eugenius IV. P.M. rosae aureae munere insignitus ponteficii exercitus imperator constituitur anno Christi 1435.

In short, the vaulting contains a quantity of beautiful figures, stucco gilding, and other ornaments. Each wall contains two scenes. The first on the right is Julius III. confirming Parma and

Piacenza to Duke Ottavio and his son in the presence of the
Cardinal Farnese, S. Agnolo his brother, S. Fiore the chamber-
lain, Salviati the elder, Chieti, Carpi, Polo and Morone, all
portraits, with the legend:

*Julius III. P. M. Alexandro Farnesio auctore Octavio Farnesio
ejus fratri Parmam amissam restituit, anno salutis* 1550.

The second represents Cardinal Farnese going to Worms as
legate to Charles V., and his meeting with the emperor and his
son, with a multitude of barons including the King of the
Romans. On the left of the entrance the first scene is the war
against the Lutherans in Germany, when Duke Ottavio Farnese
was legate in 1546, with its inscription. The second represents
Cardinal Farnese, the emperor and his sons, all four under a
baldachino carried by men who are drawn from life, and among
them is Taddeo the artist, surrounded by a company of many
lords. On one wall are two scenes with an oval between them
containing the portrait of King Philip and the legend:

*Philippo Hispaniarum regi maximo ob eximia in domum Far-
nesiam merita.*

One scene represents the marriage of Duke Ottavio to Margaret
of Austria, with Paul III. and portraits of the Cardinal Farnese
the younger, Cardinal Carpi, Duke Pier Luigi, M. Durante,
Eurialo da Cingoli, M. Giovanni Riccio of Montepulciano, the
bishop of Como, Signora Livia Colonna, Claudia Mancina, Set-
timia and Donna Maria di Mendozza. The other is the marriage
of Duke Orazio to the daughter of King Henry of France, with
the legend:

*Henricus II. Valesius Galliæ rex Horatio Farnesio Castri duci
Dianam filiam in matrimonium collocat, anno salutis* 1552.

Besides portraits of Diana in her royal mantle, and of Duke
Orazio, there are those of Catherine de' Medici, Queen of France,
Margaret the King's sister, the King of Navarre, the Constable,
the Duke of Guise, the Duke of Nemours, the Admiral, Prince
of Condé, the cardinal of Lorraine, the younger, Guise not yet a
cardinal, Sig. Piero Strozzi, Madame de Montpensier, Mlle. de
Roanne. The other end also has two scenes, with an oval between
them, containing a portrait of King Henry of France, and the
legend:

Henrico Francorum regi max. familiæ Farnesiæ conservatori.

On the right-hand Paul III. is investing the kneeling Duke
Orazio with a sacerdotal garb, and creating him prefect of Rome

in the presence of Duke Pier Luigi and other lords, with the words:

Paulus III. P.M. Horatium Farnesium nepotem summae spei adolescentem praefectum urbis creat, anno sal. 1549.

It contains portraits of the cardinal of Paris, Viseo, Morone, Badia, Trento, Sfondrato and Ardinghelli In the other scene the Pope confers the baton of general on Pier Luigi and his sons, not then cardinals, with portraits of the Pope, Pier Luigi, Carmarlingo, Duke Ottavio, Orazio, cardinal of Capua, Simonetta, Jacobaccio, S. Jacopo, Ferrara, Sig. Ranuccio Farnese a boy, Il Giovo, Il Molza and Marcello Cervini, afterwards Pope, the Marquis of Marignano, Sig. Gio. Battista Castaldo, Sig. Allessandro Vitelli and Sig. Gio. Battista Savelli. In the next hall above the hall of Spring, the vaulting is richly decorated with stucco and gilding, and in the centre is the coronation of Paul III. with four spaces forming a cross, and the legend:

Paulus Farnesius P.M. Deo et hominibus approbantibus sacra tiara solemni ritu coronatur, anno salutis 1534, iii. Non. Novemb.

Four scenes follow above the cornice, one for each wall. In the first the Pope blesses the galleys at Civitavecchia before they leave for Tunis in 1535. In the next he excommunicates the King of England in 1537. In the third is a fleet of galleys prepared by the emperor and the Venetians against the Turks with the authority and help of the Pope in 1538. The fourth represents the Perugians coming to ask pardon in 1540, after their rebellion against the Church. Each of the walls contains a large scene, interrupted by the windows and doors. The first represents Charles V. returning victorious from Tunis, kissing the feet of the Farnese Pope Paul at Rome in 1535. The next on the left, over the door, shows Paul III. at Busseto making peace between Charles V. and Francis the First in 1538, with portraits of the elder Bourbon, King Francis, King Henry, Lorenzo the elder, Tournon, Lorenzo the younger, Bourbon the younger, and two sons of King Francis. In the third the Pope is sending the cardinal of Monte as legate to the Council of Trent, with a number of portraits. In the last, between the windows, he is creating cardinals for the Council, including four who became popes, Julius III., Marcellus Cervinus, Paul IV. and Pius IV. In short, the hall is most ornate, containing everything fitted for such a place. The first room next to it, used as a dressing-room, is also richly decorated with stucco and gilding, and in the middle is a sacrifice with three nude figures, and

Alexander the Great in armour, throwing some skins on to the fire. Other scenes represent grass clothing and other savage things which would take too long to describe. This room leads to another dedicated to Sleep, for the painting of which Taddeo received the following instructions from Annibale Caro, the cardinal's agent, which I give in his own words to show his meaning better:

"The subjects which the cardinal has directed me to give you for the painting of the palace of Caprarola cannot be adequately described in words, because they comprise not only the ideas but the arrangement, attitudes, colouring and other particulars. I will write them out as fully and as clearly as I can, as they occur to me. First as regards the room with the flat ceiling, I think that as it is destined to be the bed-chamber of an illustrious lady it ought to contain suitable subjects out of the common both in invention and art. As a general idea, I should like a Night, which, besides being appropriate to sleep, would be different from the other rooms, and would afford you a rare artistic opportunity from the contrast between lights and shades of endowing the figures with charm and relief. I should like the time to be dawn, as things are then visible. But before entering into particulars I will begin with the situation and disposition of the room. We will divide it into ceiling and walls. The ceiling has a centre of oval form with four large corbels at the sides enclosing it. Between these are four corbels and as many lunettes above them. We may thus speak of five divisions. The first is the one towards the garden, the second opposite it I shall call the end, the third I shall call the right, and the fourth the left; the fifth, which is between them, will be known as the middle. The lunettes, corbels, etc., will be called after the parts on which they depend. The bed ought, I think, to be along the end wall with the head towards the left. But we will describe the whole first, and deal with the parts separately afterwards.

"Firstly, the oval of the vaulting, as the cardinal rightly thinks, should be all sky. The remainder of the vaulting, including the border, should be made to appear as if the part inside the room is not broken and will rest on the walls as you may devise. The four lunettes should also represent space, namely sky, land and sea, according to the requirements of the figures and scenes. As the ceiling is very low the lunettes can only hold small figures, so I should divide each longitudinally into three parts, leaving the ends in a line with the

tops of the corbels to look like a window and show the outside of the room, with figures in proportion with the others. The extremities of the lunettes, which I shall call horns, should remain low, and each contain a seated or recumbent figure, either within or without the room, as you see fit. To come to the room as a whole. I think that the interior should be dark except the distances in the oval and the windows at the sides, part receiving the heavenly lights and part artificial fires, represented as I shall describe presently. It should become darker as it descends towards the Night at the bottom, and lighter as it ascends towards the Dawn. We now divide the subjects. At the top of the oval, Dawn. This can be done in several ways, but I will select those which I consider to be the most graceful for painting. We will have a girl, as beautiful as the poets sing, composed of roses, purple, red, and similar charms of colour and flesh-tints. Her habit should possess three distinct colours, white, scarlet and orange, corresponding to her three conditions, and I would give her a white diaphanous vest. From the girdle to the knees she should have a scarlet tunic with folds like the clouds in a ruddy dawn. From her knees to her feet her robe should be of gold colour, for the orange as at daybreak, and the dress must be open from the thighs to show her bare legs. The vest and tunic should be moved by the wind and flying in folds. The arms should also be bare and rosy. She should have variegated wings, a crown of roses, a lamp or lighted torch in her hand, or be sending a cupid before her with a torch, and another following her who should awaken Tithonus with a torch. She should be seated on a golden seat in a car drawn by a winged Pegasus or two different horses, one a shining white, the other a glistening red, for Lampus and Phaëton as Homer calls them. She should be rising from a sparkling, luminous and tranquil sea. In the right horn should be Tithonus her husband, and in the left Cephalus her lover. Tithonus should be a white-haired man reclining on an orange-coloured bed, seeming in his second childhood, and represented as detaining her or as sighing as if her departure grieved him. Cephalus as a beautiful youth clothed in a tunic girt at the waist, sandals on his feet, a dart in his hand with a gilt point, a dog at his side, and should be about to enter a wood as if he did not care for her owing to his love for his Procris. Between Cephalus and Tithonus in the window-space behind Dawn the sun's rays, brighter than those of the dawn, should appear, but be obscured by a woman in front. She represents Vigilance,

who must seem lighted from behind by the rising sun, and as coming into the room through the window, to anticipate it. She should be tall, swift, bold, with wide-open eyes, arched brows, dressed in a transparent veil to her feet, girt at the waist, one hand holding a spear, the other grasping a fold of her gown; she should rest on her right foot and hold the other up as if about to move forward. She should raise her head to see Dawn, and seem angered that the latter has risen before her. She should wear a helmet surmounted by a cock flapping its wings and crowing. All this is behind Dawn. In the sky before her I would make some infants at various altitudes, nearer to or farther from the light of Dawn, representing the Hours preceding her and the sun. These Hours should be draped with garlands, wearing the coiffures of virgins, be winged and scattering flowers. Opposite, at the foot of the oval, we will have Night, rising like Dawn but facing the north. The latter shows her face, the former must turn her back; Dawn emerges from a quiet sea, Night plunges into a dark and misty one. The horses of one show their fronts, of the other their flanks. Night herself should be totally different from Dawn, with black skin, mantle, hair and wings, the last open for flight. She should hold up her hands with a white baby in one for Sleep, and a black one in the other, apparently asleep, for Death, because Night is called the mother of both. Her head should sink into thicker shadow and the sky should be of a deeper blue with many stars. Her car should be of bronze with wheels in four spaces to designate the four watches. On the opposite or end wall should be Oceanus and Atlas corresponding to Tithonus and Cephalus, Oceanus as a large bearded man with tangled hair and dolphins' heads peeping from his beard and hair, in addition to seaweed, shells, coral and other marine things. He should lean on a chariot drawn by whales, preceded by Tritons, nymphs, and other sea-animals, at least by some, for the space seems small to me. Atlas on the left should have the breast, arms and torso of a strong bearded man, in the usual posture of sustaining the heavens. Lower down, opposite Vigilance, Sleep ought to be, but I think it better to place it over the bed, and we will put Quiet in its place. Quiet was worshipped and had a temple, but I do not know how it was represented, unless it was the same as Security, but that can hardly be, for Quiet relates to the mind but Security to the body. We will represent Quiet as a maiden of peaceful aspect, sitting as if tired, and sleeping with her head on her left arm. A spear should rest on her shoulder and the

other arm lie listless. She should have a crown of poppies and a sceptre lying at her side which she may readily take up. In place of the cock of Vigilance she should have a brooding hen, to show that she performs her office even in repose. In the oval on the right there should be a Moon represented by a tall maiden of about eighteen, like Apollo, with flowing locks or wearing a Phrygian cap pointed at the top like the doge's, with two flaps hanging over the ears, and two horns like a crescent moon, or, according to Apuleius, with a round disk like a mirror in the middle of the forehead, with serpents here and there. She should wear a crown of dittany according to the Greeks, or of flowers, following Martian, or helichrymum as others say. Her draperies should fall to her feet, say some, while others would have them only to the knees, and girt under the paps, and covered by a mantle fastened at the right shoulder, and wearing finely wrought sandals. Pausanias, alluding, I think, to Diana, clothes her in deer-skin. Apuleius, perhaps confounding her with Isis, gives her a habit of white, yellow and red velvet and a shining black vest sprinkled with stars and a moon in the middle, adorning the edge with hanging flowers and fruit like a knotted fringe. Choose the one you prefer. Her arms should be bare with large sleeves, the right holding a burning torch and the left a drawn bow of horn says Claudian, of gold according to Ovid. Do as you please, but attach the quiver to her shoulders. Pausanias gives her two serpents on her left, and Apuleius a gilt vase with serpents for handles and apparently full of poison, the foot of the vase being decorated with palm-leaves. But I think they are speaking of Isis, and therefore I decide for the bow. She should ride in a car drawn by a black and a white horse, or if you please by a mule, following Festus Pompeius, or heifers according to Claudian and Ausonius. If you make heifers, I want the horns very small and a white spot on the right flank. The Moon should be looking towards the horn of the wall on the garden side, where Endymion her lover lies; she should lean from the car to kiss him and not be able, owing to her environment; she should look tenderly at him and illuminate him with her splendour. Endymion should be a handsome young shepherd sleeping at the foot of Mount Latmos. At the other horn should be Pan, god of shepherds, enamoured of her; he is a well-known figure. He should have a pipe hung at his neck, and be offering a mass of white wool with both hands to the Moon for love of her, begging her to come and live with him. The rest of the space should be occupied with a scene of the Lemures sacrificing, made at night

in order to drive evil spirits out of their house. The rite consisted in going about with uplifted hands and feet shod, scattering black beans which had been turned in the mouth and were thrown over the shoulder, while some were engaged in making a hubbub with basins and copper utensils. On the left of the oval should stand Mercury in the usual way with his winged cap and feet, the caduceus in his left hand, a purse in his right. He should be quite nude except for a mantle over his shoulders; a beautiful youth, but natural, without artifice, possessing a happy face, dancing eyes, smooth chin, narrow-shoulders and a ruddy skin. Some give him wings over his ears and make gold feathers issue from his hair. Make his attitude as you please, but show that he has come from heaven to induce sleep, and make him seem about to touch the bed-hangings with his wand. On the left horn I should have the Lares, his sons, the genii of private houses, dressed in dog's skin, cast over the left shoulder and reaching to the right, showing them ready to guard the house. They should sit side by side, each holding a spear, with a dog between them. Above them should be a small head of Vulcan wearing a little cap and having a smith's pincers beside him. On the horn towards the top should be a Battus who has told of the cows stolen by him and is turned to stone. An old shepherd seated should point out the place where the cows were concealed, and lean with his left arm on a crook. From the middle Battus should be of the black rock into which he was turned. The rest of the window should be occupied with the story of the sacrifices offered by the ancients to Mercury to obtain sleep. For this you will need an altar with his statue and a fire below with men throwing wood on it, some spilling wine upon it from cups and some drinking. In the middle of the oval should be Twilight between Dawn and Night. This should be a naked youth, I find, sometimes winged and at others not, with two lighted torches, one held towards Dawn and the other stretched towards Night. Some give him two faces and make him ride on a horse of the Sun and Dawn, but this would not suit our plan. I want him turned towards Night, with a large star between his legs, the star to be Venus, because Venus, Phosphorus, Hesperus and Twilight seem to be considered the same. From this point to Dawn there shall be no more stars. Having completed this part we now come to the sides and the four corbels of the vault. Beginning with the part above the bed, we will have Sleep, and we first need his house. Ovid places it in Lemnos and among the Cimerii, Homer in the Ægean Sea,

Statius with the Ethiopians, and Ariosto in Arabia. But wherever it is we need a mountain always dark and sunless, with a deep cave at the base through which flows dark silent water, a branch of Lethe. Behind this there should be an ebony bed with black hangings, in which Sleep lies. He is a beautiful placid youth, naked some say; with two vests, white over black, according to others; with wings on his shoulders, says Statius, and at the top of his head. He holds a horn under his arm which empties a livid liquor over the bed to denote oblivion, though some make it full of fruit. One hand holds a wand, the other three poppy-heads. He should sleep like a sick man with languid head and members, as if abandoned to deep slumber. About the bed should be Morpheus, Icelos and Fantasy, with a quantity of Dreams, all his children. The Dreams should be small figures, some beautiful and some ugly, both to delight and affright. They should have wings and twisted feet, to indicate their unstable and uncertain nature, and they should circle about him as if performing, changing into things possible and impossible. Morpheus is called by Ovid the deviser of figures, and I should represent him as making masks, placing some of them on their feet. Icelos is also said to have transformed himself frequently. I should represent him as a man with parts of beast, bird and serpent, as Ovid describes him. I should like Fantasy changed into several inanimate objects, and he can be represented, after Ovid, as composed partly of water, partly of stone and partly of wood. There should be two doors here, one of ivory from which proceed false dreams, and one of horn for the true ones. The true should be more clearly coloured and better made, the false indistinct and imperfect. In the next corbel, between the foot and right walls, we should have Brizo, the goddess of augury and interpreter of dreams. I have not found her dress, but I should make her like a sibyl seated beneath the elm described by Virgil, under the leaves of which she conceals countless images, some clear, some dark, and some broken and confused like dreams and visions which are seen in sleep of the five kinds described by Macrobius. Brizo should seem abstracted and reflecting upon the interpretation, and be surrounded by persons offering her all sorts of things except fish. In the corbel between the right wall and the head we should have Harpocrates, god of silence, to warn those entering the door not to make a noise. He should be a youth or boy rather dark in colour, being god of the Egyptians, with his finger to his mouth requiring silence, should carry a peach-tree branch and make a garland

of its leaves. They say that his legs were weak, and that he was raised to life by his mother Isis after being killed. Some accordingly make him stretched on the ground, others show him in his mother's lap with his feet together. But I should make him standing to harmonise with the other figures, or sitting like that of the illustrious Cardinal S. Angelo, who is winged and holds a cornucopia. About him some should be offering first-fruits of vegetables and peaches. Some represent him without a face, wearing a small cap and dressed in wolf's skin all covered with eyes and ears. Do which you please. The last corbel will do for Angerona, goddess of Secrecy, to warn those going out to keep secret what they have heard or seen, as is necessary in the service of princes. She should be placed on an altar with her mouth sealed. I do not know what dress they gave her, but I should put her in a long robe fastened at the shoulders. Let there be priests about her sacrificing in the Curia before the door, because no one was allowed to reveal things prejudicial to the republic. I have now only to speak of the frieze about the work. I should surround the work with grotesques or small figures adapted to the subjects nearest to them. I should make the scenes represent the actions of men and animals at the hours given. Beginning at the top I should make artists, mechanics, workmen and others going to their tasks as appropriate to Dawn; for instance, smiths to their anvils, the learned to their studies, huntsmen to the chase, and the muleteer to the road. Above all I want Petrarch's old lady, who ungirt and shoeless rose to spin, in the act of lighting her fire.[1] If you want animals there, do birds singing, cattle grazing, cocks crowing to announce the day, and so forth. In the frieze at the foot of the wall make things suitable to darkness, men going bird-catching, spies, adulterers, scalers of windows, and so forth; and for grotesques, porcupines, hedgehogs, badgers, a peacock expanding its tail for a starry night, bats, various owls, and such things. In the frieze of the right wall devoted to the Moon I should do night fishers, men sailing by the compass, wizards, and the like. For grotesques I would have a distant lighthouse and nets with fish, crabs seeking food by moonlight and, if there is room, an elephant kneeling to adore the moon. The frieze of the left wall should have mathematicians with their instruments, thieves, false coiners, diggers for treasure, shepherds about their fires in closed folds, and such things. For

[1] *Levata era a filar la vecchierella*
Discinta e scalza, e desto avea 'l carbone.
SONNET **XX.**

animals I would have wolves, foxes, apes, lap-dogs and other malicious creatures. But I have described these rather to show the sort of thing requisite; but as they are not such as to require a description I leave them to your imagination, for I know that painters are full of such curious ideas and graceful in the treatment of them. I cannot think now of anything else except that you should consult our illustrious lord upon everything, and add or remove anything as he may suggest, and endeavour to do yourself honour. Farewell."

But the dimensions of the room did not permit Taddeo to realise all these ingenious ideas, though those he did were very gracefully executed. In the last of the three chambers, dedicated to Solitude, Taddeo did Christ preaching to the Apostles in the desert with St. John on the right, a fine work, in which he was aided by his men. Opposite he represented men fleeing to the wood to avoid the discourse, and others trying to disturb it by throwing stones, while others again shut their eyes. There is a portrait of Charles V. here with the legend:

Post innumeros labores ociosam quietamque vitam traduxit.

Opposite is the last grand Turk, who was very fond of solitude, with the words:

Animum a negocio ad ocium revocavit.

Near him is Aristotle, with the words:

Anima fit sedendo et quiescendo prudentior.

Under another figure by Taddeo is the legend:

Quae ad modum negocii, sic et ocii ratio habenda.

Under another:

Ocium cum dignitate, negocium sine periculo.

Opposite under another figure is the motto:

Virtutis et liberae vitae magistra optima solitudo.

Below another:

Plus agant qui nihil agere videntur.

Under the last:

Qui agit plurima plurimum peccat.

In short, the room is richly decorated with fine figures, stucco and gold.

But to return to Vignola. His excellence in architecture is fully shown by his published works and his marvellous buildings, of which I shall say more in the Life of Michelagnolo. Taddeo did many things besides those mentioned, which I need not go into,

notably a chapel in the goldsmiths' church in Strada Giulia, a façade in grisaille for S. Jeronimo, and the chapel of the high altar in S. Sabina. His brother Federigo is at work upon a picture of St. Laurence on the gridiron in his chapel in S. Lorenzo in Damaso, and a Paradise opened, which is expected to prove a beautiful work.

That I may not omit anything useful or entertaining I will add this. While Taddeo was engaged upon the villa of Pope Julius and the façade of Matitolo, he did two small pictures for Cardinal Innocenzio di Monte, one being now in the cardinal's wardrobe with other ancient and modern treasures, among them being a more fanciful painting than any yet mentioned. It is about 2½ braccia high, and on looking at it from the ordinary standpoint it seems to contain nothing but some letters on a scarlet ground, and a moon in the middle which seems to grow and diminish, following the lines of the writing. But on standing below the picture, and looking into a sphere or mirror placed above it like a canopy, one sees a portrait of King Henry II. of France rather larger than life-size, with the words, *Henry II. roy de France.* It may also be seen on turning the picture upside down, but turned a different way to what it is in the mirror. It is not seen from above because it is painted on twenty-eight small leaves, which are between words which form an acrostic: *Henricus Valesius Dei Gratia Gallorum rex invicissimus.* M. Alessandro Taddei of Rome, the cardinal's secretary, and Don Silvano Razzi my friend, who have supplied me with the particulars, do not know the artist, but only that it was given to Cardinal Caraffa when in France by King Henry, and Caraffa gave it to Monte, who values it as a treasure. The letters forming the acrostic, and which are all that can be seen from the ordinary standpoint, run thus:

```
HEus tu quid vi D es nil ut reoR
Nisi    lunam    cr E scentem et  E
Regione      pos I tam   quae    eX
Intervallo       GR adatim      utI
Crescit nos      A dmonet  ut   iN
Vna  spe fide  e T    charitate   tV
Simul et ego     I lluminat        I
Verbo dei   cresc A mus        doneC
Ab ejusdem       G ratia       fiaT
Lux in nobis     A mplissima   quI
ESt aeternus   i LL e  dator  luciS
In  quo et a  qu O mortales omneS
Veram lucem      R ecipere      sI
Speramus in  van VM non sperabi MVS
```

The same wardrobe contains a fine portrait of Signora Sofonisba Anguisciola by herself, presented by her to Julius II., and an ancient MS. of the *Bucolics, Georgics* and *Æneid* of Virgil, the characters of which have led many learned men to believe that it was written actually under Cæsar Augustus or soon after, so that it is small wonder if the cardinal treasures it greatly. This is the end of the Life of Taddeo Zucchero the painter.

MICHELAGNOLO BUONAROTTI of Florence, Painter, Sculptor and Architect
(1475 – 1564)

WHILE industrious and choice spirits, aided by the light afforded by Giotto and his followers, strove to show the world the talent with which their happy stars and well-balanced humours had endowed them, and endeavoured to attain to the height of knowledge by imitating the greatness of Nature in all things, the great Ruler of Heaven looked down and, seeing these vain and fruitless efforts and the presumptuous opinion of man more removed from truth than light from darkness, resolved, in order to rid him of these errors, to send to earth a genius universal in each art, to show single-handed the perfection of line and shadow, and who should give relief to his paintings, show a sound judgment in sculpture, and in architecture should render habitations convenient, safe, healthy, pleasant, well-proportioned, and enriched with various ornaments. He further endowed him with true moral philosophy and a sweet poetic spirit, so that the world should marvel at the singular eminence of his life and works and all his actions, seeming rather divine than earthly.

In the arts of painting, sculpture and architecture the Tuscans have always been among the best, and Florence was the city in Italy most worthy to be the birthplace of such a citizen to crown her perfections. Thus in 1474 the true and noble wife of Ludovico di Lionardo Buonarotti Simone, said to be of the ancient and noble family of the Counts of Canossa, gave birth to a son in the Casentino, under a lucky star. The son was born on Sunday, 6 March, at eight in the evening, and was called Michelagnolo, as being of a divine nature, for Mercury and Venus were in the house of Jove at his birth, showing that his works of art would

be stupendous. Ludovico at the time was podestà at Chiusi and Caprese near the Sasso della Vernia, where St. Francis received the stigmata, in the diocese of Arezzo. On laying down his office Ludovico returned to Florence, to the villa of Settignano, three miles from the city, where he had a property inherited from his ancestors, a place full of rocks and quarries of macigno which are constantly worked by stonecutters and sculptors who are mostly natives. There Michelagnolo was put to nurse with a stonecutter's wife. Thus he once said jestingly to Vasari: "What good I have comes from the pure air of your native Arezzo, and also because I sucked in chisels and hammers with my nurse's milk." In time Ludovico had several children, and not being well off, he put them in the arts of wool and silk. Michelagnolo, who was older, he placed with Maestro Francesco da Urbino to school. But the boy devoted all the time he could to drawing secretly, for which his father and seniors scolded and sometimes beat him, thinking that such things were base and unworthy of their noble house.

About this time Michelagnolo made friends with Francesco Granacci, who though quite young had placed himself with Domenico del Grillandaio to learn painting. Granacci perceived Michelagnolo's aptitude for design, and supplied him daily with drawings of Grillandaio, then reputed to be one of the best masters not only in Florence but throughout Italy. Michelagnolo's desire to achieve thus increased daily, and Ludovico, perceiving that he could not prevent the boy from studying design, resolved to derive some profit from it, and by the advice of friends put him with Domenico Grillandaio that he might learn the profession. At that time Michelagnolo was fourteen years old. The author of his Life,[1] written after 1550 when I first published this work, has stated that some through not knowing him have omitted things worthy of note and stated others that are not true, and in particular he taxes Domenico with envy, saying that he never assisted Michelagnolo. This is clearly false, as may be seen by a writing in the hand of Ludovico written in the books of Domenico now in the possession of his heirs. It runs thus: "1488. Know this 1st April that I Ludovico di Lionardo Buonarroto apprentice my son Michelagnolo to Domenico and David di Tommaso di Currado for the next three years, with the following agreements: that the said Michelagnolo shall remain with them that time to learn to paint and practise that art and shall do what they

[1] Ascanio Condivi.

bid him, and they shall give him 24 florins in the three years, 6 in the first, 8 in the second and 10 in the third, in all 96 lire." Below this Ludovico has written: "Michelagnolo has received 2 gold florins this 16th April, and I Ludovico di Lionardo, his father, have received 12 lire 12 soldi." I have copied this from the book to show that I have written the truth, and I do not think that there is anyone who has seen more of Michelagnolo, who has been a greater and more faithful friend to him, or who can show a larger number of autograph letters than I. I have made this digression in the interests of truth, and let this suffice for the rest of the Life. We will now return to the story.

Michelagnolo's progress amazed Domenico when he saw him doing things beyond a boy, for he seemed likely not only to surpass the other pupils, of whom there were a great number, but would also frequently equal the master's own works. One of the youths happened one day to have made a pen sketch of draped women by his master, Michelagnolo took the sheet, and with a thicker pen made a new outline for one of the women, representing her as she should be and making her perfect. The difference between the two styles is as marvellous as the audacity of the youth whose good judgment led him to correct his master. The sheet is now in my possession, treasured as a relic. I had it from Granaccio with others of Michelagnolo, to place in the Book of Designs. In 1550, when Giorgio showed it to Michelagnolo at Rome, he recognised it with pleasure, and modestly said that he knew more of that art when a child than later on in life.

One day, while Domenico was engaged upon the large chapel of S. Maria Novella, Michelagnolo drew the scaffolding and all the materials with some of the apprentices at work. When Domenico returned and saw it, he said, "He knows more than I do," and remained amazed at the new style produced by the judgment of so young a boy, which was equal to that of an artist of many years' experience. To this Michelagnolo added study and diligence so that he made progress daily, as we see by a copy of a print engraved by Martin the German,[1] which brought him great renown. When a copper engraving by Martin of St. Anthony beaten by the devils reached Florence, Michelagnolo made a pen drawing and then painted it. To counterfeit some strange forms of devils he bought fish with curiously coloured scales, and showed such ability that he won much credit and reputation. He also made perfect copies of various old masters, making them look old with smoke and other things

[1] Martin Schongauer.

so that they could not be distinguished from the originals. He did this to obtain the originals in exchange for the copies, as he wanted the former and sought to surpass them, thereby acquiring a great name.

At this time Lorenzo de' Medici the Magnificent kept Bertoldo the sculptor in his garden on the piazza of S. Marco, not so much as the custodian of the numerous collections of beautiful antiquities there, as because he wished to create a school of great painters and sculptors with Bertoldo as the head, who had been pupil of Donato. Although old and unable to work, he was a master of skill and repute, having diligently finished Donato's pulpits and cast many bronze reliefs of battles and other small things, so that no one then in Florence could surpass him in such things. Lorenzo, who loved painting and sculpture, was grieved that no famous sculptors lived in his day to equal the great painters who then flourished, and so he resolved to found a school. Accordingly he asked Domenico Ghirlandaio that if he had any youths in his shop inclined to this he should send them to the garden, where he would have them instructed so as to do honour to him and to the city. Domenico elected among others Michelagnolo and Francesco Granaccio as being the best. At the garden they found that Torrigiano was modelling clay figures given to him by Bertoldo. Michelagnolo immediately did some in competition, and Lorenzo, seeing his genius, always expected great things of him. Thus encouraged, the boy began in a few days to copy in marble an antique faun's head, smiling, with a broken nose.[1] Although he had never previously touched marble or the chisel, he imitated it so well that Lorenzo was amazed. Seeing that in addition the boy had opened its mouth and made the tongue and all the teeth, Lorenzo jestingly said, for he was a pleasant man, "You ought to know that the old never have all their teeth, and always lack some." Michelagnolo, who loved and respected his patron, took him seriously in his simplicity, and so soon as he was gone he broke out a tooth and made the gum look as if it had fallen out. He anxiously awaited the return of Lorenzo, who, when he saw Michelagnolo's simplicity and excellence, laughed more than once, and related the matter to his friends as a marvel. He returned to help and favour the youth, and sending for his father, Ludovico, asked him to allow him to treat the boy as his own son, a request that was readily granted. Accordingly Lorenzo gave Michelagnolo a room in the palace, and he ate regularly at table with the family and other

[1] Now in the Bargello, Florence.

nobles staying there. This was the year after he had gone to
Domenico, when he was fifteen or sixteen, and he remained in
the house for four years until after the death of Lorenzo in '92.
I hear that he received a provision at this time from Lorenzo
and five ducats a month to help his father. The Magnificent also
gave him a violet mantle, and conferred an office in the customs
upon his father. Indeed all the youths in the garden received a
greater or less salary from that noble citizen, as well as rewards.

By the advice of Poliziano, the famous man of letters, Michel-
agnolo did a fight between Hercules and the Centaurs [1] on a
piece of marble given him by that signor, of such beauty that
it seems the work of a consummate master and not of a youth.
It is now preserved in his house by his nephew Lionardo as a
precious treasure, in memory of him. Not many years since this
Lionardo had a Madonna in bas-relief [2] by his uncle, more than
a braccia high, in imitation of Donatello's style, so fine that it
seems the work of that master, except that it possesses more
grace and design. Lionardo gave it to Duke Cosimo, who values
it highly, as he possesses no other bas-relief of the master.

To return to Lorenzo's garden. It was full of antiquities
and excellent paintings, collected there for beauty, study and
pleasure. Michelagnolo had the keys, and was much more
studious than the others in every direction, and always showed
his proud spirit. For many months he drew Masaccio's paintings
in the Carmine, showing such judgment that he amazed artists
and others, and also roused envy. It is said that Torrigiano
made friends with him, but moved by envy at seeing him more
honoured and skilful than himself, struck him so hard on the
nose that he broke it and disfigured him for life. For this Tor-
rigiano was banished from Florence, as is related elsewhere.

On the death of Lorenzo Michelagnolo returned home, much
grieved at the loss of that great man and true friend of genius.
Buying a large block of marble, he made a Hercules [3] of four
braccia, which stood for many years in the Strozzi palace, and
was considered remarkable. In the year of the siege it was sent
to King Francis of France by Giovambattista della Palla. It
is said that Piero de' Medici, who had long associated with
Michelagnolo, often sent for him, wishing to buy antique cameos
and other intaglios, and one snowy winter he got him to make

[1] Between Lapiths and Centaurs; now in the Casa Buonarotti, Florence.
[2] Also in the Casa Buonarotti.
[3] It went to Fontainebleau and remained in the garden of the Palace
until 1713, since which time it has been lost.

a beautiful snow statue in the court of his palace. He so honoured Michelagnolo for his ability that his father, seeing him in such favour with the great, clothed him much more sumptuously than before. For S. Spirito in Florence Michelagnolo made a wooden crucifix,[1] put over the lunette above the high altar to please the prior, who gave him suitable rooms, where he was able, by frequently dissecting dead bodies, to study anatomy, and thereby he began to perfect his great design. At the time of the expulsion of the Medici from Florence, Michelagnolo had gone to Bologna a few weeks before the event, and had then proceeded to Venice, fearing evil consequences from Piero's arrogance and bad government, for he was a member of the household. Finding no means of existence at Venice, he returned to Bologna, where he had the misfortune not to take the countersign on entering the gate to permit him to go out again, for M. Giovanni Bentivogli had ordained that those who had not the countersign should be condemned to pay fifty lire. Michelagnolo was in great distress, being unable to pay, but M. Giovanfrancesco Aldovrandi, one of the sixteen governors, took compassion on him, made him relate the circumstances, released him, and entertained him in his house for more than a year. One day Aldovrandi took him to see the ark of St. Dominic, made by Giovan Pisano and Maestro Niccolo dal l'Arca, the old sculptors. He asked him if he had the courage to do an angel holding a candlestick, and a St. Petronius, figures of about a braccia, that were wanting. Michelagnolo replied in the affirmative, and on receiving the marble made them, and they are the best figures there. He received thirty ducats for both from M. Francesco Aldovrandi. He remained rather more than a year at Bologna, and would have stayed longer to please Aldovrandi, who loved him for his design and liked to hear him read Dante, Petrarch, Boccaccio and other Tuscan poets with his Tuscan accent. But perceiving that he was wasting time, Michelagnolo gladly returned to Florence. There he did a marble St. John for Lorenzo di Pierfrancesco de' Medici, and then began a life-size sleeping Cupid also in marble. When it was done Baldassare del Milanese caused it to be shown to Pierfrancesco, who said, "If you buried it, I feel sure that it would pass for an antique at Rome if made to appear old, and you would get much more than by selling it here." It is said that Michelagnolo made it appear antique, and indeed it was an easy matter as he had wit enough for this and more. Others state that Milanese took it to Rome, buried it

[1] In 1494, now lost.

at his villa, and then sold it as an antique for two hundred ducats to the Cardinal S. Giorgio. It is also said that Milanese wrote to Pierfrancesco telling him to give thirty crowns to Michelagnolo, as he had not obtained more for the Cupid, thus deceiving the cardinal, Pierfrancesco and Michelagnolo. But it afterwards became known that the Cupid had been made in Florence, and Milanese's agent was forced to restore the money and take back the figure. It came subsequently into the hands of Duke Valentino, who gave it to the Marchioness of Mantua, and she took it home to that city where it now is.[1] The Cardinal S. Giorgio did not escape blame for not recognising the merit of the work, for when the moderns equal the ancients in perfection it is a mere empty preference of a name to the reality when men prefer the works of the latter to those of the former, though such men are found in every age. The noise of this matter so increased Michelagnolo's reputation that he was immediately invited to Rome[2] and engaged by the cardinal S. Giorgio. He stayed nearly a year, but the cardinal, knowing little of art, gave him nothing to do.

At that time the cardinal's barber, who coloured in tempera very diligently but could not design, made friends with Michelagnolo, who made him a cartoon of St. Francis receiving the stigmata which the barber executed in colours on a small panel with great diligence. It is now in the first chapel on the left on entering S. Piero a Montorio.[3] M. Jacopo Galli, an intelligent Roman noble, recognised Michelagnolo's ability, and employed him to make a marble Cupid of life-size,[4] and then to do a Bacchus of ten palms holding a cup in the right hand, and in the left a tiger's skin and a bunch of grapes with a satyr trying to eat them.[5] This figure shows that he intended a marvellous blending of limbs, uniting the slenderness of a youth with the fleshy roundness of the female, proving Michelagnolo's superiority to all the moderns in statuary. During his stay in Rome he made such progress in art that his conceptions were marvellous, and he executed difficulties with the utmost ease, frightening those who were not accustomed to see such things, for when they were done the works of others appeared as nothing beside them. Thus the cardinal of St. Denis, called Cardinal Rohan, a Frenchman, desired to leave a memorial of himself in the famous city by such a rare artist, and got him to do a marble Pietà, which

[1] It has since vanished. [2] In 1496. [3] Now lost.
[4] Probably the one now in the Victoria and Albert Museum.
[5] Now in the Bargello, Florence.

was placed in the chapel of S. Maria della Febbre in the temple of Mars, in S. Pietro.[1] The rarest artist could add nothing to its design and grace, or finish the marble with such polish and art, for it displays the utmost limits of sculpture. Among its beauties are the divine draperies, the foreshortening of the dead Christ, and the beauty of the limbs with the muscles, veins, sinews, while no better presentation of a corpse was ever made. The sweet air of the head and the harmonious joining of the arms and legs to the torso, with the pulses and veins, are marvellous, and it is a miracle that a once shapeless stone should assume a form that Nature with difficulty produces in flesh. Michelagnolo devoted so much love and pains on this work that he put his name on the girdle crossing the Virgin's breast, a thing he never did again. One morning he had gone to the place to where it stands and observed a number of Lombards who were praising it loudly. One of them asked another the name of the sculptor, and he replied, "Our Gobbo of Milan."[2] Michelagnolo said nothing, but he resented the injustice of having his work attributed to another, and that night he shut himself in the chapel with a light and his chisels and carved his name on it. It has been thus aptly described:

> Bellezza ed onestate
> E doglia e pieta in vivo marmo morte,
> Deh, come voi pur fate
> Non piangete si forte
> Che anzi tempo risveglisi da morte
> E pur, mal grado suo
> Nostro Signore e tuo
> Sposo, figliuolo e padre
> Unica sposa sua figliuola e madre.

It brought him great renown, and though some fools say that he has made the Virgin too young, they ought to know that spotless virgins keep their youth for a long time, while people afflicted like Christ do the reverse, so that should contribute more to increase the fame of his genius than all the things done before.

Some of Michelagnolo's friends wrote from Florence urging him to return, as they did not want that block of marble on the opera to be spoiled which Piero Soderini, then gonfaloniere for life in the city, had frequently proposed to give to Lionardo da Vinci, and then to Andrea Contucci, an excellent sculptor,

[1] The contract was made in 1498. The patron was Jean de Groslaye de Villiers, abbot of St. Denis and cardinal of St. Sabina, not the Cardinal de Rohan.

[2] i.e. Cristoforo Solari of Milan.

who wanted it. Michelagnolo on returning [1] tried to obtain it, although it was difficult to get an entire figure without pieces, and no other man except himself would have had the courage to make the attempt, but he had wanted it for many years, and on reaching Florence he made efforts to get it. It was nine braccia high, and unluckily one Simone da Fiesole had begun a giant, cutting between the legs and mauling it so badly that the wardens of S. Maria del Fiore had abandoned it without wishing to have it finished, and it had rested so for many years. Michelagnolo examined it afresh, and decided that it could be hewn into something new while following the attitude sketched by Simone, and he decided to ask the wardens and Soderini for it. They gave it to him as worthless, thinking that anything he might do would be better than its present useless condition. Accordingly Michelagnolo made a wax model of a youthful David holding the sling to show that the city should be boldly defended and righteously governed, following David's example. He began it in the opera, making a screen between the wall and the tables, and finished it without anyone having seen him at work. [2] The marble had been hacked and spoiled by Simone so that he could not do all that he wished with it, though he left some of Simone's work at the end of the marble, which may still be seen. This revival of a dead thing was a veritable miracle. When it was finished various disputes arose as to who should take it to the piazza of the Signori, so Giuliano da Sangallo and his brother Antonio made a strong wooden frame and hoisted the figure on to it with ropes; they then moved it forward by beams and windlasses and placed it in position. The knot of the rope which held the statue was made to slip so that it tightened as the weight increased, an ingenious device, the design for which is in our book, showing a very strong and safe method of suspending heavy weights. Piero Soderini came to see it, and expressed great pleasure to Michelagnolo who was retouching it, though he said he thought the nose large. Michelagnolo seeing the gonfaloniere below and knowing that he could not see properly, mounted the scaffolding and taking his chisel dexterously let a little marble dust fall on to the gonfaloniere, without, however, actually altering his work. Looking down he said, "Look now." "I like it better," said the gonfaloniere, "you have given it life." Michelagnolo therefore came down with

[1] In 1501. It had been given to Agostino di Duccio in 1463 and taken from him three years later.
[2] In 1504.

feelings of pity for those who wish to seem to understand matters of which they know nothing. When the statue was finished and set up Michelagnolo uncovered it. It certainly bears the palm among all modern and ancient works, whether Greek or Roman, and the Marforio of Rome, the Tiber and Nile of Belvedere, and the colossal statues of Montecavallo do not compare with it in proportion and beauty. The legs are finely turned, the slender flanks divine, and the graceful pose unequalled, while such feet, hands and head have never been excelled. After seeing this no one need wish to look at any other sculpture or the work of any other artist. Michelagnolo received four hundred crowns from Piero Soderini, and it was set up in 1504.[1] Owing to his reputation thus acquired, Michelagnolo did a beautiful bronze David [2] for the gonfaloniere, which he sent to France, and he sketched out two marble medallions,[3] one for Taddeo Taddei, and now in his house, the other for Bartolommeo Pitti, which was given by Frà Miniato Pitti of Monte Oliveto, a master of cosmography and many sciences, especially painting, to his intimate friend Luigi Guicciardini. These works were considered admirable. At the same time he sketched a marble statue of St. Matthew in the opera of S. Maria del Fiore,[4] which showed his perfection and taught sculptors the way to make statues without spoiling them, by removing the marble so as to enable them to make such alterations as may be necessary. He also did a bronze Madonna in a circle,[5] carved at the request of some Flemish merchants of the Moscheroni, noblemen in their country, who paid him one hundred crowns and sent it to Flanders. His friend, Agnolo Doni, citizen of Florence, and the lover of all beautiful works whether ancient or modern, desired to have something of his. Michelagnolo therefore began a round painting of the Virgin kneeling and offering the Child to Joseph,[6] where he shows his marvellous power in the head of the Mother fixedly regarding the beauty of the Child, and the emotion of Joseph in reverently and tenderly taking it, which is obvious without examining it closely. As this did not suffice to display his powers, he made seated, standing and reclining nude figures in the background, completing the work with such finish and polish that it is

[1] It was removed to the Accademia in 1873.
[2] In 1502, now lost.
[3] One in the Royal Academy, London, and the other in the Bargello.
[4] In 1503.
[5] Now in Notre Dame, Bruges, done for John and Alexander Mouscron in 1505.
[6] Painted in 1503; now in the Uffizi.

considered the finest of his few panel paintings. When finished he sent it wrapped up to Agnolo's house, by a messenger, with a note and a request for seventy ducats as payment. Agnolo being a careful man, thought this a large sum for one picture, though he knew it was worth more. So he gave the bearer forty ducats, saying that was enough. Michelagnolo at once sent demanding one hundred ducats or the return of the picture. Andrea being delighted with the picture, then agreed to give seventy ducats, but Michelagnolo being incensed by Agnolo's mistrust, demanded double what he had asked the first time, and Agnolo, who wanted the picture, was forced to send him one hundred and forty crowns.

When Lionardo da Vinci was painting in the Great Hall of the Council, as related in his Life, Piero Soderini, the gonfaloniere, allotted to Michelagnolo a part of that hall,[1] for he perceived his great genius, and the artist chose the war of Pisa as his subject.[2] He was given a room in the dyers' hospital at S. Onofrio, and there began a large cartoon which he allowed no one to see. He filled it with nude figures bathing in the Arno owing to the heat, and running in this condition to their arms on being attacked by the enemy. He represented them hurrying out of the water to dress, and seizing their arms to go to assist their comrades, some buckling their cuirasses and many putting on other armour, while others on horseback are beginning the fight. Among other figures is an old man wearing a crown of ivy to shade his head trying to pull his stockings on to his wet feet, and hearing the cries of the soldiers and the beating of the drums he is struggling violently, all his muscles to the tips of his toes and his contorted mouth showing the effects of the exertion. It also contained drums and nude figures with twisted draperies running to the fray, foreshortened in extraordinary attitudes, some upright, some kneeling, some bent, and some lying. There were also many groups sketched in various ways, some merely outlined in carbon, some with features filled in, some hazy or with white lights, to show his knowledge of art. And indeed artists were amazed when they saw the lengths he had reached in this cartoon. Some in seeing his divine figures declared that it was impossible for any other spirit to attain to its divinity. When finished [3] it was carried to the Pope's hall amid the excitement of artists and to the glory of Michelagnolo, and all those

[1] In 1504.
[2] The scene represented the battle of Cascina, which took place on 28 July, 1364, when Sir John Hawkwood surprised the Florentines.
[3] In 1506.

who studied and drew from it, as foreigners and natives did for many years afterwards, became excellent artists, as we see by Aristotile da Sangallo, his friend, Ridolfo Ghirlandaio, Raphael Sanzio, Francesco Granaccio, Baccio Bandinelli, Alonso Berugetta a Spaniard, with Andrea del Sarto, Franciabigio, Jacopo Sansovino, Rosso, Maturino, Lorenzetto, Tribolo, then a child, Jacopo da Pontormo, and Perino del Vaga, all great Florentine masters. Having become a school for artists, this cartoon was taken to the great hall of the Medici palace, where it was entrusted too freely to artists, for during the illness of Duke Giuliano it was unexpectedly torn to pieces and scattered in many places,[1] some fragments still being in the house of M. Uberto Strozzi, a Mantuan noble, where they are regarded with great reverence, indeed they are more divine than human.

The Pietà, the colossal statue and the cartoon gave Michelagnolo such a name that when, in 1503,[2] Julius II. succeeded Alexander VI., he sent for the artist, who was then about twenty nine, to make his tomb, paying him one hundred crowns for the journey. After reaching Rome, it was many months before he did anything. At last he settled on a design for the tomb, surpassing in beauty and richness of ornament all ancient and imperial tombs, affording the best evidence of his genius. Stimulated by this, Julius decided to rebuild S. Pietro in order to hold the tomb, as related elsewhere. Michelagnolo set to work with spirit, and first went to Carrara to obtain all the marble, accompanied by two apprentices, receiving 1000 crowns for this from Alamanno Salviati at Florence. He spent eight months there without receiving any further provision, his mind being full of projects for making great statues there as a memorial to himself, as the ancients had done, for he felt the fascination of the blocks. Having chosen his marble, he sent it by sea to Rome, where it filled half the piazza of S. Pietro towards S. Caterina, and the space between the church and the corridor leading to Castello. Here Michelagnolo made his studio for producing his figures and the rest of the tomb. In order that the Pope might readily come to see him work, he made a drawbridge from the corridor to the studio. His intimacy with the Pope grew out of this, but it afterwards brought him great annoyance and persecution, giving rise to much envy among artists. Of this work,

[1] See Vol. III., p. 190. J. A. Symonds gives reasons for doubting this story, *Life of Michelangelo*, i. 164.
[2] It was in 1505.

during Julius's life and after his death, Michelagnolo did four complete statues and sketched eight, as I shall relate.

The work being devised with great invention, I will describe the ordering of it. Michelagnolo wished it to stand isolated, in order to make it appear larger, showing all four sides, twelve braccia on one, and eighteen for the other two. About it he arranged a series of niches separated by terminal figures clothed from the middle upwards and bearing the first cornice on their heads, each one in a curious attitude and having a nude prisoner bound, standing on a projection from the basement. These prisoners were to represent the provinces subdued by the Pope and rendered obedient to the Church. Other statues, also bound, represented the sciences and fine arts doomed to death like the Pope who had protected them. At the corners of the first cornice were four large figures, Active and Contemplative Life, St. Paul and Moses. Above the cornice the work was on a smaller scale with a frieze of bronze bas-reliefs and other figures, infants and ornaments. As a completion there were two figures above, one a smiling Heaven, supporting the bier on her shoulders, with Cybele, goddess of the earth, who seems to grieve that the world has lost such a man, while the other rejoices that his soul has passed to celestial glory. There was an arrangement to enter at the top of the work between the niches, and an oval place to move about in the middle, like a church, in the midst of which the sarcophagus to contain the Pope's body was to be placed. In all it was to have forty marble statues without counting the reliefs, infants and ornaments, the carved cornices and other architectural parts. For greater convenience Michelagnolo ordered that a part of the marble should be taken to Florence, where he proposed to spend the summer to escape from the malaria of Rome. There he completed one face of the work in several pieces, and at Rome divinely finished two prisoners [1] and other statues which are unsurpassed. That they might not be otherwise employed, he gave the prisoners to Signor Ruberto Strozzi, in whose house Michelagnolo had fallen sick. They were afterwards sent to King Francis as a gift, and are now at Ecouen (*Cevan*) in France. He sketched eight statues at Rome and five at Florence, and finished a Victory [2] above a prisoner, now owned by Duke Cosimo, who had it from the artist's nephew Lionardo. The duke has placed it in the great hall of the palace painted by Vasari.

Michelagnolo finished the Moses in marble, a statue of five

[1] In 1513. They are now in the Louvre. [2] Now in the Bargello.

braccia, unequalled by any modern or ancient work. Seated in
a serious attitude, he rests with one arm on the tables, and with
the other holds his long glossy beard, the hairs, so difficult to
render in sculpture, being so soft and downy that it seems as if
the iron chisel must have become a brush. The beautiful face,
like that of a saint and mighty prince, seems as one regards it
to need the veil to cover it, so splendid and shining does it
appear, and so well has the artist presented in the marble the
divinity with which God had endowed that holy countenance.
The draperies fall in graceful folds, the muscles of the arms and
bones of the hands are of such beauty and perfection, as are the
legs and knees, the feet being adorned with excellent shoes, that
Moses may now be called the friend of God more than ever,
since God has permitted his body to be prepared for the resurrec-
tion before the others by the hand of Michelagnolo. The Jews
still go every Saturday in troops to visit and adore it as a divine,
not a human thing. At length he finished this part, which was
afterwards set up in S. Pietro ad Vincola.

It is said that while Michelagnolo was engaged upon it, the
remainder of the marble from Carrara arrived at Ripa, and was
taken with the rest to the piazza of S. Pietro. As it was necessary
to pay those who brought it, Michelagnolo went as usual to the
Pope. But the Pope had that day received important news
concerning Bologna, so Michelagnolo returned home and paid
for the marble himself, expecting to be soon repaid. He returned
another day to speak to the Pope, and found difficulty in enter-
ing, as a porter told him to wait, saying he had orders to admit
no one. A bishop said to the porter, "Perhaps you do not know
this man." "I know him very well," said the porter, "but I am
here to execute my orders." Unaccustomed to this treatment,
Michelagnolo told the man to inform the Pope he was away
when next His Holiness inquired for him. Returning home, he
set out post at two in the morning, leaving two servants with
instructions to sell his things to the Jews, and to follow him to
Florence. Reaching Poggibonsi, in Florentine territory, he felt
safe, not being aware that five couriers had arrived with letters
from the Pope with orders to bring him back. But neither
prayers nor letters which demanded his return upon pain of
disgrace moved him in the least. However, at the instance of
the couriers, he at length wrote a few lines asking the Pope to
excuse him, saying he would never return as he had been driven
away like a rogue, that his faithful service merited better treat-
ment, and that he should find someone else to serve him.

On reaching Florence, Michelagnolo finished in three months the cartoon of the great hall which Piero Soderini the gonfaloniere desired him to finish. The Signoria received at that time three letters from the Pope demanding that Michelagnolo should be sent back to Rome. On this account it is said that, fearing the Pope's wrath, he thought of going to Constantinople to serve the Turk by means of some Franciscan friars, from whom he learned that the Turk wanted him to make a bridge between Constantinople and Pera. However, Piero Soderini persuaded him, against his will, to go to the Pope, and sent him as ambassador of Florence, to secure his person, to Bologna whither the Pope had gone from Rome,[1] with letters of recommendation to Cardinal Soderini, the gonfaloniere's brother, who was charged to introduce him to the Pope. There is another account of this departure from Rome: that the Pope was angry with Michelagnolo, who would not allow him to see any of his things. The artist suspected his assistants of having received bribes from the Pope more than once to admit him to look at the chapel of his uncle Sixtus, which he was having painted, on certain occasions when Michelagnolo was not at home, or at work. It happened once that Michelagnolo hid himself, for he suspected the betrayal by his apprentices, and threw down some planks as the Pope entered the chapel, and not thinking who it was, caused him to be summarily ejected. At all events, whatever the cause, he was angry with the Pope and also afraid of him, and so he ran away.

Arrived at Bologna, he first approached the footmen and was taken to the palace of the Sixteen by a bishop sent by Cardinal Soderini, who was sick. He knelt before the Pope, who looked wrathfully at him, and said as if in anger: "Instead of coming to us, you have waited for us to come and find you," inferring that Bologna is nearer Florence than Rome. Michelagnolo spread his hands and humbly asked for pardon in a loud voice, saying he had acted in anger through being driven away, and that he hoped for forgiveness for his error. The bishop who presented him made excuses, saying that such men are ignorant of everything except their art. At this the Pope waxed wroth, and striking the bishop with a mace he was holding, said: "It is you who are ignorant, to reproach him when we say nothing." The bishop therefore was hustled out by the attendants, and the Pope's anger being appeased, he blessed Michelagnolo, who was loaded with gifts and promises, and ordered to prepare a bronze

[1] In 1506.

statue of the Pope, five braccia high, in a striking attitude of majesty, habited in rich vestments, and with determination and courage displayed in his countenance. This was placed in a niche above the S. Petronio gate.

It is said that while Michelagnolo was engaged upon it Francia the painter came to see it, having heard much of him and his works, but seen none. He obtained the permission, and was amazed at Michelagnolo's art. When asked what he thought of the figure, he replied that it was a fine cast and good material. Michelagnolo, thinking that he had praised the bronze rather than the art, said: "I am under the same obligation to Pope Julius, who gave it to me, as you are to those who provide your paints," and in the presence of the nobles he angrily called him a blockhead. Meeting one day a son of Francia, who was said to be a very handsome youth, he said: "Your father knows how to make living figures better than to paint them." One of the nobles asked him which was the larger, the Pope's statue or a pair of oxen, and he replied, "It depends upon the oxen, those of Bologna are certainly larger than our Florentine ones." Michelagnolo finished the statue in clay before the Pope left for Rome; His Holiness went to see it, and the question was raised of what to put in the left hand, the right being held up with such a proud gesture that the Pope asked if it was giving a blessing or a curse. Michelagnolo answered that he was admonishing the people of Bologna to be prudent. When he asked the Pope whether he should put a book in his left hand, the pontiff replied, "Give me a sword; I am not a man of letters." The Pope left 1000 crowns wherewith to finish it in the bank of M. Antonmaria da Lignano. After sixteen months of hard work it was placed in front of the church of S. Petronio, as already related. It was destroyed by the Bentivogli, and the bronze sold to Duke Alfonso of Ferrara, who made a cannon of it, called the Julius, the head only being preserved, which is now in his wardrobe.

After the Pope had returned to Rome, and when Michelagnolo had finished the statue, Bramante, the friend and relation of Raphael and therefore ill-disposed to Michelagnolo, seeing the Pope's preference for sculpture, schemed to divert his attention, and told the Pope that it would be a bad omen to get Michelagnolo to go on with his tomb, as it would seem to be an invitation to death. He persuaded the Pope to get Michelagnolo, on his return, to paint the vaulting of the Sistine Chapel. In this way Bramante and his other rivals hoped to confound him, for by

taking him from sculpture, in which he was perfect, and putting him to colouring in fresco, in which he had had no experience, they thought he would produce less admirable work than Raphael, and even if he succeeded he would become embroiled with the Pope, from whom they wished to separate him. Thus, when Michelagnolo returned to Rome, the Pope was disposed not to have the tomb finished for the time being, and asked him to paint the vaulting of the chapel. Michelagnolo tried every means to avoid it, and recommended Raphael, for he saw the difficulty of the work, knew his lack of skill in colouring, and wanted to finish the tomb. But the more he excused himself, the more the impetuous Pope was determined he should do it, being stimulated by the artist's rivals, especially Bramante, and ready to become incensed against Michelagnolo. At length, seeing that the Pope was resolute, Michelagnolo decided to do it.[1] The Pope commanded Bramante to make preparations for the painting, and he hung a scaffold on ropes, making holes in the vaulting. When Michelagnolo asked why he had done this, as on the completion of the painting it would be necessary to fill up the holes again, Bramante declared there was no other way. Michelagnolo thus recognised either that Bramante was incapable or else hostile, and he went to complain to the Pope that the scaffolding would not do, and that Bramante did not know how it should be constructed. The Pope answered, in Bramante's presence, that Michelagnolo should design one for himself. Accordingly he erected one on poles not touching the wall, a method which guided Bramante and others in similar work. He gave so much rope to the poor carpenter who made it, that it sufficed, when sold, for the dower of the man's daughter, to whom Michelagnolo presented it. He then set to work on the cartoons. The Pope wanted to destroy the work on the walls done by masters in the time of Sixtus, and he set aside 15,000 ducats as the cost, as valued by Giuliano da San Gallo. Impressed by the greatness of the work, Michelagnolo sent to Florence for help, resolving to prove himself superior to those who had worked there before, and to show modern artists the true way to design and paint. The circumstances spurred him on in his quest of fame and his desire for the good of art. When he had completed the cartoons, he waited before beginning to colour them in fresco until some friends of his, who were painters, should arrive from Florence, as he hoped to obtain help from them, and learn their methods of fresco-painting, in which some of them

[1] He was engaged upon this work from 1508 to 1512.

were experienced, namely Granaccio, Giulian Bugiardini, Jacopo di Sandro, Indaco the elder, Agnolo di Donnino and Aristotile. He made them begin some things as a specimen, but perceiving their work to be very far from his expectations, he decided one morning to destroy everything which they had done, and shutting himself up in the chapel he refused to admit them, and would not let them see him in his house. This jest seemed to them to be carried too far, and so they took their departure, returning with shame and mortification to Florence. Michelagnolo then made arrangements to do the whole work singlehanded. His care and labour brought everything into excellent train, and he would see no one in order to avoid occasions for showing anything, so that the most lively curiosity was excited. Pope Julius was very anxious to see his plans, and the fact of their being hidden greatly excited his desire. But when he went one day he was not admitted. This led to the disturbance already referred to, when Michelagnolo had to leave Rome. Michelagnolo has himself told me that, when he had painted a third of the vault, a certain mouldiness began to appear one winter when the north wind was blowing. This was because the Roman lime, being white and made of travertine, does not dry quickly enough, and when mixed with pozzolana, which is of a tawny colour, it makes a dark mixture. If this mixture is liquid and watery, and the wall thoroughly wetted, it often effloresces in drying. This happened here, where the salt effloresced in many places, although in time the air consumed it. In despair at this, Michelagnolo wished to abandon the work, and when he excused himself, telling the Pope that he was not succeeding, Julius sent Giuliano da San Gallo, who explained the difficulty and taught him how to obviate it. When he had finished half, the Pope, who sometimes went to see it by means of steps and scaffolds, wanted it to be thrown open, being an impatient man, unable to wait until it had received the finishing-touches. Immediately all Rome flocked to see it, the Pope being the first, arriving before the dust of the scaffolding had been removed. Raphael, who was excellent in imitating, at once changed his style after seeing it, and to show his skill did the prophets and sybils in la Pace, while Bramante tried to have the other half of the chapel given to Raphael. On hearing this Michelagnolo became incensed against Bramante, and pointed out to the Pope without mincing matters many faults in his life and works, the latter of which he afterwards corrected in the building of S. Pietro. But the Pope daily became more

convinced of Michelagnolo's genius, and wished him to complete the work, judging that he would do the other half even better. Thus, singlehanded, he completed the work in twenty months, aided only by his mixer of colours. He sometimes complained that owing to the impatience of the Pope he had not been able to finish it as he would have desired, as the Pope was always asking him when he would be done. On one occasion Michelagnolo replied that he would be finished when he had satisfied his own artistic sense. "And we require you to satisfy us in getting it done quickly," replied the Pope, adding that if it was not done soon he would have the scaffolding down. Fearing the Pope's impetuosity. Michelagnolo finished what he had to do without devoting enough time to it, and the scaffold being removed it was opened on All Saints' day, when the Pope went there to sing Mass amid the enthusiasm of the whole city. Like the old masters who had worked below, Michelagnolo wanted to retouch some things *a secco*, such as the backgrounds, draperies, the gold ornaments and things, to impart greater richness and a better appearance. When the Pope learned this he wished it to be done, for he heard what he had seen so highly praised, but as it would have taken too long to reconstruct the scaffold it remained as it was. The Pope often saw Michelagnolo, and said, "Have the chapel enriched with colours and gold, in which it is poor." He would answer familiarly, "Holy Father, in those days they did not wear gold; they never became very rich, but were holy men who despised wealth." Altogether Michelagnolo received 3000 crowns from the Pope for this work, and he must have spent twenty-five on the colours. The work was executed in great discomfort, as Michelagnolo had to stand with his head thrown back, and he so injured his eyesight that for several months he could only read and look at designs in that posture. I suffered similarly when doing the vaulting of four large rooms in the palace of Duke Cosimo, and I should never have finished them had I not made a seat supporting the head, which enabled me to work lying down, but it so enfeebled my head and injured my sight that I feel the effects still, and I marvel that Michelagnolo supported the discomfort. However, he became more eager every day to be doing and making progress, and so he felt no fatigue, and despised the discomfort.

The work had six corbels on each side and one at each end, containing sibyls and prophets, six braccia high, with the Creation of the World in the middle, down to the Flood and Noah's drunkenness, and the generations of Jesus Christ in

the lunettes. He used no perspective or foreshortening, or any fixed point of view, devoting his energies rather to adapting the figures to the disposition than the disposition to the figures, contenting himself with the perfection of his nude and draped figures, which are of unsurpassed design and excellence. This work has been a veritable beacon to our art, illuminating all painting and the world which had remained in darkness for so many centuries. Indeed, painters no longer care about novelties, inventions, attitudes and draperies, methods of new expression or striking subjects painted in different ways, because this work contains every perfection that can be given. Men are stupefied by the excellence of the figures, the perfection of the foreshortening, the stupendous rotundity of the contours, the grace and slenderness and the charming proportions of the fine nudes showing every perfection; every age, expression and form being represented in varied attitudes, such as sitting, turning, holding festoons of oak-leaves and laurel, the device of Pope Julius, showing that his was a golden age, for Italy had yet to experience her miseries. Some in the middle hold medals with scenes, painted like bronze or gold, the subject being taken from the Book of Kings. To show the greatness of God and the perfection of art he represents the Dividing of Light from Darkness, showing with love and art the Almighty, self-supported, with extended arms. With fine discretion and ingenuity he then did God making the sun and moon, supported by numerous cherubs, with marvellous foreshortening of the arms and legs. The same scene contains the blessing of the earth and the Creation, God being foreshortened in the act of flying, the figure following you to whatever part of the chapel you turn. In another part he did God dividing the waters from the land, marvellous figures showing the highest intellect and worthy of being made by the divine hand of Michelagnolo. He continued with the creation of Adam, God being borne by a group of little angels, who seem also to be supporting the whole weight of the world. The venerable majesty of God with the motion as He surrounds some of cherubs with one arm and stretches the other to an Adam of marvellous beauty of attitude and outline, seem a new creation of the Maker rather than one of the brush and design of such a man. He next did the creation of our mother Eve, showing two nudes, one in a heavy sleep like death, the other quickened by the blessing of God. The brush of this great artist has clearly marked the difference between sleeping and waking, and the firmness presented by the Divine Majesty, to speak humanly.

He then did Adam eating the apple, persuaded by a figure half woman and half serpent, and he and Eve expelled from Paradise, the angel executing the order of the incensed Deity with grandeur and nobility, Adam showing at once grief for his sin and the fear of death, while the woman displays shame, timidity and a desire to obtain pardon, as she clasps her arms and hands over her breast, showing, in turning her head towards the angel, that she has more fear of the justice than hope of the Divine mercy. No less beautiful is the sacrifice of Cain and Abel, one bringing wood, one bending over the fire, and some killing the victim, certainly not executed with less thought and care than the others. He employed a like art and judgment in the story of the Flood, containing various forms of death, the terrified men trying every possible means to save their lives. Their heads show that they recognise the danger with their terror and utter despair. Some are humanely assisting each other to climb to the top of a rock; one of them is trying to remove a half-dead man in a very natural manner. It is impossible to describe the excellent treatment of Noah's drunkenness, showing incomparable and unsurpassable art. Encouraged by these he attacked the five sibyls and seven prophets, showing himself even greater. They are of five braccia and more, in varied attitudes, beautiful draperies and displaying miraculous judgment and invention, their expressions seeming divine to a discerning eye. Jeremiah, with crossed legs, holds his beard with his elbow on his knee, the other hand resting in his lap, and his head being bent in a melancholy and thoughtful manner, expressive of his grief, regrets, reflection, and the bitterness he feels concerning his people. Two boys behind him show similar power; and in the first sibyl nearer the door, in representing old age, in addition to the involved folds of her draperies, he wishes to show that her blood is frozen by time, and in reading she holds the book close to her eyes, her sight having failed. Next comes Ezekiel, an old man with fine grace and movement, in copious draperies, one hand holding a scroll of his prophecies, the other raised and his head turned as if he wished to declare things high and great. Behind him are two boys holding his books. Next comes a sibyl, who, unlike the Erethrian sibyl just mentioned, holds her book at a distance, and is about to turn the page; her legs are crossed, and she is reflecting what she shall write, while a boy behind her is lighting her lamp. This figure has an expression of extraordinary beauty, the hair and draperies are equally fine, and her arms are bare, and as perfect as the other parts. He did next

the Joel earnestly reading a scroll, with the most natural expression of satisfaction at what he finds written, exactly like one who has devoted close attention to some subject. Over the door of the chapel Michelagnolo placed the aged Zachariah, who is searching for something in a book, with one leg raised and the other down, though in his eager search he does not feel the discomfort. He is a fine figure of old age somewhat stout in person, his fine drapery falling in few folds. There is another sibyl turned towards the altar showing writings, not less admirable with her boys than the others. But for Nature herself one must see the Isaiah, a figure wrapped in thought, with his legs crossed, one hand on his book to keep the place, and the elbow of the other arm also on the volume, and his chin in his hand. Being called by one of the boys behind, he rapidly turns his head without moving the rest of his body. This figure, when well studied, is a liberal education in all the principles of painting. Next him is a beautiful aged sibyl who sits studying a book, with extraordinary grace, matched by the two boys beside her. It would not be possible to add to the excellence of the youthful Daniel, who is writing in a large book, copying with incredible eagerness from some writings, while a boy standing between his legs supports the weight as he writes. Equally beautiful is the Lybica, who, having written a large volume drawn from several books, remains in a feminine attitude ready to rise and shut the book, a difficult thing practically impossible for any other master. What can I say of the four scenes in the angles of the corbels of the vaulting? A David stands with his boyish strength triumphant over a giant, gripping him by the neck while soldiers about the camp marvel. Very wonderful are the attitudes in the story of Judith, in which we see the headless trunk of Holofernes, while Judith puts the head into a basket carried by her old attendant, who being tall bends down to permit Judith to do it, while she prepares to cover it, and turning towards the trunk shows her fear of the camp and of the body, a well-thought-out painting. Finer than this and than all the rest is the story of the Brazen Serpent, over the left corner of the altar, showing the death of many, the biting of the serpents, and Moses raising the brazen serpent on a staff, with a variety in the manner of death and in those who being bitten have lost all hope. The keen poison causes the agony and death of many, who lie still with twisted legs and arms, while many fine heads are crying out in despair. Not less beautiful are those regarding the serpent, who feel their pains diminishing with returning life. Among them is

a woman, supported by one whose aid is as finely shown as her need in her fear and distress. The scene of Ahasuerus in bed having the annals read to him is very fine. There are three figures eating at a table, showing the council held to liberate the Hebrews and impale Haaman, a wonderfully foreshortened figure, the stake supporting him and an arm stretched out seeming real, not painted, as do his projecting leg and the parts of the body turned inward. It would take too long to enumerate all the beauties and various circumstances in the genealogy of the patriarchs, beginning with the sons of Noah, forming the generation of Christ, containing a great variety of draperies, expressions, extraordinary and novel fancies; nothing in fact but displays genius, all the figures being finely foreshortened, and everything being admirable and divine. But who can see without wonder and amazement the tremendous Jonah, the last figure of the chapel, for the vaulting which curves forward from the wall is made by a triumph of art to appear straight, through the posture of the figure, which by the mastery of the drawing and the light and shade, appears really to be bending backwards. O, happy age! O, blessed artists who have been able to refresh your darkened eyes at the fount of such clearness, and see difficulties made plain by this marvellous artist! His labours have removed the bandage from your eyes, and he has separated the true from the false which clouded the mind. Thank Heaven, then, and try to imitate Michelagnolo in all things.

When the work was uncovered everyone rushed to see it from every part and remained dumbfounded. The Pope, being thus encouraged to greater designs, richly rewarded Michelagnolo, who sometimes said in speaking of the great favours showered upon him by the Pope that he fully recognised his powers, and if he sometimes used hard words, he healed them by signal gifts and favours. Thus, when Michelagnolo once asked leave to go and spend the feast of St. John in Florence, and requested money for this, the Pope said, "When will this chapel be ready?" "When I can get it done, Holy Father." The Pope struck him with his mace, repeating, "When I can, when I can, I will make you finish it!" Michelagnolo, however, returned to his house to prepare for his journey to Florence, when the Pope sent Cursio, his chamberlain, with five hundred crowns to appease him and excuse the Pope, who feared what Michelagnolo might do. As Michelagnolo knew the Pope, and was really devoted to him, he laughed, especially as such things always turned to this advantage, and the Pope did everything to retain his good-will.

On the completion of the chapel the Pope directed Cardinal Santiquattro and the Cardinal of Agen, his nephew, to have his tomb finished on a smaller scale than at first proposed. Michelagnolo readily began it anew, hoping to complete it without the hindrance which afterwards caused him so much pain and trouble. It proved the bane of his life, and for some time made him appear ungrateful to the Pope who had so highly favoured him. On returning to the tomb he worked ceaselessly upon designs for the walls of the chapel; but envious Fortune would not allow him to complete the monument he had begun so superbly, for the death of Julius occurred then.[1] It was abandoned at the election of Leo X., a Pope of no less worth and splendour, who, being the first Florentine Pope, desired to adorn his native city with some marvel executed by a great artist and worthy of his position. Accordingly he directed Michelagnolo to prepare designs for the façade of S. Lorenzo, the church of the Medici at Florence, as he was to direct the work, and so the tomb of Julius was abandoned. When Michelagnolo made every possible objection, saying that he was under obligation to Santiquattro and Agen, Leo replied that he had thought of this, and had induced them to release him, promising that Michelagnolo should do the figure for the tomb at Florence as he had already begun to do. But this caused great dissatisfaction to the cardinals and Michelagnolo, who departed weeping.

Endless disputes now arose, because the façade should have been divided among several persons. Moreover, many artists flocked to Rome, and designs were prepared by Baccio d'Agnolo, Antonio da San Gallo, Andrea and Jacopo Sansovino, and the gracious Raphael of Urbino, who afterwards went to Florence with the Pope for the purpose. Michelagnolo therefore determined to make a model, not acknowledging any superior or guide in architecture. But his resolve to do without help led to the inactivity of himself and the other masters, who in despair returned to their accustomed avocations. Michelagnolo went to Carrara [2] with a commission to receive 1000 crowns from Jacopo Salviati. But Jacopo being closeted in a room with some citizens on certain affairs, Michelagnolo would not wait, but left at once for Carrara without a word. On hearing of Michelagnolo's arrival, Jacopo, who could not find him in Florence, sent the 1000 crowns to Carrara. The messenger desired him to give a receipt, but Michelagnolo said that he was working for the Pope and not for himself, and it was not

[1] On 21 September, 1513.　　　　　　[2] In 1517.

his practice to give receipts, so that the messenger returned without one.

While Michelagnolo was at Carrara selecting marble for the façade and also for the tomb of Julius, which he hoped to finish, he received a letter from Leo, who had heard that the highest mountain of the Petra Santa range at Seravezza in Florentine territory contained marble of equal beauty and excellence to that of Carrara. Michelagnolo knew as much before but did not wish to take note of it, because he was friendly with the Marquis Alberigo, lord of Carrara, and preferred Carrara for his sake, or perhaps he thought, as the event proved, that he would lose time. However, he was forced to go to Seravezza, although he declared it would involve more trouble and expense, especially as it was a beginning there and perhaps the report was not true. But the Pope would not listen, and it was necessary to make a road of several miles through the mountains, breaking the rocks with maces and pickaxes, and driving piles in the marshy places. In fulfilling the Pope's wish Michelagnolo thus spent many years, and at length obtained five columns of some size, one of which is on the piazza of S. Lorenzo at Florence, the others being on the coast. Marquis Alberigo, seeing himself left in the lurch, became very hostile to Michelagnolo, though it was not his fault. He quarried much marble in addition, which has remained there for more than thirty years. But Duke Cosimo has directed the completion of the road, two awkward miles still being left to do, to have this marble brought, and also from another quarry discovered by Michelagnolo, to finish numerous undertakings. In the same place Michelagnolo discovered a hard and beautiful variegated marble under Stazema, between which and the sea Duke Cosimo has made a road of more than four miles for transporting the stone.

To return to Michelagnolo. He went back to Florence after wasting much time first on one thing and then on another, and made a model for the windows with curved gratings of the corner rooms of the Medici palace, where Giovanni da Udine decorated a chamber with painting and stucco. He directed the making of perforated copper jalousies, executed by Piloto the goldsmith, which are certainly admirable. He spent many years in quarrying marble, though meanwhile he made wax models and other things for the work. However, it dragged on so long that the money appointed for it by the Pope was consumed by the war in Lombardy, and it was interrupted by Leo's death, the foundations being laid and a large marble column brought from Carrara to

the piazza of S. Lorenzo and nothing more. The death of Leo so astounded artists and the arts both in Rome and Florence that, during the life of Adrian VI., Michelagnolo devoted himself in Florence to the tomb of Julius. But when Adrian was succeeded by Clement VII., who proved himself as eager as Leo and his other predecessors to earn renown in architecture, painting and sculpture, Giorgio Vasari, then a child, was taken from Florence in 1525 by the cardinal of Cortona,[1] and put to learn art with Michelagnolo. But as the latter was summoned to Rome by the Pope to begin the library of St. Lorenzo and the new sacristy to contain the Medici tombs, he decided that Vasari should go to Andrea del Sarto until this was arranged, and so he took him to Andrea's shop himself. Michelagnolo left for Rome in haste, being tormented by Francesco Maria, duke of Urbino, nephew of Pope Julius, who complained of the artist, saying that he had received 16,000 crowns for the tomb while he amused himself in Florence, and threatening him if he did not devote his attention to it. When he reached Rome Pope Clement advised him to make an account with the duke's agent, when it seemed likely that he would be found to be the creditor rather than the debtor by what he had done, and so the matter rested. After discussing many things it was decided to finish the sacristy and new library of St. Lorenzo at Florence. Accordingly Michelagnolo left Rome, and vaulted the cupola,[2] getting Piloto the goldsmith to make a ball with seventy-two faces and of great beauty. While it was building some friends said, "You ought to make your lantern quite different from Brunellesco's." To which he replied, "I might make alterations, but not improvements." He introduced four tombs for the bodies of the fathers of the two popes, Lorenzo the elder and his brother Giuliano, and for Giuliano, Leo's brother, and Duke Lorenzo, his nephew. He proposed to imitate the old sacristy of Brunellesco, but with other ornaments. He introduced a varied and more novel composition than ancient and modern masters have been able to employ, for his fine corners, capitals, bases, doors, tabernacles and tombs vary considerably from the common rule and from the lines laid down by Vitruvius and the ancients. This licence has encouraged others to imitate him, and new fancies have sprung up, more like grotesques than regular ornament. Artists therefore owe Michelagnolo a great debt for having broken the chains which made them all work in one way. He showed it even better in the library of St. Lorenzo, in the handsome

disposition of the windows and ceiling and the marvellous vestibule. Nothing so graceful and vigorous in every part was ever seen, comprising the bases, tabernacles, corners, convenient staircase with its curious divisions, so different from the common treatment as to excite general wonder. At that time he sent Pietro Urbano of Pistoia, a pupil, to Rome, to begin a naked Christ bearing the Cross,[1] a marvellous figure placed next the principal chapel in the Minerva by M. Antonio Metelli.

After the sack of Rome and the expulsion of the Medici from Florence, the Government appointed Michelagnolo to be controller-general of all the fortifications, and he designed fortifications for the city and surrounded the hill of St. Miniato with bastions, not only earthworks with the usual fascines, but with a framework below of oaks and chestnuts and other good materials, using rough bricks made of tow and dung, carefully laid. The Signoria of Florence sent him to Ferrara[2] to see the fortifications of Duke Alfonso and his artillery and munitions. The duke received him very graciously and begged him to do something for him. Michelagnolo promised, and although he was constantly engaged on his return in fortifying the city, he did a divine Leda in tempera for the duke, and laboured secretly on the statues for the tombs of St. Lorenzo. He remained some six months on the hill of St. Miniato to superintend the fortifications, for if the enemy could take it, the city was lost, and so he applied all his diligence to the work.

At this time he did seven statues for the sacristy, some finished and some not. In this as in the architecture it must be admitted that he surpassed everyone in the three professions. Among the statues there is a Madonna with her legs crossed, and the Child, who is seated astride the upper knee, is turning round in a charming attitude to His Mother's breast. The Mother holds Him with one hand, and supporting herself with the other prepares to satisfy Him. Although unfinished, the perfection of the work is apparent. Much greater wonder was excited by the tombs of the Medici. Thinking the earth alone insufficient for their greatness, he wished to unite all the powers of the world, and adorn their tomb with four statues, Night and Day on one, and Dawn and Twilight on the other. They are executed in wonderful attitudes, the muscles being made in a way that would have restored the art to splendour if it had been lost. He did two other statues of the princes in armour, Duke Lorenzo in thoughtful pose, his legs being the finest imaginable. The other

[1] Sent to Rome in 1521. [2] In 1529.

is Duke Giuliano with bold head and throat, deep-set eyes, prominent nose, half-open mouth, divine hair, hands, arms, knees and feet, so that the eye never wearies of regarding them. Indeed his cuirass and buskins seem divine and not mortal. What shall I say of the nude female Dawn with her melancholy spirit, showing her desire to rouse from sleep, as she seems to have found on rising that the duke's eyes are closed for ever, and so she displays the greatest grief? What shall I say also of the unique Night? What century, ancient or modern, has ever seen such statues, showing not only the quiet of the sleeper, but the sorrow of one who has lost something noble and great? It may be imagined that this Night has obscured all those who for some time sought, not to surpass it, but to equal it. The figure displays the somnolence of those who sleep. Thus many learned persons made Latin verses and rhymes in the vernacular in its praise, such as the following, the author of which is not known [1]:

I a Notte che tu vedi in si dolce atti
Dormire, fu da un angelo scolpita
In questo sasso ; e perche dorme ha vita
Destala, se no'l credi, e parleratti. [2]

To this Michelagnolo, in the person of his Night, replied:

Grato mi e il sonno, e piu l'esser di sasso
Mentre che il danno e la vergogna dura,
Non veder non sentir, m'e gran ventura ;
Pero non mi destar : deh parla basso. [3]

If the hostility between Fortune and Genius had allowed him to complete this, Art might have shown Nature how much she surpassed her in every thought. While Michelagnolo was engaged upon this work with love and care the siege of Florence took place in 1529, so that he could do little or nothing more, as the citizens had given him the charge of the fortifications. He had lent the republic 1000 crowns, and was one of the Nine of the militia, a council of war, and so he devoted all his powers to perfecting the defences. After the investment was completed, when all hope of aid had disappeared and the difficulty of the defence increased, he decided to leave Florence for Venice secretly, to secure his personal safety. Accordingly he slipped

[1] The lines are by Gio. Batt. Strozzi the elder.
[2] The night which thou seest sleeping in such graceful pose was by an angel wrought in this stone; though asleep she lives; rouse her if thou doubtest it, and she will speak to thee.
[3] Sweet is sleep to me and even more to be of stone, while the wrong and shame endure. To be without sight or sense is a most happy chance for me, therefore do not rouse me. Hush! speak low.

out by way of S. Miniato, taking with him his pupil Antonio
Mini and Piloto the goldsmith, his faithful friend, each of them
carrying a number of crowns fastened in their doublets. At
Ferrara they found that, owing to the suspicions of wartime and
the league of the Pope and Emperor against Florence, Duke
Alfonso was keeping himself secretly informed by the inn-
keepers of the names of all those who stayed with them, and
had the list of foreigners with their nationality brought to him
every day, and thus he learned of the presence of Michelagnolo
and his friends, though they did not want to be known, and
rejoiced greatly, because he had become his friend. Alfonso was
a magnanimous prince and a patron of genius all his life long.
He immediately sent some of the first men of his court to bring
Michelagnolo to the palace with his horses and all his things and
provide them with good quarters there. Michelagnolo was forced
to obey, and to give what he could not sell, and he went with
them to the duke without removing his things from the inn. The
duke received him very graciously, but complained of his reserve,
and then by making him rich presents tried to detain him in
Ferrara, with a good provision. But Michelagnolo would not
remain, though the duke begged that he would at least stay
during the war, and made him munificent offers. Unwilling to
be surpassed in courtesy, Michelagnolo thanked the duke, and
turning to his companions, said he had brought 12,000 crowns
to Ferrara, which he placed at the duke's disposal. The duke
then took him through the palace, as he had done before, showing
him his treasures, including a portrait of himself by Titian which
Michelagnolo highly praised. But he would not remain in the
palace, deciding to return to the inn. The host was secretly
enjoined by the duke to do them great honour, and to take
nothing for their entertainment.

Michelagnolo then went to Venice, where several nobles
wished to make his acquaintance. But as he never had much
opinion of their knowledge of art, he left the Giudecca where he
lodged, and where he is said to have made a most original and
ornate design for the Rialto bridge, at the prayers of the Doge
Gritti. But he was earnestly entreated to return to his country,
though they begged him not to abandon the undertaking, and
sent him a safe-conduct. At length, conquered by love of his
native place, he returned, not without peril of his life, and mean-
while finished the Leda for Duke Alfonso, which was afterwards
taken to France by his pupil Anton Mini.[1] He repaired the

[1] It was destroyed from prudery in the reign of Louis XIII.

campanile of S. Miniato, a tower which had caused much annoyance to the enemy's camp by its two pieces of artillery. They had attacked it with heavy cannon, inflicting much damage, and would have destroyed it. Michelagnolo fortified it with large bales of wool and strong mattresses and ropes, so that it is still standing. It is said that during the siege he had the opportunity of fulfilling an earlier desire to do a marble block from Carrara of nine braccia, which Pope Clement had given to Baccio Bandinelli after both had asked for it. As it was public property, Michelagnolo asked the gonfaloniere for it, and so obtained it, although Baccio had made a model and had knocked away much of the stone. So Michelagnolo made a model which was considered marvellous, but on the restoration of the Medici the block was again given to Baccio.

After the settlement Baccio Valori, the papal commissary, was commissioned to imprison in the Bargello some of the most deeply implicated citizens. The court sent to Michelagnolo's house, but the artist's suspicions were aroused and he had fled to a friend, with whom he remained hidden for several days. At length, after the first heat, Clement remembered the genius of Michelagnolo, and sought diligently for him, promising that nothing should be said, that he should receive his former provisions and his work at S. Lorenzo. For this he appointed Giovambatista Figiovanni as proveditore, an old servant of the Medici and prior of S. Lorenzo. Thus reassured, Michelagnolo began a marble Apollo of three braccia drawing an arrow from his quiver, to win the friendship of Baccio Valori, and almost completed it. It is now in the chamber of the Prince of Florence, a most rare work although not quite finished.[1]

At this time Duke Alfonso of Ferrara, having learned that Michelagnolo had produced a remarkable work, and being anxious not to lose such a jewel, sent a nobleman to Florence with letters of credit. Michelagnolo received him courteously, and showed him his Leda embracing the Swan and Castor and Pollux issuing from the egg, a large picture painted in tempera. The duke's envoy expecting from Michelagnolo's great reputation that he would have done something great, and not perceiving the excellence of the work, exclaimed, "This is a small thing." Michelagnolo asked what his profession was, for he knew that those who practise a thing are best qualified to pass judgment on it. The envoy smiled and replied, "I am a merchant," thinking that Michelagnolo did not know him to be a noble, and as it were

[1] Now in the Bargello.

mocking at such a question and despising the industry of the Florentines. Michelagnolo, who well knew what he meant, said, "You will have done bad business for your master this time; begone!" Then, as his pupil Anton Mini had two sisters to marry, and asked his master for the picture, Michelagnolo gave it to him readily, together with the greater part of his divine designs and cartoons, and with two chests of models, with a large number of finished cartoons for painting, and some of work done. Anton having then the fancy to go to France, took them with him and sold the Leda to King Francis through merchants. It is now at Fontainebleau. The cartoons and designs suffered a sad fate, for Anton died there in a little while, and they were stolen, an irreparable loss to the country, depriving it of such useful labours. The cartoon of Leda, however, has returned to Florence, and Bernardo Vecchietti has it, while four pieces of the cartoon of the chapel, of nudes and prophets, brought by Benvenuto Cellini the sculptor, are now owned by the heirs of Girolamo degli Albizzi. It was necessary for Michelagnolo to go to Pope Clement at Rome, and the pontiff, as the friend of genius, though much incensed against him, pardoned him everything, and ordered him to return to Florence to finish the library and sacristy of S. Lorenzo. To shorten the work he divided a number of the statues among other masters, allotting two to Tribolo, one to Raffaello da Montelupo, and one to Frà Agnolo the Servite, while he helped them by making the clay models. So all worked bravely, while Michelagnolo devoted himself to the library, finishing the carved wooden ceiling with models made by the Florentines Carota and Tasso, both excellent carvers and masters. The book-shelves were done by Battista del Cinque and Ciapino his friend, both good masters. To finish it Giovanni da Udine was brought to Florence, who with his Florentine assistants decorated the tribune with stucco, so that all felt eager to finish the task. Just as Michelagnolo was proposing to begin the statues, the Pope was seized with a desire to have the walls of the Sistine Chapel painted with a Last Judgment, to show the powers of the art of design, and on the opposite wall he wanted to have Lucifer cast down from heaven with the rebel angels. Michelagnolo had made sketches for these ideas long before, one of which was executed in the Trinità at Rome by a Sicilian painter who had served Michelagnolo many months and ground his colours. This work in the crossing of the church at the chapel of St. Gregory, although badly executed, possesses a certain wonderful power in the varied attitudes and groups of

nudes raining from heaven, and converted into terrible devils on reaching the earth, a curious fancy.

While Michelagnolo was busy with his designs for the Judgment,[1] the agents of the Duke of Urbino assailed him daily for having received 16,000 crowns for the tomb of Julius II. Although he was now old Michelagnolo would willingly have finished it had the opportunity occurred, for he would gladly have been at Rome and never returned to Florence, as he was much afraid of Duke Alessandro, believing that he bore him no good will. For when the duke sent Sig. Alessandro Vitelli to consult him upon the best site for the citadel of Florence, he refused to go unless commanded by Pope Clement. At length an arrangement was made concerning the tomb, that it should not be made square and stand alone, but with one side only, as Michelagnolo should determine, and that he should introduce six statues by his own hand. In this contract the Duke of Urbino granted him permission to serve the Pope for four months of the year, in Florence or elsewhere. But although Michelagnolo believed the matter to be settled, it was not, for Clement, eager to see the full extent of his powers, desired him to devote himself to the cartoon of the Judgment. But though he showed the Pope that he was occupied upon it, he was secretly working with all his might upon the statues for the tomb.

On the death of Clement in 1533 the work of the sacristy and library at Florence was stopped, in spite of the efforts to finish it. Michelagnolo then thought himself free at length to devote his energies to the tomb of Julius. But the new Pope, Paul III., soon summoned him and required his services, offering him gifts and favours, and wanted him to remain near his person. Michelagnolo, however, declined until the tomb should be finished, alleging his contract with the Duke of Urbino. His refusal angered the Pope, who said, "I have been longing for this opportunity for thirty years, and shall I not have it now I am Pope? I will tear up the contract, and I am determined that you shall serve me, come what may." Michelagnolo, seeing his determination, was tempted to leave Rome and find some means of finishing the tomb elsewhere. However, he had a prudent fear of the Pope, and thought that he would satisfy him with words, for Paul was very old, and await his opportunity.

The Pope, who wished to employ Michelagnolo on some noteworthy work, one day called at his house with ten cardinals. He saw and admired all the statues for the tomb of Julius,

[1] He was at work on this fresco from 1535 to 1541.

especially the Moses which the cardinal of Mantua declared
sufficient by itself to honour the dead Pope. The Pope also saw
the cartoons for the wall of the chapel, which he thought stu-
pendous, and again besought him to serve him, promising that
he would persuade the Duke of Urbino to rest content with
three statues if the others were made from Michelagnolo's
models by excellent masters. Accordingly, by means of the
Pope, Michelagnolo made a new contract with the Duke's agents,
binding himself to do three statues, depositing 1580 ducats in
the bank of the Strozzi, though he might have avoided it. He
thought he had done enough to acquit himself of this long and
harassing task, which was executed in the following manner in
S. Pietro ad Vincola.[1]

He made a carved basement with four projections, each with
a figure representing a prisoner, as at first arranged, but for
which a caryatid was substituted. On each base he placed a
corbel upside down to relieve the poverty of the lower part.
Between the caryatids were three niches, originally intended
for Victories. Instead he put Leah, Laban's daughter, in one,
for Active Life, holding a mirror to show the consideration
necessary for action. In another he put a garland of flowers for
the virtues that adorn life and render it glorious after death.
The third contained Rachel, Leah's sister, for Contemplative
Life, her hands clasped, one knee bent and her face raised to
heaven, as if in ecstasy. Michelagnolo executed these statues
himself in less than a year. In the middle niche, which was square,
he originally proposed to make one of the doors into the tomb.
He afterwards converted it into a niche, and placed there the
magnificent statue of Moses, already sufficiently described. The
caryatids, whose heads serve as capitals, bear the architraves,
frieze, and cornice, projecting above them, carved with rich
foliage, ovals, denticulations and other rich ornaments. Above
the cornice is another order without carving, with other and
different caryatids immediately above the first, like pilasters,
with variously moulded cornices, the whole corresponding with
what is below. The space corresponding to that occupied by the
Moses has a marble sarcophagus, with the recumbent statue
of Pope Julius made by Maso dal Bocco the sculptor. The right-
hand niche contains a Virgin and Child by Scherano da Settig-
nano the sculptor, from Michelagnolo's model, both statues of
merit. The niches above those containing the Active and Con-
templative Life contain two larger seated statues of a prophet

[1] It was finished as it now stands in 1545.

and a sibyl executed by Raffaello da Montelupo, as related in the Life of his father Baccio, which were not done to Michelagnolo's satisfaction. Above the whole was a richly decorated projecting cornice with marble candelabra above the caryatids, the arms of Pope Julius in the middle, and a window above the prophet and sibyl for the convenience of the friars of the church, the choir being behind, to permit the voices to penetrate to the church, and to allow the office to be seen. Indeed, the work has turned out admirably, though it is very different from the original design.

As he had no choice, Michelagnolo decided to serve Paul, who wished him to continue what had been ordained by Clement without altering anything, for the Pope bore such love and admiration for that artist that he only sought to please him. Thus when Paul desired to put his arms under Jonah, where those of Julius had been, Michelagnolo objected that it was not well to wrong the memory of Julius and Clement, and the Pope respected the man who meant to be just without adulation, a thing princes rarely experience. Michelagnolo therefore made a shield of well-baked bricks carefully chosen at the wall of the chapel, to project half a braccia from the top of the chapel, so that no dust or other soil could lodge on the work. I will not enter into the particulars of the invention or composition of this scene, as it has been so often copied and printed in all sizes that it would be a waste of time. Suffice it to say that the purpose of this remarkable man was none other than to paint the most perfect and well-proportioned composition of the human body in the most various attitudes, and to show the emotions and passions of the soul, displaying his superiority to all artists, his great style, his nudes, and his knowledge of the difficulties of design. He has thus facilitated art in its principal object, the human body, and in seeking this end alone he has neglected charming colouring, fancies, new ideas with details and elegances which many other painters do not entirely neglect, perhaps not without reason. Thus some, not so grounded in design, have tried varied and new inventions with divers tints and dark colours, hoping to win a place among the first masters. But Michelagnolo, firmly founded in the profundity of his art, has shown the true road to perfection to all who have sufficient knowledge.

To return to the scene. Michelagnolo had already finished three-quarters of his work when the Pope went to see it. M. Biagio of Cesena, master of the ceremonies and a scrupulous man, who accompanied him, when asked his opinion, said it was

a disgrace to have put so many nudes in such a place, and that the work was better suited to a bathing-place or an inn than a chapel. This angered Michelagnolo, and in revenge, as soon as they had gone, he drew M. Biagio, from memory, as Minos in Hell among a troop of devils, with a great serpent wound about his legs. It was in vain that M. Biagio besought the Pope to make Michelagnolo remove it, and there it still is. About this time Michelagnolo fell a considerable height from the scaffold and injured his leg. In his pain and anger he refused to be attended. But Maestro Baccio Rontini, a Florentine, his friend and a clever physician, who loved the arts, took compassion on him and went to his house. When no one answered his knock, he entered by a secret way, and passing from room to room found Michelagnolo in desperate case. Baccio refused to leave him before he was healed, when he returned to his work, and by continued application finished it in a few months, realising the saying of Dante—

" Morti li morti, i vivi parean vivi," [1]

showing the misery of the damned and the joy of the blessed. In this Judgment he not only far surpassed the other great masters who had worked there, but his own celebrated work in the vaulting. He has imagined the terror of those days, representing too the sorrow of those who have not lived well, the Passion of Christ, with nude figures in the air bearing the cross, the column, the lance, the sponge, the nails and the crown, in varied attitudes, with a facile mastery of the difficulties. Christ is seated, and turns with a terrible expression towards the damned, to curse them, while the Virgin in great fear shrinks into her mantle and hears and sees the ruin. A quantity of figures form a circle, prophets, apostles, and notably Adam and St. Peter, one as the origin of men come to judgment and the other as the foundation of the Christian religion. At their feet is a fine St. Bartholomew showing his flayed skin. There is also a nude St. Laurence, besides countless saints and other figures embracing and rejoicing at attaining eternal happiness by the grace of God as a reward for their actions. At the feet of Christ are the seven angels described by St. John, with the seven trumpets, the sound of which makes the hair rise, so terrible are they to see. There are two angels, each holding the Book of Life, and hard-by are the seven mortal sins in the shape of devils dragging souls to Hell, in fine attitudes and admirably foreshortened. In the

[1] The dead look dead, the living alive.
Purgatorio, Canto XII. 67 (Cary's Translation).

Resurrection Michelagnolo has shown how the dead receive their bones and flesh and fly to heaven like the living, some of the blessed aiding them, together with many other ideas appropriate to such a work, studied and worked at by him. Thus in the barque of Charon we see him fiercely beating with his oar the souls thrust into it by the devils, as in the well-known words of Dante—

> Caron demonio con occhi di bragia
> I oro accennando, tutte le raccoglie:
> Batte col remo qualunque si adagia.[1]

It is impossible to describe the variety in the heads of the devils, veritable monsters of hell. The sinners display their sin and fear of damnation. The whole work is finely and harmoniously executed, so that it looks as if it had been done in one day, and no illuminator could have equalled its execution. Indeed, the number of figures and the force and grandeur of the painting are such that it is impossible to describe it. Every human emotion is represented and marvellously expressed. The proud, envious, avaricious, luxurious, and others, may be recognised by an intelligent observer from their attitudes and treatment. It is marvellous that this great man, who was always wise and prudent and had met many people, should have acquired a practical knowledge of the world such as is gained by philosophers by means of speculations and books. A man of judgment who understands painting will see the tremendous power of art in the thoughts and emotions of the figures, never displayed by any other artist. Thus we notice how he varied the attitudes in the divers gestures of young and old, men and women, so that no one can be insensible to the terrific character of his art joined to his natural grace; for he impresses those who are unskilled as well as connoisseurs in such matters. Here are foreshortenings which seem in relief, done with softness and harmony, while his treatment of the parts show what paintings may be when executed by good and true masters. The outlines are such as no other could have done, and display an actual judgment, damnation and resurrection. This great painting is sent by God to men as an example to show what can be done when supreme intellects descend upon the earth, infused with grace and divine knowledge. It takes captive those who think they know art, who tremble at the genius of the master in seeing his handiwork,

[1] Charon, demonaic form
With eyes of burning coal, collects them all
Beck'ning, and each, that lingers, with his oar
Strikes.
 Inferno, Canto III. 109-11 (Cary's Translation).

while in regarding his labours their senses are overcome by thinking how other pictures can possibly bear comparison with them. Happy indeed is he who has seen this stupendous marvel of our century. Most happy and fortunate was Paul III. in that God consented to confer this memorial, this triumph which the pens of authors will commemorate under his rule. How much are his merits enhanced by the artist's skill! Artists born in this century owe Michelagnolo a great debt, for he has removed the veil from all imaginable difficulties in his painting, sculpture and architecture. Michelagnolo laboured upon this work for eight years and uncovered it in 1541, I think on Christmas Day, to the marvel of all Rome and the whole world. I was at Venice, and when I went to Rome to see it I was thunderstruck.

Pope Paul had caused a chapel called la Paolina to be built by Antonio da Sangallo on the same floor, in imitation of that of Nicholas V. He wished Michelagnolo to do two large square paintings.[1] In one the artist did a Conversion of St. Paul with Christ in the air and a multitude of naked angels with beautiful movements, and Paul in fear and amazement fallen from his horse to the ground, surrounded by the soldiers engaged in lifting him, while others flee in varied and beautiful attitudes, terrified at the voice and glory of Christ, and a fleeing horse drags along the man who is seeking to retain it, the whole scene being executed with extraordinary art and design. The other is a crucifixion of St. Peter, who is represented naked on the cross, a remarkable figure. The executioners having made a hole in the ground are about to put the cross in it, so that Peter shall be head downwards. Michelagnolo, as is mentioned elsewhere, only devoted himself to perfection in art, for we have here no trees, buildings, landscapes, or any variations or charms of art, because he never cared for such things, not wishing, perhaps, to lower his great mind to them. These were his last paintings, executed at the age of seventy-five. He has told me that they cost him great labour, as painting, especially in fresco, is not work for an old man. He arranged that Perino del Vaga should decorate the vaulting with stucco and painting from his designs, and this was in conformity with the wish of Paul III. But the work was delayed, nothing more being done, as many things are left unfinished either owing to the fault of irresolute artists or of the neglect of princes in urging them on.

Pope Paul had begun to fortify Borgo, and had taken thither Antonio da Sangallo and several lords to discuss the matter. He

[1] He did them between 1542 and 1549.

wished Michelagnolo to assist, knowing that the fortifications of S. Miniato at Florence had been designed by him. After many discussions his opinion was asked. He being opposed to the advice of Sangallo and the others said so frankly, to which Sangallo retorted that sculpture and painting were his arts, not fortification. Michelagnolo replied that he knew but little of sculpture and painting, but as he had thought much about fortifications and had experience, he thought he knew more than Antonio or any other member of his family, and in the presence of the company he pointed out many of the errors they had committed. The dispute waxed so hot that the Pope was obliged to impose silence, but before long Michelagnolo brought designs for all the fortifications of the Borgo, which prepared the way for all that was done afterwards and led to the abandonment of the S. Spirito gate nearly completed by Sangallo.

Michelagnolo's spirit could not rest idle, and as he was unable to paint he took a piece of marble to make four figures larger than life-size, of a dead Christ, as a pastime, and because he said the use of the mallet kept him in health. This Christ, taken down from the cross, was supported by the Virgin, assisted by Nicodemus and one of the Maries, as the Madonna, overcome by grief, does not possess the strength. No better presentation of a dead body has ever been made than the Christ with his lifeless limbs in different postures, varying not only from others but from the master's own work. It is laborious work and truly divine, but it was left unfinished, as I shall relate, and it suffered many misfortunes, although Michelagnolo intended it for his own tomb at the foot of the altar where he hoped to be laid.

In 1546 Antonio da Sangallo died, leaving the direction of the fabric of S. Pietro vacant, and various opinions as to his successor obtained among the deputies about the Pope. At length the Pope, inspired I believe by God, decided to send for Michelagnolo. But the master refused the post, to escape such a burden, saying that architecture was not his art. But his prayers availed nothing, and the Pope ultimately commanded him to accept it. Much against his will, therefore, he was obliged to take it up. So one day he went to S. Pietro to see Sangallo's wooden model and examine the structure. He found there all the faction of Sangallo, who, putting the best face on the matter, came forward and said how glad they were that the work had been given to Michelagnolo, and that the model was a meadow that would afford inexhaustible pasture. You speak truly, said Michelagnolo, meaning, as he afterwards told a friend, that it

would serve for sheep and oxen who know nothing of art. He used to say publicly that Sangallo had made the building without sufficient light, that he had used too many ranges of columns on the exterior one above the other, and that with his numerous projections and angles his style had much more of the German than of the good antique or modern manner. He might besides have saved fifty years in finishing it and more than 300,000 crowns of the cost, executing it with greater majesty, design, beauty and convenience. Michelagnolo afterwards made a model to bring the work to its present form, proving that he spoke the truth. This model cost him twenty-five crowns and was completed in fifteen days. That of Sangallo is said to have exceeded 4000, and took many years to make. From this we see that he was working for gain, and prolonged the work from year to year not intending to finish it, while Michelagnolo determined to carry it through. Such methods did not please him, and while the Pope was forcing him to take the office of architect, he said one day openly that he did not want to have anything to do with those who had intrigued with their friends to prevent him from having the work, and if he was to have charge of it he would not employ one of them. These words spoken in public excited much animosity against him, as may readily be believed, which increased daily when they saw him change all the dispositions both inside and out, so that they never gave him any peace and were always seeking fresh means of annoying him. At length Pope Paul gave him absolute powers over the building to do and undo at will and to direct other ministers. Michelagnolo, seeing the confidence which the Pope placed in him, desired that the deed should contain that he worked for the love of God in this task, without any reward, although the Pope had at first given him the ferry of the river at Parma, worth 600 crowns. He lost this by the death of Duke Pier Luigi Farnese, and received in exchange a chancery of Rimini of less value. This did not affect him, and although the Pope frequently sent him money for such provision he always refused it, as M. Alessandro Ruffini, then the Pope's chamberlain, and M. Pier Giovanni Aliotti, bishop of Forli, testify.

At length Michelagnolo's model was approved by the Pope. It made S. Pietro smaller but much grander, to the satisfaction of all men of judgment, although many who think themselves connoisseurs, without reason, do not approve of his dispositions. He found that the four principal piers built by Bramante, and

left unaltered by Antonio da Sangallo, which bear the weight of the principal tribune, were feeble. He partly strengthened them, making two spiral staircases beside them mounting to the top, with easy steps for the carriage of materials by mules, and enabling a man on horseback to ride to the level of the top of the arches. He carried the first cornice round the arches making it of travertine, with marvellous grace, impossible to improve upon, and very different from the others. He began the two great apses of the transept, and where eight tabernacles had been designed towards the Campo Santo by Bramante, Baldassarre and Raphael, continued by Sangallo, Michelagnolo reduced the number to three, forming three chapels vaulted with travertine and containing windows of striking grandeur. As these designs of Michelagnolo and Sangallo have been printed and published, I do not think it necessary to describe them, except to say that Michelagnolo used every diligence in the places where changes had to be made to see that they were rendered strong, so that they should not be altered subsequently by others, a wise and prudent provision, for it is not sufficient to do well if the work is not assured against the presumption of the ignorant; and if one trusts more to words than deeds, and to the favours of the unwise, great disasters may supervene.

The Roman people, favoured by the Pope, desired to give a beautiful, useful and convenient form to the Capitol, making steps and winding staircases adorned with antique statues, and they asked Michelagnolo's advice.[1] He prepared a rich and beautiful design, making a façade of travertine on the east side where the senate house stands, with steps rising to a terrace on two sides, by which one approaches the middle of the hall of the palace, furnished with rich balusters serving as a parapet. To decorate the front he placed two ancient recumbent marble rivers on pedestals, the Tiber and the Nile, each of nine braccia, and in a large niche in the middle of the way he set up a Jupiter. On the south side, where the palace of the Conservadori stands, he made a rich façade, to complete the square, with a loggia full of columns and niches, containing numerous ancient statues and various ornaments about the doors and windows. Opposite, on the north side, he made a similar one, below Araceli, and steps in front on the west, with a terrace and parapet of balusters at the principal entrance, adorned by a row of pedestals containing all the noble statues with which the Capitol is now enriched.

[1] This work was done in 1536. The statues of rivers are now in the Vatican Museum.

On an oval pedestal in the middle of the piazza stands a bronze equestrian statue of Marcus Aurelius, which Pope Paul had removed [1] from the piazza of the Lateran where Pope Sixtus had placed it. It is so fine here that it is worthy of a place among the notable works of Michelagnolo, and its completion is now in the hands of M. Tommaso de' Cavalier, a Roman noble, and one of the best friends Michelagnolo ever had, as I shall relate. Pope Paul had got Sangallo to push on with the Farnese palace, and as it needed a cornice for the top he asked Michelagnolo to design one. Unable to refuse the Pope who loaded him with so many favours, he made a wooden model of six braccia of the proper size, and had it placed *in situ* on the palace to show the effect. It pleased the Pope and all Rome, and being executed it proved the finest and most varied cornice ever seen in ancient or modern times. After Sangallo's death the Pope wished Michelagnolo to have charge of the building, and he made the marble windows with beautiful columns of variegated marble above the principal door, and a large escutcheon of Paul III., founder of the palace, also of marble. Inside, from the first floor of the court, he built upwards the other two stories, decorating them with beautiful ornaments and graceful windows, adding an incomparable cornice, thus forming the finest court in Europe by his genius. He enlarged the great hall and arranged the reception-room before it, making the vaulting in a new form of a half-oval. At that time an ancient Hercules, of marble, seven braccia in each direction, was found in the Antonine baths, holding the bull by the horns, with another figure helping him, surrounded by numerous shepherds, nymphs and various animals, a work of extraordinary beauty, the figures being perfect, made from one block without pieces. It was thought it would do for a fountain, and Michelagnolo advised that it should be taken into the second court and restored for that purpose. This advice gave general satisfaction, and the Farnese have lately had it carefully restored with this idea.[2] Michelagnolo then directed the construction of a bridge over the Tiber to another palace and garden of the Farnese, so that from the principal door of the Campo di Fiore one looked straight through the court, fountain, Strada Julia, the bridge and the other beautiful garden, right to the other door into the Strada di Trastevere, a rare thing worthy of the Pope, and of the genius, judgment and design of Michelagnolo.

In 1547 Bastiano of Venice died, and as the Pope wished to

[1] In 1538. [2] The Farnese bull is now at Naples.

have the ancient statues of his palace restored, Michelagnolo recommended Guglielmo dalla Porta, a Milanese sculptor, who had been introduced to him as a youth of promise by Frà Bastiano. For him Michelagnolo obtained the office of the Piombo and the task of restoring the statues. But Frà Guglielmo proved ungrateful, and afterwards joined Michelagnolo's opponents.

When Julius III. succeeded Paul in 1549, the Cardinal Farnese directed Frà Guglielmo to construct a great tomb for the late Pope, to be placed in St. Pietro under the first arch of the new church under the tribune. As this blocked the plan of the church, Michelagnolo judiciously advised that it should not go there, and this aroused the hostility of the friar, who thought he acted from envy. But he afterwards recognised that the master was right, and that the fault rested with Guglielmo, who had the opportunity and did not finish it, as will be said elsewhere.

In 1550 I went to Rome to serve Julius III., being glad of such employment, which brought me near to Michelagnolo. He desired that the tomb should be in one of the niches where the Column of the Possessed now is, which is its proper place, and I set myself to induce Pope Julius to select the other niche for his own tomb. But the opposition of the friar prevented his tomb from being finished, and the other was never made, just as Michelagnolo had predicted.

In this year Pope Julius began a marble chapel in S. Pietro a Montorio, with two tombs for Cardinal Antonio de' Monti, his uncle, and M. Fabiano, his grandfather, the founder of that illustrious house. Vasari having made designs and models for these, the Pope wished Michelagnolo to value them, Vasari beseeching the Pope to let Michelagnolo have charge of them. Vasari proposed Simon Mosca for the carving and Raffael Montelupo for the figures; but Michelagnolo advised him not to have carving of foliage, saying that with marble figures it was best to have nothing else. Vasari feared that the work would look poor, but when it was finished he admitted the master's good judgment. Michelagnolo did not want Montelupo to have the figures because he had done so badly in the tomb of Julius II., and he agreed the more readily to Vasari's recommendation of Bartolommeo Ammannati, although he had a personal dislike for him and for Nanni di Baccio Bigio. It arose from a small matter, for when boys they had taken away many of Michelagnolo's designs from his pupil, Antonio Mini, moved more by love of art than mischief. These were all returned by

the magistracy of the Eight, and at the intercession of his friend,
M. Giovanni Norchiati, canon of S. Lorenzo, he would not ask
for further punishment. Vasari, in speaking of this with Michel-
agnolo, laughingly said that he did not think they deserved any
blame, and in their place he would have taken not drawings
only but everything he could lay hands on, simply to learn art.
He added that those who aspire to talent should be encouraged
and rewarded, and not be treated like those who steal money
and goods; and so he turned the matter into a jest. The work
was begun, and that same year Vasari and Ammannati went to
Carrara from Rome for the marble.

At that time Vasari spent every day with Michelagnolo, and
one morning in the Holy Year for visiting the seven churches, the
Pope granting them double indulgence. Between the churches
they had many useful discussions on arts and crafts, and Vasari
wrote down the whole dialogue, which he will publish at a
fitting opportunity, with other matters relating to the arts.
That year Pope Julius confirmed the powers of Michelagnolo
over S. Pietro given him by Pope Paul III., and though the
faction of Sangallo spoke against it, the Pope would hear nothing,
for Vasari had shown him that Michelagnolo had given life to
the building, and he succeeded in persuading the Pope that
nothing should be done concerning the design without consulting
the master, and this was strictly adhered to. Thus he took
Michelagnolo's advice about the villa Julia and the Belvedere,
where he constructed a new flight in place of the semicircular
staircase of eight steps, and then eight more turned inwards
already constructed by Bramante. This was erected in the great
recess in the middle of Belvedere. Michelagnolo also designed
the square staircase with the balustrade of peperino marble of
great beauty, now standing.

That year Vasari had finished printing his Lives of the Painters,
Sculptors and Architects in Florence without writing the life of
anyone then living, although some were old, except Michel-
agnolo, to whom he presented the work. The master accepted it
gladly. Vasari had received much information from him, as
being the oldest and most judicious artist, and after reading it
Michelagnolo sent him the following sonnet written by himself,
which I rejoice to put here in memory of his friendship:

> Se con lo stile e co' colori avete
> Alla natura pareggiato l'arte
> Anzi a quella scemato il pregio in parte,
> Che'l bel di lei piu bello a noi rendete
> Poiche con dotta man posto vi sete

A piu degno lavoro, a vergar carte,
Quel che vi manca, a lei di pregio inparte,
Nel dar vita ad altrui, tutto togliete,
Che se secolo alcuno omai contese
In far bell' opre, almen cedale, poi
Che convien ch'al prescritto fine arrive.
Or le memorie altrui, gia spente, accese
Tornando, fate or che fien quelle e voi,
Malgrado d'essa, eternalmente vive.[1]

Vasari departed for Florence, leaving the care of Montorio to Michelagnolo. M. Bindo Altoviti, then consul of the Florentine nation, was a great friend of Vasari, and told him that it would have been better to have had the tomb erected in the Florentine church of S. Giovanni, and that he had spoken of it to Michelagnolo, who agreed, and would see the work done. This pleased M. Bindo, and being very intimate with the Pope, he warmly advocated the placing of the tombs and chapel done for Montorio in that church, adding that this would induce the Florentines to spend money on the church and finish it. If the Pope made the principal chapel, the merchants would do six and the remainder would be taken up one by one. The Pope therefore changed his mind, and though the model had been made and the price fixed, he went to Montorio and sent for Michelagnolo, to whom Vasari wrote daily, and who replied, relating his doings. On 1 August, 1550, Michelagnolo wrote to him of the Pope's change of plan. These are his very words:

"My DEAR M. GIORGIO,

"I have written nothing to you about the Pope giving up the rebuilding of S. Piero a Montorio, as I know you are informed by your man. Now I have this to tell you. Yesterday morning the Pope went to Montorio and sent for me. I met him on the turning bridge, and had a long discussion with him about the tombs, and finally he said he had decided not to have the

[1] With pencil and with palette hitherto
You made your art high Nature's paragon;
Nay more, from Nature her own prize you won,
Making what she made more fair to view.
Now that your learned hand with labour new
Of pen and ink a worthier work hath done,
What erst you lacked, what still remained her own,
The power of giving life, is fained for you.
If men in any age with Nature vied
In beauteous workmanship, they had to yield
When to the fated end years brought their name,
You, reilluming memories that died
In spite of Time and Nature have revealed
For them and for yourself eternal fame.

Symonds' translation.

tombs there, but in the Florentine church, and asked me for my opinion and designs. I encouraged him in his purpose, thinking that this might lead to the finishing of the church. With regard to your last three letters, my pen is unequal to attaining such heights, but if I only had a part of the qualities you ascribe to me I should rejoice, because then you would have in me a servant good for something. But as you are the raiser of the dead, I am not surprised that you should add life to the living, or the bad living long due to die. To conclude, I am ever yours, MICHELAGNOLO BUONARROTTI, at Rome."

Meanwhile, the nation was looking for money, and difficulties arose, so that nothing was concluded and the matter lapsed. Vasari and Ammannati, having obtained all the marble at Carrara, sent a great part to Rome with Ammannati, who took a letter from Vasari to Michelagnolo to ask the Pope where the tomb was to be, so that he might begin it. Michelagnolo immediately spoke to the Pope, and wrote back:

"My DEAR M. GIORGIO,
 "Immediately Bartolommeo arrived here I went to speak to the Pope, and seeing that he wanted to have the tombs at Montorio, I looked out a mason from S. Pietro. Tantecose heard of it, and wanted to send another after his own mind. I withdrew, not desiring a contest with the master of the winds, for as a light man I do not want to be carried away Heaven knows where. So I fancy we must think no more about the Florentine church. Return soon, and fare you well. I can think of no more. Oct. 13, 1550."

Michelagnolo called Monsignor of Forli [1] Tantecose because he wanted to do everything, for he was master of the Pope's chamber, head of the medals, cameos, bronze figurettes, paintings and designs, and he desired to have the control of everything. Michelagnolo avoided him because he was always thwarting him, and the master feared trouble if he had anything to do with him. Thus the Florentine nation lost a fine opportunity, to my great sorrow, and God knows if it will occur again. I have mentioned the story because it shows how Michelagnolo was always ready to help his friends, his country and the arts.

Vasari had no sooner reached Rome, before the beginning of 1551, when the Sangallo faction made a conspiracy against Michelagnolo, to induce the Pope to summon all the builders in

[1] Pier Giovanni Aliotti, bishop of Forli.

S. Pietro, to show him by false calumnies that Michelagnolo had spoiled the structure. He had already made the king's recess, where the three chapels are, with the three windows above, and not knowing what was to be done in the vaulting, they had ignorantly informed Cardinal Salviati the elder and Marcello Cervini, afterwards Pope, that S. Pietro was badly lighted. When all were assembled the Pope told Michelagnolo that they stated that the recess was badly lighted. He answered: "I should like to hear these deputies speak." Cardinal Marcello replied: "We are they." Michelagnolo said: "Monsignor, three more windows of travertine are to go to the vaulting." "You never told us that," said the cardinal. "I am not obliged to tell you or anybody else what I propose to do," retorted the artist. "Your office is to collect the money, and protect it from thieves; you must leave the design and charge of the building to me." Turning to the Pope, he said: "Holy Father, you see what profit I have; for if these labours do not benefit my soul, I am losing my time and trouble." The Pope, who loved him, laid his hands on his shoulders, and said: "Do not doubt that you will gain both in soul and body." The Pope's love for him was thus greatly increased by removing this obstacle, and he commanded that he and Vasari should be at the villa Julia on the following day. There they had long discussions on the work, nothing being done or proposed without consulting Michelagnolo. Michelagnolo went there frequently with Vasari, and on one occasion, when the Pope was standing by the fountain of Acqua Vergine with twelve cardinals, Michelagnolo arrived. The Pope, who always paid the highest honours to his genius, wished the master to sit beside him, but Michelagnolo humbly refused. He did a model for the façade of the palace which the Pope wished to build next to S. Rocco, proposing to use the mausoleum of Augustus for the rest of the building. This would be hidden by the façade, which is most varied, ornate and original, restricted by no laws of architecture, ancient or modern, for Michelagnolo possessed a most original genius. The model is now in the possession of Duke Cosimo, who had it from Pius IV. when he went to Rome, and he holds it to be one of his choicest treasures. The Pope thought so much of Michelagnolo that he always sided with him against the cardinals and others who tried to calumniate him, and he wished all artists, however great their reputation and ability, to go and call upon him. The Pope had such respect for him that, in order not to annoy him, he did not venture to ask him to do many things which he might have attempted, old as he was.

Under Paul III. Michelagnolo had begun to rebuild the Ponte S. Maria at Rome,[1] damaged and weakened by the current and its age. He made the foundations with coffer-dams and diligently repaired the piles, finishing a great part, and incurred great expenses on wood and travertine. In a congregation of the clerks of the chamber under Julius III. it was proposed to give it to Nanni di Baccio Bigio to finish in a short time at a small cost, pretending to relieve Michelagnolo, who neglected it, they said, and who would never get it done. The Pope, who disliked quarrels, innocently gave power to those clerks who had charge of it as their affair. They gave it to Nanni with a free hand,[2] without Michelagnolo knowing of it. Nanni, not understanding the necessary precautions, removed a great quantity of travertine with which the bridge had been annually strengthened and paved, and which rendered it stronger and safer, and put cement in its place, with buttresses outside, so that it seemed completely restored. But it was so weakened that it was destroyed five years after in the flood of 1557, showing the ignorance of the clerks of the chamber and the damage suffered by Rome in neglecting the advice of Michelagnolo, who frequently predicted this accident to his friends. I remember, when we were passing it on horseback, he said, "Giorgio, this bridge shakes, let us ride carefully lest it fall while we are on it."

But to return to a former question. When the work at Montorio was finished, to my great delight, I returned to Florence to serve Duke Cosimo in 1554. My departure grieved Michelagnolo and myself, for every day his enemies annoyed him first in one way and then in another. We wrote to each other every day, and in April that year, when Vasari heard that Michelagnolo's nephew Lionardo had a son, who had been christened before a company of high-born ladies, he wrote to him, receiving the following reply:

"My DEAR GIORGIO,

"Your letter afforded me great pleasure seeing that you remember the poor old man, and also for your congratulations on the birth of another Buonarroto, for which I thank you heartily. But I do not like so much ceremony, for no man ought to laugh while all the world weeps, and I do not think Lionardo should have celebrated a birth with as much joy as befits the death of one who has lived well. Do not wonder that I did not answer at once, I did not wish to appear mercenary. But if I

deserved a tithe of your praises I should think myself to have partly repaid one to whom I am a debtor, for I owe you much more than I can ever repay, being old, though I hope to balance the account in the other life. So I ask your patience and remain yours. Things here are just so so."

In the time of Paul III. Duke Cosimo had sent Tribolo to Rome to see if he could persuade Michelagnolo to return to Florence to finish the sacristy of S. Lorenzo. But Michelagnolo excused himself, saying that he was too old to support the fatigue, and giving many other reasons why he could not leave Rome. Tribolo then asked about the staircase of the library of S. Lorenzo, for which Michelagnolo had prepared many stones, as there was no model or any certainty of the design, only some indications on the ground in bricks and in other things. But Michelagnolo would only reply that he did not remember, in spite of Tribolo's prayers, who used the duke's name. The duke then directed Vasari to write and ask Michelagnolo what finish should be given to these stairs, hoping that his friendship would lead him to say something which would enable the work to be completed. Vasari wrote saying that he would alone carry out as faithfully as he could any instructions given. Michelagnolo then sent a description of the arrangement of the staircase dated September 28, 1555.

"My DEAR M. GIORGIO,

"With regard to the library staircase of which they have said so much to me, rest assured that I would not have needed so much solicitation if I had remembered my dispositions. I have turned over in my mind, as in a dream, a staircase, but I do not think it is exactly the one I thought of then because it is clumsy. However, I give it here. Take a quantity of boxes oval at the base, each about one palm deep, but not of equal length and breadth, and lay the first and largest on the pavement at a distance from the door wall according as you want the stairs easy or steep. Put another upon it, smaller in every direction, leaving room for the foot to rest, thus diminishing each step as it recedes towards the door, the last step being of the same width as the door space. The oval part of the step should have a wing on either side. The steps of the wings should rise similarly, but should not be oval. The middle flight is to serve for the main staircase and the ends of the wings must be towards the wall. From the middle downwards to the pavement the staircase must

be about three palms from the wall, so that the basement of the vestibule shall not be obstructed and every face shall be left free. I am writing nonsense but I know you will find something suitable for your purpose."

Michelagnolo also wrote at that time that, on the death of Julius and the succession of Marcellus, who supported the faction opposed to him, that faction had begun once more to annoy him. Hearing this, the duke made Giorgio write telling him to leave Rome and come to Florence, when the duke would only ask him to give advice and design his buildings, that the duke would give him everything he wished without his doing any work with his own hands. M. Lionardo Marinozzi also, the duke's chamberlain, took letters from his master and Vasari. But when Paul IV. succeeded Marcellus, Michelagnolo went to kiss the Pope's foot, and as he received considerable offers and was anxious to finish S. Pietro, he decided to remain. He excused himself to the duke, and wrote as follows to Vasari:

"My Dear M. Giorgio,
 "I call God to witness that it was against my will that I was forced by Pope Paul III., ten years ago, to take up the building of S. Pietro. If the work had been carried on until now as it was then I should be near the end and should like to return to Florence, but it has been much delayed for lack of money, and to abandon it now that we have come to the most difficult part would be shameful, and I should lose the fruit of the labours of the last ten years which I have endured for the love of God. I write this in answer to yours, and I have a letter of the duke that makes me marvel that his highness has deigned to write so kindly. I thank God and the duke as much as I am able. I am wandering, for I have lost my memory and my wits, and writing is a great trouble to me because it is not my vocation. The conclusion is to say that I cannot abandon the building to a lot of rascals who would ruin it, and perhaps bring it altogether to a standstill."

Michelagnolo also wrote saying that he had a house and many conveniences in Rome, worth thousands of crowns, and he suffered from pains in the reins and sides like all old men, as his physician Master Eraldo would testify, and that he had not the spirit for anything but death. He asked Vasari, as in many other letters, to beg the duke to pardon him, and, as I have said,

he wrote to the duke, excusing himself, saying that if he had been able to travel he would have gone to Florence at once. Had he done so, I think he would never have returned, owing to the affection the duke bore him. Meanwhile he pressed on with his building to establish it so that it should never be changed. At this time he was told that Paul IV. proposed to alter his Last Judgment in the chapel because of the nudes there. He replied, "Tell the Pope this is a small matter, but let him reform the world, pictures are quickly mended." He was removed from the office of the chancery at Rimini. He refused to speak of this to the Pope, who knew nothing about it. The cup-bearer had taken it proposing to pay him a hundred crowns a month for the work of S. Pietro, but when he sent a month's salary to the house, Michelagnolo refused it.

That same year occurred the death of his servant Urbino, whom he had rather made a companion. He had come to live with Michelagnolo in Florence in 1530, after the siege, when his pupil Antonio Mini went to France, and had served his master for twenty-six years, in his old age and sickness, sleeping in his clothes at night to guard him, so that Michelagnolo loved him dearly and made him a rich man. To Vasari's letter of condolence he replied:

"My DEAR M. GIORGIO,

"I find it hard to write, but I must answer your letter. You know that Urbino is dead, to my great loss and unspeakable grief, for he was a great favour from God to me. The favour is that whereas when living he kept me alive, in dying he has taught me not to fear death, but to desire it. I had him twenty-six years, and found him devoted and faithful. I made him rich, and hoped for his support in my age, but he has been taken away, and I can only hope to see him again in Paradise. God by his happy death has given me a foretaste, for he was more grieved about leaving me a prey to the vexations of the world than at death itself; the greater part of me has gone with him, and nothing is left to me but infinite sorrow. I send you my respects."

Michelagnolo was employed under Paul IV. on the fortifications of Rome in several places, the Pope having instructed Salustio Peruzzi to do the great door of the Castle of St. Angelo, now half-ruined. He was also employed in distributing the statues, and in seeing and correcting the models of the sculptors.

At that time the French army approached Rome, and Michelagnolo feared for the city and himself. So he decided to depart with Antonio Franzese of Castel Durante, who had been left there by Urbino to serve him. Accordingly he fled to the mountains of Spoleto, where he visited certain hermitages. At this time Vasari wrote to him, sending him a little work which Carlo Lenzoni, a Florentine citizen, had left at his death to M. Cosimo Bartoli to have it printed and dedicated to Michelagnolo.[1] The master sent the following reply:

"My DEAR M. GIORGIO,
 "I have received the book of M. Cosimo, and write to thank you, and ask you to thank him for me. To-day with considerable fatigue and great delight I have visited the hermits of the Spoleto mountains, so that less than half of me has returned to Rome, for true peace can only be found in the woods. I have no more to say, and hope you are well and happy. —Sept. 18, 1556."

Michelagnolo worked almost every day as a pastime on the stone already mentioned, with the four figures, but now broke it for this reason. It had many flaws, and was so hard that the chisel frequently struck sparks, and also because his judgment was so exacting that nothing he did satisfied him. He finished few statues in his manhood, the completed ones having been done in his youth, such as the Bacchus, the Pietà, the David, the Christ of the Minerva. It would not be possible to make the slightest alterations in these without injury. The others of Dukes Giuliano and Lorenzo, Night, Dawn, Moses and two others, eleven statues in all, remain unfinished. As he used to say, he would have sent few or none away if he had to please himself, for his art and judgment were so advanced that so soon as he had found a small error in a figure he let it alone and took up another block, thinking he would not experience the same fortune. He often said that this was the reason why he produced so few statues and pictures. He gave the broken Pietà to Francesco Bandini. At this time Tiberio Calcagni, a Florentine sculptor, had become a great friend of Michelagnolo through Francesco Bandini and M. Donato Giannotti. One day, in Michelagnolo's house, where the Pietà was, he asked the master why he had broken it and ruined such marvellous work. He replied it was because of the importunity of his servant Urbino, who urged him to finish it

[1] "Difesa della Lingua Toscana e di Dante."

every day, and in hurrying he had removed a piece of the Virgin's elbow; he had come to hate it, and had been much bothered by a vein, and losing patience he broke it and would have smashed it to atoms had not Antonio his servant asked for it. Tiberio then spoke to Bandino, who desired something of his, and Bandino induced Tiberio to promise Antonio two hundred gold crowns, and begged Michelagnolo that if Tiberio would finish it for Bandino with the help of his models the labour should not be wasted. Michelagnolo agreed, and accordingly he made them a present of it. They at once removed it, and Tiberio put some of the pieces together, but this work was stopped by the deaths of Bandino, Michelagnolo and Tiberio. It is now in the hands of Pierantonio Bandino, Francesco's son, in his villa of Montecavallo.

To return to Michelagnolo. Requiring some marble to pass his time in chiselling, he got another piece on which another Pietà had been sketched, but much smaller. Pirro Ligorio the architect, having entered the service of Paul IV. and superintending the building of S. Pietro, he began to harass Michelagnolo about it, saying he was in his second childhood. The master in his anger would have returned to Florence, as Giorgio besought him to do in his letters. But he felt himself too old, being now eighty-one, and he wrote to Vasari sending him some religious sonnets, saying he was at the end of his life and must fix his thoughts, being at the twenty-fourth hour, with every thought pointing to death. He wrote:

"God wills, Vasari, that I must travail another year or so, and I know you will call me old and foolish for making sonnets, but as many call me dotard I mean to earn the title. I know your love, and should like my weak body to be laid beside my father's, as you suggest. But my death will be a great loss to S. Pietro, because, as I have built my part so that it cannot be changed, I hope to live long enough to disappoint several intriguers who are awaiting my speedy decease." With this letter he sent the following sonnet:

> "*Giunto è gia 'l corso della vita mia*
> *Con tempestuoso mar per fragil barca*
> *Al comun porto, or' a render si varca*
> *Conto e ragion d'ogni opra trista e pia.*
> *Onde l'affetuosa fantasia,*
> *Che l'arte mi fece idolo e monarca*
> *Conosco or ben quant'era d'error carca,*
> *E quel ch'a mal suo grado ogun desia.*
> *Gli amorosi pensier, gia vani e lieti,*
> *Che fien'or, s'a due morti mi avvicino ?*

D'una so certo, e l'altra mi minaccia.
Nè pinger nè scolpir fia piu che queti
L'anima volta a quello amor divino,
Ch'aperse, a prender noi in croce, le braccia." [1]

His thoughts were turned to God, and he left the care of the arts persecuted as he was by the evil-disposed artists and some in charge of the fabric, who wanted as he said to get it into their hands. Vasari replied by order of Duke Cosimo, in a short letter, advising him to return, and with a sonnet of corresponding rhymes. Michelagnolo was willing to leave Rome, but he was too old and feeble, and his infirmity kept him there. In June 1557 he made a model of the vaulting for the recess of the Kings' Chapel, to be made in travertine. But an error occurred because he could not go there so frequently as usual, as the foreman took the measure with only one centry when there should have been several. Michelagnolo sent the designs to his confidential friend Vasari, with these words at the foot of two:

"The foreman took the centry coloured red for the whole vault, but when he reached the centre of the half-circle he became aware of his error, as shown in black in the design. This error has been carried so far that it will be necessary to remove a large number of stones, for all is travertine with no masonry of bricks, and the diameter of the arch without the surrounding cornice is twenty-two palms. The mistake has arisen because age has prevented me from going so often as usual, although I had prepared an exact model, as I do of everything, and the vault which I hoped would be done by now will not be finished this winter, and if shame and pain could kill, I should not be living now. I beg you to excuse me to the duke for not being in Florence."

Of another drawing showing his plan, he wrote:

"M. Giorgio, that you may better understand the difficulty

[1] Now hath my life across a stormy sea,
Like a frail bark, reached that wide port where all
Are bidden, ere the final reckoning fall
Of good and evil for eternity.
Now know I well how that fond phantasy
Which made my soul the worshipper and thrall
Of earthly art is vain; how criminal
Is that which all men seek unwillingly.
Those amorous thoughts which were so lightly dressed,
What are they when the double death is nigh?
The one I know for sure, the other dread.
Painting nor sculpture now can lull to rest
My soul, that turns to His great love on high,
Whose arms to clasp us on the cross were spread.
Symonds' Translation.

of the vaulting and its earth connection, you must divide it into three parts corresponding with the windows beneath, which are divided by the piers, which rise pyramidically to the top of the vault, in harmony with the bases and sides of it. It was necessary to regulate them by countless centrys, changing them frequently from point to point without any general rule, and the circles and squares approaching the middle of their deepest part must diminish and increase on so many sides and reach to so many points that the true method is hard to find. However, with a model such as I make for everything, such an error as using a single centry for the whole should never have occurred, and this loss involved a shameful and expensive removal of many stones. The entire vaulting with sections and ornaments is of travertine like the posts below, an unusual thing in Rome."

These difficulties caused Duke Cosimo to relinquish his efforts to bring Michelagnolo to Florence, and he told the master that he was more anxious he should continue S. Pietro than do anything else in the world, and that he should be free from worry. On the same sheet Michelagnolo wrote to Vasari thanking the duke for his kindness, saying: "God be thanked, I can still serve Him with my poor body, though my memory and brain have gone to await it elsewhere." The letter was dated August 1557, and Michelagnolo thus perceived that the duke esteemed his life and honour more than he did himself. On all these matters and many others I have his own letters. Seeing little going on in S. Pietro, and having well advanced the frieze inside the windows and of the double columns without, which form a circle above the great round cornice to take the cupola, Michelagnolo was encouraged by his best friends, the Cardinal di Carpi, M. Donato Giannotti, Francesco Bandini, Tommaso de' Cavalieri, and Lottino, at least to make a model of the cupola, as the vaulting was being delayed. He remained irresolute for several months and at last began one, slowly making a clay model before beginning a larger one in wood from his plans and elevations. He began the latter, which was finished in little more than a year by Maestro Giovanni Franzese, with great study and labour. It was of such size that the small details, including the ancient Roman palm were perfect, and it had finished parts, the columns, bases, capitals, doors, windows, cornices, projections, and every detail, so that no Christian country possesses a monument more grand or ornamental.

If I have spent time in speaking of lesser things, I think it right to describe the design of the tribune as conceived by

Michelagnolo, and I will write of it as shortly as possible, to preserve the work from the envy and malice of the presumptuous which harassed Michelagnolo in his life. My description may help the faithful executors to understand the master's intention and bridle the desire of the malignant to change it, while it will instruct and delight the choice spirits who love this art. The model provides for a span of one hundred and eighty-six palms from wall to wall across the great tribune over the great surrounding cornice, which rests on four large double pilasters with carved Corinthian capitals, decorated with architrave, frieze and cornice, the whole in travertine. The cornice rests on the four large arches of the three niches, and the entrance forming the cross of the building. At the place where the cupola springs from the tribune is a base of travertine with a way 6 palms broad, going round, 33 palms 11 inches across, and 11 palms 10 inches high to the cornice. The cornice above is about 8 palms, and the projection 6½ palms. There are four entrances into the tribune above the arches of the niches, dividing the thickness of the basement into three parts. The inside one is 15 palms, the outside 11 palms, and the middle 7 palms 11 inches, making a thickness of 33 palms 11 inches. The middle space is empty and serves as a passage, with a barrel vault going round. Each of the four entrances has doors with four steps, one to the level of the cornice of the first basement 6½ palms broad, the second to the inner cornice surrounding the tribune 8¾ palms broad, affording easy access to the building, and there are 201 palms between the entrances, which being four in number make a circuit of 806 palms. There is a step from the basement level where the columns and pilasters rest, which forms a frieze about the windows; this is 14 palms 1 inch high. About it on the outside is a short cornice only projecting 10 inches, the whole of travertine. In the thickness of the third part is a step at every fourth part, facing two ways, 4¼ palms broad. This leads to the level of the columns. From this point start eighteen huge travertine piers, each adorned with two columns, and between them are the spaces for the windows to light the tribune. These are turned towards the middle, from which they are 36 palms distant, and 19½ from the front face. On the outside of each are two columns, the dado at the foot of them being 8¾ palms and 1½ palms high. The base is 5 palms 8 inches broad, . . . palms 11 inches high. The shaft is 43½ palms, the diameter being 5 palms 6 inches at the base, and at the top 4 palms 9

inches. The Corinthian capital is 6½ palms high and 9 palms in diameter at top. Three sides of the columns show, the fourth being set in the wall with half a pier forming a sharp angle inside, and in the middle is a door in the arch 5 palms broad, 13 palms 5 inches high. The space between this and the capital of the piers and columns is filled with masonry and joins the other two piers, which are similar. These turn and form an ornament beside the sixteen windows round the tribune, the lights of which are 12½ palms broad by about 22 high. The exterior is decorated with varied architraves 2¾ palms broad, and on the outside they are decorated with pediments and quarter-circles. They narrow to the interior to admit more light, and are lower on the inside to admit light above the frieze and cornice. Each one stands between two flat piers, corresponding in height to the columns outside, making thirty-six columns outside and thirty-six piers inside. Above the piers is the architrave, 4⅝ palms high, and the frieze 4½ and the cornice 4⅔, projecting 5 palms. Above are balusters for a passage, and there are steps with thickness of the space of 15 palms with two branches and another flight to mount to the top of the columns, so that the staircase, without impeding the light of the windows, communicates with a newel staircase of the same breadth which rises to the point where the cupola begins. The order, distribution and ornament are so varied, convenient and strong, durable and rich, providing an effectual support for the two vaults of the cupola, that they form the most marvellous and well-contrived structures to be seen by understanding eyes. Strength is assured by the joints of the stones, all of which are strong, and the water is ingeniously carried off by numerous secret channels, the whole being so perfect that all other buildings erected hitherto are as nothing by comparison, and it is a pity that those in charge did not work at it with all their might that the author might have seen his beautiful and striking work completed before his death. Michelagnolo carried the building to this point, and only the vaulting of the tribune remained.

As we have his model, I will continue by describing the arrangements he left for this. He established three points forming a triangle, thus: A B The point C is the lowest, and
 C
forms the beginning with which he determined the first half-circle of the tribune, and the form, height and breadth of the vaulting, which he directed should be constructed entirely of well-baked bricks. This was 4½ palms thick both at top and

bottom, leaving a space in the middle of 4½ palms at the foot which serves for the steps to the lantern, rising from the level of the cornice where the balusters are. The section of the other part at the point designated B, 4½ palms at the foot for the thickness of the vault, and the last section for the exterior, broad at the base and narrowing to the top, is at the point marked A occupying all the middle space inside containing the steps, 8 palms high, to admit of walking upright. The thickness of the vaulting gradually diminishes from 4½ palms to 3½ at the top, and the outside vault is united to the inside one with bands and steps so that one bears the other. Thus, of eight divisions, four rest on the arches and the other four are tied upon the pilasters, to endure for ever. The steps between the vaults are made thus: They rise from the level where the vaulting begins in one of the four parts, each having two approaches crossing the steps in X-shape, and leading to the middle of the section C. Having mounted half the section straight, the remaining part rises more gently, one curved, the other straight, until the eye is reached, where the lantern begins. About this begins a series of lesser doubled pilasters, corresponding with those below, and windows like those inside. Above the first great cornice inside the tribune he began the spaces of the vaulting, which are formed by sixteen ribs, as broad as the pilasters at the base and diminishing pyramidically to the eye of the lantern, resting at the foot on a pedestal of the same breadth, 12 palms high, which rests on the plane of the cornice and encircles the tribune. The spaces between the ribs contain eight large ovals, each 29 palms high with rectangular apartments above, narrowing towards the top, 24 palms high. Above these is a circle of 14 palms forming in all a rich ground, for Michagnolo designed the decoration of the ribs and these other parts to have cornices of travertine.

I must now mention the surface and decoration of the section of the vault where the roof is, which rises from a basement 25½ palms high, and rises from a socle which projects 2 palms, as do the mouldings at the top. He proposed to make the roof of lead as on old S. Pietro, and made sixteen spaces, beginning at the point where the double columns end, with two windows between to light the middle space, thirty-two in all, and lighting the staircase between the vaults. To these he added corbels bearing a quarter-circle, the whole forming a roof to throw off the rain. From the central point between the two columns the ribs sprung from where the cornice ends, being broad at the base

and narrowing at the top, sixteen in all, and 5 palms broad. Between them was a square channel 1½ palms broad containing a staircase of steps about 1 palm high, mounting to the point where the lantern begins. These steps are made of travertine and are protected from the weather. Like the rest of the work he designed the lantern to diminish towards the top, concluding with a small temple of round columns in pairs like those beneath, arranging the pilasters to allow a passage about them, and to admit a view through the windows into the tribune and the church. He made the architrave, frieze and cornice around it, projecting over the columns, above which are spiral shafts and niches rising to the summit of the coping and narrowing pyramidically at a third of their height, towards the ball which bears the cross. I might have entered into many details, such as provision for earthquakes, aqueducts, various lights and other things, but as the work is unfinished I content myself with having touched upon the principal parts as best as I could. A brief sketch suffices, as the work is in existence and may be seen, and this sketch will serve to enlighten those who have no knowledge of it.

The completion of the model caused great satisfaction not only to Michelagnolo's friends but to all Rome, and it resulted in established and stable conditions for the fabric, for when Paul IV. died, the new Pope, Pius IV., while leaving Pirro Ligorio as architect of the palace, to finish the little palace of the wood of Belvedere, made advances to Michelagnolo and confirmed to him the powers over S. Pietro granted by Paul III., Julius III. and Paul IV., restoring to him a part of the income taken away by Paul IV., and in his time the work of S. Pietro progressed merrily. The Pope employed Michelagnolo on many things besides and in particular to design a tomb for the Marquis of Marignano, his brother, allotted by the Pope to the knight Lione Lioni of Arezzo, an excellent sculptor and a great friend of Michelagnolo, to be placed in the duomo of Milan. At that time Lione made a most life-like medal of Michelagnolo, and on the reverse, as a compliment to him, a blind man led by a dog, and the legend:

Docebo iniquos vias tuas, et impii ad te convertentur.

Michelagnolo was greatly delighted, and gave him a wax model of Hercules crushing Antæus, and some designs. There are no other portraits of Michelagnolo except two paintings, one by Bugiardino, the other by Jacopo del Conte, a bronze

relief by Daniello Ricciarelli and this medal, copies of which I have seen at several places in and out of Italy. That same year [1] Cardinal Giovanni de' Medici, Duke Cosimo's son, went to Rome to receive the red hat from Pius IV., and arranged for Vasari co go with him in his train. Giorgio went gladly and remained about a month, enjoying the society of Michelagnolo, who was very fond of him and was seeing him constantly. By the duke's order Vasari brought with him the wooden model of the ducal palace at Florence, with the designs of the new apartments built and decorated by him, which Michelagnolo wished to see, as at his age he could not see the work itself. This was copious, diverse with varied fancies and inventions on the Sky, Saturn, Ops, Ceres, Jupiter, Juno, Hercules, one in every room, with their legends. The other rooms beneath these were called after heroes of the Medici house, Cosimo the elder, Lorenzo, Leo X., Clement VII., Sig. Giovanni, Duke Alessandro and Duke Cosimo, containing not only their deeds but the portraits of themselves and their children, and the rulers, soldiers and men of letters of old time. Vasari has written a dialogue on these explaining the whole matter, which was read by Annibale Caro and greatly delighted Michelagnolo. It will be published soon when I have more time. [2] These things aroused Vasari's desire to undertake the great hall, as the ceiling was low and badly lighted. But the duke could not decide to raise it, not because he feared the expense, but owing to the danger of making the king-posts thirteen braccia higher. However he agreed with his usual judgment to consult Michelagnolo, who on seeing the numerous inventions became not a judge but a partisan, seeing that the work was easy and could be quickly executed. So on Vasari's return he wrote advising the duke to execute the work, which was worthy of his greatness.

That same year Duke Cosimo and the Duchess Leonora visited Rome, and immediately on their arrival Michelagnolo went to see them. The duke received him graciously, honouring his genius and making him sit beside him, talking to him familiarly of all his works and projects in painting and sculpture in Florence, and especially of the hall. Michelagnolo again advised the duke to go on with it, and expressed regret that he was not young enough to serve him. The duke said he had found a method of working porphyry, and as Michelagnolo seemed incredulous, the

[1] 1560.
[2] It was not issued until 1588, when it was published by his nephew with the title *Rafionamento di G. V. sopra le invenzioni . . . nel palazzo publico, Firenze.*

duke sent him the head of Christ by Francesco del Tadda, which amazed him. Michelagnolo made several other visits during the duke's stay in Rome, and when the duke's son, Don Francesco de' Medici, visited him he always addressed Michelagnolo with his cap in his hand, such was his reverence for him, and Michelagnolo wrote to Vasari saying he grieved he was old and ailing, as he would have liked to do something for that lad, and he tried to buy some beautiful antique to send him. At that time the Pope asked Michelagnolo for a design for the Pià gate. He made three of great beauty, and the Pope chose the least costly, and this was erected amid great admiration. Michelagnolo, seeing the Pope's humour, made several other designs for restoring the other gates of Rome, and asked the Pope to convert the baths of Diocletian into a Christian church as S. Maria degli Angioli, and made a handsome design which has since been carried out by many skilful architects for the Carthusian friars, to the admiration of the Pope, prelates and courtiers, at his judgment in using the shell of the baths and forming a handsome church contrary to the opinion of all architects, thus winning great praise and honour. For this place he designed a bronze ciborium for the Sacrament, mostly cast by Jacopo Ciciliano, an excellent founder, capable of producing the most delicate work without roughness and easily polished, greatly pleasing Michelagnolo.

The Florentine nation had often proposed to begin the church of S. Giovanni in the Strada Giulia. The heads of the wealthiest houses met together, and had collected a good sum of money for the purpose, each one promising according to his means.[1] A discussion then arose among them whether they should follow the old order or do something better, and they decided to build a new erection on the old foundations, appointing as overseers Francesco Bandini, Uberto Ubaldini and Tommaso de' Bardi. These requested Michelagnolo for a design, saying that it was a disgrace to the nation to have wasted so much money without any profit, and if his genius could not finish it, they had no remedy. He promised gladly to oblige them with as much good will as over anything he had ever done, as in his old age he loved to work first for the honour of God and next for his beloved country. In this discussion Michelagnolo had with him Tiberio Calcagni, a young Florentine sculptor, very anxious to learn art, who on going to Rome had taken up architecture. Michelagnolo was fond of him, and gave him his broken marble Pietà to finish, and also a marble bust of Brutus [2] larger than life,

of which the head only was done. He had copied this Brutus from one on a very ancient cornelian owned by Sig. Giuliano Cesarino, at the prayers of M. Donato Giannotti, his intimate friend, for Cardinal Ridolfi. As old age prevented Michelagnolo from drawing any more, he made use of Tiberio, whom he found amiable and discreet, and directed him to prepare a plan for the site of the church. This was done, and although they did not think that Michelagnolo had yet done anything, he informed them through Tiberio that he had served them, and ultimately showed them five plans of beautiful churches which made the trustees marvel, and told them to choose one. They refused, preferring his judgment, but he insisted, and they unanimously selected one of the richest. Then Michelagnolo told them that neither the Romans nor the Greeks had ever possessed such a temple, un-usual words for him, as he was very modest. They finally decided that Michelagnolo should direct everything, and that Tiberio should bear the labour of executing the work, expecting he would serve them well. So they gave the plan to Tiberio, who made a finished copy with sections and elevations, and showed the method of execution. In ten days Tiberio finished a clay model of eight palms, and as this pleased the nation, they had a wooden one made, now in their consulate. It is the rarest church ever seen for its beauty, richness and great variety. It was begun, and 5000 crowns expended, but the assignments failing, it has most unfortunately been abandoned. Michelagnolo allotted to Tiberio a chapel in S. Maria Maggiore, begun for Cardinal S. Fiore, and left unfinished at the cardinal's death, and that of Michelagnolo, and Tiberio, whose early decease was a great loss.

Michelagnolo had spent seventeen years in the building of S. Pietro, and the deputies had frequently desired to remove him. Not succeeding, they sought every means of opposing him, hoping to force him to resign, seeing that he was so old and unable to do much. Thus, when Cesare da Castel Durante the overseer died, Michelagnolo sent Luigi Gaeta, a mere youth, but quite adequate, until he found a suitable man, in order that the building might not suffer. A section of the deputies had frequently attempted to appoint Nanni di Baccio Bigio, who promised great things, and they dismissed Luigi in order to get the work into their hands. When Michelagnolo heard this, he wrathfully declared he would go no more to the building. They accordingly began to spread a report that he was no longer competent, and that it would be necessary to appoint a substitute because he had exclaimed that he would no longer be bothered

with S. Pietro. When this came to Michelagnolo's ears, he sent Daniello Ricciarelli of Volterra to the Bishop Ferratino, one of the overseers, who had told the cardinal of Carpi that Michelagnolo had told a servant that he would be bothered no more with the building. Daniello said this was not Michelagnolo's intention; but Ferratino replied that it was a pity that the master had not communicated his intentions, but that a substitute ought to be appointed, and he would willingly have accepted Daniello. He then informed the deputies in Michelagnolo's name that they had a substitute; however, Ferratino presented not Daniello but Nanni instead, who was accepted, and lost no time in erecting a scaffolding by the Pope's stables on the hill to ascend to the top of the great apse, facing that side, and bringing great beams of fir-wood, saying it was better so, as otherwise too much rope would be needed. When Michelagnolo heard this he at once went to the Pope to the piazza of the Capitol, and speaking loudly he was brought into the chamber, where he said, "Holy Father, the deputies have substituted for me a man whom I do not know, but as they and your Holiness feel I am no longer fit, I will return to Florence to rest, as the Grand Duke so much desires, and there end my days, and I therefore ask for my *congé*." The Pope was hurt, and comforting him with fair words told him to repair on the following day to Araceli, where he would assemble the deputies and hear what they said. They declared that the building was being spoiled and contained errors. The Pope knew this was not true, and ordered Sig. Gabrio Scierbellone to go with Nanni to the building and ask him to point them out. Sig. Gabrio thereupon perceived that Nanni's accusations proceeded merely from malignity, and so Nanni was ignominiously expelled in the presence of many lords, it being said that he had ruined the Ponte S. Maria, and that at Ancona, where he had proposed to clear the port at small cost, he had done more harm in one day than the sea had in ten years. That was the end of Nanni at S. Pietro, and Michelagnolo devoted himself entirely to the church, having spent the seventeen years in strengthening it, for he feared that envy might cause it to be changed after his death, and it is now so strong that it may be safely vaulted. So we see that God, who protects the good, defended him through his life, and has always favoured this building. Thus even during his life Paul IV. ordained that nothing of his plans should be changed, and Pius V., his successor, did the like, appointing as executors Pirro Ligorio and Jacopo Vignola; but when Pirro presumptuously wished to alter

something he was immediately removed in disgrace. The Pope, who was as zealous for the structure as for the Christian religion, when in 1565 Vasari went to kiss his feet, and again in 1566, would discuss nothing except to secure that the designs left by Michelagnolo should be carried out. To obviate any interference, the Pope commanded Vasari to go with M. Guglielmo Sangalletti, the Pope's secret treasurer, to Bishop Ferratino, head of the builders of S. Pietro, directing him to observe all the directions and memoranda communicated by Vasari, so that no presumptuous man should move a jot of what the genius of Michelagnolo had devised. Vasari's great friend, M. Giovambatista Altoviti, was then present. Ferratino readily heard Vasari, and promised faithfully to observe everything and also to protect the labours of the great Michelagnolo.

About a year before Michelagnolo's death, Vasari had secretly induced Duke Cosimo to get the Pope, through M. Averardo Serristri, his ambassador, to take great care of Michelagnolo, as he was much broken, and if any accident happened, that his property, designs, cartoons, models and money should be inventoried and kept for the use of S. Pietro, and for the sacristy and library of S. Lorenzo, if anything concerning them should be found, so that they should not be carried away as frequently happens. This plan was duly carried out. In the following Lent the master's nephew Lionardo desired to go to Rome, as though divining that Michelagnolo was near his end, and when Michelagnolo fell sick of a slow fever he made Daniello send for Lionardo. But the malady growing worse, while M. Federigo Donati, his physician, and others were about him, he made his will with perfect consciousness, leaving his soul to God, his body to the earth and his property to his nearest relations, warning his friends in this passing life to remember the Passion of Christ, and so he passed to a better life at eleven at night on 17 February, 1563, in the Florentine use, 1564 following the Roman.

Michelagnolo was devoted to the labours of the arts, seeing that he mastered every difficulty, possessing a genius admirably adapted to the excellent studies of design. Being perfect in this, he often made dissections, examining the ligatures, muscles, nerves, veins, and various movements, and all the postures of the human body, and even of animals, especially horses, which he loved to keep. He liked to examine the arrangement and method of everything, and no one could have treated them better even if they had studied nothing else. Thus in all his inimitable works, both with brush and chisel, he has displayed

such art, grace and vivacity that I may say with due respect that he has surpassed the ancients, making difficulties appear easy, though they are found by those who copy them. Michelagnolo's genius obtained recognition in his life, and not, as in so many cases, after his death, as Julius II., Leo X., Clement VII., Paul III., Julius III., Paul IV. and Pius IV. always required him by them, and so did Solyman the Sultan, Francis of Valois, King of France, Charles V., the Signory of Venice and Duke Cosimo, simply on account of his great talents. This only occurs to men of great genius like his, for all the arts were perfected in him in a manner God has vouchsafed to none other. His imagination was so perfect that he could not realise with his hands his great and sublime conceptions, and so he frequently abandoned his works and spoiled many, for I know that before his death he burned a great number of his designs, sketches and cartoons, in order that no one should perceive his labours and tentative efforts, that he might not appear less than perfect. I have found some of his drawings in Florence, and put them in my book, and though they show his greatness, yet we see that when he wished to create Minerva from the head of Jupiter he would have needed Vulcan's hammer. He used to make his figures of nine, ten or twelve heads, endeavouring to realise a harmony and grace not found in Nature, saying that it was necessary to have the compasses in the eye not in the hand, because while hands perform the eye judges. He observed the same method in architecture.

Let no one marvel that Michelagnolo loved solitude, for he was devoted to art, which claims man for itself alone; and because those who study must avoid society, the minds of those who study art are constantly preoccupied, and those who consider this to be eccentricity are wrong, for he who would do well must avoid cares and vexations, since genius demands thought, solitude and comfort, and a steadfast mind. Nevertheless he loved the friendship of many great and learned men at seasonable times, while Cardinal Ippolito de' Medici was much attached to him. Learning that a Turkish horse of his pleased Michelagnolo for its beauty, the cardinal sent it to him with ten mules laden with fodder, and a servant to look after it, a gift the artist gladly accepted. Another friend was Cardinal Pole, whose ability and goodness Michelagnolo loved. Other friends were Cardinal Farnese and Cardinal S. Croce, afterwards Pope Marcellus, Cardinal Ridolfi, Cardinal Maffeo, Monsignor Bembo, Carpi, and many other prelates whom I need not mention, Monsignor Claudio

Tolomei, M. Ottaviano de' Medici, his godfather, who named a son after him, M. Bindo Altoviti, to whom he gave the cartoon of Noah's drunkenness in the chapel, M. Lorenzo Ridolfi, M. Annibal Caro, M. Giovan. Francesco Lottini of Volterra and, far more than all the rest, M. Tommaso de' Cavalieri, a Roman noble, a young man devoted to art, who learned to draw, and for whom he made stupendous designs in black and red chalk, including a Rape of Ganymede, the Vulture eating the Heart of Tityus, the Fall of the Chariot of the Sun into the Po, and a Bacchanalia of Infants, all most rare and unique. Michelagnolo drew a life-size portrait of M. Tommaso, his first and last, for he abhorred drawing anything from life unless it was of the utmost beauty. These cartoons secured M. Tommaso a good success, such as Michelagnolo had already given to Frà Bastiano of Venice; indeed, M. Tommaso has preserved these wonderful drawings as keepsakes, and courteously allows artists to use them. Michelagnolo always cultivated the friendship of noble, meritorious and worthy men, showing his judgment and taste in all things. M. Tommaso afterwards induced Michelagnolo to do several designs for friends, such as the Annunciation for the Cardinal di Cesis, coloured by Marcello, a Mantuan, and placed in the marble chapel built by the cardinal in la Pace at Rome. He also did another Annunciation, coloured by Marcello, for S. Giovanni Laterano, the design being in the hands of Duke Cosimo, who received it from Lionardo Buonarroti, the artist's nephew, and who values it highly. The duke also owns a Christ in the Garden, and many other designs, sketches and cartoons of Michelagnolo, with a statue of Victory over a prisoner, five braccia high, and four prisoners sketched, illustrating a safe method of making marble figures without spoiling the blocks. The method is this. One takes a figure of wax or other firm material and immerses it in a vessel of water; the figure is then gradually raised, displaying first the uppermost parts, the rest being hidden, and as it rises more and more the whole comes into view. This is the way to carve figures, and it was observed by Michelagnolo in his prisoners, which the duke keeps to serve as a model for his academicians.

Michelagnolo loved the society of artists, and associated much with them, as with Jacopo Sansovino, Rosso, Pontormo, Daniello of Volterra and Vasari, to whom he showed great affection, inducing him to study architecture, and intending to employ him, whom he often consulted, and with whom he discussed art. Those who say he would not teach are wrong, as he was

always assisting friends and those who asked advice; but as I was often present, modesty commands my silence, for I will not disclose the faults of others. He had bad fortune with those who lived with him as he did not light upon men capable of imitating him; for though Piero Urbano of Pistoia, his pupil, possessed intelligence, he would never take pains, while Antonio Mini though willing had not the aptitude, for hard wax does not take a good impression. Ascanio dalla Ripa Transone worked hard, but never realised anything in works or designs, spending several years over a panel for which Michelagnolo had given him a cartoon. The high expectations formed about him ultimately vanished in smoke. I remember that Michelagnolo, taking compassion on his slowness, assisted him, but it availed little, and he often told me that if he had had a good pupil he would, old as he was, have done anatomy, and written a treatise upon it to help artists, but he feared that he could not express his ideas as he wished through want of practice in speaking, although in his letters he has clearly expressed his ideas in a few words. He was very fond of reading the Italian poets, especially Dante, whom he much admired and whose ideas he adopted. Petrarch was also a favourite author of his, and he delighted in composing serious madrigals and sonnets, upon which commentaries have since been made. M. Benedetto Varchi delivered a notable lecture in the Florentine Academy on the sonnet beginning:

Non ha l'ottimo artista alcun concetto,
Ch'un marmo solo in se non circonscriva.

He wrote many to the illustrious Marchioness of Pescara,[1] and received replies from her in both verse and prose. He admired her qualities as she loved his, and she often went to Rome from Viterbo to see him. Michelagnolo designed for her a marvellous Pietà with two little angels, and Christ on the Cross expiring, a divine thing, as well as Christ and the Woman of Samaria at the Well. He loved the Bible, like a good Christian, and cherished a great veneration for the writings of Girolamo Savonarola, having heard him preach. He delighted in reproducing human beauty in art, separating the beautiful from the less beautiful, as without this imitation it is not possible to reach perfection; but he did not indulge in lascivious thoughts, which he avoided, as he showed by his virtuous life, for he was most temperate, devoting himself to work when a youth, and resting content

[1] Vittoria Colonna, who married Ferrante Francesco d'Avalos, Marquis of Pescara, in 1509. He died in 1525: she survived him until 1547.

with a little bread and wine, while he showed himself very temperate as an old man, taking his nourishment in the evening after the day's work, until he had finished his Last Judgment. Although rich he lived like a poor man, and friends never or rarely ate at his table. He did not like presents, as he always felt it put him under an obligation. His sobriety made him watchful and sleepless, and he often rose at night, unable to sleep, to use his chisel, making a helmet of paper, and keeping a lighted candle above the middle of his head, which lighted the work without embarrassing his hands. Vasari, who often saw the helmet, noticed that he did not use wax lights, but candles made of goat fat, which are excellent, and sent him four packets weighing forty pounds. His servant brought them to him at two in the morning, and when Michelagnolo refused them, he said, "Sir, they have broken my arms, and I don't want to take them back to the house; before your door there is a heap of mud, they will stand easily in that, so I will light them all." The master said, "Put them down, I do not want you to play pranks at my door." They say that in his youth he often slept in his clothes, as if being tired by work he did not wish to undress and have the trouble of dressing again.

Some have called him miserly, but they are wrong, for in art and in life he showed himself the contrary. Thus he gave to M. Tommaso de' Cavalieri, M. Bindo and Frà Bastiano designs of considerable value, and to Antonio Mini, his pupil, all his designs, cartoons, the Leda, and models in clay and wax, which went to France. To Gherardo Perini, a Florentine noble, he gave some divine heads on three sheets in black hæmatite, which came into the hands of the most illustrious Don Francesco, prince of Florence, who treasures them as jewels, as they are. To Bartolommeo Bettini he gave a cartoon of Cupid kissing Venus, a divine thing, now in the possession of his heirs in Florence. For the Marquis del Vasto he did a cartoon of a *Noli me tangere*; both works excellently painted by Pontormo. He gave the two captives to Sig. Ruberto Strozzi, and to Antonio his servant and to Francesco Bandini he presented the Pietà which he had broken. I do not think a man who gave such things, worth thousands of crowns, can be taxed with avarice. What is more, I know that he prepared several designs and went to inspect many paintings and buildings, for which he never asked anything. With regard to the money he earned, he won it by his labour, and not by offices or exchanges, and before calling him miserly we must remember that he succoured many poor, secretly provided the dowry of a

good number of girls, and enriched those who helped and served him, as, for example, Urbino, his servant and pupil, whom he made very wealthy. He had served for some time, and one day Michelagnolo asked him, "What will you do if I die?" "Serve another," he replied. "Poor fellow," said his master, "I will protect you from want," and he gave him 2000 crowns at one time, the act of an emperor or a pope. He would sometimes give his nephew 3000 or 4000 crowns, and finally left him 10,000 crowns, besides the property at Rome.

Michelagnolo possessed a tenacious memory, and retained anything he had once seen, so that he could use it; and he never did two things alike, because he remembered everything he had done. In his youth he was one day with some painters, and they were amusing themselves by making crude figures without design, like the things scratched on walls. Here his memory proved an advantage, for he recalled one of these and drew it as if it had been before his eyes, surpassing all the others, a difficult thing in a man so full of designs, accustomed to trace nothing but the most correct figures. He was justly haughty to those who injured him, but never sought revenge, he rather endured patiently, being most modest, prudent and wise in speech, answering with gravity and sometimes with pleasant and witty words. Many of his sayings were noted, and I will give some, though it would take too long to relate all.

One day, in discussing death, a friend said that he must regret that his continuous labours in art allowed him no rest. "That is nothing," he answered, "for if life pleases us we ought not to be grieved at death, which comes from the same Master." A citizen once found him contemplating Donato's St. Mark on Orsanmichele in Florence, and asked him what he thought of it. He replied he had never seen a man who looked more virtuous, and if St. Mark was such he could believe all that he had written. A design was shown to him by a child who was then learning, and when some excused the boy, saying he had not long been studying art, Michelagnolo retorted, "That is clear." He said much the same to a man who had painted a Pietà, and had not acquitted himself well, remarking that it was a pitiful sight (*pietà*) to see. Learning that Sebastiano of Venice was going to paint a friar in the chapel of S. Piero a Montorio, he said this would spoil the work. When asked why, he replied, "They have spoiled the great world, so it will be no great matter for them to ruin a little chapel." A painter had devoted much time and labour upon a work, and made a good deal out of it on its being

uncovered. When asked his opinion of the artist Michelagnolo said, "While he is eager to be rich he will always remain poor." A friend who said Mass and was a monk came to Rome in his pilgrim's attire and saluted Michelagnolo, who pretended not to recognise him so that the man was compelled to disclose his name. Michelagnolo expressed surprise at seeing him so dressed, and then added, as if with joy, "How fine you are! How good it would be for your soul if you were within such as you seem without!" The same man recommended a friend to Michelagnolo, who gave him a statue to do. When the friar asked that something more might be given him Michelagnolo readily agreed; but the friar had acted from envy, thinking his request would not be granted, and when he saw what had been done he was displeased. This was reported to Michelagnolo, who said that nothing annoyed him more than these gutter-men, using an architectural metaphor meaning that it is impossible to deal with with those who have two mouths. A friend asked him what he thought of one who had copied some of the most celebrated antique marble figures, boasting he had imitated them, and had far surpassed the ancients. He replied, "One who follows others never surpasses them, and a man who cannot do good original work is unable to use that of others to advantage." A painter had done a work containing an ox which was better than all the rest. Someone asked why he had made this more life-like than the other things. Michelagnolo replied, "Every painter draws himself well." When passing S. Giovanni in Florence his opinion of the gates was asked, "They are so beautiful that they would adorn Paradise," he replied. He served a prince who changed his plans daily. Michelagnolo said to a friend, "This prince has a mind like a weather-cock, turned by every wind." He went to see a sculpture which was to be put out of doors, and the sculptor was taking pains to arrange the lights of the windows to show it to advantage. Michelagnolo said, "Do not trouble, the light of the piazza is what you have to fear," meaning that the popular opinion decides upon the worth of public works. There was a great prince who fancied himself as an architect in Rome, and had made some niches to hold figures three quadri high, with a ring at the top, and in these he wanted to put statues, which did not prove a success. He asked Michelagnolo what he should do, who replied, "Hang eels round the ring." One of the governors of S. Pietro was a signor who professed to understand Vitruvius and to be a judge. Michelagnolo was told, "You have a man of great mind for your building!"

"That is true," he replied, "but of bad judgment." A painter had made a scene containing nothing but what was borrowed from drawings and other works. It was shown to Michelagnolo, and an intimate friend asked his opinion. He answered, "He has done well, but at the day of judgment, when all bodies will recover their members, nothing will be left of it," a warning to artists to use their own wits. At Modena he saw many excellent terra-cotta works coloured like marble by Antonio Bigarino, who could not work marble. He said, "If this clay should become marble, woe to the ancient statues." He was told that he ought to take up the challenge of Nanni di Baccio Bigio, who was ever anxious to compete with him. But he replied, "He who competes with inferiors gains no glory." A priest and friend said, "It is a pity you have not married, as you might have had several children and left them the fruit of your labours." He answered, "I have a wife too many already, namely this art, which harries me incessantly, and my works are my children, and they will live a while however valueless. Woe to Lorenzo di Bartoluccio Ghiberti if he had not made the doors of S. Giovanni, for his children and nephews have sold and destroyed everything he did, whereas they still stand." One night Vasari was sent by Julius III. to Michelagnolo for a design. He found the master engaged upon the marble Pietà which he broke. Recognising the knock, Michelagnolo rose from his work and took a lantern. When Vasari had explained his errand, he sent Urbino upstairs for the design and began to speak of other things. Vasari's eyes wandered to a leg of Christ which he was trying to alter, and in order that Vasari might not see it he let the lantern fall, and so they were in the dark. He called Urbino to bring a light, and he came out of his place and said, "I am so old that death frequently drags at my mantle to take me with him, and one day my person will fall like this lantern." However, he liked the society of some men, such as Menighella, a clumsy painter of Valdarno but a very amusing man, who sometimes came to him for a drawing of St. Roch or St. Anthony to paint for the peasants. Michelagnolo, whom it was hard to persuade to work for kings, put aside everything to make simple designs suitable to his friend's style and requirements. Among other things he made for him a model of a crucifix of great beauty. Of this Menighella took copies which he went about selling. He would make Michelagnolo burst with laughter, especially in relating his adventures. For example, a labourer wanted Menighella to paint a St. Francis, but did not like the grey

robe, as he desired a brightly coloured one, so Menighella made him a brocaded cope and he was satisfied. Michelagnolo also liked Topolino the carver, who imagined himself to be a good sculptor, though he was a very poor one. He remained many years in the Carrara mountains sending marble to Michelagnolo, and never loaded a boat without sending three or four little figures of his own, at which Michelagnolo died of laughing. Finally, having sketched a Mercury in marble he gave it to Topolino to finish, and when it was nearly done he wished to see it and give his opinion. "You are a fool, Topolino," he said, "to want to make figures. Don't you see that this Mercury is over $\frac{1}{3}$ braccia short from the knees to the feet, and is dwarfed and deformed?" "That is nothing," he replied, "if that is all I will put it right, leave it to me." Michelagnolo laughed again at his simplicity and departed. Topolino then took a piece of marble, and cutting under the knees, he made a neat joint and gave the figure a pair of boots, affording the additional length required. When Michelagnolo returned he laughed again, and marvelled that a blunderer should have more resource than a skilled man.

While Michelagnolo was finishing the tomb of Julius II., he caused a stonecutter to execute a caryatid to be placed on the tomb of S. Piero ad Vincola, saying, "Cut away here, plane it here, polish it there," so that the man had made a figure without knowing it. When he looked at what he had done in amazement, Michelagnolo said, "What do you think of it?" "It looks well," he replied. "I am much obliged to you." "Why?" "Because through you I have found a talent which I did not think I possessed."

But to make the story shorter I will only add that Michelagnolo enjoyed excellent health, being thin and wiry, and had only experienced two serious illnesses as a man, though he had been a delicate child. He supported every fatigue, but in his old age he suffered with his kidneys, and eventually with the stone, of which his friend Realdo Colombo cured him by means of injections after many years. He was of medium stature, with broad shoulders, though in proportion with the rest of the body. As he grew old he wore shoes of dog's skin on his bare feet during winter for months together, and when he wished to remove them the skin often came with them. Over his stockings he wore shoes of Cordovan leather, buttoned inside, a whim of his. His face was round, his forehead square and roomy with seven straight lines, and his temples projected

considerably beyond his ears, which were rather large and standing out. His body was in proportion to his face and somewhat large; his nose was flat, having been broken, as related in the Life of Torrigiano; his eyes were rather small, of horn-colour, with bluish-yellow spots. His lids had few hairs, his lips were thin, the lower thicker and projecting a little more than the upper. His chin was well-proportioned; his beard and hair were black sprinkled with many white hairs, his beard not being very long or thick and bifurcated. He was sent into the world by God to help artists to learn from his life, his character and his works what a true artist should be. I thank God that I have experienced one of the greatest boons an artist can enjoy, in being born in his time, in having him for a master, and having such friendly relations with him, as is well known and as his letters to me testify. Indeed, owing to his friendship I have been able to write many true things about him which others could not have done. The other advantage is, as he often reminded me, "Giorgio, thank God for giving you a patron like Duke Cosimo, who carries out his ideas and plans without thinking of the expense, for you know that others whose lives you have written have not had this experience."

Michelagnolo was buried in S. Apostolo, in the sight of all Rome, with honoured obsequies, attended by all artists, his friends, and the Florentines. The Pope intended to erect a special memorial to him in S. Pietro.

Lionardo, his nephew, did not reach Rome until all was over, although he had travelled post. He had consulted Duke Cosimo, who wished the body to be brought to Florence with every imaginable pomp, that he might honour the master as he had not been able to do when alive. It was secretly wrapped up like merchandise, in order to avoid a disturbance in Rome, which might have prevented the removal. Before the body arrived the principal painters, sculptors and architects of the academy met together, at the summons of their lieutenant, Don Vincenzio Borghini, who reminded them that by their articles they were bound to honour the death of all their brethren, and having affectionately done so on the decease of Frà Giovann' Agnolo Montorsoli, who died before the founding of the academy, they should do the same to honour Buonarroti, who had been unanimously elected as the first academician and chief of them all. They all answered that they would do everything in their power. It not being easy for them all to meet every day, they elected a committee of four for the obsequies, Angelo Bronzino and

Giorgio Vasari, painters, and Benvenuto Cellini and Bartolommeo Ammannati, sculptors, all distinguished in their arts, to consult with the lieutenant and decide what was to be done, with full powers from the company. They undertook the charge gladly, because both young and old came forward, offering to do the requisite paintings and statues for the ceremony. They then arranged that the lieutenant by virtue of his office, and the consuls in the name of the company, should inform the duke and ask for his aid and favour, especially that the obsequies might be performed in S. Lorenzo, which contained the principal part of Michelagnolo's work in Florence, and that the duke should allow M. Benedetto Varchi to pronounce the funeral oration, so that the artist's genius might be praised by the eloquence of that great man, who would not undertake this charge without a word from the duke, in whose service he was, although, as he loved and admired the memory of Michelagnolo, they felt certain he would not refuse. This done they separated, and the lieutenant wrote to the duke in these words:

"The academy and company of painters and sculptors having decided to honour the memory of Michelagnolo Buonarroti, if your Excellency wills it, as the greatest artist of all time, and especially as a fellow-countryman, and in consideration of the great advantages which the arts have derived from the perfection of his works and inventions, think ourselves bound to make the utmost possible return to his genius. They have intimated this desire to your Excellency in a letter asking for assistance. They have asked me, and I feel bound by virtue of my office of lieutenant, to which your Excellency appointed me for this year, because the matter seems most fitting, and much more because I know how much your Excellency favours genius, protecting men of talent in this age, and even surpassing your ancestors, and as Lorenzo the Magnificent directed the erection of a statue to Giotto in the principal church, and a handsome marble tomb to Frà Filippo at his own cost, and many other things on various occasions, I have ventured to recommend to your Excellency the petition of the academy to honour the virtue of Michelagnolo, a pupil of the school of Lorenzo the Magnificent, which will give the greatest pleasure to them and to everyone, and be no small incitement to artists, and show all Italy the goodness and greatness of your Excellency. May God long preserve your life to be a blessing to your people, and a support to genius."

The Duke replied:

"REVEREND AND WELL BELOVED,—The readiness shown by the academy to honour Michelagnolo Buonarroti has afforded us much consolation after the loss of such a man, and not only will we grant what the memorial requests, but we will have his body brought to Florence, in accordance with his wish as we are advised. We are writing to this effect to the academy exhorting them to employ every means to celebrate the genius of that great man. God be with you."

The letter of the academy referred to was in these terms:

"MOST ILLUSTRIOUS DUKE,—The men of the company of design, created by your favour, knowing that by means of your Excellency's ambassador the body of Michelagnolo Buonarroti is to be brought to Florence, have assembled to discuss the celebration of his obsequies in the best manner possible. Knowing your Excellency's love for Michelagnolo, they beseech you first to grant that they may celebrate the obsequies in the church of S. Lorenzo, built by your ancestors, and containing such beautiful works by him both in sculpture and architecture, near which it is proposed to build a school for the continual study of architecture, sculpture and painting for the said academy. Secondly, they beg you to cause M. Benedetto Varchi not only to compose the funeral oration, but to deliver it himself as he has freely promised if your Excellency will consent. Thirdly, they beseech you to employ the same goodness and liberality in assisting in the requirements of the obsequies, thus helping the academy, whose resources are very small. All these questions have been discussed before M. Vincenzio Borghini, prior of the Innocenti, your Excellency's lieutenant in the academy," etc.

The duke made the following reply:

"WELL BELOVED,—We are content to satisfy fully all your petitions, such is the affection we bear to the rare genius of Michelagnolo Buonarroti and to all of your profession. Therefore, do not abandon what you propose to do for the obsequies, and we will not fail to remember your needs. M. Benedetto Varchi has been written to about the oration, and the master of the hospital is instructed to do what pertains to him. Farewell. From Pisa."

The letter to Varchi ran:—"M. Benedetto, our well beloved: our affection for the rare genius of Michelagnolo Buonarroti makes us desire to honour his memory in every possible way, and we should be delighted if you would kindly recite the funeral oration, especially if you pronounce it yourself according to the arrangements made by the deputies of the Academy. Farewell."

M. Bernardino Grazzini also wrote to the deputies saying that

the duke could not possibly be more interested in the matter, and they might look for every assistance and favour from him. While these things were going on in Florence, Lionardo Buonarrotti, who on hearing of his uncle's illness had gone post to Rome, though he arrived too late, learned from Daniello of Volterra, a very intimate friend of Michelagnolo, and others who had been about the good old man, that he had begged that his body might be taken to his noble country Florence, which he had always loved. Lionardo therefore hurriedly but with caution removed the body from Rome and forwarded it to Florence like merchandise.

With regard to this last wish of Michelagnolo, the truth is that his long absence from Florence, contrary to the opinion of some, was due to nothing but the air, which being sharp and subtle proved injurious to his health, while in the more temperate climate of Rome he remained healthy until his ninetieth year, in the full enjoyment of all his faculties, and so strong that he worked up to the very last day.

The body reached Florence suddenly and almost unexpectedly on Saturday, 11 March, and was placed below the high altar in the company of the Assunta, and below the steps behind the high altar of S. Piero Maggiore. That day nothing was done. The following day being the second Sunday in Lent, all the painters, sculptors and architects met about S. Piero bringing nothing but a velvet pall with gold fringe to cover the coffin, on which lay a crucifix. At midnight they all stood about the body, the oldest and best artists supplying a quantity of torches, the younger men crowding to carry the bier, esteeming themselves happy if they could raise it on their shoulders, to be able to boast in after days of having borne the body of the greatest man their art had ever known. Many persons who had seen them gathered about S. Piero, especially when it was bruited that the body of Michelagnolo had come and was to be carried to S. Croce, and although every precaution to secure secrecy had been taken the report spread, and such a crowd assembled that some tumult and confusion arose, though quiet rather than pomp was desired, the rest being reserved for a more convenient time. But the contrary happened, because the news spread and the crowd filled the church in a twinkling, so that the body could only be taken to its resting-place in the sacristy to be unpacked, with the utmost difficulty. Although a number of monks, a quantity of candles, and many people dressed in black make a magnificent show at funerals, it was certainly a great thing to see so many excellent men suddenly gathered into one band,

some of whom are distinguished now, and others will some day be even more so, performing the last rites about the body. All the artists in Florence were there, and they have always been very numerous. Indeed the arts have always so flourished there that, without offence to other cities, I may call Florence the nest and home of the arts, as Athens was of the sciences. Besides the artists a great number of citizens followed, and those standing at the sides blocked the way. What is more, all spoke the praises of Michelagnolo, and said that a great man is honoured for his worth even after no more can be expected from him. For these reasons the demonstration was more significant than the greatest ceremony with gold and banners. Arrived at S. Croce, and after the friars had performed the usual rites, the body was carried into the sacristy not without great difficulty, owing to the crowd there. The lieutenant, who took part in his official capacity, thinking to please many, and, as he afterwards confessed, desiring to see dead a man whom he had not seen alive, except at an age when he could not remember, decided to open the coffin. Those present expected to see signs of decay, as he had been dead twenty-five days, and twenty-two in the coffin, but we saw him untouched, without any bad smell, so that he seemed to be quietly sleeping. His features were almost exactly as in life, except a slight colour of death, and not a member was impaired, the head and cheeks when touched being as if he had only been dead a few hours. The press of the crowd being over, it was decided to put him by the Cavalcante altar near the door leading into the cloister of the chapter-house. Meanwhile the news spread, and such crowds of youths came to see him that it was very hard to shut the coffin. If it had been day instead of night, it would have been necessary to keep it open many hours to satisfy the crowd. The following morning, while the painters and sculptors were beginning to arrange the ceremony, the numerous wits, who always abound in Florence, pinned Latin and Italian verses to the coffin, and this was continued so that the number printed formed a small part in comparison with those written.

To come to the obsequies. They were not solemnised on the day after St. John's day, as had been proposed, but postponed to July 14. Benvenuto Cellini being somewhat indisposed from the first and having taken no part, the other three deputies, after making Zanobi Lastricati the sculptor proveditore, decided to produce something ingenious and worthy of their art rather than a pompous and costly ceremonial. Indeed, they said that

artists in honouring a man like Michelagnolo ought not to seek royal pomp or superfluous vanity, but ingenious and charming inventions, to display their knowledge, art thus honouring art. Thus, although we knew the duke would supply any amount of money, as we had already asked and received much, we decided to have something artistic and beautiful rather than rich and costly. Nevertheless the magnificence was equal to anything ever done by the academicians, and the honour was as remarkable for magnificence as for ingenious inventions. It was finally arranged to have the catafalque in the middle nave of S. Lorenzo between the side doors, one leading into the cloister, the other into the street. It was rectangular, twenty-eight braccia high with a Fame at the top, eleven braccia long and nine broad. The catafalque was raised two braccia from the ground by a pedestal, the side towards the principal entrance bearing two beautiful recumbent rivers, the Arno and the Tiber. The Arno had a cornucopia full of flowers and fruits, to signify the fruitfulness of Florence in these professions, which have filled the world, and especially Rome, with extraordinary beauty. The other figure holds in its extended arms flowers and fruits from the cornucopia opposite. This showed that Michelagnolo had spent a great part of his life at Rome, and there produced the marvels that amaze the world. The Arno had the lion as a sign, and the Tiber the wolf with the little Romulus and Remus. Both were colossal figures, resembling marble, of extraordinary grandeur and beauty. The Tiber was by Benedetto da Castello, a pupil of Baccio Bandinelli, the other by Battista di Benedetto, a pupil of Ammannato, both youths of the highest promise. From the pedestal rose a front of five and a half braccia with cornices beneath, above, and at the sides, leaving a space in the middle, four braccia square. On the front where the rivers stood was painted Lorenzo de' Medici receiving the little Michelagnolo into his garden, having heard of the first-fruits of his great genius. This was painted by Mirabello and Girolamo del Crocifissaio, great friends and partners, who undertook to do the work together. They displayed great vigour in the attitude of Lorenzo, a portrait from life, graciously receiving the respectful child, and after examining him consigning him to some masters to be taught. The second scene following this, facing the side door opening on the street, represented Pope Clement showing favour to Michelagnolo, and employing him on the library and new sacristy of S. Lorenzo, contrary to the general opinion, which supposed that the Pope was angry with the artist for the part

he had played in the siege of Florence. This was by the hand of
Federigo Fiammingo, called del Padoano, painted with great
dexterity and smoothness, representing Michelagnolo showing
the Pope the plan of the sacristy. Behind him little angels and
other figures bore models of the library, the sacristy, and the
statues there, all most carefully finished. The third square
facing the high altar contained a great Latin epitaph composed
by the learned M. Pier Vettori, which ran:

*Collegium pictorum, statuariorum, architectorum auspicio opeque
sibi prompta Cosmi ducis auctoris suorum commodorum, suspiciens
singularem virtutem Michaelis Angeli Buonarrotae, intelligensque
quanto sibi auxilio semper fuerit praeclara ipsius opera, studuit se
gratum ergo illum ostendere, summum omnium, qui unquam fuerint,
P.S.A. ideoque monumentum hoc suis manibus extructum magno
animi ardore ipsius memoriae dedicavit.*

This epitaph was borne by two little angels, each weeping and
extinguishing a torch, lamenting at the extinction of such rare
genius. The last scene opposite the door leading to the cloister
represented Michelagnolo fortifying S. Miniato for the siege of
Florence, which was considered impregnable and marvellous.
This was by Lorenzo Sciorini, a pupil of Bronzino, and a youth
of great promise. The lower part or base had a projecting
pedestal on each side containing a statue of more than life-
size, with another beneath conquered and subdued, of the same
size, but in curious attitudes. The first on the high-altar side was
a slender youth of great spirit and beauty representing Genius,
with two wings on his temples, such as Mercury sometimes
wears, and below him was Ignorance, the mortal enemy of
Genius, a fine figure with ass's ears, made with incredible
diligence. Both these statues were by Vincenzio Danti of Perugia.
I shall speak of him and of his rare works more at length else-
where. On the second pedestal, facing towards the new sacristy,
was a female figure representing Christian Love, being an
aggregate of all the theological virtues, which the Pagans called
moral. Thus, when Christians were celebrating so worthy a
Christian, it was right to find a place for this virtue, for without
it all other qualities of the mind and body are of little account.
This figure stood over a prostrate Vice or Impiety by Valerio
Cioli, an ingenious youth worthy of praise as a diligent and
judicious sculptor. Towards the old sacristy was another figure
representing Minerva, or Art. For we may say that after good
morals, which take the first place, follow the arts which provide
men with honour, wealth and glory, while their excellent works

secure fame for great men after death, when having passed beyond envy they are by common consent recognised as excellent. For this reason she stood over Envy, a shrivelled hag with viperous eyes and breathing poison, being girded with snakes and holding a viper in her hand. These two statues were by a mere child, Lazzaro Calamec of Carrara, who has displayed a fine vivacious mind in some paintings and sculptures. The two statues on the fourth pedestal opposite the organ were by his uncle, Andrea Calamec, a pupil of Ammannato. The first represented Study, as those who work little and slowly can never rise to eminence, while Michelagnolo never rested from work from his earliest childhood to the age of ninety. This Study was a strong and bold youth, with two wings at his wrists, to indicate speed in work. He stood over Slothfulness or Idleness, a lean woman, sleepy and heavy in every act. These four figures formed a charming group, and looked like marble, the clay being painted white, producing an excellent effect. On the level where they stood rested another pedestal, about four braccia high, but narrower than the one beneath by the depth of the mouldings. Each face had a painting six and a half braccia long and three high, and above it was another surface like the lower one, only smaller. Each side had a projection for a life-size figure. These were four women, easily recognisable from their instruments as Painting, Architecture, Sculpture and Poetry. Above the scene of Lorenzo receiving Michelagnolo was a beautiful painting of Michelagnolo presenting his stupendous model of the cupola of S. Pietro to Pius IV., a much-admired work painted by Piero Francia of Florence. The statue of Architecture on the left of it was by Giovanni di Benedetto of Castello, who had been so successful with the Tiber already described. The second scene facing the side door represented Michelagnolo painting his Last Judgment, the model for all foreshortening and other difficulties of art. This was done with much grace and diligence by the apprentices of Michele di Ridolfo. The statue of Painting on the left, facing the new sacristy, was by Battista del Cavaliere, a youth no less excellent as a sculptor than for his admirable character. The third picture facing the high altar represented Michelagnolo talking with a female Sculpture, who holds a tablet with the words of Bœthius, *Simili sub imagine formans.* About the artist were some of his finest works in sculpture. The painting was executed with excellent invention and style by Andrea del Minga, and the statue of Sculpture on the left, of not inferior merit, was by Antonio di Gino Lorenzi, sculptor. The fourth

scene represented Michelagnolo writing his compositions surrounded by the nine Muses as described by the poets, and Apollo in front with his lyre and laurel crown, and holding another crown which he offers to place on Michelagnolo's head. This beautiful and finely composed work, with its vigorous attitudes, was by Giovanmaria Butteri, the statue of Poetry on the left being by Domenico Poggini, equally skilled in sculpture, making dies for money and medals, working bronze and writing poetry.

Such was the decoration of the catafalque, which resembled the mausoleum of Augustus at Rome, though, being rectangular, it was perhaps more like the Septizonium of Severus, the true one printed next the Antonianus in the *Nuove Rome*, not the one near the Capital, commonly but erroneously so called. On the topmost pedestal was a base a braccia high and somewhat less in breadth and length upon which the figures were seated, with the legend about them: *Sic ars extollitur arte.* Upon the base rested a pyramid nine braccia high, the sides of which facing the principal door and the high altar bore medallions with the portrait of Michelagnolo in relief, excellently done by Santi Buglioni. At the top of the pyramid was a ball in proportion, as if it contained the ashes of the deceased, and upon it rested a life-size Fame, painted like marble, in the act of flying and spreading the praises of the great artist with a trumpet having three mouths. Zanobi Lastricati made this figure, for in spite of his labours as director he wished to show his skill and ability. The height from the ground to the top of the Fame was twenty-eight braccia. The whole church was draped with black hangings, not fixed in the usual way to the central columns only, but each space between the piers framing the surrounding chapels was decorated with some painting, affording both wonder and delight. In the space of the first chapel next the high altar, and by the old sacristy, was a painting six braccia high by eight long, representing Michelagnolo in the Elysian fields, and on his right figures larger than life of the famous painters and sculptors, each distinguished by some sign: Praxiteles by the satyr in the villa of Julius III., Apelles by the portrait of Alexander the Great, Zeuxis by the picture of the grapes which deceived the birds, and Parrhasius by the curtain which deceived Zeuxis. They were accompanied by later artists from the time of Cimabue. Giotto bore a tablet with the portrait of young Dante like that painted by Giotto in S. Croce; Masaccio was a portrait; so also was Donatello, who had his Zuccone of the Campanile beside him; Brunellesco had his cupola of S. Maria del Fiore.

Other portraits were those of Frà Filippo, Taddeo Gaddi, Paolo
Uccello, Frà Giovanni Agnolo, Jacopo Pontormo, Francesco
Salviati, and others, all welcoming Michelagnolo as the divine
poet Dante represents them as welcoming Virgil, and a line of the
poet was written on a letter held by the River Arno, which is
lying in a beautiful attitude at Michelagnolo's feet:

> *Tutti l'ammiran tutti onor gli fanno.*[1]

This painting was by Alessandro Allori, pupil of Bronzino,
and not unworthy of his great master, for it was greatly praised
by all who saw the work. The space of the chapel of the Sacra-
ment at the crossing contained a painting, five braccia by four,
of the school of the arts, children, up to men of twenty-four,
surrounding Michelagnolo and offering him the first-fruits of
their labours in painting and sculpture, which he graciously
receives, teaching them art while they listen attentively in
attitudes full of grace and beauty. The composition of this
scene could not be improved upon, and Batista, a pupil of
Pontormo, who painted it, received great praise. The verses
at the bottom ran:

> *Tu pater, tu rerum inventor, tu patria nobis*
> *Suppeditas praecepta tuis ex, inclyte, chartis.*

Proceeding towards the principal door and before reaching
the organ, there was a chapel space six braccia high by four
broad containing a representation of the extraordinary favour
shown by Julius III. to Michelagnolo in entertaining him at his
villa to consult him on some buildings. The master is seated
beside the Pope, and they converse together, while the cardinals,
bishops and other courtiers remain standing. This is harmoni-
ously composed and in excellent relief, the figures being vigorous,
so that an old and experienced master might not have done
better. The artist, Jacopo Zucchi, therefore, a young pupil of
Giorgio Vasari, showed great promise in this work. Not far off
and somewhat below the organ, Giovanni Strada, a skilful
Flemish painter, had represented, in a space six braccia long
by four high, Michelagnolo's visit to Venice during the siege
of Florence. To his lodgings on the Giudecca there, the doge
Andrea Gritti and the Signoria sent nobles and others to make
offers to him, the painter showing much judgment and know-
ledge in the whole composition and in every detail, such as the
attitudes, the animated faces, the movements of each figure,
the invention, design and excellent grace.

[1] Dante, *Inferno*, Canto IV. 133, "All admire, all do him honour."

To return to the high altar. In the first picture next the new sacristy, in the space of the first chapel, painted by Santi Titi, a youth of good judgment and considerable experience in painting in Florence and Rome, was represented another signal favour accorded to Michelagnolo in Rome three years before he died by Sig. Francesco Medici, prince of Florence, who on Buonarrotti's entrance immediately rose and courteously offered him his seat, standing himself reverently to hear him, as sons hear a good father. At the feet of the prince was a boy, executed with great diligence, holding a ducal cap, and about them stood soldiers dressed in the ancient style, excellently done. But the best figures were those of the prince and Michelagnolo, the elder man speaking and the younger listening attentively. In the picture opposite the tabernacle of the Sacrament, nine braccia high by twelve long, Bernardo Timante Buontalenti, a favourite painter of the prince, had beautifully represented the rivers of the three principal parts of the world grieving with the Arno at the common loss, namely the Nile, Ganges and Po. The sign of the Nile was a crocodile with a garland of wheat to show the fertility of the country; the Ganges had a griffin and a garland of gems, while the Po had a swan and a crown of black amber. These rivers are led to Tuscany by Fame, a flying figure, and surround the Arno, who is crowned with cypress and holds up an empty urn and a cypress-branch, while beneath her is a lion. To show that Michelagnolo's soul had gone to bliss, the painter had represented a splendour in the air, and a little angel with the lyric line:

Vivens orbe peto laudibus aethera.

On pedestals at the sides stood two figures holding back a curtain, disclosing the rivers, the soul of Michelagnolo and Fame. Each figure stood over another. The one on the right of the rivers, representing Vulcan, held a torch, and below him was Hatred, struggling to rise. A vulture bore the legend:

Surgere quid properas Odium crudele ? Jaceto

because superhuman things ought neither to be hated nor envied. The other figure was Aglaia, one of the Graces and the wife of Vulcan, representing Proportion. She held a lily, a flower dedicated to the Graces and also said to be suitable for funerals. She stood over Disproportion with an ape or monkey, and this line above:

Vivus et extinctus docuit sic sternere turpe.

Below the rivers were two more lines:

Venimus, Arne, tuo confixa ex vulnere moesta
Flumina, ut ereptum mundo ploremus honorem.

The picture was considered very fine for its invention, the beauty of the verses, the general composition and the charm of the figures. As the artist did not receive a commission as the others did, but produced it of his own accord to honour Michelagnolo with such assistance as his friends afforded him, he deserves the greater praise. Another picture, six braccia long by four high, near the side door, by Tommaso da San Friano, a young artist of ability, represented Michelagnolo sent to Julius II. by Soderino as ambassador of Florence. Not far from this, a little below the side door, in another picture, Stefano Pieri, pupil of Bronzino, a diligent and studious youth, painted Michelagnolo seated beside Duke Cosimo, and conversing with him, a thing that had frequently happened in Rome. Above the black draperies surrounding the church, where there were no paintings, each of the chapel spaces contained images of death, devices, and other such things, different from what are usually made, and exhibiting much beauty and fancy. Some of the figures of Death seemed to be sorrowing at having to remove such a man, and bore a scroll with the words *Coegit dura necessitas.* Nearby was a world from which sprang a three-headed lily, the stalk of which was broken, a clever idea due to Alessandro Allori. Other figures of Death were made in different ways, but most praise was given to Eternity, holding a palm, and her feet on the neck of one in a disdainful pose, as if to say that Michelagnolo would live in spite of him. The motto was *Vincit inclita virtus,* and the design Vasari's. Each of the figures of Death bore Michelagnolo's device of three crowns or circles interlaced, the circumference of one passing through the centres of the others, used either to indicate the three professions of sculpture, painting and architecture, which cannot be separated, or with some subtle meaning, as he was a man of great intelligence. The academicians considering him perfect in all three, changed the circles into crowns with the motto *Tergeminis tollit honoribus,* to show that he deserved the crown in each profession. In the pulpit where Varchi pronounced the funeral oration, afterwards printed, there was no decoration, the bas-reliefs being by the great Donatello, and much finer than any decoration that could have been attempted. The opposite one not having then been raised on the columns, a picture four braccia by two was placed

on it, representing Fame or Honour, a youth with a trumpet in his right hand and treading on Time and Death to show that Fame and Honour keep alive those who have produced great works, in spite of Time and Death. This was by Vincenzio Danti, sculptor of Perugia.

The church being thus adorned, filled with lights and packed with a great crowd, for men left everything to see this sight, the lieutenant of the academy entered accompanied by the halberdiers of the duke's guard, the consuls and the academicians, in fact all the painters, sculptors and architects in Florence. These were seated between the catafalque and the high altar, and a great number of nobles placed in order of precedence. Then followed the solemn Mass of the Dead with music and ceremonies of every kind, at the conclusion of which Varchi mounted the pulpit, though he had not performed such an office since the funeral of the Duchess of Ferrara, Duke Cosimo's daughter, and there pronounced the eulogy of the divine Michelagnolo, with his unique eloquence. It was indeed a great good fortune for Michelagnolo that he did not die before the foundation of our academy, as his death would not then have been so sumptuously celebrated. It was also his good chance to die before Varchi and obtain the eulogy of that great man, which was printed, as well as another fine oration in praise of Michelagnolo and painting by the noble and learned M. Lionardo Salviati, then about twenty-two, and of rare ability in composing in Latin and Tuscan, who will be even better known in the future. But what praise can suffice for Don Vincenzio Borghini, the chief director and counsellor of these obsequies? All the artists produced their best work, but it would have been useless without an experienced head to direct everything. As the whole city could not, in a single day, see the apparatus as the duke desired they should, it was left standing for several weeks, to the delight of the people and the strangers who came from neighbouring places. I will not add here the numerous epitaphs and Latin and Tuscan verses written in Michelagnolo's praise, as they would form a work by themselves, and they have been published by other writers. But I will add that the duke directed that Michelagnolo should have an honoured tomb in S. Croce, where he had desired to lie beside his ancestors. The duke gave Lionardo Buonarrotti the marble, which Batista Lorenzi was to carve after Vasari's design. It contains the head of Michelagnolo and is to have statues of Painting, Sculpture and Architecture, by the Florentine sculptors Batista Giovanni dell Opera and Valerio Cioli, who

are at work and will soon finish them and put them in their places. The expense, beyond the marble supplied by the duke, is borne by Lionardo, but in order that nothing should be lacking to honour such a great man, the duke has placed his bust and an inscription in the duomo, which contains similar memorials of the other great Florentines.

Description of the Works of FRANCESCO PRIMATICCIO of BOLOGNA, Abbot of San Martino, Painter and Architect
(1504 – 1570)

HITHERTO I have only written of men no longer living from the year 1200 to this year 1567, concluding with Michelagnolo, though two or three have died after him. I now think it well to mention several distinguished living artists. I do so the more readily as they are all great friends, and three of them are already so advanced in years that little more can be expected of them, although from habit they are still doing something. I will then briefly mention those who have profited by their instruction to become the best artists, and of others on the way to perfection. I will begin with Francesco Primaticcio, following with Titian and Jacopo Sansovino. Francesco was born at Bologna of the noble family of the Primaticci, celebrated by Frà Leandro Alberti and Pontano, and was first destined for commerce. But he cared little for it, his lofty mind turning to design, for which he had a natural bent, and by means of study he soon showed great promise. Proceeding to Mantua, where Giulio Romano was engaged upon the T palace for Duke Federigo, he was placed in company with several other youths assisting Giulio there. After studying art there with great diligence for six years, he learned to use his colours excellently and to manipulate stucco, being considered one of the best of all the youths engaged there in design and colouring. This appears in a large room decorated by him with two stucco friezes, one above the other, containing a quantity of figures of Roman soldiery. He also did several paintings for the palace from Giulio's designs. He thus acquired such favour with the duke that when King Francis of France, hearing of the palace, wrote asking that a youth might be sent to him who could paint and do stucco, the duke sent Francesco in 1531. The year before Rosso had been sent to serve the king, and had done many things,

notably the Bacchus and Venus, and Cupid and Psyche. However, it is said that Francesco did the first stucco and frescoes of any account in France, decorating many rooms and loggias for the king, who liking his style sent him to Rome in 1540 to procure marble antiquities. In this Primaticcio displayed great diligence, buying in a short time one hundred and twenty-five pieces. At the same time he had the bronze horse in the Capitol, a great part of the reliefs of the column, the statue of Commodus, the Venus, the Laocoon, the Nile and Tiber, and the Cleopatra in the Belvedere modelled by Jacopo Barozzi of Vignola, to be cast in bronze.

Meanwhile the death of Rosso [1] took place in France, and as he left a long gallery unfinished Primaticcio was recalled. Packing his marble treasures and moulds he returned to France, and began by making casts of a great number of the antique figures, to be placed in the queen's garden at Fontainebleau, to the delight of the king, who there established a sort of new Rome, for they looked like original antiques. I must say that in making the casts Primaticcio had the assistance of two excellent founders, who made the surface so smooth that it was not necessary to polish it. Primaticcio was next employed to finish the gallery begun by Rosso, and this he soon did, making more stucco and paintings than are contained in any other place. The king, being well pleased with his eight years' service, appointed him to be one of his chamberlains and soon afterwards, in 1544, made him abbot of St. Martin's.[2] Yet Francesco never ceased to produce paintings and stucco for the king and others. He was helped by many Bolognese, and among others by Giovambatista, son of Bartolommeo Bagnacavallo, no less skilful a painter than his father. Ruggieri of Bologna also served him a long while, and is still with him. Prospero Fontana of Bologna also was called to France, but Primaticcio did not employ him much, for he fell dangerously ill on his arrival and returned to Bologna. Bagnacavallo and Fontana are indeed skilful artists, and I have employed both, the first at Rome and the second at Rimini and Florence.

But of all Primaticcio's assistants none has done him more honour than Niccolo da Modena, mentioned elsewhere, who surpassed all the others in skill. From the abbot's designs he decorated the ball-room with an almost countless number of figures, all of life-size, in a clear style so that they resemble oil-paintings more than fresco. In the great gallery he next did sixty scenes from the abbot's designs of the exploits of Ulysses,

but in much darker colouring because he used natural earths without mixing them with white, thus obtaining a most striking relief. He has painted them so harmoniously that they look as if they had been done in one day. He therefore merits great praise, especially as he never retouched them *a secco* as is now so frequently done. The vaulting of the gallery is all decorated with stucco and paintings of the artists mentioned above and other youths, from the abbot's designs; so also is the old hall, and a lower gallery above the pond of great beauty containing the best works there, which it would take too long to describe. At Medone [1] the abbot did numberless decorations for the cardinal of Lorraine in his great palace called la Grotta, but of such extraordinary grandeur, resembling ancient edifices, that it might well be called le Terme. Not to mention other particulars, there is a beautiful room called the Pavilion decorated with cornices full of foreshortened figures of great beauty. Below is a large room with fountains decorated with stucco and full of figures in full relief, and with shells and other marine objects of marvellous beauty. The vaulting is finely decorated with stucco by Domenico del Barbiere, painter of Florence, an artist equally excellent in such reliefs and in design, and who has displayed rare talent in some things which he has coloured. In the same place a Florentine sculptor called Ponzio has done many excellent figures in stucco. But owing to the number of the works done for these princes I can only touch upon the abbot's principal productions to illustrate his excellence in painting, design and architecture. Indeed I should not think it troublesome to enter into particulars of things I know so much of as these.

In design Primaticcio is excellent, as we see by a sheet of his in our book representing the heavens. He sent it to me himself, and I value it highly for his sake and its own excellence. After the death of King Francis the abbot retained his position under King Henry, and Francis II. appointed him commissioner-general over all the buildings in the kingdom, an office of great honour formerly held by the father of the cardinal de la Bourdai-sière or Monsignor de Villeroy. On the death of Francis II. the abbot continued to serve the present king, by whose order and that of the queen-mother he has begun the tomb of King Henry in the middle of a chapel with six sides, and one of the king's children at each of the four ends of the tomb. The fifth side is occupied by the altar, and the sixth by the door. This is a work

[1] Meudon, near Paris.

worthy of that great king and of the genius of that skilful artist, containing as it does so many marble and bronze statues with a good number of bas-reliefs. The abbot has in his last years excelled in every branch of art, and has been employed by his patrons not only on buildings, painting and stucco, but in devising festivities and masquerades. He has been very kind and liberal to his friends and relations as well as to the artists who have served him. In Bologna he conferred many benefits upon his relations, buying them good houses, including the one where M. Antonio Anselmi now lives, who married one of the nieces of the abbot, who also married another niece, sister of the first, giving her a good dowry.

Primaticcio has lived more like a lord than an artist, and has shown himself most friendly to his fellow-artists. When he sent for Prospero Fontano to come to France, he also sent home a good sum of money. As Prospero fell sick the abbot could not avail himself of his services, and as I was passing through Bologna in 1563 I recommended Prospero to him, and such was the abbot's courtesy that before I left I saw a letter of the abbot giving Prospero freely all the money he had received. Owing to such acts artists honour the abbot as a father. I must add that Prospero was employed with much success by Julius III. on the palace of the villa Giulia, and in the palace of Campo Marzio, then owned by Sig. Balduino Monte and now by Sig. Ernando, the cardinal, a son of Duke Cosimo. In Bologna he did many works in oils and fresco, notably a St. Catherine disputing with the philosophers, in oils, in the Madonna del Baracane, considered a very fine work. He also painted many frescoes in the principal chapel of the governor's palace.

Another great friend of Primaticcio, Lorenzo Sabatini, an excellent painter, would have gone with the abbot to France, had he not been encumbered with a wife and several children. He has displayed excellent style and much skill in all his works, as we see by those at Bologna. In 1566 Vasari employed him on the apparatus made in Florence for the wedding of the prince to Queen Joan of Austria, when he did six figures in fresco of great beauty in the chamber between the great hall and that of the Two Hundred. But as he is still winning fresh laurels, I will say no more, except that notable success may be anticipated from his devoted study of art.

In this connection I will say something of Pellegrino of Bologna,[1] a painter of great promise and ability. After studying

[1] Pellegrino Tibaldi, 1527-1600.

the works of Vasari at Bologna in the refectory of S. Michele in Bosco, and those of other painters of repute, he went to Rome in 1547, and there drew the most famous things until 1550, when he assisted Perino del Vaga at the Castle of S. Angelo. He painted a battle-scene in the chapel of St. Denis in S. Luigi de' Franzesi, his work being no whit inferior to that of Jacopo del Conte of Florence and Girolamo Sciolante of Sermoneta in the same chapel. Indeed, many thought he showed more vigour, grace, and design, and therefore Monsignor Poggio frequently employed him. Having built a palace on the Esquiline Mount outside the Popolo gate, he wished Pellegrino to do some figures on the façade and paint a loggia facing the Tiber; these were executed with great diligence, the work being considered very beautiful and graceful. In the house of Francesco Formento, between the Pellegrino and Parione roads, he did two other figures in a court, and in the Belvedere made a large coat-of-arms with two figures for Julius III. In S. Andrea, a church built by that Pope outside the Popolo gate, he did St. Peter and St. Andrew, much-admired figures, the drawing for the Peter and other carefully executed sheets being in our book. Being sent to Bologna by Monsignor Poggio, he painted many scenes in fresco on his palace, one especially beautiful with nude and draped figures, excellently composed, in which he surpassed himself, and has not hitherto done better. In S. Jacopo there he began a chapel for Cardinal Poggio, which was completed by Prospero Fontana Pellegrino was then taken by the cardinal of Augsburg[1] to the Madonna of Loreto, and there decorated a beautiful chapel with stucco and painting. In the vaulting in a rich stucco border are a Nativity and Presentation in the Temple, with the Transfiguration in the middle. For the altarpiece he painted John baptising Christ, introducing a portrait of the cardinal kneeling. On the side walls he painted St. John preaching and his decollation. In the Paradise below the church where the Theatines now confess he painted scenes of the Judgment, and some figures in grisaille. Being invited soon after to Ancona by Giorgio Morato, he did a large oil-painting of John baptising Christ for S. Agostino, with St. Paul and other saints at the side, and a predella of numerous small and graceful figures. In the church of S. Ciriaco sul Monte, for the same patron, he did a Christ of five braccia in relief, with a beautiful stucco framing at the high altar, which was much admired. He did a fine stucco ornament at the high altar of S. Domenico there, and would have done the altarpiece also, but

[1] Otto Truchses.

owing to a difference with the patron it was given to Titian. Having finally undertaken the loggia of the merchants at Ancona, which partly faces the sea and partly faces the principal street of the city, he decorated the newly built vaulting with large stucco figures and paintings, devoting every effort to it and producing a truly beautiful work. For the figures are all well made, and he has introduced some fine foreshortened nudes, in imitation of those of Michelagnolo in the chapel at Rome. As that district possesses no architects or engineers more capable than he, Pellegrino has superintended the architecture and fortifications of the province, and finding painting more difficult and perhaps less profitable than architecture, he abandoned the former to do many things for the fortifications of Ancona and several other places in the States of the Church, especially Ravenna. In Pavia he began a palace for the Sapienza for Cardinal Borromeo, and not having entirely abandoned painting, he is now decorating in fresco the refectory of S. Giorgio for the monks of Monte Oliveto, which will be a beautiful work, as he has shown me the design. But as he is only thirty-five and is making continual progress, I will say no more. I will be equally brief in speaking of Orazio Fumaccini, another Bolognese painter who has done an excellent scene over one of the doors of the Hall of the Kings at Rome, as he also is young, and shows that he will not be inferior to his compatriots who have been referred to in this work.

The Romagnols, moved by the example of their neighbours the Bolognese, have also worked nobly in the arts. Besides Jacopone da Faenza, who painted the tribune of S. Vitale at Ravenna, there have been many excellent men since. Maestro Luca de Longhi of Ravenna, a good, quiet and studious man, has produced many excellent oil-paintings and portraits in his native city, among them two little panels done not long since for the Rev. Don Antonio da Pisa, abbot of the monks of Classi, not to speak of numerous others. In fact, if he had left Ravenna, where he has always lived with his family, his diligence and judgment would have made him most rare, because he has worked with patience and study, as I can testify, for when I stayed two months in Ravenna I practised and discussed art with him. His little daughter Barbara draws very well, and has begun to colour with considerable grace and style. He had a rival, Livio Agresti of Furli, who, having done some scenes in fresco for the abbot de' Grassi in the church of Spirito Santo, and some other works, left Ravenna for Rome, where by studying

design he has become skilful, as we see by his frescoes done there. His first works in Narni also possess considerable merit. In S. Spirito at Rome he painted several figures and scenes in fresco in a chapel, executed with care and diligence. This led to his employment on one of the lesser scenes above the door in the Hall of the Kings in the Vatican, where he acquitted himself as well as the others. For the cardinal of Augsburg he did seven on cloth of silver, considered very beautiful in Spain, whither the cardinal sent them as a gift to King Philip to adorn a chamber. He painted another piece of cloth of silver, now to be seen in the church of the Theatines at Forli. Having become an excellent designer, skilful colourist, and good in composing scenes, he entered the cardinal's service with a good provision, and is continually producing admirable works for him.

Marco da Faenza[1] is an admirable master in the Romagna, especially vigorous and skilful in fresco and unequalled in arabesques. Examples may be seen throughout Rome, and in Florence the greater part of the decorations in the twenty different rooms of the ducal palace, and the frieze of the ceiling of the principal hall, painted by Giorgio Vasari, are by his hand. He also decorated a great part of the principal court of the palace for the coming of Queen Joan, executed in a short time. Enough, for he is still alive, and as ready as ever to win fresh laurels.

Duke Ottavio Farnese now has at Parma a painter called Miruolo, a native, I believe, of the Romagna. In addition to some works at Rome, he has done some scenes in fresco in a small palace erected by the duke at Parma containing graceful fountains by Giovanni Boscoli, sculptor of Montepulciano, who did stucco for many years under Vasari for Duke Cosimo's palace at Florence, and ultimately entered the service of the Duke of Parma with a good provision, where he continues to produce works worthy of his rare ability. The same cities and provinces contain many other distinguished artists, but as they are still young I will take a more convenient opportunity of giving them the notice they deserve. This is the end of the works of Abbot Primaticcio. I must add that his portrait is from a pen sketch by his friend Bartolommeo Passerotto, painter of Bologna, and when it came into my hands I put it in my book of designs.

[1] Marco Marchetti, ob. 1588.

The Works of TITIAN OF CADORE, Painter
(1477 – 1576)

TITIAN was born at Cadore, a little village on the Piave, five miles from the foot of the Alps, in 1480, of the Vecelli family, one of the noblest there. At the age of ten he showed great intelligence, and was sent to an uncle, an honoured citizen of Venice, who perceived his bent for painting and put him with Gian. Bellini, a famous painter of the time, to study design, where he soon displayed his natural intelligence and judgment, which are necessary to painting. Gian. Bellini and the other painters of the country, through not having studied antiquities, employed a hard, dry and laboured style, which Titian acquired. But in 1507 arose Giorgione, who began to give his works more tone and relief, with better style, though he imitated natural things as best he could, colouring them like life, without making drawings previously, believing this to be the true method of procedure. He did not perceive that for good composition it is necessary to try several various methods on sheets, for invention is quickened by showing these things to the eye, while it is also necessary to a thorough knowledge of the nude. Besides, to have nude or draped models always before the eyes is no small tax. Thus by means of drawings it becomes easier to work out a composition, and so become skilful and judicious without the labour of making paintings as already described, not to mention that drawing fills the mind with good ideas; and one learns to retain natural objects in the head without it being necessary to have them always at hand, and to be obliged to conceal inability to draw by splendour of colouring as the Venetian painters have done for many years, for example Giorgione, Palma, Pordenone, and others who did not see Rome or perfect works.

On seeing Giorgione's style Titian abandoned that of Bellini, although he had long practised it, and imitated Giorgione so well that in a short time his works were taken for Giorgione's. As he advanced in years, skill and good judgment Titian did many frescoes, which I cannot describe in order, as they are scattered in many places. Skilled judges, however, considered that they showed promise of a great future. When he first adopted Giorgione's style, at the age of eighteen, he made the portrait of a noble of ca Barbarigo, his friend, considered very beautiful for the natural flesh-colour, the hairs which might be

counted, and the points of a doublet of smooth silvered material. It was so excellent that, if Titian had not written his name on the dark background, it would have been attributed to Giorgione.

That master having done the façade of the Fondaco de' Tedeschi,[1] Barbarigo succeeded in having some scenes on the same building facing the Merceria allotted to Titian. He then did a large picture with life-like figures now in the hall of M. Andrea Loredano, by S. Marcuola. It represents the Flight into Egypt, with a great wood and some landscapes excellently done, because Titian had spent some months in doing such things, and had entertained some Germans in his house, excellent painters of landscape and foliage. He introduced several life-like animals into the wood, drawing them from Nature. He then did a portrait of M. Giovanni Danna, a Flemish noble and merchant, his gossip, and an *Ecce Homo*,[2] which he himself and others consider a very fine work. He also did a Virgin and other figures of men and children, all portraits of persons of that house. In the following year, 1507, when the Emperor Maximilian was waging war with the Venetians, Titian, as he himself relates, did Raphael, Tobias and a dog in the church of S. Marziliano, with a distant landscape showing St. John the Baptist kneeling in prayer, his face illuminated by a heavenly glory. It is thought he did this before beginning the work already referred to at the Fondaco de' Tedeschi. Many nobles not being aware that Giorgione had been replaced, or that Titian was engaged there, met the former and congratulated him on his greater success with the façade towards the Merceria than with that on the Grand Canal. Giorgione felt so mortified at this that, until Titian had finished all the work and it was well known that he had done that section, Giorgione largely refrained from appearing in public, and thenceforward he refused to hold intercourse with Titian or be friends with him.

In 1508 Titian published wood-engravings of the Triumph of Faith, with a quantity of figures, comprising our first parents, the patriarchs, prophets, sibyls, innocents, martyrs, apostles, and Jesus Christ borne in triumph by the Evangelists and the four Doctors, with the holy confessors following, a work displaying vigour, style and knowledge. I remember that Frà Bastiano del Piombo told me that if Titian had gone to Rome and seen

[1] 1506–8.
[2] Dated 1543, once in the collection of the Duke of Buckingham, later in the Vienna Gallery.

the works of Michelagnolo, Raphael and the ancient statues there, and had studied design, he would have produced stupendous things, seeing his skill in colouring, in which he deserves to be called the best master of our day for his imitation of natural tints; and with a foundation of great draughtsmanship he would have overtaken the Urbinate and Buonarroto. Titian next went to Vicenza, and painted a fine Judgment of Solomon under the loggia where public audience is given. Returning to Venice he painted the façade of the Grimani, and in Padua did some scenes in S. Antonio [1] in fresco of the acts of the patron saint. In S. Spirito he did a small panel of St. Mark seated among saints,[2] some of which are portraits, painted in oils with great diligence. Many have believed this to be a work of Giorgione.

A scene in the hall of the Great Council having been left unfinished, owing to the death of Giovan Bellini, representing Frederick Barbarossa kneeling before Alexander III. at the doors of S. Marco, who puts his foot on his neck, Titian completed it, changing many things and introducing portraits of his friends and others. This induced the senate to give him an office in the Fondaco de' Tedeschi, called la Senseria, worth 300 crowns a year,[3] a post usually conferred upon the best painter of the city, for which he is obliged to paint the portraits of the doges for eight crowns only, paid to him by the prince, the portrait being placed in a public position in the palace of S. Marco.

In 1514 Alfonso of Ferrara was decorating a chamber, and had caused Dosso, a Ferrarese artist, to paint scenes of Æneas, Mars and Venus, and Vulcan with two smiths in a cave. He wished to have some paintings done there by Gian. Bellini, who decorated another wall with a vat of red wine surrounded by bacchantes, players, satyrs and other drunken figures, with a naked Silenus riding an ass surrounded by people holding fruits and grapes. This was a work coloured with great diligence, and one of the finest Gian. ever did, although there is something hard in the draperies, which are treated in the German style. This is not surprising, as he imitated a picture of Albert Dürer, brought to Venice at that time and placed in S. Bartolommeo, a rare work, full of fine figures done in oils. On the back Giovanni Bellini wrote *Joannes Bellinus Venetus*, p. 1514. But as it was not finished, he being an old man, Titian was sent for to complete it, as he was better than the others. Being anxious to make a

[1] Actually in the Scuola del Santo, in 1511.
[2] About 1512; now in the sacristy of S. Maria della Salute.
[3] In 1516.

name, he executed two scenes with great care.[1] The first contains
a river of red wine surrounded by people playing and singing,
both male and female, as if drunk. One figure of a naked woman
asleep is of great beauty, and seems alive, as do the other
figures. To this work Titian affixed his name. In the one next
this he made several cupids in various attitudes, greatly pleasing
his patron, as he did with the other scene. Very natural is one
of the cupids pissing in the river and looking at his reflection
in the water. The others surround a pedestal resembling an altar
containing a statue of Venus, holding a sea-shell and surrounded
by the Graces and Beauty, fine figures executed with incredible
diligence. On the door of a cupboard Titian painted a marvellous
half-length Christ, to whom a Hebrew peasant is showing the
tribute money.[2] Our foremost artists declare this and other
paintings of that chamber to be the best works Titian has ever
done, and indeed they are remarkable, and he deserved the rich
rewards of his patron, whom he drew leaning on a great piece
of artillery. He also drew the Signora Laura, afterwards the
duke's wife, a stupendous work.[3] Great indeed are the efforts
of men of ability when assisted by the liberality of princes. At
this time Titian acquired the friendship of the divine M. Ludo-
vico Ariosto, who knew his merit and celebrated him in the
Orlando Furioso:

> . . . *E. Tiziano chi onora*
> *Non men Cador, che quei Venezia e Urbino.*

Returning to Venice, Titian did for the father-in-law of
Giovanni da Castel Bolognese an oil-painting on canvas of a
naked shepherd and a stranger offering him a flute to play, with
a beautiful landscape. This is now at Faenza in Giovanni's
house. At the high altar of the Franciscan church of Ca grande
he did an Assumption[4] with the twelve Apostles below, but
little can now be seen because it is painted on canvas, and it has
perhaps been ill-preserved. In the Pesari Chapel of the same
church he did a Virgin and Child, St. Peter and St. George, with
portraits of the donors kneeling, among them the bishop of
Baffo and his brother, just returned from his victory over the
Turks.[5] In the little church of S. Niccolo in the same convent
he did a panel of St. Nicholas, St. Francis, St. Catherine, and a
nude St. Sebastian taken from life, the beautiful legs and torso

[1] In 1519, the Bacchanal and Venus worship, both in the Prado, Madrid.
[2] Now at Dresden.
[3] Supposed to be the Laura de' Dianti now in the Louvre.
[4] The Assumption painted for the Frari in 1516.
[5] Painted in 1526. Baffo is Paphos.

being exactly like life.[1] Very beautiful also is the Virgin with the Child, who are regarded by all the other figures. This work was drawn on wood by Titian himself and engraved and printed by others. For the church of S. Rocco he next did Christ bearing the Cross, dragged by a rope by a Jew, a figure which many have attributed to Giorgione.[2] This is now the chief object of devotion in Venice, and has received more crowns as alms than Titian and Giorgione ever earned in their lives. Being summoned to Rome by Bembo, then secretary of Leo X. and whose portrait he had done, to see the city and Raphael and the others, Titian kept putting it off, so that when Leo and Raphael died in 1520 he had never been there. For S. Maria Maggiore he did St. John the Baptist in the Desert,[3] a life-like angel, and a distant landscape with graceful trees over a river. He made portraits of Prince Grimani and Loredano, considered admirable, and afterwards of King Francis,[4] who was then leaving Italy to return to France.

The year that Andrea Gritti was appointed doge, Titian made a remarkable portrait of him in a picture containing the Virgin, St. Mark and St. Andrew.[5] This wonderful work is in the Collegio chamber. He has also painted the portraits of the other doges of his time, as he was bound to do, Pietro Lando, Francesco Donato, Marcantonio Trevisano, and Il Veniero. But he was excused on the ground of his great age from doing those of the brothers Pauli.

Pietro Aretino, the most celebrated poet of our day, having gone to Venice before the sack of Rome, became very friendly with Titian and Sansovino. This proved of great advantage to Titian, in spreading his name as far as Pietro's pen reached, especially to notable princes, as I shall relate.

But to return to Titian's works. He did the altarpiece of St. Peter Martyr in S. Giovanni e Paolo,[6] making the saint larger than life, in a wood of tall trees, fallen to the ground with a wound in the head from a soldier and showing the fear of death, while another friar is fleeing in terror. In the air are two nude angels issuing from the lightning which lights the lovely landscape and the whole work. It is the most complete, celebrated, the best-conceived and executed of all Titian's paintings. When

[1] Painted in 1523; now in the Vatican Gallery.
[2] Vasari himself does so in the Life of that master.
[3] Now in the Accademia, Venice.
[4] Probably the Louvre portrait, painted about 1530.
[5] Painted in 1531. Gritti became doge in 1522. The picture was destroyed by fire in 1577.
[6] Set up in 1530, destroyed by fire in 1867.

Titian's great friend Gritti saw it, who was also the patron of Sansovino, he gave him the scene of the rout of Chiaradadda to do in the hall of the Great Council. He represented the fury of the fighting soldiers in the midst of a terrible rain. It is considered the finest of the scenes in that hall.[1] At the foot of a staircase in the same palace he painted a Virgin in fresco. Not long after he did a Christ seated at table with Cleophas and Luke for a noble of ca Contarini.[2] The noble rightly thought it worthy of a public position, and generously gave it to the Signoria. It remained for some time in the doge's apartments, but it is now in the Golden Hall over the door leading into the hall of the Council of the Ten, where it may be seen by all. About the same time he did a Virgin mounting the steps of the Temple for the Scuola of S. Maria della Carita,[3] containing all manner of portraits. In the Scuola of S. Fantino he did a St. Jerome in penitence, much admired by artists, but destroyed by fire together with the church two years ago.

It is said that when Charles V. was at Bologna in 1530 Titian was summoned thither by Cardinal Ippolito de' Medici, through the influence of Pietro Aretino, to make the portrait of the emperor in full armour.[4] Charles was so pleased that he gave him 1000 crowns, of which he had to give half to Alfonso Lombardi, who had made a model for a marble bust, as related in his Life. On returning to Venice Titian found that many nobles had taken up Pordenone, loudly praising his works on the ceiling of the hall of the Pregai and elsewhere. They had obtained for him a commission to execute a panel in S. Giovanni Elemosinario, to be done in competition with Titian, who shortly before had done St. John the Almoner there habited as a bishop.[5] But Pordenone could not nearly attain to the excellence of Titian in spite of the diligence he displayed. Titian next did a fine Annunciation for S. Maria de' Angeli at Murano. But as they would not give the 500 crowns he demanded, he sent it, by the advice of M. Pietro Aretino, to Charles V., who was greatly pleased and gave him 2000 crowns. A picture of Pordenone was placed where this should have gone. When Charles V. returned to Bologna [6] leading the army of Hungary, to hold a conference with Pope Clement, he wanted to have a new portrait of himself by Titian, who before leaving Bologna also did a portrait of

[1] Done 1537–8; destroyed in the fire of 1577.
[2] Possibly the picture in the Louvre.
[2] Painted in 1540; now in the Accademia, Venice.
[4] Now in the Prado, Madrid.
[5] In 1533. [6] In 1532.

Cardinal Ippolito de' Medici, in Hungarian dress,[1] and a smaller one of him in full armour; both are now in the wardrobe of Duke Cosimo. At the same time Titian did portraits of Alfonso Davalos, the Marquis del Vasto,[2] and Pietro Aretino, who introduced him to Federigo Gonzaga, duke of Mantua. Titian proceeded to the dominions of the prince and made a life-like portrait of him and the cardinal, his brother, and did twelve busts[3] in a room decorated by Giulio Romano, of the twelve Cæsars, under each of which Giulio afterwards did a scene from their lives. In his native Cador Titian did a panel of the Virgin and St. Tiziano the bishop, with himself kneeling.[4] The year that Pope Paul III. went to Bologna[5] and thence to Ferrara Titian accompanied the court, and there painted a fine portrait of the Pope[6] and a replica for the Cardinal S. Fiore. Both were well paid for by the Pope, and are now in Cardinal Farnese's wardrobe at Rome, while many copies have been made which are scattered about Italy. About the same time Titian drew Francesco Maria, duke of Urbino, a marvellous work, on which M. Pietro Aretino wrote the sonnet beginning:

> *Se il chiaro Apelle con la man dell' arte*
> *Rassembro a' Alessandro il volto e il petto.*

The same duke's wardrobe contains two charming female heads[7] by Titian and a young recumbent Venus, surrounded by flowers and delicate draperies of great beauty, and a head of Mary Magdalene with dishevelled hair, a remarkable work. It also contains the portraits of Charles V., King Francis when young, Duke Guidobaldo II., Sixtus IV., Julius II., Paul III., the cardinal of Lorraine the elder, and the Sultan Solyman, all of great beauty. The same wardrobe has a portrait of Hannibal the Carthaginian carved in an ancient cornelian, and a beautiful marble bust by Donato.

In 1541 Titian did the high altarpiece for the friars of S. Spirito at Venice, representing the Descent of the Holy Spirit, God as fire and the Holy Spirit as a dove.[8] The picture being damaged some time ago the friars had it repaired, and it is now above the altar. In S. Nazzaro at Brescia he did the high altarpiece in five panels.[9] The middle one contains a Resurrection, with the soldiers, and at the sides are St. Nazaire, St. Sebastian,

[1] Now in the Pitti Gallery. [2] The Allegory, now in the Louvre.
[3] In 1536–7. [4] In 1560; more probably by his son Orazio.
[5] 1543. [6] Now in the Naples Museum.
[7] The former is now in the Uffizi and the latter in the Pitti Gallery.
[8] Now in S. Maria della Salute. [9] In 1522.

with Gabriel and the Virgin Mary forming an Annunciation. On the bottom wall of the Duomo of Verona he did an Assumption, considered one of the best modern works of the city. In 1541 he made a full-length portrait of Don Diego Mendoza, then ambassador of Charles V. to Venice, a handsome figure. From this time he began to make full-length figures, a practice which has since come into use. In that way he did the cardinal of Trent, then a youth.[1] For Francesco Marcotini he did a portrait of Pietro Aretino, but not so fine as that which Aretino sent to Duke Cosimo.[2] He also sent to the duke the portrait of his father Giovanni de' Medici [3] taken from a death-mask in Aretino's possession. Both are in the duke's wardrobe among numerous other noble paintings.

The same year, while Vasari was engaged in Venice for thirteen months in doing a ceiling for M. Giovanni Cornaro and some things for the company of la Calza, Sansovino, who was directing the building of S. Spirito, had obtained from him designs for three great oil-paintings for the ceiling. But as Vasari left they were allotted to Titian, who did them admirably, paying great attention to the foreshortening from below. One represents Abraham sacrificing Isaac, the second David and Goliath, and the third Cain killing Abel. At the same time Titian painted his own portrait for his children. In 1546 he went to Rome [4] at the summons of Cardinal Farnese and met Vasari, who had returned from Naples to decorate the hall of the cardinal's chancery. Titian being introduced by the cardinal to Vasari, the latter took him to see the sights of Rome, and after Titian had rested a few days apartments in Belvedere were given him to make portraits of Pope Paul, Farnese [5] and Duke Ottavio. These he executed admirably, to the great satisfaction of his patrons. At their persuasion he did an *Ecce Homo* for the Pope, but it did not seem a good work to artists, perhaps suffering by comparison with the paintings of Michelagnolo, Raphael, Pulidoro and others, and not being up to the level of his other works and portraits.

One day, when Michelagnolo and Vasari visited Titian at Belvedere, they saw a naked Danæ with Jupiter in her lap, transformed into a shower of gold, and praised it greatly as was polite. After they had gone Buonarrotti criticised Titian's

[1] Carlo Madruzzi, not painted before 1548.
[2] Now in the Pitti; painted in 1545.
[3] Painted in 1546; now in the Uffizi.
[4] It was the year before.
[5] Now in the Naples Museum.

methods, praising him a good deal, and saying he liked his colouring and style, but that it was a pity good design was not taught at Venice from the first, and that her painters did not have a better method of study. If this man, said he, were aided by art and design as he is by Nature, especially in copying from life, he would not be surpassed, for he has ability and a charming and vivacious style. This is very true, for without design and a study of selected ancient and modern works, skill is use-less, and it is impossible by mere drawing from life to impart the grace and perfection of Nature, so that certain parts frequently lack beauty.

Titian left Rome after receiving many gifts from his patrons, notably a rich benefice for his son Pomponio. He set out for Venice after Orazio, another son, had made a portrait of M. Batista Ceciliano, an excellent violinist, a very good work. Titian also did other portraits for Duke Guidobaldo of Urbino. Arrived at Florence, Titian was amazed at the treasures of the city as much as he had been at Rome. He visited Duke Cosimo at Poggio a Caiano, offering to paint his portrait, but the duke refused, possibly in order not to wrong the excellent native artists. On reaching Venice Titian finished an address to his soldiers for the Marquis del Vasto,[1] for whom he did portraits of Charles V., the Catholic king, and many others. That done, he painted a small Annunciation in S. Maria Nuova at Venice, and then assisted by his apprentices did a Last Supper for the refectory of S. Giovanni e Paolo. At the high altar of S. Salvadore he did a Transfiguration, and painted an Annunciation for another altar of that church. But though good he did not think highly of these last works, and they do not possess the perfection of his other paintings. It is almost impossible to mention all Titian's works, for they are countless, especially the portraits. Thus I shall only refer to the most important, and not in order of time, as that is of small consequence. He made several por-traits of Charles V., and did the last at the emperor's court, to which he had been summoned.[2] The emperor indeed, since he had known Titian, would allow no one else to portray him, and gave him 1000 crowns every time he painted him. Charles created Titian a knight, with a provision of 200 crowns on the chamber of Naples. When he also drew Charles's son Philip, King of Spain, he received from him another provision of 200 crowns, and these, added to his 300 crowns in the Fondaco de'

[1] Painted in 1541; now in the Madrid Gallery.
[2] Titian was at Augsburg in 1548; he was knighted in 1533.

Tedeschi, gave him an assured income of 700 crowns a year without it being necessary for him to do any work. Titian sent the portraits of Charles and Philip to Duke Cosimo, who has them in his wardrobe. He drew Ferdinand, king of the Romans, afterwards emperor, and all his children, including Maximilian, the present emperor, and his brother. He drew Queen Mary and the Duke of Saxony, when a prisoner, for Charles V. But why lose time on these? There is scarcely a famous prince or great lady but has been portrayed by this artist, who was truly remarkable in this particular. He made portraits of Francis I. of France, Francesco Sforza, duke of Milan, the Marquis of Pescara, Antonio da Leva, Massimiliano Stampa, Sig. Giovanbatista Castaldo, and countless others. He did besides many other works at various times. At Venice he did for Charles V. a large altarpicture of the Trinity with the Virgin and Child, the dove above and a background of fire representing Love, the Father surrounded by burning cherubim, with the emperor on one side and the empress on the other wrapped in linen, praying with clasped hands amid many saints, as the emperor directed. Charles was then at the height of his prosperity and had begun to betray his intention of withdrawing from the world, to die like a Christian and win salvation, as he subsequently did. He told Titian that he wanted this picture for the monastery where he afterwards ended his days, and an engraving of this very rare work is expected soon.[1] Titian did for Queen Mary a Prometheus bound to the Caucasus and attacked by Jove's eagle, Sisyphus [2] rolling his stone, and Tityus and the vulture. Her Majesty had all these, except the Prometheus, and in addition a Tantalus of the same size in oils on canvas. He also did a marvellous Venus and Adonis, the goddess fainting and the youth about to leave her, and they are accompanied by some most natural dogs. In a panel of the same size he did Perseus freeing Andromeda from the marine monster, a work of unsurpassable charm,[3] as is a Diana at the spring, with her nymphs converting Actæon into a stag. He also painted Europa crossing the sea on a bull.[4] These paintings are now in the possession of the Catholic king, who values them highly for the vivacity of the figures and the natural colouring.

Titian's methods in these paintings differ widely from those

[1] It was painted in 1554 and is now in the Prado, Madrid.
[2] The Prometheus and Sisyphus are now in the Prado, as is the Venus and Adonis, painted in 1554.
[3] Now in the Wallace Collection, Hertford House
[4] Painted in 1562.

he adopted in his youth. His first works are executed with a certain fineness and diligence, so that they may be examined closely, but these are done roughly in an impressionist manner, with bold strokes and blobs, to obtain the effect at a distance. This is why many in trying to imitate him have made clumsy pictures, for if people think that such work can be done without labour they are deceived, as it is necessary to retouch and recolour them incessantly, so that the labour is evident. The method is admirable and beautiful if done judiciously, making paintings appear alive and achieved without labour. Finally Titian did an Adoration of the Magi[1] in a picture three braccia high by four broad, with a number of figures a braccia high, a very charming work. So also is a replica of this done by him for the elder cardinal of Ferarra. He did another beautiful panel of Christ mocked by the Jews,[2] placed in a chapel of S. Maria delle Grazie at Milan. For the Queen of Portugal he did a fine Christ at the Column, somewhat smaller than life. For the high altar of S. Domenico at Ancona he did Christ on the Cross, with the Virgin, St. John and St. Dominic at the foot, in his later style. At the altar of St. Laurence, in the church of the Crocicchieri, at Venice, he did the martyrdom of that saint,[3] who lies fore-shortened on the gridiron, with men kindling the fire, and a number of figures and a building. As it is night two servants hold torches, which illuminate that part of the picture not lighted by the fire under the gridiron, which is large and very bright. He has also made lightning in the heavens, rending the clouds and overpowering the fire and the torches, above the saint and principal figures. In addition the people in the distance have lights and candles in their windows. In fine, the whole of th s beautiful work shows great art, ability and judgment. At the altar of St. Nicholas in S. Sebastiano Titian painted that saint on a stone seat with an angel holding his mitre, for M. Niccolo Crasso the advocate.[4] He then did a dishevelled Magdalene with her hair falling over her shoulders, throat and breast, to send to the Catholic king. She raises her eyes to heaven, showing her penitence in the redness of her eyes and her tears for her sin. This picture, therefore, greatly moves those who behold it, and what is more, although very beautiful, it moves not to lust but to compassion. When finished, it so pleased Silvio, a Venetian noble, that he gave Titian 100 crowns for it, so that the artist was forced to do another of equal beauty for the Catholic king.[5]

[1] Painted in 1560; now in the Prado, Madrid. [2] Now in the Louvre.
[3] Now in the Gesuiti, Venice; painted in 1556. [4] In 1563. [5] In 1561

Among Titian's portraits are one of a Venetian friend of his called Il Sinistri, and another of M. Paolo da Ponte, whose daughter Giulia he also drew, a beautiful maiden and his god-daughter. He also drew Signora Irene, a beautiful and learned maiden, a good musician and a student of design, who died about seven years ago, and was celebrated by almost all the writers of Italy. He drew M. Francesco Filetto, the famous orator, with his son in the same picture in front of him, who seems alive. This is in the house of M. Matteo Giustiniano, a patron of the arts, who has employed Jacomo da Bassano to paint a picture, of great beauty, like many other works of Bassano, scattered about Venice and much prized, most of them being small and representing animals of all kinds. Titian made another portrait of Bembo after he was cardinal, of Frascatoro, and of Cardinal Accolti of Ravenna, now in Duke Cosimo's wardrobe. Danese the sculptor has a portrait by Titian of a noble of ca Delfini. By the same hand are M. Niccolo Zono, la Rossa, wife of the grand Turk, aged sixteen, and Cameria her daughter, with beautiful dresses and hair. Titian's friend, the lawyer M. Francesco Sonica, has a portrait of himself by the master, and a large Flight into Egypt; the Virgin, having dismounted from the ass, is seated on a stone by the wayside with St. Joseph near, while the little St. John offers the Christ-child some flowers culled by an angel from the branches of a tree. In the middle is a wood full of animals, and in the distance the ass is grazing, the whole forming a most graceful picture, placed by the owner in his palace near S. Justina in Padua. In the house of a noble of the Pisani, near S. Marco, is a marvellous portrait of a lady by Titian. For Monsignor Giovanni della Casa, a Florentine, illustrious for his birth and learning, Titian did a beautiful portrait of a lady whom Giovanni loved in Venice, to which picture he wrote the sonnet beginning:

> Ben veggo io, Tiziano, in forme nuove
> l'idolo mio, che i begli occhi apre e gira.

Finally Titian sent to the Catholic king a Last Supper [1] of extraordinary beauty, seven braccia long. Besides these and many other less important works he has the following things in his house, which he has sketched out and begun: the Martyrdom of St. Laurence [2] like the one mentioned, intended for the Catholic king; a large Crucifixion done for M. Giovanni d' Arna; a picture begun for the Doge Grimani, father of the

[1] Painted in 1564; in the Escorial. [2] Sent to Spain in 1567.

Patriarch of Aquilea; and three large pictures begun for the hall of the great palace of Brescia[1] to decorate the ceiling, as related in the notice of Cristofano and his brother, Brescian painters. Many years ago he began for Alfonso I., duke of Ferrara, a naked maiden bowing to Minerva; there is a figure beside her and the sea in the distance with Neptune in his chariot. Owing to the duke's death it was left unfinished, and remained on Titian's hands. He has also nearly finished a *Noli me tangere*, with life-size figures, and another picture of Christ laid in the sepulchre, with the Virgin and the other Maries. There is another Madonna which is among the good things in the house. He has also done an excellent portrait of himself, as already related, finished four years ago. Finally he has done a half-length figure of St. Paul reading, who seems filled with the Holy Spirit. All these and many more he has done up to his seventy-sixth year. He has always been a most healthy and fortunate man, beyond any of his fellows, and has received nothing but favours from Heaven. His house at Venice has been frequented by all the princes, learned men and gallants of his time, because in addition to his genius he possesses the most courtly manners. He has had some rivals in Venice whom he has easily surpassed, and he has retained the favour of the nobles. He has gained much wealth, as his works have been well paid for, and in his latter years he would have done well to have worked only for amusement, in order not to circulate works which may damage a reputation won in his best years. When the present writer was in Venice in 1566 he visited Titian as his friend, and found him, old as he was, engaged in painting. I was pleased to see his works and to talk with him, and he introduced me to M. Gian. Maria Verdezzotti, a young Venetian noble of great ability, the friend of Titian, and a fair designer and painter, as shown by some admirable landscapes. He has two figures, Apollo and Diana, painted by Titian, who treats him as his son.

Titian therefore having adorned Venice, Italy and other parts of the world with noble paintings, deserves the honour of artists, and to be imitated in many things, for his works will endure as long as the memory of famous men. Although many have studied under him, the number of his actual pupils is not large, as he did not teach much, the pupils picking up more or less from his works according to their aptitude. Among others he had one Giovanni, a Fleming,[2] and a praiseworthy master, both in small and large

[1] Destroyed by fire in 1575. [2] Johannes Calcar.

figures, and marvellous in portraits. He lived some time at
Naples, and died there. His were the anatomical designs engraved
and published by Andrea Vesalio, with his works, and they are
worthy of honour for all time.

But the closest imitator of Titian was Paris Bordone.[1] Born
at Treviso, of a Trevisan father and Venetian mother, he was
brought to Venice at the age of eight, to stay with certain of
his kindred. After learning grammar and having become an
excellent musician, he went to Titian, but did not remain long,
for he perceived that the master was not very painstaking with
his pupils, and decided to leave, although the others urged him
to stay and have patience. He grieved much that Giorgione was
then dead, for that master's style pleased him exceedingly, and
he thought much more of Giorgione's reputation of being a
willing and careful teacher of what he knew. Not being able to
do better, Paris resolved to adopt Giorgione's style. He succeeded
well and acquired great credit, so that at eighteen he was com-
missioned to do a picture for the Franciscan church of S. Niccolo.
Titian, however, succeeded, by means of his influence and
favour, in depriving him of it, and prevented him from showing
his skill, perhaps induced by a desire of gain. Paris was next
summoned to Vicenza to do a scene in fresco in the loggia of
the piazza, next to Titian's Judgment of Solomon. He did a
scene of Noah and his sons, considered as fine as Titian's, indeed
those who do not know the truth believe both to be by the same
hand. Returning to Venice Paris did some nudes in fresco at the
foot of the Rialto bridge, which led to his employment in doing
façades for houses in Venice. Summoned to Trevisi, he there did
façades and other works, including many portraits, which gave
considerable satisfaction, of M. Alberto Unigo, M. Marco Sera-
valle, M. Francesco da Quer, the Canon Rovere and Monsignor
Alberti. In the middle of the duomo there he did a Nativity,
and then painted a Resurrection at the instance of the vicar.
In S. Francesco he did a panel for the knight Rovere, another
in S. Girolamo, and one in Ognissanti,[2] with various saints in
divers attitudes and habits, all being beautiful. He did another
panel in S. Lorenzo, and decorated three chapels in S. Polo[3];
in the principal one he did a Resurrection, in the second saints
and angels, and in the third Christ in a cloud, and the Virgin
presenting St. Dominic to Him. All these works have proved
Paris to be a skilful man, fond of his city.

In Venice, where he almost always lived, he has done many

works at various times. The finest of these and the best he ever did is in the Scuola of S. Marco by S. Giovanni e Paolo, of the fisherman presenting the ring to the Signoria of Venice, with a fine building in perspective, about which the doge and senate are seated.[1] Many of the senators are portraits and wonderfully vigorous. The beauty of this work led to his employment by many nobles; thus for the great Foscari house by S. Barnabà he did many pictures, including Christ in Hades, considered a remarkable thing. In S. Job on the Reio canal he did a fine panel, and another in S. Giovanni in Bragola, and the like at S. Maria della Celeste and S. Marina. But seeing that to win employment in Venice it was necessary to court favour too much, Paris, being a quiet man and averse from such ways, resolved to do only the works that fortune put in his way, and not to go begging for employment. Accordingly in 1538 he took an opportunity to go to France to serve King Francis, and did many portraits of ladies and various other paintings. At the same time he painted a fine picture of a church for Monsignor de Guise, and did a Venus and Cupid for his chamber. For the cardinal of Lorraine he did an *Ecce Homo*, Jupiter and Io, and many other works. To the King of Poland he sent a beautiful painting of Jupiter and a nymph. To Flanders he sent two other fine pictures, St. Mary Magdalene in the desert with angels and Diana bathing with her nymphs, done for Candiano of Milan, physician of Queen Mary, to be presented to her. He did several works for the palace of the Fuggers at Augsburg, valued at 3000 crowns. He did a large picture for the Prineri, great men of the same city, including the five orders of architecture in perspective. He also did a chamber picture owned by the cardinal of Augsburg. In S. Agostino at Crema he did two pictures, one a portrait of Sig. Giulio Mafrone as St. George in full armour. He did many admirable works in Civitale di Belluno, notably a panel in S. Maria and another in S. Giosef of great beauty. To Sig. Ottaviano Grimaldo at Genoa he sent a portrait of life-size and great beauty, and another one of a luxurious lady. Proceeding to Milan he did a panel for the church of S. Celso of some figures in the air and a landscape below, at the instance of Sig. Carlo da Roma, it is said, in whose palace he did two large oil-paintings: a Venus and Mars under Vulcan's net and David watching Bathsheba bathing with her attendants. He next did the portrait of his patron and of Paula Visconti his wife, with some beautiful little fragments of landscape. At the same time he painted several fables of Ovid

[1] Painted in 1540; now in the Accademia, Venice.

for the Marquis of Astorga, who took them with him to Spain. For Sig. Tommasso Marini he painted many things which I need not mention. Let this suffice for Paris. At the age of seventy-five he remains quietly at home, working for pleasure and at the request of some princes and other friends, shunning rivalry and vain ambition to avoid the disturbing influence of the malignant and envious, so that he lives quite simply. He has done a fine picture for the Duchess of Savoy of Venus and Cupid sleeping, guarded by a servant, which cannot be over-praised.

But here I must speak of a kind of painting which, though abandoned elsewhere, still flourishes at Venice, namely mosaic. The chief cause of this was Titian, who has himself worked at it and has procured honoured provisions for those who have done the like. Thus divers works have been carried out, the old mosaics in S. Marco being nearly all restored, in a much more excellent style than was known in Florence and Rome in the time of Giotto, Alesso Baldovinetti, the Ghirlandaio and Gherardo the illuminator. Titian and other excellent painters designed all those done in Venice, making designs and coloured cartoons, and attaining the perfection now seen in the porch of S. Marco, where in a niche there is a fine Judgment of Solomon of the utmost beauty that could not be better done in colours. In the same place is the tree of the Virgin by Ludovico Rosso, full of sybils and prophets, in a harmonious and gentle style with good relief.[1] But no one has done better in this art in our day than Valerio and Vincenzio Zuccheri,[2] Trevisans, who have executed several scenes in S. Marco, notably that of the Apocalypse, with the Evangelists in the form of animals about the throne of God, the seven candlesticks and many other things, so well done that from below they look like oil-paintings. They have also done many small pictures which resemble illuminations, though they are inlaid stone. There are also portraits of Charles V., Ferdinand his brother who succeeded him in the empire, and Maximilian, Ferdinand's son, the present emperor. There also is the head of the illustrious Bembo, the glory of our century and that of the Magnificent . . . , executed with un-equalled diligence and harmony, with unsurpassed management of the lights, flesh-tints, shadows and other things. It is a pity that this excellent art of mosaic, owing to its beauty and dura-bility, is not more practised than it is, and that princes who can have it done pay no attention to it. Bartolommeo Bozzato has also done mosaics in S. Marco in competition with the Zuccheri,

[1] 1542-52. [2] *Rectius* Zuccati.

and has always produced admirable work. But the presence and advice of Titian have been of the greatest assistance. He had a pupil called Girolamo,[1] who assisted him in many works. I do not know his surname except di Tiziano.

JACOPO SANSOVINO, Sculptor and Architect
of the Venetian Republic
(1486 – 1570)

THE family of Tatti in Florence is mentioned in the books of the commune as early as 1300 as having come from Lucca, a noble city of Tuscany, and has always possessed numbers of industrious and distinguished men, highly favoured by the Medici. Of this house was Jacopo, the subject of the present memoir, born in January 1477, his father being one Antonio, a very worthy man, and his mother Francesca. In his boyhood he received the usual instruction, and early showed intelligence, and beginning to design a little on his own account he soon showed that Nature intended him for this more than for letters. Thus he went unwillingly to school, and learned the tiresome elements of grammar unwillingly. His mother, whom he greatly resembled, perceived this and helped him, having him taught design in secret, for she wished her son to be a sculptor, to emulate the rising glory of Michelagnolo Buonarrotti, then a youth, and she was moved by the omen that both Jacopo and Michelagnolo were born in the same via S. Maria, near the via Ghibellina. But after some time the child was put to trade, which he found even more distasteful than letters, and he besought his father to allow him to follow his natural bent.

At that time Andrea Contucci of Monte a Sansovino, the home of Julius III., came to Florence with a reputation both in Italy and Spain of being the best sculptor and architect after Buonarrotti. He remained in the city to do two marble figures. Jacopo was sent to him to learn sculpture. Andrea recognised the boy's promise, and carefully taught him all he knew, and he became very fond of him, and the youth returned his affection, while men judged that he would not only equal but far surpass his master. Such was the affection between the two, who were like father and son, that Jacopo began to be known as del Sansovino and not as de' Tatti, and the title will cling to him for ever.

[1] Girolamo Dante.

Jacopo's natural ability was such that, although he did not show much diligence, he produced his work with ease, grace and a certain lightness pleasing to the eye, so that every sketch of his possesses movement and vigour, such as few sculptors show. He derived great assistance also from his friendship from child-hood with Andrea del Sarto, as they followed the same style in design and achieved the same grace in execution, the one in painting, the other in sculpture, and helped each other by discussing difficulties, Jacopo making models for Andrea. The picture of St. John the Evangelist for S. Francesco of the nuns of via Pentolini was thus copied from a fine clay model made by Sansovino at the time in competition with Baccio da Montelupo.

The art of Porta S. Maria wishing to have a bronze statue of four braccia set up in a niche of Orsanmichele, opposite the cloth-shearers, preferred to allot it to Baccio as the older master, although Jacopo made the finer clay model. This model is now owned by the heirs of Nanni Unghero, and is of great beauty. Being then friendly with Nanni, Jacopo made him some large clay models of children, and one of St. Nicholas of Tolentino which were carried out in wood, of life-size and placed in the saint's chapel at S. Spirito. By these things Jacopo became known to all the artists of Florence, and as he was considered intelligent and of a good character, Giuliano da S. Gallo, the architect of Julius II., took him to Rome, to his great delight. The ancient statues in Belvedere pleased him beyond measure, and he set himself to copy them. Bramante, also architect of Julius, who then lived in Belvedere, on seeing these drawings and a recumbent figure in relief done for an inkstand, began to take notice of the youth, and directed him and Zaccheria Zachi of Volterra, Alonso Berughetta a Spaniard, and Vecchio da Bologna,[1] to make large wax models of the Laocoon, which he had copied, to be cast in bronze. When all were done Bramante brought Raphael to see them, who decided that the young Sansovino had far surpassed the others. So, by the advice of Cardinal Domenico Grimani, Bramante directed that Jacopo's model should be cast in bronze. This was successfully done, and he gave the cast to the cardinal, who valued it as much as the original, and left it at his death to the Signoria of Venice. After keeping it for many years in the treasury of the hall of the Council of Ten, they at length gave it to the cardinal of Lorraine in 1534, who took it to France.

[1] Domenico Aimo, called Il Varignana.

While Sansovino was steadily gaining a reputation in Rome, Giuliano da S. Gallo fell sick at his house in Borgo Vecchio, and was carried in a litter to Florence for a change of air. Sansovino had lodged with him, and Bramante found him a room in the same borgo in the palace of Domenico dalla Rovere, cardinal of S. Clemente, where Perugino then lodged, being engaged in painting the chamber of the Borgia Tower for Pope Julius. Seeing Sansovino's good style, Pietro got him to make wax models for him, including a Deposition from the Cross, with many ladders and figures of great beauty. These models were afterwards collected by M. Giovanni Gaddi, and are now in his house on the piazza di Madonna in Florence. Thus Sansovino came into close relations with Luca Signorelli, Bramantino of Milan, Bernardino Pinturicchio, Cesari Cesariano, then famous for a commentary on Vitruvius, and many other distinguished spirits of the age. Bramante wishing to make him known to Pope Julius, asked him to restore some antiquities. In this he showed such grace and diligence that the Pope and all who saw them decided that they could not be improved upon. This praise spurred Sansovino to renewed study, but being delicate and with some disorder caused by the escapades of youth, he fell sick, and was forced to return to Florence to save his life. Restored by his native air, his youth and the care of the physicians, he soon recovered completely.

M. Pietro Pitti required a marble Madonna for the façade of the Mercato Nuovo, containing the clock, and decided to give it to the one who made the best model among the numerous skilful masters, young or old, then in Florence. Accordingly he sent a Bacchus to be made by Baccio da Montelupo, Zaccheria Zachi of Volterra, who had also returned to Florence that year, Baccio Bandinelli and Sansovino, to be judged by that worthy man and famous painter Lorenzo di Credi. He awarded the palm to Sansovino, as did the other judges, artists and connoisseurs. But although Jacopo received the work he had much difficulty in obtaining the market through the envy of Averardo da Filicaia, who favoured Bandinello and hated Sansovino and did everything to delay the work. The other citizens, indignant at this, decided that he should do one of the large marble Apostles for S. Maria del Fiore. He therefore made a model of St. James, subsequently given to M. Bindo Altoviti, and executed with such perfection that he produced a marvellous figure showing extraordinary study in every part, in the draperies, arms and hands, with a grace unequalled in marble. He has made the

folds of the drapery so slender in places that it is not thicker than cloth, and shows the texture, a difficult task demanding great patience and showing the perfection to which art has attained. Sansovino finished it in 1565, and it was placed in S. Maria del Fiore in December to honour the coming of Queen Joan of Austria, wife of Don Francesco de' Medici, prince of Florence and Siena. It is considered rare among the other marble Apostles executed in competition by other artists, as related in their Lives. At this time he made a beautiful marble Venus in a niche for M. Giovanni Gaddi; the model was in the house of M. Francesco Montevarchi, a great friend of art, but it perished in the flood of the Arno in 1558. For M. Giovanni Jacopo did a boy of tow, a marble swan of unequalled beauty, and many other things. For M. Bindo Altoviti he got Benedetto da Rovezzano to decorate a chimney with carved macigno at great expense, where Sansovino did a scene in small figures for the frieze of Vulcan and the other gods, a remarkable work. Much finer are the two marble boys supporting the Altoviti arms, which have been removed by Don Luigi di Toledo, who now lives there, to a fountain in his garden in Florence, behind the Servites. Two other marble boys by him of extraordinary beauty are in the house of Giovan Francesco Ridolfi, also supporting arms.

All these works established Sansovino's reputation as an excellent master at Florence and among artists. Thus Giovanni Bartolini, having built a lodge in his garden of Gualfonda, wished Sansovino to make him a young marble Bacchus of life-size. The model so pleased Giovanni that he gave Jacopo the marble, and the artist worked at it with a will that gave wings to his hands and ideas. He wished to make it perfect, studying from life a boy of his called Pippo del Fabbro, making him stand naked most of the day, although it was winter. When finished, the statue was considered the finest work of a modern master for the unusual treatment of an uplifted arm holding a cup of the same marble, with carefully perforated fingers, the whole attitude being harmonious from every point of view, and the arms and legs appear to be living flesh both to sight and touch, so that those who see it admit its reputation to be well deserved and not high enough. When it was finished, during Giovanni's life, all strangers and natives alike came to admire it in that court of Gualfonda. But after Giovanni's death his brother Gherardo Bartolini gave it to Duke Cosimo, who keeps it in his rooms as a rare work, with other beautiful

marble statues.[1] For Giovanni Jacopo also did a handsome wooden crucifix, now in their house, with many works by the ancients and Michelagnolo. For the reception in Florence of Leo X., in 1514, the Signoria and Giuliano de' Medici directed the erection of many wooden triumphal arches in various parts of the city. Sansovino not only designed many of these but helped Andrea del Sarto to make the wooden façade of S. Maria del Fiore, with statues, scenes and orders of architecture, as it should have been, although in the German style. Not to speak of the canvas covering done to cover the piazza of S. Maria del Fiore on St. John's day, I must say that Sansovino made the façade of the Corinthian order, like a triumphal arch, with a front on double columns and niches between filled with figures of the Apostles, and above them half-relief scenes from the Old Testament painted like bronze, some still being in the Lanfredini house, on the lung' Arno. Over all were projecting architraves, friezes and cornices and beautiful frontispieces. The angles of the arches contained scenes in grisaille, beautifully painted by Andrea del Sarto. In short, when Pope Leo saw this work of Sansovino he said it was a pity it was not the real façade begun by Arnolfo. For the same occasion Sansovino did a horse of clay jumping over a prostrate figure, on a pedestal, the figure being of nine braccia. The vigour of this gave great pleasure and earned the praise of Pope Leo. Jacopo Salviato accordingly took Sansovino to kiss the Pope's foot, who showed him great favour. When the Pope left Florence to confer with Francis I. at Bologna, he decided to return to the city. Jacopo was therefore directed to erect a triumphal arch at the S. Gallo gate, and he made it marvellously beautiful like the others, full of excellent statues and paintings. The Pope having decided on a marble façade for S. Lorenzo, Sansovino prepared designs by his order, while awaiting the arrival of Raphael and Buonarrotti from Rome, and Baccio d' Agnolo was employed to make a wooden model from them. Buonarrotti having made another, he and Sansovino were directed to go to Pietrasanta. There they found a quantity of marble, but difficult to remove, and they lost so much time that when they returned to Florence they found the Pope had left for Rome. Thither they both went with their several models, Jacopo arriving as Buonarrotti was showing his to the Pope in the Borgia tower. He did not obtain what he expected, for he thought he should at least do some of the statues under Michelagnolo, as the Pope had promised him and informed

[1] Now in the Bargello, Florence.

Michelagnolo, but on reaching Rome he learned that Buonarrotti wished to work alone.

That he might not return empty-handed to Florence, he decided to remain in Rome to study sculpture and architecture. Having undertaken a marble Virgin and Child for Giovan Francesco Martelli of Florence, he made them of great beauty, and they were set up over an altar on the right of the principal door of S. Agostino. He gave the clay model to the prior de' Salviati, who put it in a chapel of his palace at the corner of the piazza of S. Pietro at the end of the Borgo Nuovo. Not long since he did a marble St. James of four braccia for the altar of the chapel built by Cardinal Alborense in the Chapel of the Spaniards at Rome, possessing movement and grace and executed with finish and judgment, bringing him great fame. While thus engaged he began the Servite church of S. Marcello after preparing the plans and model, a work of great beauty. For M. Marco Cosci he did a fine loggia in the via Flaminia leading from Rome to Pontemolle. For the company of the Crucified of the church of S. Marcello he did a graceful wooden processional crucifix. For Cardinal Antonio di Monte he began a large structure at his villa on the Acqua Vergine, outside Rome. A marble portrait of the cardinal on the door of the principal hall of the palace of Sig. Fabiano at Monte Sansovino is perhaps by Jacopo. He built the convenient house for M. Luigi Leoni, and a palace for the Gaddi in Banchi afterwards bought by Filippo Strozzi, of great beauty and very ornate.

The Florentine nation being at that time raised up by the favour of Pope Leo, by comparison with the Germans, Spaniards and French, who had begun or finished the churches of their nations in Rome, they asked permission to build a church for themselves. The Pope gave instructions for this to Ludovico Capponi, then their consul, and it was decided to erect a great church to St. John the Baptist behind Banchi at the end of Strada Julia, on the Tiber, which for grandeur, costliness and design should surpass those of the other nations. Competitive designs were submitted by Raphael, Antonio da Sangallo, Baldassarre of Siena and Sansovino, and after seeing all the Pope picked out Jacopo's as the best. It had a tribune at each of the four sides and a larger one in the middle, like the plan in the second book of architecture of Sebastiano Serlio.[1] The heads of the nation with the Pope's

[1] Sebastiano Serlio was an architect of Bologna. His treatise on architecture was divided into seven books. He was engaged on work at the palace of Fontainebleau, and died in 1578.

concurrence then began a part of this church, twenty-two yards long. But as there was not room, and they wanted the façade to be on the Strada Julia, in a line with the houses, they had to encroach at least fifteen yards on the Tiber. This pleased many as being more magnificent and costly, and beginning the work they spent more than 40,000 crowns, which would have sufficed to build more than half the church. Meanwhile Sansovino fell down and injured himself seriously, being taken to Florence to recover, and leaving his work to Antonio da Sangallo. But before long the death of Leo deprived the nation of its principal support, and the building was abandoned during the life of Adrian VI. On the election of Clement it was ordained that Sansovino should return and finish the building on the original plan. So it was taken up, and meanwhile he undertook to make the tombs of the cardinals of Aragon and Agen, beginning the marble for the decoration and making several models for the figures. All Rome was in his power, for he did many things for all those lords, being favoured by the three popes, and especially by Pope Leo, who gave him a knighthood of St. Peter, which he sold when ill and expecting death.

But to chastise the pride of Rome God permitted Bourbon and his army to sack it on the six days of May 1527. In this disaster, when so many men of genius suffered, Sansovino was forced to fly to Venice, to the great loss of Rome. He intended to proceed to France to serve the king, who had sent for him. But while he was at Venice arranging his affairs, for he had lost everything, Prince Andrea Gritti, a great patron of genius, heard of his arrival and desired to see him. It happened that at the selfsame moment Cardinal Domenico Grimani had told him that Sansovino was just the man to repair the cupola of S. Marco, their principal church, which from bad foundations, age and faulty construction was cracking and threatening to fall. So Andrea sent for Jacopo, received him graciously, and after a long discussion asked him to repair the tribune. Jacopo promised, and at once began the work. He supported the whole of the interior with a wooden framework to bear the vault, securing the exterior with iron bands and shoring up the walls, while he made new foundations under the piers and rendered the building safe for ever. His work amazed Venice and pleased not only Gritti but the senate, who, as the master of the procurators of S. Marco died at the time, gave Jacopo the foremost post among their engineers and architects, with the house and a good provision.[1]

[1] In 1529.

In that office Jacopo showed every care for the buildings, and in the management of the accounts and books, and in all the duties of his position. He became very friendly with the rulers, rendering their things grand and beautiful, making the church, city and piazza more beautiful than any previous holder of the office had done, illuminating everything by his genius, though with little or no expense to the rulers. Thus, in 1529, between the two columns of the piazza were some butchers' stalls and several wooden conveniences, a great blot on the dignity of the palace and piazza, and they were the first things seen by strangers entering Venice by way of S. Giorgio. Jacopo showed Prince Gritti his intention of removing these to their present situation, and by making some places for vegetable-sellers he increased the income of the Procurazia by seven hundred ducats yearly, while he embellished the piazza and the city. Not long after he saw that by removing a house in the Merceria leading to the Rialto near the clock, which paid only twenty-six ducats rent, he could make a street to the Spadaria, increasing the rents of the houses and shops all round, and so he had the house pulled down, making a gain of one hundred and fifty ducats a year. He also built the hostelry of il Pellegrino on that spot, and another in campo Rusolo, which brought in four hundred ducats. He carried out similar improvements in the buildings in Pescaria, and in several other places, so that during his term of office he is reckoned to have enriched the city by more than two thousand ducats a year. Not long after, by the order of the procurators, he began [1] the beautiful and rich library opposite the public palace, in the Corinthian and Doric orders, with carvings, cornices, columns, capitals and half-length figures everywhere, without sparing any expense, for it is full of rich pavements, stucco scenes in the rooms and public staircases decorated with paintings as related in the Life of Battista Franco, besides having many rich ornaments which give majesty and grandeur to the principal door, all of which go to prove Sansovino's great ability. This has led to all houses and palaces in the city, which were formerly built in the same style in the same proportions, being erected with new designs and better order, following Vitruvius. This work is considered peerless by many good judges who have seen much of the world. Jacopo then built the palace of M. Giovanni Delfino beyond the Rialto on the Grand Canal opposite the Riva del Ferro, at a cost of thirty thousand ducats. [2] He also built the palace of M. Leonardo Moro at S. Girolamo, which

[1] In 1536. [2] Now Manin.

closely resembles a fortress. He erected the palace of M. Luigi
de' Garzoni, thirteen paces every way larger than the Fondaco
de' Tedeschi, with water supplied in every part and adorned with
four handsome figures by Sansovino. It is at Ponte Casale. But
most beautiful of all is the palace of M. Giorgio Cornaro on the
Grand Canal,[1] undoubtedly surpassing the others in convenience,
majesty and grandeur, and reputed the finest in Italy. Passing
over private things, he also built the Scuola della Misericordia,
a very considerable work, costing a hundred and thirty thousand
crowns, which when finished will prove the most superb edifice
of Italy. His also is the bare-footed friars' church of S. Fran-
cesco della Vigna, a grand and important work, though the
façade is by another master.[2] He designed the Corinthian
loggia about the campanile of S. Marco, richly decorated with
columns and four niches containing four bronze figures of great
beauty, rather less than life-size, and various bas-reliefs.[3] This
forms a handsome base to the campanile, one face being thirty-
five feet long, and so is Sansovino's ornament, which is one
hundred and sixty feet high from the ground to the cornice of
the bell-windows, and one hundred and twenty-five feet from
the cornice to the corridor above, the dado above which is
twenty-eight and a half feet high. From the level of the
corridor to the pyramid is sixty feet to the point where the
angel stands, on a square six feet high, the angel which turns
with every wind being ten feet, making a total height of two
hundred and ninety-two feet.

But the finest, richest and strongest of Jacopo's buildings is
the mint of Venice,[4] constructed entirely of iron and stone,
without a scrap of wood, as a precaution against fire. The
interior is conveniently arranged, no mint in the world being so
well adapted for the work, or so strong. It is entirely in rustic-
work, not seen before in that city, where it excited considerable
wonder. His also is the charming church of S. Spirito in the
lagoons. In Venice the façade of S. Gimignano gives splendour to
the piazza, as the façade of S. Giuliano does to the Merceria, and
the rich tomb of Prince Francesco Veniero[5] to S. Salvador. He
also did the new vaulting for the Rialto on the Grand Canal,
making a convenient place where a market is held almost every
day for the natives and others who resort to the city. Very wonder-
ful and novel was his work for the Tiepoli at the Misericordia, in

[1] Palazzo Corner Ca Grande; now the Prefettura, erected in 1532.
[2] Palladio.
[3] Begun in 1540; destroyed by the fall of the campanile in 1902.
[4] Begun in 1536. [5] Who died 1536.

making new foundations of large stones under their sumptuous palace on the Grand Canal, which owing to bad foundations would have fallen in a few years, while the owners now live there in absolute safety. In spite of these numerous buildings, he never ceased to make beautiful works in marble and bronze for his own delight. Above the holy water-vessel of the friars of ca Grande[1] is an admirable marble St. John the Baptist by him.

The chapel of the Santo at Padua contains a large marble half-relief of a miracle of St. Anthony of Padua, highly valued there. At the bottom of the steps of the palace of S. Marco he made two colossal figures, seven braccia high, of Neptune and Mars, to show the power of the republic by land and sea.[2] For the Duke of Ferrara he made a fine statue of Hercules, and did six bronze half-reliefs for S. Marco of the life of St. Mark, one braccia long by one and a half high, to decorate a pulpit, which are much prized for their variety. Over the door of S. Marco he did a life-size marble Virgin, considered very beautiful. The bronze door of the sacristy is also his. It is divided into two parts, containing scenes from the life of Christ excellently done in half-relief. Over the arsenal door he did a beautiful marble Virgin and Child. All these works have at once adorned the republic, displayed the genius of Sansovino and the magnificence and liberality of the rulers and also of the artists, in giving him all the sculpture and architecture executed in the city in his day. In truth, Jacopo's ability merited the recognition of his pre-eminent position in the city among artists, and nobles and common people alike admired his talent. Among other things his knowledge and judgment have practically renewed the city, where he has taught the true methods of building. Three beautiful stucco figures of his are still in the hands of his son, a Laocoon, a Venus and a Madonna surrounded by angels, all unequalled in Venice. This son also has designs by Jacopo for sixty churches, unsurpassed from the time of the ancients onwards. I have heard that the son will publish them for the benefit of the world, and that he has already had some engraved, accompanying them with designs of his father's labours in various parts of Italy.

Sansovino was always ready to serve the procurators, in spite of his numerous public and private labours, for foreigners also flocked to him for models and designs for buildings, for figures or advice, including the Duke of Ferrara who had a colossal Hercules, and the Dukes of Mantua and Urbino. The procurators on their part did nothing without his help or advice, and were

[1] The Frari. [2] In 1567.

always employing him for their friends and relations as well as themselves, and he was always ready to take any pains to satisfy them, without any reward. He was most prized and loved by Prince Gritti, by M. Vettorio Grimani, the cardinal's brother, by M. Giovanni da Legge, the knight, all procurators, and by M. Marcantonio Giustigniano, who knew him in Rome. These illustrious men of the world fully recognised his worth and valued him accordingly, as did all the city, knowing that the office had never seen his like, and being well aware of his reputation in Florence, Rome and all Italy among princes and able men, and they felt that his descendants as well as himself should derive lasting benefits from his singular merits.

Jacopo was of medium stature, not stout, and upright in bearing. He was fair, with a red beard, and in his youth very handsome and graceful, so that many ladies of rank fell in love with him. In age he appeared venerable with a white beard, and walked like a young man, so that at ninety-three he was strong and healthy and could see the smallest things without glasses. When writing he kept his head up, and did not lean as others do. He was fond of dressing well and was always polished in person. He enjoyed the society of women to his extreme old age and was fond of conversing with them. In his youth his disorders injured his health, but he felt no ill-effects in age, so that for fifty years he would never send for a physician although he sometimes felt unwell. Nay, when he had an apoplectic stroke for the fourth time at eighty-four, he recovered by remaining two months in bed in a dark, warm place, refusing medicine. His stomach was so good that he could eat anything, and in summer he lived almost exclusively on fruit, often eating as many as three cucumbers at a time with half a lemon in his extreme old age. He was of a most prudent disposition, looking into the future, and judging things by the past; he was attentive to his affairs, spared no pains and never left his work for pleasure. He talked well and fluently upon anything he understood, choosing his illustrations with great felicity, and this rendered him agreeable to great and small as well as to his friends. His memory remained green in his last years, and he clearly recalled his childhood, the sack of Rome, and many events which had happened in his time. He had a high spirit, and from a youth delighted to compete with his betters, for he said this was the way to succeed, and with inferiors one grew worse. He valued honour above everything, kept his word faithfully, and his patrons frequently had proof of his inflexible integrity, so that they considered him not as

their servant but as a father and brother, honouring his un-feigned goodness. He was liberal to all, and often deprived himself to oblige his relations, and he lived in honour and repute, esteemed by all. If at times he allowed himself to be overcome by passion, for he was very hot-tempered, it was soon over, and often a few humble words would bring tears to his eyes.

He bore a passionate love for sculpture, and to keep the art vigorous he instructed many pupils, forming a seminary of that art in Italy. Among those who became famous were Niccolo Tribolo and Solosmeo, Florentines, Danese Cattaneo of Carrara, of great excellence in poetry as well as sculpture, Girolamo da Ferrara, Jacopo Colonna of Venice, Luca Lancia of Naples, Tiziano da Padova, Pietro da Salò, Bartolommeo Ammannati of Florence, the present sculptor and proto-master of the Grand Duke of Tuscany, and lastly Alessandro Vittoria of Trento, most rare in marble portraits, and Jacopo de' Medici, a Brescian. These keeping alive the memory of their master by their ability have produced many notable things in various cities. Jacopo was much honoured by princes, Alessandro de' Medici asking his opinion on the making of the citadel of Florence. Duke Cosimo also, when Sansovino went to Florence on his affairs in 1540, came to ask his opinion on the same fortress and en-deavoured to induce Jacopo to enter his service, offering him a large provision. When he returned from Florence, Duke Ercole of Ferrara detained him and made every effort to keep him. But he had become accustomed to Venice, where he had passed a great part of his life, and being much attached to the pro-curators, who greatly honoured him, he would not be persuaded by anyone. Paul III. also sent for him to take charge of S. Pietro in place of Antonio da San Gallo, employing for this Monsignor della Casa, then legate in Venice. But all was in vain, for he declared he would not leave a republic to live under an absolute prince. King Philip of Spain, passing through Germany, showed him great favour at Peschiera, whither Jacopo had gone to see him. Sansovino was excessively desirous of glory, and spent much to that end in order to leave a memorial of himself, to the loss of his descendants. Connoisseurs say that, although he yielded to Michelagnolo, he was superior in some things, having no peer in making draperies, children and the expression of women. His marble draperies were slender, well executed in beautiful folds, showing the lines of the body, while he made his children soft, tender, without such muscles as adults have, their fleshy arms and legs being exactly like life. His women are sweet and charming

and of the utmost grace, as is clearly seen by various Virgins of his in marble and bas-relief, his Venuses and other figures in various places. This man, so celebrated in sculpture and distinguished in architecture, having lived in favour with God and man, endowed with splendid talents, lived to the age of ninety-three, when feeling somewhat tired he went to bed to rest, and without any sort of illness, though he tried to rise and dress himself, he remained there for a month and a half, gradually failing, received the sacraments of the Church, and although he hoped to live a year or so, he died on 2 November, 1570, when, in spite of his great age, his loss grieved all Venice. He left a son Francesco, born at Rome in 1521, learned in laws and humanities. Jacopo saw three grandchildren, a boy called after him and two girls, one called Fiorenza, who died, to his great grief, and the other Aurora. His body was carried to his chapel in S. Gimignano, where his son put up a marble statue made during his life, with the following epitaph[1]:

Jacopo Sansovino Florentino, P. qui Romæ Julio II. Leoni X., Clementi VII., Pont. Max. maxime gratus, Venetiis architecturæ sculpturaeque intermortuum decus, primus, excitavit, quique a senatu ob eximiam virtutem liberaliter honestatus, summo civitatis moerore decessit, Franciscus f. hoc mon. p. vixit ann. XCIII. ob. v. cal. Dec. MDLXX.

The Florentine nation celebrated his funeral in public in the Frari, with some ceremony, the oration being pronounced by the excellent Camillo Buonpigli.

Sansovino had many pupils. In Florence Niccolo, called Il Tribolo, has already been mentioned. Then there was Solosmeo of Settignano, who, with the exception of the large figures, finished the whole of the marble tomb at Monte Cassino containing the body of Piero de' Medici, drowned in the Garigliano. Girolamo da Ferrara, called Il Lombardino, was another pupil, mentioned in the Life of Benvenuto Garofalo, from whom, as well as from Sansovino, he learned his style. Besides the work at Loreto already mentioned, he did a great deal at Venice, both in marble and bronze. Although he came to Sansovino at the age of thirty possessing little design, in spite of his having done some things in sculpture, for he was a man of letters and a courtier rather than an artist, yet he studied to good purpose as appears in his work in the library and in the loggietta of the campanile of S. Marco. He did so well in these that, later

[1] Now in the Seminario, Venice.

on, he was able to do the bronze statues and prophets at Loreto, as stated.

Another pupil, Jacopo Colonna, who died at Bologna thirty years ago, when engaged on an important work, did a nude St. Jerome in marble at S. Salvadore at Venice, which may still be seen in a niche by the organ, a fine figure and much admired. In S. Croce on the Guidecca he did in marble a nude Christ showing His wounds, an artistic work. In S. Giovanni Nuovo he did three figures, Saints Dorothy, Lucy and Catherine. S. Marino has an armed captain on horseback of his. These works bear comparison with any in Venice. In S. Antonio at Padua he did the titular saint and St. Bernardino draped, in stucco. In the same material he did a Minerva, Venus and Diana, larger than life and in full relief for M. Luigi Cornaro. In marble he did a Mercury and in terra cotta a young nude Marsyas picking a thorn out of his foot. He has extricated it and holds his foot with one hand to look at the wound, while with the other he prepares to wipe it. As this is his best work M. Luigi proposed to have it cast in bronze. For the same patron he made another Mercury in stone, afterwards presented to Duke Federigo of Mantua.

Tiziano da Padova, another pupil, did some small marble figures for the loggietta at Venice, and the chapel of S. Giovanni in S. Marco has a fine bronze cover to a sarcophagus by him. He had made a statue of St. John, one of four Evangelists, with four scenes of St. John, very artistically, to be cast in bronze, when his death at the age of thirty-five deprived the world of an admirable artist. The richly decorated stucco vaulting of the chapel of S. Antonio at Padua is his. He had begun an enclosure of five bronze arches, full of scenes of that saint for this chapel, with figures in full and half-relief, but his death and the disagreements of those left in charge put a stop to it. Several portions were cast with good results, and wax models were made for others at the time of his death. When Vasari made his apparatus for the company of the Scalzo in Canareio this Tiziano did some clay statues and several terminal figures. He was frequently employed for scenery, theatres, arches and the like, for he showed invention, fancy and variety, and above all he was quick.

Pietro da Salo, another pupil, devoted himself to carving foliage up to the age of thirty, until, under Sansovino's tuition, he took to making marble figures, so that in two years he could work unaided. This appears by some good work of his in the tribune of S. Marco, and a statue of Mars, over life-size, placed

with three others by good artists on the façade of the palace. He also did two figures in the hall of the Council of Ten, a man and a woman, set up with two by a sculptor of high repute, Danese Cataneo, also a pupil of Sansovino. The figures decorate a chimneypiece. He further did three figures at S. Antonio, over life-size and in full relief, of Justice, Fortitude and a Venetian general, skilfully executed. He did a well-posed Justice on a column in the piazza of Murano and another in the piazza of the Rialto, Venice, to support the stone where state decrees are announced, called the Hunchback of the Rialto. These works prove him an excellent sculptor. In the Santo at Padua he made a fine Thetis and a Bacchus squeezing grape-juice into a cup. This is the best and most difficult figure he ever did. He left it to his sons, who are ready to sell it to the one who will show the best appreciation of their father's labours and pay the best price for it.

Another pupil, Alessandro Vittoria of Trent,[1] an excellent sculptor and sincere friend to art, has displayed his ready skill and fine style in numerous and highly valued works both in stucco and in marble. Two beautiful and much-admired female figures, each ten paces high, at the door of the library of S. Marco, are his. He did four figures for the Contarini tomb in the Santo at Padua, two slaves or prisoners with a Fame and a Thetis, all in stone, as well as an angel, ten feet high, on the campanile of the duomo, Verona, a very fine statue. To the duomo of Trau in Dalmatia he sent four Apostles, each five feet high. He also did some very graceful silver figures for the Scuola of S. Giovanni Evangelistà at Venice, in full relief, as well as a silver St. Theodore, two feet high. He did two figures, each three feet high, for the Grimani Chapel in S. Sebastiano, and a Pietà with two figures in stone in S. Salvatore, Venice, considered good. He did a Mercury for the balcony of the palace of S. Marco overlooking the piazza, considered a good figure. For S. Francesco della Vigna he did three large-size figures in stone, of great beauty, grace and finish, namely the Saints Anthony, Sebastian and Roch. In the church of the Cerchieri he did two figures in stucco, six feet high, for the high altar, of great beauty. Of the same material he made all the decoration of the new staircase of the palace of S. Marco, painted by Battista Franco with scenes and grotesques. He did the same for the staircase of the library, all important works. He did a chapel for the friars minor and a large marble slab of an Assumption in half-relief of great

[1] 1525-1608.

beauty, with five large figures below, in admirable style with stately drapery, carefully finished. These were Saints Jerome, John the Baptist, Peter, Andrew and Leonard, all six feet high, and his best work up to now. In the front of this work are two graceful marble figures of eight feet. He has also made many admirable portrait-busts in marble, namely Sig. Gio. Battista Ferida placed in S. Stefano; Camillo Trevisano the ambassador in S. Giovanni e Paolo; the famous M. Antonio Grimani, also in S. Sebastiano; and in S. Gimignano the incumbent of the church. He has also done M. Andrea Loredano, M. Priano da Lagie, and the brothers Vincenzo and Gio. Battista Pellegrini, ambassadors. As he is young, fond of work, skilful, affable and desirous of fame, indeed a most admirable character, it is probable that we shall see works that will bear out his name of Vittorio, if he lives, and win him the palm from all his compatriots.

Tommaso da Lugano remained many years with Sansovino, and did several figures in company with others for the library of S. Marco of great beauty. After leaving Sansovino, he did a Madonna and Child with the little St. John so beautifully made as to stand comparison with any of the fine modern statues at Venice. This work is in the church of S. Sebastiano. A marble bust of the Emperor Charles V. by him is considered a marvel and pleased his majesty greatly. As he prefers marble to stucco or bronze, the Venetian nobles have many fine works of his in this material in their houses. This suffices for him.

Of the Lombards it remains to speak of Jacopo Bresciano, a youth of twenty-four, who left Sansovino not long ago. He gave promise of future excellence during the many years he spent at Venice, which he has realised by his work in his native Brescia, notably in the Palazzo Publico. But if he lives and continues to study, we shall see even better, for he has a refined and admirable intelligence.

Among the Tuscans Bartolommeo Ammanati of Florence has frequently been mentioned. He worked under Sansovino at Venice and then in Padua, for M. Marco da Mantova, a distinguished physician. In the courtyard of his house he made a giant of a single piece of stone, as well as his tomb and many statues. In 1550 Ammannati went to Rome, where Giorgio Vasari gave him four marble statues of four braccia each, for the tomb of the old Cardinal de' Monti in the church of S. Pietro a Montorio, allotted to Vasari by Pope Julius III. These statues were considered very fine, and won him the esteem of Vasari. So he

introduced him to Julius III., who gave him work to do. Thus
both he and Vasari worked together at la Vigna for a while. But
after Vasari had entered the service of Duke Cosimo at Florence,
the Pope being dead, Ammanati found himself without employ-
ment, as the Pope was dissatisfied with his work in Rome, and
he wrote begging Vasari to help him with the duke, as he
had done at Rome. Vasari readily complied and brought him
to serve his excellency, for whom he modelled many statues in
marble and bronze, which have not yet been executed. He did
two bronze figures, over life-size, for the garden of Castello, a
Hercules crushing Antæus, from whose mouth water flows in-
stead of his spirit. He also did a colossal marble Neptune ten
and a half braccia high for the piazza. But I say no more,
as the fountain where the Neptune is to stand is not finished.
Ammannati is acting as the architect to the Pitti, an honourable
position which affords him great opportunities for displaying his
qualities and the greatness of the duke. I could say much more
about him, but as he is a personal friend and others are writing
of him, I will add nothing further and avoid meddling with what
others can probably do better.

The last of Sansovino's pupils to be mentioned is Danese
Cataneo of Carrara, who was with him at Venice when quite
a child. He left his master at the age of nineteen and did a marble
child in S. Marco and a St. Laurence in the church of the friars
minor. He did another child in S. Salvatore and a nude Bacchus
squeezing juice from a vine in S. Giovanni e Paolo, which is
now in the Casa de' Mozzanighi at S. Barnabà. He did a large
number of figures for the library of S. Marco and the loggietta,
as mentioned already, besides the two in the hall of the Council
of Ten. He made marble busts of Cardinal Bembo and of Con-
tarini, commander of the Venetian forces. Both are in S. Antonio,
Padua, surrounded by a rich ornament. In S. Giovanni di Ver-
dara at Padua is a portrait of the learned jurisconsult Girolamo
Gigante by him. For S. Antonio on the Giudecca, Venice, he
has made a most life-like portrait of Giustiniano, lieutenant of
the Grand Master of Malta, and of Tiepolo, their general, but
these have not yet been set up. His most signal work, however,
is a rich marble chapel in S. Anastasia, Verona, with large
figures, done for Sig. Ercole Fregoso in memory of Sig. Jano,
once governor of Genoa and then captain of the Venetians, in
whose service he died. This is of the Corinthian order, in the
form of a triumphal arch, divided by four large fluted columns,
the capitals of olive-leaves, with a suitable base, forming a space

half as broad again as one of the sides. There is an arch between
the columns on which the architrave and cornice rest, and in the
middle, within an arch, a fine decoration of pilasters with cornice
and pediment, the ground being a handsome piece of black
parangone with a fine nude Christ in full relief, larger than life,
showing His wounds, a portion of drapery about the thighs
falling to the ground. Above the angles of the arch are the
symbols of the Passion, and between the two columns, on the
right, is a statue of Sig. Jano Fregoso, on a pedestal, armed in the
antique style, except that his arms and legs are bare. His left hand
rests on the pommel of his girded sword, while his right holds the
general's baton. Behind him is a Minerva in half-relief, in the
air, holding in one hand a ducal wand, like that of the doges
of Venice, and in the other a flag with the device of St. Mark.
Between the other columns is military Virtue, in armour and
helmet, with the evergreen above and the device of an ermine
on the breastplate, standing on a rock, surrounded by mud,
with the words *Potius mori quam fœdari* and the Fregoso device.
Above is Victory holding a laurel-wreath and a palm. Above the
column, architrave, frieze and cornice is another row of pilasters,
and above the moulding are two marble figures and two trophies
of the size of the other figures. One of the statues is Fame, about
to fly, who points to heaven and blows a trumpet. It wears
delicate draperies, all the rest being nude. The other is Eternity,
dressed more soberly, standing majestically, holding a circle
into which it looks, while the right hand lifts its skirt, on which
are balls representing the centuries and the celestial sphere
surrounded by serpents swallowing their tails. In the middle
space above the cornice surrounding these two parts are two
steps on which are seated two large naked cherubs holding a
shield surmounted by a helmet with the Fregoso device, and
under the steps is an inscription in large gilt letters. The whole
forms a really admirable work, executed with great care in every
part and gracefully composed.

Danese is not only an excellent sculptor but a good and ad-
mired poet, as his works prove. Thus he has always associated
intimately with the greatest and ablest men of our time. This
same work shows his poetic fancy. The nude statue of the Sun
in the court of the Zecca at Venice above the well is by Danese.
The Signoria wanted a Justice, but Danese considered a Sun
more appropriate for the spot. It holds a golden rod in the
left hand and a sceptre in the right, with an eye at the end,
while the solar rays surround its head. The globe of the world

is surrounded by snakes swallowing their tails, and there are mounds of gold generated by the globe from him. Danese wanted to have the Moon for silver, the Sun for gold, and another for copper, but the Signoria considered the one for gold sufficed as being the most perfect of the metals. Danese has begun another work in memory of the Doge Loredano, which is expected to surpass all his other productions, to be placed in S. Giovanni e Paolo, Venice.[1] But as he is still alive and at work, for the good of the world and art I will say no more about him or of Sansovino's other pupils. However, I will take this opportunity to give some brief notes about other excellent artists of the Venetian district.

Vicenza has at various times possessed sculptors, painters and artists, some of whom were mentioned in the Life of Vittore Scarpaccia, chiefly those who flourished in the time of Mantegna, and who learned from him, such as Bartolommeo Montagna, Francesco Veruzio and Giovanni Speranza, many of whose paintings are scattered about Vicenza. The same place contains many sculptures by one Gion, sculptor and architect, which are tolerable, although his profession is to carve foliage and animals, as he does admirably, although an old man. Girolamo Pironi has also done praiseworthy work in sculpture and painting in many parts of his native town.

But the one who merits the highest praise among the Vicentines as a man of wit and judgment is Andrea Palladio,[2] the architect. This is proved by his numerous works at his native place and elsewhere, notably the Palazzo della Comunità, which is much admired, with two Doric porticoes of handsome columns. He has also erected a fine palace, grand beyond all belief, for Count Ottavio de' Vieri, with a profusion of ornaments; and a similar one for Count Giuseppe at Porto, befitting a great prince and of unsurpassable magnificence. He is making another for Count Valerio Coricetto, very similar in majesty and grandeur to the ancient buildings so much admired. Similarly, for the Counts of Valmorana he has almost completed a superb palace which yields in no particular to the others. On the piazza commonly called Isola of the same city he has erected another magnificent structure for Sig. Valerio Chereggiolo, and a fine house at Pugliano near Vicenza for the knight Bonifazio Pugliana. At Finale, in the same district, he has erected another building for M. Biagio Saraceni and one at Bagnolo for Sig. Vittore Pisani with a rich court adorned with Doric columns.

[1] Set up in 1572. [2] 1518-80.

At Lisiera near Vicenza he has erected another fine building for Sig. Francesco Valmorana with four towers at the angles. At Meledo on a high hill he has begun a magnificent palace for Count Francesco Trissino and Lodovico, his brother, with loggias, staircases and other conveniences. At Campiglia he is building a similar abode for Sig. Maria Ropetta, with such accessories, rich apartments, courts and chambers for various accomplishments as befit a king rather than a simple gentleman. At Lunede he has made another for Sig. Girolamo Godi and another at Ugurano for Count Jacopo Angarano, of great beauty, though it seems a small thing in the eyes of that great nobleman. At Quinto near Vicenza he built, not long ago, another palace for Count Marcantonio Tiene, of inexpressible magnificence. In short, Palladio has erected so many fine buildings in and about Vicenza that they would by themselves suffice to constitute a noble city with its district. At Venice he has begun several buildings, but the monastery of la Carita, in imitation of the ancients, is more marvellous than the rest. The atrium is 40 feet by 54, its wings being half as long again as the breadth. The columns are Corinthian, 3½ feet thick and 35 feet high. From the atrium one enters the peristyle or cloister as the friars call it, divided into five parts towards the atrium and seven at the sides. It has three rows of columns, one above the other, Doric, Ionic and Corinthian. Opposite the atrium is the refectory, two bays long and reaching to the level of the peristyle, with its offices conveniently disposed about it. The staircases are spiral and oval in shape. There is no well or column in the middle to support the steps, which are 15 feet broad and are fitted into the wall, resting on each other. The building is entirely of brick, except the bases of the columns, the capitals, the imposts of the arches, the steps, the face of the cornice and all the windows and doors. For the Benedictine monastery of S. Giorgio Maggiore at Venice Palladio built a fine large refectory, with its reception-rooms in front. He has begun a new church, and from the model it promises to be a stupendous and magnificent structure when complete. He has also begun the façade of S. Francesco della Vigna, of Istrian stone, for the Very Rev. Grimani, Patriarch of Aquileia, at a lavish outlay. The columns are Corinthian, 4 palms thick and 40 high. The whole of the basement has been erected. At Le Gambarie on the Brenta, seven miles from Venice, he has built a most commodious dwelling for MM. Niccolo and Luigi Foscarini, Venetian nobles. He has built another at Marocco near Mestre for the knight Mozzenigo; one at Piombino

for M. Giorgio Cornaro; one at Montagnana for M. Francesco
Pisani; one at Zigogiari near Padua for the knight Adoardo da
Tiene, a Vicenzan noble; one at Udine in Friuli for Sig. Florio
Antimini; one for M. Marco Zeno at Motta, also in Friuli, with
a handsome court and surrounding portico; a large structure
at Fratta in the Polesine for Sig. Francesco Badoaro, with hand-
some and ingenious loggias. Near Asolo of Treviso he has also
erected a very convenient dwelling for the Very Rev. Daniello,
Patriarch-elect of Aquileia, who has commented on Vitruvius,
and for M. Marc Antonio, his brother, as fine as can be imagined.
Among other things he has made a fountain there like the one
done for Pope Julius at the villa Giulia, Rome, adorned with
stucco and paintings by excellent masters. At Genoa M. Luca
Giustiniano has erected a building from Palladio's designs,
considered very handsome, as are all the above. It would take
too long to describe in detail all his inventions and ingenious
ideas. A work of his will soon appear in two volumes, one showing
ancient buildings and the other his own, so I need add nothing
further. This much suffices to show what an excellent artist he
is in the judgment of all who see his admirable works. As he is
still young and devotes himself unceasingly to his art, even
greater things may be expected of him. I must add that with
all this ability he possesses an affable and courteous disposition
which renders him a favourite with all. Thus he deserves his
place in the Florentine Academy of Design, beside Danese,
Giuseppe Salviati, Tintoretto and Battista Farinata of Verona.

Bonifazio, painter of Venice, of whom I did not previously
know, is also worthy of a place among the admirable artists
named, for his skill as a colourist. In addition to many pictures
and portraits at Venice, he has done a panel for the altar of the
Relics in the church of the Servites there, of Christ surrounded
by the Apostles and Philip saying, "Lord, show us the Father,"
which is skilfully executed in good style. At the altar of Our
Lady in the nuns' church of Spirito Santo he has done a fine
picture, with a quantity of men, women and children of every
age, who, together with the Virgin, are adoring God the Father,
in the air, surrounded by angels. Another painter of repute in
Venice is Jacopo Fallaro, who on the organ-shutters of the
Gesuati there has painted the Blessed Giovanni Columbini
receiving the habit from the Pope in consistory, with a number
of cardinals. Another Jacopo, called Pisbolica, has done a picture
in S. Maria Maggiore, Venice, of Christ in the air with many
angels and, beneath, Our Lady with the Apostles. One Fabrizio,

a Venetian, has painted the front of a chapel in the church of
S. Maria Sebenico, with the consecration of the font, including
many portraits from life, executed gracefully in a good style.

LIONE LIONI OF AREZZO, and other Sculptors
and Architects
(ob. 1592)

OWING to what I have incidentally said of the knight Lione
above, it will not be amiss here to give an ordered account of
his works, which are really worthy of notice and the memory
of man. Having originally studied as a goldsmith, and produced
many beautiful works in his youth, particularly portraits for
medals on steel dies, he became so excellent in a few years that
he was known to all the princes and great men, especially Charles
V., who, recognising his ability, set him to more important work
than medals. Thus, soon after meeting the emperor, he made a
bronze statue of him, larger than life, with removable armour
so well arranged that when clothed it is hard to believe that the
figure is nude, and when nude it seems impossible to adapt
armour to it. The statue rests on the left foot and the right
spurns Fury, a recumbent, chained figure, with torches and
various arms beneath it. It stands at Madrid, with the legend on
the pedestal: *Cæsaris virtute furor domitus.* Lione next did a large
die for the emperor's medals, with Jupiter fulminating on the
reverse. For this the emperor gave him an income of 150 ducats
yearly on the mint of Milan, a convenient house near Moroni,
a knighthood, and many privileges to ennoble his family. While
Lione was at Brussels with the emperor he had rooms in the same
palace, and Charles sometimes came to see him work. Not long
after he did marble statues of the emperor, the empress, King
Philip, and a bust of the emperor to stand between two bronze
reliefs. In bronze he made busts of Queen Mary, Ferdinand, then
King of the Romans, and Maximilian his son, the present emperor,
Queen Leonora, and many others, placed in Queen Mary's
gallery in her palace at Brindisi,[1] for it was she who had employed
him to do them. They did not remain there long, because King
Henry of France turned them out from revenge, leaving on the

[1] *Rectius* Binche. They were done in 1549.

walls the words *Vela fole Maria*,[1] for the queen had treated him
in like manner a few years before. However this may be, the
gallery did not progress, and the statues are now in the palace
of the Catholic king at Madrid, and some are at Alicante, a
seaport, whence the king intended to send them to Granada,
where the Kings of Spain are buried. When Lione left Spain,
he brought away 2000 crowns in ready-money, while he had
received many gifts and favours from the court. For the Duke
of Alva Lione made the duke's own bust and busts of Charles V.,
King Philip, the bishop of Arras, now Cardinal Granvella, and
some oval pieces of bronze two braccia each, richly decorated,
and containing half-length figures of Charles V., King Philip and
the cardinal, all with basements decorated with graceful little
figures. For Sig. Vespasiano Gonzaga he did a bronze bust of
Alva, placed in his house at Sabbioneto. For Sig. Cesare Gonzaga
he did a bronze statue of four braccia, with a figure struggling
with a hydra below, of Don Ferdinand, his father, who by his
skill and valour overcame the envy which had sought to disgrace
him with Charles for the government of Milan. The figure wears
a toga, and is armed partly in the ancient and partly in the
modern style. It is to be set up at Guastalla in memory of the
valorous captain Don Ferrante. Lione also made the tomb of
Sig. Giovan. Jacopo Medici, marquis of Marignano, brother of
Pius IV., placed in the duomo of Milan, about twenty-eight
palms long and forty high. It is all of Carrara marble and
decorated with four columns, two black and two white, sent as
a treasure by the Pope from Rome to Milan, and two large ones of
variegated stone like jasper. They stand under the same cornice,
with a device no longer used, as desired by the Pope, who had
the whole done under Michelagnolo's direction except Lione's
five bronze figures. The first and largest is a statue of the marquis,
more than life-size, holding a general's baton, the other hand
resting on a helmet which stands on an ornate column. On his
left is a smaller statue of Peace and on his right Military Skill,
both seated and of sad aspect. The two above are Providence and
Fame, with a beautiful bronze Nativity between them in bas-
relief. Two marble figures bearing the prince's arms complete
the structure, for which Lione received 7800 crowns, according
to the agreement made in Rome by Cardinal Morone and Sig.

[1] In 1553 Queen Mary set fire to the chateau of Folembrai. In the follow-
ing year King Henry revenged himself by attacking and burning a small
fortress in Upper Hainault, writing on the walls, *Voilà pour Folembrai*,
words which have thus been phonetically rendered by Vasari.—*Bottari*.

Agabrio Serbelloni. For Sig. Giovanibatista Castaldo Lione did
a bronze statue to be placed in some monastery, with ornaments.
For the Catholic king he did a marble Christ over three braccia
high, with the cross and other mysteries of the Passion, which
is much admired. Finally he has in hand the statue of Alfonso
Davalo, Marquis del Vasto, allotted to him by the Marquis of
Pescara, Alfonso's son, four braccia high, which should be an
admirable cast for the diligence he is employing and his uninter-
rupted good fortune in founding. To show his spirit and natural
skill, Lione has at great cost built a house in the territory
of Moroni, full of fancies and probably unique in all Milan.
The façade contains six prisoners of six braccia as pillars, and
between them are caryatids, windows and cornices of great
variety and grace. The lower parts correspond with the upper,
the friezes being all of various implements of the arts of design.
The principal door leads to a passage into a court containing
the equestrian statue of Marcus Aurelius in the middle on four
columns, a cast of the one on the Capitol. He has had the house
dedicated to Marcus Aurelius, but his device of the prisoners
has been variously interpreted. He has many other casts of
notable modern and ancient sculptures. His son Pompeo, who
is now serving King Philip of Spain, is no whit inferior to his
father in making steel dies for medals and marvellous casts. In
that court he competes with Giovanni Paolo Poggini of Florence,
who serves that king and has made many medals. But Pompeo,
after a service of many years, proposes to return to Milan to
enjoy his Aureliana house and the fruits of his labours and those
of his father.

With respect to dies and medals, I think the moderns can be
said to have attained to the excellence of the ancient Romans
in figures, and surpassed them in the lettering and other parts.
We see this by twelve reverses recently made by Pietro Paolo
Galeotti for the medals of Duke Cosimo, representing Pisa
restored to her former state by the duke, who has drained the
country and marshes, and made other improvements: the water
brought to Florence from various places; the building of the
magistrates decorated; the union of Florence and Siena; the
building of a city and two fortresses in Elba; the column brought
from Rome and set up in the piazza of S. Trinità at Florence;
the completion and augmentation of the library of S. Lorenzo;
the foundation of the knights of S. Stefano; the settlement
of the government on the prince; the fortification of the state;
the militia or trained bands of the state; the Pitti palace with

its royal gardens, waters and buildings. But I shall deal with these reverses and their inscriptions in another place. They are of the utmost beauty, and executed with exceeding grace and finish, while the duke's head is of great beauty. Stucco-work and medals are also now made with the utmost perfection, and Mario Capocaccia of Ancona has done some heads in coloured stucco of great beauty, including that of Pius V., which I saw not long since, and one of Cardinal Alessandrino. I have also seen similar beautiful heads by Pulidoro, painter of Perugia.

To return to Milan. In reviewing the things of Gobbo, the sculptor mentioned elsewhere, I saw nothing out of the common except an Adam and Eve, a Judith, a marble St. Helena, placed round the duomo, and recumbent figures of Ludovico il Moro and Beatrice his wife for a tomb by Giovan Jacomo della Porta, sculptor and architect of the duomo of Milan, who did many things under Gobbo in his youth. These are all executed with great finish. Giovan Jacomo has done many beautiful works in the Certosa of Pavia, especially for the tomb of the count of Virtu and for the façade. A nephew called Guglielmo learned the art from him, and diligently studied the works of Lionardo da Vinci about 1530, deriving great profit. In 1531 he accompanied his uncle to Genoa, whither the latter was summoned to make the tomb[1] of S. Giovanni Batista, and earnestly studied design under Perino del Vaga. But yet he did not abandon sculpture and made one of the sixteen pedestals for the tomb, and succeeding admirably, all the rest were allotted to him. He then did two marble angels in the company of S. Giovanni, two marble portraits for the bishop of Servega, and a marble Moses, larger than life, which was placed in S. Lorenzo. After doing a marble Ceres over the door of the house of Ansaldo Grimani, he made a life-size statue of St. Catherine over the door of la Cazzuola.[2] He then did the Three Graces with four marble boys, sent to the master of the horse of Charles V. in Flanders, with another life-size Ceres. After producing these works in six years, Guglielmo went to Rome in 1537, where his uncle recommended him to Frà Bastiano, the Venetian, his friend, to introduce him to Michelagnolo. That master, observing Guglielmo's spirit and assiduity, favoured him, and first caused him to restore some antiques in the Farnese house. He did so well that Michelagnolo introduced him to the Pope's service, who had seen a tomb made by him, mostly of metal, for Bishop Sulisse,[3] with bas-reliefs of the Virtues and other things, made with much grace, as well

[1] Correctly, altar.　　[2] Now in the Genoa Accademia.　　[3] i.e. de Solis.

as the bishop's effigy. It was afterwards sent to Salamanca in Spain. While Guglielmo was restoring the statues, now in the loggia before the upper hall of the Farnese Palace, Frà Bastiano died in 1547. By the favour of Michelagnolo and others, Guglielmo endeavoured to obtain the office of the Piombo, thus rendered vacant, with the task of making the tomb of Paul III. for S. Pietro, for which he designed figures of the Virtues better than those done for Bishop Sulisse, placing four children at the angles, and making a bronze statue of the Pope seated in the attitude of peace, seventeen palms high. Fearing lest the metal should cool owing to the size of the cast, he put it in the lower furnace, from which he gradually raised it into the mould above. In this unusual manner he obtained a fine cast as smooth as wax, so that it hardly needed polishing. It is now under the first arches bearing the tribune of the new S. Pietro. He meant the tomb to stand alone, and had designed four marble figures for it, as arranged by M. Annibale Caro, who was charged by the Pope and Cardinal Farnese to supervise this. One was a nude recumbent Justice, her sword-belt across her breast, and the sword bare. She holds the fasces in one hand and a flame in the other. She is young, her hair bound up, her nose aquiline, and her aspect full of expression. The second was Prudence as a young matron holding a mirror and a closed book, partly nude and partly draped. The third was Abundance, a young maiden crowned with ears of corn, holding a cornucopia and an antique bushel, dressed so far as to show the nude under the drapery. The fourth and last was Peace, a mother with a boy who has lost his eyes, and bearing the wand of Mercury. By Caro's direction he did a bronze relief, to be executed with two rivers, one for a Lake and the other for a River, which is in the Farnese state. Besides these he made a mount full of lilies, with the rainbow, but it was not carried out for reasons given in the Life of Michelagnolo, though the beauty of these parts show what it would have been. The air of the piazza affords a good light and permits a good judgment of works.

For several years Frà Guglielmo has been engaged upon fourteen reliefs, to be executed in bronze, representing the life of Christ, each four palms broad by six high, except one of the Nativity, which is twelve palms high by six broad, all containing beautiful fancies. The other thirteen are the entry of Mary with the Christ-child into Jerusalem, riding on an ass, with two figures in high relief and many in half- and bas-relief; the Last Supper, the thirteen figures well composed, and a rich building;

the washing of the disciples' feet; the Agony in the Garden, with five figures and a varied crowd in bas-relief; Christ before Annas, with six large figures, and many in bas-relief and one far off; Christ at the column; crowned with thorns; the *Ecce Homo*; Pilate washing his hands; Christ bearing the cross, with fifteen figures, and others in the background; the Crucifixion, with eighteen figures; and the Deposition from the Cross. If cast they would form a remarkable series, showing great study and labour. Pope Pius IV. intended to have them done for one of the doors of S. Pietro, but his death prevented the realisation of the project. Finally Frà Guglielmo made wax models for three altars of S. Pietro, a Deposition from the Cross, Peter receiving the keys, and the coming of the Holy Spirit, which would have made good reliefs. He has enjoyed great opportunities for work, and does still, as the great income of the Piombo allows him to study for glory as others cannot; but from 1547 to the present year, 1567, he has completed nothing thoroughly, and indeed the holder of the office usually becomes lazy. Before he was friar of the Piombo he did many marble heads and other works besides those mentioned, though it is true he has done the four great prophets in stucco in the niches between the pilasters of the first great arch of S. Pietro. He was also employed on the cars for the feast of the Testaccio, and on other masquerades done in Rome many years ago.

His pupil Guglielmo Tedesco, among other works, has made a rich model and decoration of small bronze statues copied from the best antiques, for a wooden study presented by the count of Pitigliano to Duke Cosimo, representing the horse of the Capitol, those of Montecavallo, the Farnese Hercules, the Antinous and the Apollo Belvedere, with the heads of the twelve emperors with others, all well made and resembling the originals.

Milan possessed another sculptor who died this year, called Tommaso Porta. He was excellent with marble, and has copied marble antique heads which have been sold as antiques, while no one equals him at masks. I have a marble one on the chimney-piece in my house at Arezzo which everyone takes to be an antique. He did the twelve heads of the emperors in marble, which are very fine. Pope Julius III. took them, and gave him an office of 100 crowns a year, keeping the heads in his room for some months as treasures. It is believed that Frà Guglielmo and others who envied him succeeded in having them sent back to him, when they were sold to merchants and sent to Spain. No imitator of the antique equals him, and I think him worthy

of mention, especially as he has passed to the better life, leaving his fame and name.

One Lionardo of Milan [1] has done many things in Rome, and recently he has produced marble statues of St. Peter and St. Paul in the Chapel of Cardinal Giovanni Riccio da Montepulciano which are much admired. The sculptors Jacopo and Tommaso Casignuola have made the tomb of Paul IV. in the Caraffa Chapel in the Minerva, with a statue of the Pope in his mantle, the frieze and other things of divers colours, making a marvellous work. Thus we see all the arts combined by modern ingenuity, and sculptors imitating painting with their colours. The tomb was erected by the gratitude of our most Holy Father and Pope Pius V., most worthy of a long life.

Nanni di Baccio Bigio the Florentine sculptor, besides what has already been written of him, studied in his youth under Raffaello da Montelupo, and some small things which he did in marble showed great promise. He went to Rome and studied under Lorenzetto the sculptor, paying attention to architecture also, as his father had done. He did a statue of Clement VII. in the choir of the Minerva, and a marble Pietà copied from Michelagnolo's placed in the German church of S. Maria *de Anima*, a very admirable work. Not long since he did one like it for Luigi del Riccio, a Florentine merchant, which is now in S. Spirito at Florence, for Luigi's chapel, admirable for the diligence bestowed upon it by Nanni out of love for his country. Under Antonio da Sangallo, Nanni next studied architecture and was engaged on S. Pietro while Antonio lived; falling from a scaffold 60 braccia high, his life was preserved by a miracle. Nanni erected many buildings in and out of Rome, and tried to get larger things, as related in the Life of Michelagnolo. His is the palace of Cardinal Montepulciano in Strada Julia, and a door of Monte Sansavino done for Julius III., with an unfinished cistern, a loggia and other things of the palace built by the elder Cardinal del Monte. Nanni also did the Mattei house and many other buildings. Another famous architect is Galeazzo Alessi of Perugia. In his youth he served the cardinal of Rimini, whose chamberlain he was, and among his first works he restored for the cardinal the rooms of the fortress of Perugia, so finely and commodiously for such a small place as to cause amazement, as the rooms have often held the Pope and all his court. After many other works for the cardinal the Genoese sent for him, and he entered the service of the republic, repairing and fortifying

[1] Leonardo Sormanno.

the mole and port, making it quite different. Enlarging it towards
the sea, he made a handsome port in a semicircle, decorated with
rustic columns and niches, with two bulwarks at the ends to
protect the port. Towards the city he made a large gate to
receive the guard, of the Doric order, and a platform above it
for artillery as large as the space between the bulwarks, to
defend the port. Besides this he made a model, with the approval
of the Signoria, for the enlargement of the city, showing great
ingenuity. Galeazzo also made the Via Nuova at Genoa,[1] with
the numerous modern palaces designed by him, so that many
declare it to be the most magnificent street in Italy, and the
richest in palaces. The nobles are under a great debt to Galeazzo,
who has designed and carried out a work with buildings which
render their city incomparably grander than before. He laid
out other streets outside Genoa, especially three leading from
the Ponte Decimo towards Lombardy. He restored the walls of
the city towards the sea, and did the tribune and cupola of the
duomo. He also erected many private buildings, the palace of
M. Luca Justiniano in the town, that of Sig. Ottaviano Grimaldi,
the palaces of two doges, one for Sig. Batista Grimaldi, and many
others which I need not mention. He did the lake and island
for Sig. Adamo Centurioni, full of water and fountains with
various beautiful fancies, and the noble fountain of Captain
Learco near the city. Among the various fountains which he
has made, the finest is the bath in the house of Sig. Gio. Batista
Grimaldi at Bisagno. It is round, with a basin in the middle in
which eight or ten persons can bathe comfortably. The warm
water flows from four marine monsters who seem to be coming
out of the lake; the cold issues from frogs on the heads of the
monsters. A platform approached by three steps surrounds the
lake, where two persons can easily pass. The surrounding wall
is divided into eight spaces, four with as many large niches,
each containing a round vase half in and half out of the niche,
and a man can bathe in each, hot and cold water issuing from
a mask spouting through the horns, and the waste going through
the mouth. One of the other four spaces contains the door, and
the other three have windows and seats, all eight being divided
by terminal figures bearing the cornice which surrounds the bath.
From the middle of the vault hangs a large crystal ball on which
the sphere of heaven is painted, and containing the globe of the
earth. At night this gives a light which makes the place as bright
as noon. For the sake of brevity I omit to speak of the ante-

[1] Now Via Garibaldi.

bath, the dressing-room, the little bath full of stucco, and the
paintings which adorn the place. Suffice it to say that they are
equal to the rest of the work. In Milan Galeazzo erected the
palace of Sig. Tommaso Marini, duke of Terranuova and perhaps
the façade of S. Celso, the round auditorium of the exchange,
the church of S. Vittore, and many other buildings. When he
could not be present in person he has sent designs to all Italy
of numerous edifices, palaces and temples. But this must suffice
for this excellent artist.

I must also mention Rocco Guerrini of Marradi, because he is
an Italian, although I do not know particulars, as his works are
in France; I hear, however, that he is an excellent architect,
especially in fortification, and that in the last wars he has
produced much ingenious and honourable work. I have put last
these living sculptors and architects that I may not deprive the
talent of anyone of its due reward, when I have not had an
opportunity of dealing with them before.

GIULIO CLOVIO, Illuminator
(1498–1578)

FOR many centuries, and perhaps for yet other centuries, there
has been no more excellent illuminator or painter of small things
than Giulio Clovio, who has far surpassed all others in this
exercise. He was born at Grisone in the diocese of Madrucci in
Sclavonia or Croatia, although his ancestors came from Mace-
donia, and his baptismal name was Giorgio Julio. He studied
letters as a child, and then his natural instinct led him to take
up design. At eighteen he came to Italy to learn, and entered
the service of Cardinal Marino Grimani, studying design for
three years. He made more progress than had perhaps been
expected, as we see by designs for some medals and reverses
executed for the cardinal with the pen, with extraordinary
diligence. Finding himself naturally better at small than at
great things, he wisely decided to take up miniatures, for he
did them with marvellous grace and beauty, being advised to
do so by many friends, notably Giulio Romano, a noted painter,
and one of the first to teach the employment of colours prepared
with gum and in tempera. Clovio began with a Virgin from a
book of the life of the Virgin. This was among the earliest of the

wood-engravings of Albert Dürer. Having succeeded in this he did a Judgment of Paris in grisaille, by the influence of Sig. Alberto da Carpi, then serving King Louis and Queen Mary, sister of Charles V. in Hungary, for the king. He gave the queen a Lucretia killing herself, with some other things considered very beautiful. On the death of the king and the disasters in Hungary Giorgio was obliged to return to Italy. No sooner had he arrived than Cardinal Campeggio the elder took him into his service. For the cardinal he did a Madonna and some other small things, and intending to study art more thoroughly, he drew and imitated the works of Michelagnolo. The sack of Rome in 1527 interrupted his plans, for he was taken prisoner by the Spaniards and ill-treated. In his misery he vowed to become a friar if he escaped from these modern Pharisees. He got away to Mantua and entered the monastery of S. Ruffino of regular flagellants, where he was promised quiet and freedom from anxiety, with leisure to serve God and time to work at his illuminating.

Having taken the habit with the name of Don Giulio, he made profession at the end of a year, and for three years remained quietly with the friars, changing from monastery to monastery as he pleased, and always at work on something. During that time he decorated a large choir-book with delicate illuminations and charming borders, including among other things a remarkable *Noli me tangere*. Encouraged by this, he did in larger figures the woman taken in adultery, with several figures, copied from a recent painting by Titian. Not long after, while changing monasteries, Frà Giulio unfortunately broke his leg. In order to effect a speedy cure, the fathers took him to the monastery of Candiana, where he stayed for some time unhealed, perhaps owing to the usual bad treatment of the physicians as well as the friars. When Cardinal Grimani heard this, he induced the Pope to let him take Giulio into his service. Thus Don Giulio abandoned the habit and, his leg being cured, he accompanied the cardinal to Perugia, where he was legate, and illuminated these works: an office of the Virgin with four beautiful scenes, three large scenes of St. Paul in an epistolary, one of which was sent not long since to Spain. He also did a beautiful Pietà and a Crucifixion, which after the cardinal's death came into the hands of M. Giovanni Gaddi, clerk of the chamber. All these works made Giulio a reputation at Rome, so that Cardinal Alessandro Farnese, a great patron of talented men, after seeing his works, took him into his service, where he has since remained. For the

cardinal he has executed countless rare illuminations, only part of which I can mention. He painted a small Virgin and Child surrounded by saints and figures, with Paul III. kneeling, from life, which with the other figures seems only to lack breath and speech. This was sent to Spain to Charles V., who was astonished by it. The cardinal next set Giulio to illuminate an office of the Virgin written in letters devised by Monterchi, who is admirable at such work. On this task Giulio resolved to show his full powers, and displayed the utmost study and diligence, producing a work so stupendous that it seems impossible that eye and hand can have made it. It is divided into twenty-six scenes, two sheets opposite each other, and different borders round each scene with figures and arabesques appropriate to it. I must relate briefly the particulars, as everyone cannot see it. The first plate, when matins begins, has an Annunciation with a border full of miraculous children. The opposite plate contains Isaiah speaking to King Ahaz. The second, at the lauds, is a Visitation with a metal-coloured border, and the scene opposite is Justice and Peace embracing. At prime is the Nativity, opposite the Fall and expulsion from Paradise, the border of both being full of nudes and other figures and animals copied from life. At tierce he did the Angels appearing to the shepherds, with the Tiburtine Sibyl and Octavian opposite, the border being of various coloured figures, with Alexander the Great and Cardinal Alessandro Farnese in the background. At sexta is the Circumcision, with Paul III. as Simeon, portraits of Mancina and Septima, Roman ladies of the greatest beauty, and a border extending to the other scene of John baptising Christ, which is full of nudes. At none he did an Adoration of the Magi, and on the opposite side Solomon adored by the Queen of Sheba, with a rich border, and both in figures smaller than ants, representing the Feast of Testaccio, marvellous for the perfection of such minute work. It includes all the liveries of Cardinal Farnese at that time. At vespers is the Flight into Egypt, and, opposite, the Drowning of Pharaoh in the Red Sea, with a varied border. At the compline there is the Coronation of the Virgin in heaven with a multitude of angels, and on the opposite side Ahasuerus crowning Esther, with a suitable border. At the Mass of the Virgin he made a border of cameos with an Annunciation, and the scenes are the Virgin and Child and God creating the heaven and the earth. Before the Penitential Psalms is the death of Uriah the Hittite, with horses and men lying wounded and dead; opposite is David in penitence, with ornaments and then

grotesques. But most marvellous is a tangle of the names of saints, and in the margin are angels surrounding the Trinity, with Apostles and other saints, and on the other side the Virgin Mary with all the virgin saints. The margin contains the Corpus Christi procession at Rome with officials bearing torches, bishops, and cardinals, the Sacrament borne by the Pope, with the rest of the court and guard of lances, and the Castle of St. Angelo firing artillery, a marvellous work. At the beginning of the Office of the Dead are two scenes, Death triumphing over all mortal powers and the common people, and, opposite, the Resurrection of Lazarus, with Death fighting men on horseback. At the Office of the Cross he has made Christ crucified, and on the opposite side Moses and the brazen serpent. At the Office of the Holy Spirit is the descent upon the Apostles, and facing it the building of the Tower of Babel.[1] This work was a labour of nine years, so that its value is immeasurable. The stories are rich with curious and beautiful ornaments, various postures of nude men and women, well studied in every part, and arranged in the borders to embellish the work, which from its variety seems divine, not human, especially by the perfection of the colouring, the receding figures, the buildings, landscapes, and all the requisites of perspective, exciting general marvel, not to speak of the admirable trees of every variety which seem to have been formed in Paradise. The scenes and inventions display design, order in composition, variety and richness in the habits, being executed with the utmost grace. We may therefore say that Don Giulio surpassed the ancients and moderns in this style, and has been the Michelagnolo of small works. He did a little picture of small figures for the cardinal of Trent, so beautiful that the cardinal gave it to Charles V. Giulio next did a Virgin for the cardinal and a portrait of King Philip of great beauty, and therefore given to the Catholic king. For the same Cardinal Farnese he did a panel of the Virgin and Child, St. Elizabeth, the little St. John, and other figures, sent to Rigomes in Spain. In another, now in the cardinal's possession, he did St. John in the desert, with beautiful landscapes and animals, and a similar one for the cardinal to be sent to King Philip. A Pietà of his was given by the cardinal to Paul IV., who always kept it near him. A scene of David cutting off Goliath's head was given by the cardinal to Margaret of Austria, who sent it to King Philip, her brother, with another done for herself to match it of Judith cutting off the head of Holofernes.

[1] Formerly in the Library of the Naples Museum.

Many years ago Giulio spent several months with Duke
Cosimo,[1] when he did some works for him, some of which were
sent to the emperor and other lords and some kept by the duke.
Among other things the duke made him draw a small head of
Christ from a very ancient one in his possession, which had
belonged to Godfrey de Bouillon, and was said to resemble the
true likeness of the Saviour more than any other. Don Giulio
did a Crucifixion for the duke, with the Magdalene, a marvellous
work, and a small Pietà,[2] the design for which is in our book,
with another by him of a Madonna and Child, dressed as a Jewess
and surrounded by a choir of angels and naked souls beseech-
ing her. To return to the duke. He always greatly admired Don
Giulio's ability, and tried to obtain his works, and but for his
respect for Farnese he would not have let him go. The duke also
has a small picture by Giulio of a Rape of Ganymede, copied
from Michelagnolo's, which is now in the possession of Tommaso
de' Cavalieri, as mentioned elsewhere. The duke also has in his
scriptorium a St. John the Baptist seated on a rock, and some
admirable portraits by the same hand. Giulio gave a Pietà with
the Maries and an exact replica to Cardinal Farnese, who sent
it to the empress, the wife of Maximilian and sister of King
Philip. He sent another little picture by the same hand to the
emperor representing St. George killing the serpent, in a beautiful
landscape, executed with great diligence. But for beauty and
design Giulio surpassed this by a larger picture done for a
Spanish noble, of the Emperor Trajan, taken from the medals,
and the province of Judæa on the reverse. This was also sent to
Maximilian, the present emperor. For Cardinal Farnese he did
two other little pictures, Christ bearing the Cross and Christ
taken to Mount Calvary, accompanied by a great multitude, the
Virgin and other Maries following in attitudes fit to move a
heart of stone. In two large sheets for a missal done for the car-
dinal, he has represented Christ teaching the gospel to the
Apostles, and the Last Judgment, so stupendous and wonderful
that I am confounded at thinking of it and feel sure that nothing
more beautiful can be imagined in a miniature. It is remarkable
that in many of these works, and notably in the Office of the
Virgin, Giulio has made figures not larger than a tiny ant, with
all the members as distinct as if they had been of life-size, and
scattered about are portraits of men and women, as faithfully
done as if they were by Titian or Bronzino, and of life-size. The
borders contain small nude figures and others, like cameos, that

[1] In 1553. [2] The former in the Uffizi, the latter in the Pitti.

have a gigantic nature, tiny as they are, such was the skill and diligence of Giulio. I have written this notice for the benefit of those who cannot see his works, which are almost all in the hands of the great. I say almost all, because some private people have beautiful portraits by him in little boxes of lords, friends and ladies whom they have loved. But such works are not public, and cannot be seen by all like paintings, sculpture, and buildings. And now, although Don Giulio is old, and attends to holy things far removed from worldly affairs, he is always at work on something in his rooms in the Farnese palace, where he is most courteous and ready to show his productions to those who wish to go and see them among the other marvels of Rome.

Divers Italian Artists

There now lives in Rome an excellent artist called Girolamo Siciolante of Sermoneta, and though I have said something of him in the Life of Perino del Vaga, whose pupil he was and whom he assisted at the Castle of St. Angelo and in many other works, I will here dilate upon his merits. Among his first works was a panel twelve palms high, painted in oils, twenty years ago, and now in the abbey of St. Stefano near the territory of Sermoneta, representing St. Peter, St. Stephen and St. John the Baptist, of life-size, with some infants. He then did a panel in oils for S. Apostolo at Rome of a Dead Christ, the Virgin, St. John, the Magdalene, and other figures executed with great diligence. In the marble chapel of Cardinal Cesis in the Pace he decorated the vault with four scenes in the stucco ornament, a Nativity, the Adoration of the Magi, the Flight into Egypt, and the Massacre of the Innocents, an admirable work executed with invention, judgment and diligence. Soon after he did a fine panel fifteen palms high at the high altar of the same church, of the Nativity, and another in oils for the sacristy of S. Spirito of the Descent of the Holy Spirit upon the Apostles, a very graceful work. In S. Maria *de Anima*, the German church, he painted the chapel of the Fuggers in fresco, where Giulio Romano had previously done the altarpiece, with large scenes of the life of the Virgin. In S. Jacopo of the Spaniards he did a fine Crucifixion at the high altar, with angels, the Virgin and St. John, and two large pictures on either side, nine palms high, of St. James the Apostle and St. Alfonso the bishop, showing much study and diligence. In S.

Tommaso at the Piazza Giudea, he painted a whole chapel in fresco, answering to the court of the Cenci house, representing the Nativity of the Virgin, the Annunciation and the Birth of Christ. For Cardinal Capodiferro he painted a fine hall in his palace of deeds of the ancient Romans. He did the high-altar picture of S. Martino, Bologna, which was much praised. For Signor Pier Luigi Farnese, duke of Parma and Piacenza, whom he served for some time, he did many works, notably a picture eight palms high in Piacenza for a chapel of the Virgin, St. Joseph, St. Michael, St. John the Baptist and angels. On returning from Lombardy he did a Crucifixion in the passage of the sacristy of the Minerva, and another in the church. He next did St. Catherine and St. Agatha in oils. In S. Luigi he did a scene in fresco in competition with Pellegrino Pellegrini of Bologna and Jacopo di Conte of Florence. In an oil-painting, sixteen palms high in the church of S. Alo, opposite the Misericordia, a company of the Florentines, he painted, not long since, a Virgin, St. James the Apostle, St. Alo and St. Martin. In the chapel of Countess Carpi in S. Lorenzo at Lucina he did St. Francis receiving the stigmata, in fresco. In the Hall of the Kings, in the time of Pius IV., he did a much-praised scene in fresco over the door of the Sistine Chapel, of King Pepin giving Ravenna to the Church and taking prisoner Astolfo, king of the Lombards. I have Girolamo's own design for this in my book, with many others by the same hand. He is now engaged upon the Chapel of Cardinal Cesis in S. Maria Maggiore, having done a large Martyrdom of St. Catherine of great beauty, as are the other things which he is continually engaged upon there. I do not mention his portraits and other small works, because these suffice to show his excellence, and his productions are countless.

In the Life of Perino del Vaga I remarked that Marcello, a Mantuan painter,[1] earned a great reputation for the things he did under him during many years. He has painted the picture and all the chapel of St. John in S. Spirito, with the portrait of a commendator of S. Spirito who built the church and the chapel, a good likeness and a fine picture. Seeing his good style, a friar of the Piombo gave him a fresco to paint over the door leading into the convent, in the Pace, of Christ disputing with the doctors, a fine work. But he preferred doing portraits and small things to larger works, and has left numbers, including some very good ones of Paul III. He did a number of small things from Michelagnolo's designs, including the Last Judgment, finely executed,

[1] Marcello Venusti.

incomparable for its size. Therefore M. Tommoro de Cavalieri, his constant patron, made him paint a beautiful Annunciation from Michelagnolo's design, as a picture for S. Giovanni Laterano. Lionardo Buonarrotti gave Michelagnolo's design to Duke Cosimo with some others of fortifications, architecture and other notable things. This is enough for Marcello, who continues to produce small things executed with incredible patience.

Like the others, Jacopo del Conte of Florence lives in Rome. I will here add some further particulars of him. Being much inclined to making portraits from his youth, he wished to make it his principal profession, although he has done a considerable number of panels and frescoes in Rome and elsewhere. Of his portraits I can only say that from Paul III. downwards he has done all the popes, and famous lords and ambassadors of the court, the great captains and leading Colonna and Orsini, Sig. Piero Strozzi and countless bishops, cardinals and other prelates and lords, including men of letters and others of repute in Rome, so that he and his family have enjoyed great honour and consideration in Rome. He designed so well as a boy that great expectations were entertained of him if he studied, but he preferred to follow his natural bent; however, his things compel praise. There is a dead Christ by him in the church of il Popolo, and a panel with scenes of St. Denis in the saint's chapel in S. Luigi. But his finest work was two scenes in fresco in the company of the Misericordia of the Florentines, done previously and mentioned in another place, representing a Deposition from the Cross, containing the thieves and the fainting Madonna, finely executed in oils. He has done many pictures and figures in various styles for Rome, and several drawings of nude and draped figures of great beauty. He has also done numerous heads of lords, ladies and princesses who have been at Rome, including Signora Livia Colonna, a lady of distinguished lineage and talent and of incomparable beauty. He is still alive and working.

I could mention many Tuscans and other Italians whom I have lightly passed over because they are old or young, and who will be known more by their works than by writings. I will however mention Adone Doni of Assisi, referred to in the Life of Cristofano Gherardi. He has done many pictures in Perugia and throughout Umbria, especially at Fuligno. But his best works are in the chapel where St. Francis died in S. Maria degli Angeli at Assisi, representing acts of the saint done in oils on the wall, which are much admired. At the end of the refectory

of that convent he has done the Passion of Christ in fresco, and many other works which honour him as much as his courtesy and generosity.

Two youths are now at work in Orvieto, which has always summoned strangers to adorn it, one a painter called Cesare del Nebbio, the other a sculptor. With these masters the Orvietans will no longer be obliged to look abroad for foreigners to adorn their city. Niccolo dalle Pomarance, a young painter, having done a Resurrection of Lazarus in the duomo of Orvieto, will rank by this and his other things with the two mentioned above.

As we have come to the end of living Italian masters, I will merely say that I have heard that a Florentine sculptor, Ludovico, has done some notable things in England and at Bari. But I cannot say so much about him as I should wish, as I have not found anything about his relations or his surname, and have never seen his works.

Divers Flemish Artists

In many places I have already given somewhat vague notices of some famous Flemish painters and engravings. I intend here to give the names of others, as I have not been able to obtain full notice of their works, who have come to Italy to learn the Italian style, and most of whom I have known, for their merits and industry deserve so much. Passing over Martin[1] of Holland, John van Eyck of Bruges, and Hubert, his brother, who invented oil-painting in 1510, and left many works in Ghent, Ypres and Bruges, where he lived and died, I come to Roger Van der Weyden of Brussels, who did many works in several places, but chiefly in his native land, and four beautiful oil-paintings, dealing with Justice, in the Government palace. His pupil Hans[2] did a small picture of the Passion of Christ which is in Florence, in the duke's possession. He was succeeded by Lucas of Louvain, a Fleming, Peter Christus, Justus of Ghent, Hugh of Antwerp,[3] and many others, who retained the Flemish style, having never left their country, and although Albert Dürer came to Italy he retained the same style, though his heads are vigorous and vivacious, as all Europe knows. Passing over these and Luke of Holland, I met in Rome in 1532 Michael Cockuysen,[4] who

[1] Schongauer. [2] Hans Memling. [3] Hugo van der Goes.
[4] Lucas van Leyden and Michel Coxcie.

practised the Italian style and did many frescoes in that city,
decorating two chapels in S. Maria *de Anima*. Returning home
he showed his skill, and I hear that he has copied for King
Philip of Spain the Triumph of the Lamb of John van Eyck
at Ghent. Martin Hemskerk studied in Rome somewhat later,
being skilled in figures and landscapes. He has done many
paintings in Flanders, and designs for copper-engravings executed
by Jerome Kock, whom I met in Rome while I was serving
Cardinal Ippolito de' Medici. These have all excelled in com-
posing scenes and have closely observed the Italian style.

In 1545 I met in Naples John Kalcker, an admirable Flemish
painter and my great friend. He was so skilled in the Italian
style that his works would not be taken for those of a Fleming.
But he died young at Naples, a man of great promise, leaving his
anatomical studies to Vesalio. Before these, Divik of Louvain
and Quentyn[1] were very celebrated, the latter following Nature
as closely as possible, as did his son. Gios of Cleves[2] was a
fine colourist and excellent at portraits, doing many for King
Francis of France of various lords and ladies. Other famous
painters of the same country were John of Hemsen, Matthew
Kock of Antwerp, Bernard of Brussels,[3] John Cornelis of Amster-
dam, Lambert of the same,[4] Henry of Dinant,[5] Joachim Patenier
of Bouvines, and John Schoorel, canon of Utrecht, who intro-
duced into Flanders many new methods from Italy. Others were
John Bellagamba of Douay, Dierick of Haarlem[6] and Francis
Mostaeret of some skill in painting landscapes in oils, and fan-
tastic dreams and imaginings; Jerome Hertoghen Bos,[7] Peter
Breughel of Breda imitated him, and Launcelot[8] was excellent
at fires, night meteors, devils, and such things. Peter Coeck
possessed inventions for scenes, and made splendid cartoons for
tapestries and arras. He had skill and a good style in architecture,
and so has translated into German the architectural works of
Sebastiano Serlio of Bologna. John de Mabuse[9] was almost the
first to take to Flanders from Italy the true method of making
scenes full of nude figures and poetical fancies, and the great
tribune of the abbey of Middelburg in Zeeland is by his hand.
I have received notice of all these from Maestro John della
Strada[10] of Bruges, painter, and Giovanni Bologna of Douai,
sculptor, both Flemings and excellent artists. With regard to

[1] Dierik Bouts and Quentyn Matsys. [2] Joos van Cleve.
[3] Bernard van Orley. [4] Lambert Lombard.
[5] Herri met de Bles. [6] Dierk Stuerbout.
[7] Jerome Bosch. [8] Launcelot Blondeel of Bruges.
[9] Jan Gossaert (Mabuse). [10] Jan van der Straet.

living artists, the first for painting and many copper-engravings is Francis Floris of Antwerp, pupil of Lambert Lombard, considered most excellent. No one has better expressed the emotions of grief, joy and other passions, or has displayed such original fancy, so that they call him the Flemish Raphael. It is true that engravings of his works do not bear this out; but the engraver, however skilful, never achieves the excellence of the original. Another pupil of the same master, William Cuyp, of Breda and Antwerp, is a grave, judicious man, fond of copying Nature, and a clever inventor, more skilled than the others in obtaining tone and grace, though he has not the vigour and facility of Floris.

Michael Cockuysen, mentioned above, is very famous among the Flemish artists, his figures being virile and severe. M. Domenico Lampsonio, a Fleming, compares these last three artists to a trio in which each takes his part. Anthony More of Utrecht in Holland, painter of the Catholic king, is highly esteemed among the above. His colours in portraits are said to vie with Nature and deceive the sharpest eye. Lampsonio writes to me that More, who is most courteous and beloved, has done a beautiful Resurrection, with two angels and St. Peter and St. Paul. Martin de Vos is also considered a good inventor and colourist, drawing admirably from Nature. But for landscapes, James Grimer, Hans Bolz [1] and others of Antwerp of whom I could not obtain particulars, have no peer. Peter Arsen,[2] called Peter Lungo, did a panel with shutters in his native Amsterdam, of the Virgin and saints, which cost 2000 crowns. Lambert of Amsterdam is also reputed a good painter. He lived many years in Venice, and quite caught the Italian style. He was father of Federigo, who being a member of our academy will be mentioned elsewhere. Peter Breughel of Antwerp is also an excellent master, and Lambert van Hort of Amersfort in Holland, and Giles Mostaeret, brother of the Francis mentioned, is a good architect. Peter Pourbus, a youth, has shown promise of becoming a great painter.

To say something of the illuminators, Marin of Zierickzee, Luke Hurembout of Ghent, Simon Benich of Bruges and Gerard have excelled in this art, and also some ladies, namely Susanna,[3] Luke's sister, called for this to the service of Henry VIII. of England, where she lived in honour during his reign; Clara Skeysers [4] of Ghent, who died a spinster of eighty; Anne, daughter of Maestro Segher, physician; Levina, daughter of

[1] Hans Bol.
[2] Pieter Aertsen.
[3] Gerard Horebout and Susanna Bening.
[4] Keiser.

Maestro Simon of Bruges aforesaid, for whom King Henry obtained a good marriage, and who has been much honoured by Queen Mary and by Queen Elizabeth; and Catherine, daughter of Maestro John of Hemsen,[1] who went to Spain to serve the Queen of Hungary with a good provision, together with many others.

Many have excelled in stained glass, for instance Art van Hort of Nimuegen, burgess of Antwerp, Jacob Felart, Divik Stas of Campen, John Ack of Antwerp, who did the windows of the chapel of the Sacrament in S. Gudule at Brussels, The Flemings Walter and George[2] have also done many windows in Tuscany for the Duke of Florence from Vasari's designs.

The most celebrated Flemings in sculpture and architecture are Sebastian d'Oia of Utrecht, who served Charles V. and then King Philip with fortifications; William of Antwerp; William Cucur of Holland, a good architect and sculptor; John Dale, sculptor, poet and architect; James Bruca, sculptor and architect,[3] who did many works for the Queen-Regent of Hungary, and who was the master of our academician Giovanni Bologna of Douai, mentioned hereafter. Another good architect is John di Minescheren of Ghent, and Matthew Manemacken of Antwerp[4] is a good sculptor in the service of the King of the Romans. Cornelius Floris, sculptor, brother of Francesco, is an excellent sculptor and architect, being the first to introduce the method of making grotesques into Flanders. Other sculptors are William Palidam, brother of Henry, John de Sart of Nimuegen, Simon of Delft,[5] Gios Jason of Amsterdam; while Lambert Suave of Liège is a good architect and engraver, in which he is followed by George Robin[6] of Ypres, Divik Volcaerts[7] and Philip Galle, both of Haarlem, and Luke Leyden, with many others, who have all been to Italy to learn and sketch antiquities and have returned home accomplished masters. But the greatest of all these was Lambert Lombard of Liège, a well-lettered man, a judicious painter and excellent architect, the master of Francis Floris and William Cay. I have received much information about him and others from the letters of the learned and judicious M. Domenico Lampsonio of Liège, who was the intimate of Cardinal Pole of England, and is now the secretary of the Prince Bishop of Liège.

[1] Jan Sander van Hemessen.
[2] Arnold van der Hout, Dirk Jacob Felart, Dirk van Staren, Jan van Aken, Wouter Crabeth and Georg his brother.
[3] Sebastian van Oge, William Cueur, Jan van Dalen, Jacob van Breuck.
[4] Jan de Heere and Matthaeus Manemaker.
[5] William van den Broeck, Jan der Sart, Simon van Delft.
[6] Joris Robin. [7] Dirik Volkaertsen Corenhert.

He sent me the life of Lambert in Latin, and has several times saluted me in the name of many artists of his country. Here is a letter of his, dated 30 October, 1564: "Four years ago I had intended to thank you for two signal benefits; I know this must seem a strange beginning from one whom you have never seen or known, and so it would have been strange to me had I not known you. God and my good fortune brought to my hands, I know not how, your most excellent Lives of the Architects, Painters, and Sculptors. But at that time I did not know a word of Italian, whereas now, although I have never seen Italy, I thank God I can read your book, and have even ventured to write this. Your book has whetted my desire to learn the language, which I might never have done had not I been impelled by the extraordinary love I have borne for the arts since I was a child, and especially for your own charming art of painting, which is delightful to all, and hurtful to none. I was then ignorant and without judgment, but now, thanks to the repeated perusal of your book, I understand enough, little as it is, to add a new joy to life, which I value more than the honours and riches of this world. I also meddle a little with oils, drawing natural objects, especially nudes and all manner of draperies, though I have never ventured upon things which demand a more certain and practised hand, such as landscapes, trees, water, clouds, glory, fires, etc. But perhaps I may yet make progress in these by reading your book. However, so far I have contented myself with portraits, the more so as the numerous occupations of my office do not give me time. To show my gratitude to you for having taught me a beautiful language and the art of painting, I would send you a small portrait of myself done at a mirror, if I knew whether you were at Rome, Florence, or your native Arezzo."

The letter also contains many other things. He afterwards asked me in the name of several prominent men of those countries, who have heard that these Lives are to be re-issued, to treat of painting, sculpture, and architecture, with illustrative figures, as has been done by Albert Dürer, Serlio and Leon Battista Alberti, whose writings have been translated by M. Cosimo Bartoli, a Florentine noble and academician. I should have been more than pleased to comply, but my purpose has been simply to write the lives and works of our artists, and not to teach the arts. Besides, the work has grown so large that it is perhaps too long already, though I could not do otherwise, or deprive anyone of his due praise, or the world of the pleasure and benefit which I hope it will derive from these labours.

DESCRIPTION OF THE WORKS OF
GIORGIO VASARI

So far I have spoken of the works of others, with all the care and sincerity in my power. I now propose to complete my task by setting down the works which Heaven has permitted me to achieve. Although these are not so perfect as I could wish, yet any impartial observer will allow the care and labour I have bestowed upon them, so that if they do not merit praise they may at least escape blame. Besides, as they are public, they cannot be hidden. It might happen that others would write about them, and so it is better for me to confess the truth and point out my own shortcomings, of which I am only too conscious. Of this at least I am sure, that though they may not lay claim to excellence and perfection yet they show an ardent desire to do good work, the most painstaking effort and the deepest devotion to our arts. So I claim it is good law that some measure of pardon should be extended to me because I openly confess my fault.

To begin at the beginning. I have already said enough about the origin of my family, my birth and childhood and how my father Antonio directed my steps in the right way with the utmost kindness; more particularly in design, to which he found I had a great leaning. This may be found in the Life of Luca Signorelli, my kinsman, that of Francesco Salviati and in many other places, so that repetition is superfluous. I may say, however, that after I had copied all the good pictures to be found in the churches of Arezzo, the first principles were taught me with some system by the Frenchman Guglielmo da Marzilla, whose life and works have been described. In 1524 I was taken to Florence by Silvio Passerini, cardinal of Cortona, and devoted some study to design under Michelagnolo, Andrea del Sarto and others. But when the Medici were driven out of Florence, and notably Alessandro and Ippolito, to whose service I was closely attached in these tender years, thanks to the cardinal, my father's brother, Don Antonio, fetched me back to Arezzo, my

father having died of the plague just before. To avoid the plague my uncle kept me away from the city, and so it happened that, to fill up my time, I went about in the country districts painting frescoes for the peasants, although I had practically never touched coloured colours before. This showed me that to work on one's own account is a teacher and guide in itself, and affords excellent practice. The following year, the plague being over, my first work was a small picture for the Servite church of S. Piero, Arezzo. It stood against a pilaster and represents St. Agatha, St. Roch and St. Sebastian in half-length figures. The famous painter Rosso, who came to Arezzo at the time, happened to see it, and perceiving some merit, due to Nature, he desired to make my acquaintance. Afterwards he helped me with designs and with advice. Not long after, thanks to him, M. Lorenzo Gamurrini employed me to paint a picture for which Rosso supplied the design. To this I devoted all my skill, care and labour, both to learn and to make a name. If my powers had equalled my good will I should soon have become a reputable painter, so diligently did I study art. But I found the difficulties much greater than I had anticipated. However, I did not lose heart and returned to Florence. Realising that it would be a long time before I could be in a position to help three sisters and two younger brothers, left to me by my father, I put myself with a goldsmith. I did not long remain there, as with the siege of Florence in 1529 I went with the goldsmith Manno, my very good friend, to Pisa. There I gave up goldsmith's work and painted in fresco the arch over the door of the old company of the Florentines and some oil-paintings. I owed the commission to Don Miniato Pitti, then abbot of Agnano, outside Pisa, and to Luigi Guicciardini, who was then at Pisa. As the war grew fiercer and fiercer, I decided to return to Arezzo. I could not take the usual direct route and so traversed the Modena mountains to Bologna. There I found them at work on some triumphal arches for the coming of Charles V. Young as I was I might have obtained honourable and useful employment, as I was good at design. I might have stayed there to work, but my anxiety to see my family and relations induced me to return to Arezzo, as I found agreeable companions for the journey. There I found my affairs in good order, owing to the care of my uncle Antonio. My mind being thus set at rest, I devoted myself to design and also did some small and unimportant things in oils. Meanwhile Don Miniato Pitti had become either abbot or prior of Monte Oliveto of

Siena, and sent for me. Accordingly I did some paintings for him and for Albenga, their general. When Don Miniato subsequently became abbot of S. Bernardo, Arezzo, I did him two paintings for the organ well. The monks were pleased and got me to do some paintings in fresco on the vaulting and façade of a portico at the principal door of the church. This was the four Evangelists with God the Father, and some other life-size figures. Although, being young, I did not achieve all that a more experienced painter would have done, yet I applied what skill I had, and the fathers were not dissatisfied, making allowance for my youth and inexperience.

No sooner had I completed this work than the Cardinal Ippolito de' Medici, happening to travel post through Arezzo, took me to Rome in his train, as related in Salviati's Life. Thanks to the consideration of the cardinal I had opportunities to devote many months there to the study of design. I may truly say that this opportunity and my studies at that time were my principal teacher in the arts, although those I have mentioned above afforded me no little help. I never ceased to cherish the most ardent desire to learn and was drawing day and night, without relaxation. Another great help in those days was the competition with other youths, my equals and companions, who have since, for the most part, become excellent in our arts. Another powerful stimulus was the desire for glory and the sight of so many who had become rare masters and attained to rank and honour. I sometimes asked myself, why should not I attain by toil and study to what so many others have achieved? They were made of flesh and blood like myself. Spurred by such thoughts and by the dependence of my family upon me, I resolved to spare no toil, discomfort or effort in order to attain my end. With this resolve I left nothing in Rome, Florence, or any other place where I stayed, that I did not draw; not only paintings but sculpture and architecture, both ancient and modern. In addition to the profit I gained by drawing Michelagnolo's vaulting and chapter-house, I drew everything of Raphael, Pulidoro and Baldassare of Siena, in company with Francesco Salviati, as related in his Life. In order to have drawings of everything, we arranged always to draw different things, and at night each copied the other's work, to save time and to study more thoroughly. As a rule we took our very modest morning meal standing. After this incredible labour, the first work to issue from my own foundry was a life-size Venus with the Graces worshipping and adorning her, for the Cardinal de'

*I 787

Medici. 1 will not dwell upon this, because it was a youthful work, but I refer to it because I like to recall those early days of my first start. The cardinal and others gave me to understand that it was a good beginning and full of life. Among other things my fancy led me to represent a lecherous Satyr, hidden in the bushes and gloating over the sight of the naked Venus and the Graces. This so delighted the cardinal that he got me to begin a new and larger picture of a combat of satyrs with fauns, nymphs and infants, practically a Bacchanal. I set to work to make the cartoons for this and then sketched in the colours on a canvas ten braccia long. As the cardinal was leaving for Hungary, he introduced me to Pope Clement, and left me under his protection. The Pope gave his chamberlain, Jeronimo Montaguto, charge over me, with letters, so that if I wished to escape from the air of Rome that summer I should be received at Florence by Duke Alessandro. It had been well if I had done this, as the climate of Rome, combined with my labours, induced a sickness so severe that I had to be carried to Arezzo on a litter to recuperate. On recovering my health I proceeded on the 10th of December to Florence. The duke received me graciously and soon after handed me over to the care of M. Ottaviano de' Medici, who took me under his protection and treated me as a son as long as he lived. I shall always revere his memory and think of him as a most affectionate father. I was thus able to renew my studies, and thanks to him I took my place in the new sacristy of S. Lorenzo, containing the works of Michelagnolo, who was away in Rome at the time. I studied them very carefully for a while, especially as they were on the ground. After that I set to work and painted a dead Christ borne by Nicodemus, Joseph and others to burial, with the Maries following weeping, a picture of three braccia. When it was finished Duke Alessandro had it, and so it gave me a good start. Not only did the duke value it, but it afterwards went to the chamber of Duke Cosimo, and is now in that of the illustrious prince, his son. Although I have sometimes wished to touch it up and improve it I have not been allowed to do so.

After seeing this first work, Duke Alessandro directed that I should finish the ground-floor chamber of the Medici palace, left incomplete by Giovanni da Udine; so I did four scenes from Cæsar's life. These were: his swimming with his Commentaries in his hand and his sword in his mouth; his burning of Pompey's papers, to avoid seeing the machinations of his enemies; his making himself known to a boatman, when in

danger at sea, and his triumph, but this last was not quite finished. At this time, although I was not more than eighteen, the duke gave me a provision of six crowns a month, a place at table, a servant, apartments and many other advantages. Although aware that I did not come near deserving all this, yet I devoted all my powers to my work, and was not afraid of asking my elders when I did not know anything. Thus Tribolo, Bandinello and others often helped me in my work and with advice. For example I did a portrait of three braccia of Duke Alessandro from life, his seat composed of prisoners bound together, with other fancies. I remember that besides the portrait, which was a good likeness, I nearly went out of my mind in getting the right polish for the armour, so anxious was I to have every detail correct. In my despair of approximating to the reality I brought Jacopo da Pontormo to look at the picture and give his advice, as I esteemed him for his many great qualities. After looking at the picture, and knowing my enthusiasm, he said kindly: My son, so long as the real armour is alongside, your work will always look like paint, as although white lead is the strongest colour known to art, polished steel is stronger and more brilliant. Take away the real and you will see that your mimic armour is not so bad as you think. When the portrait was finished I gave it to the duke, who presented it to M. Ottaviano de' Medici, in whose house it now is, beside the portrait of Catherine, the duke's youthful sister, afterwards Queen of France, and that of Lorenzo de' Medici the Magnificent. The same house has other pictures of my youthful days: Abraham sacrificing Isaac, Christ in the Garden and a Last Supper.

Meanwhile the cardinal, in whom all my hopes rested, had died, and I began to realise how vain for the most part are the hopes of this world and that a man must rely chiefly upon himself. Perceiving that the duke was intent upon fortification and building, I began, in order to serve him better, to practise architecture, to which I devoted much time. When preparations were being made for the reception in Florence of the Emperor Charles V. in 1536, the duke directed those in charge of the decorations to engage my help in designing arches and other things, as related in Tribolo's Life. This was done, and in addition to the large banners of the castle and citadel I was given the façade of a triumphal arch, forty braccia high by twenty broad, at S. Felice in Piazza, near the decoration of the S. Pier Gattolini gate. These were all great works and beyond my powers.

What is worse, these favours excited widespread jealousy against me, so that some twenty men who assisted me with the banners and other things left me in the lurch, being prevailed on to do this in order that I might not be able to carry out these important works. But I had anticipated the malignity of men whom I had always been ready to help, and partly by working myself, day and night, and partly with the assistance of painters from other parts, who helped me covertly, I succeeded in overcoming all these difficulties. Meanwhile Bertoldo Corsini, the general supervisor for his excellency, had reported to the duke that I had undertaken too much and could never get done in time, especially as I had no men and the work was much in arrear. Accordingly the duke sent for me and told me what he had heard. I replied that my work was well forward, as his excellency could satisfy himself, and that the result would bear this out. Not long after I had gone he came secretly to where I was working and was in a position to appreciate to some extent the envy and malice of my detractors. When the time came for everything to be in order, my works were all finished and in their places greatly to the satisfaction of the duke and everyone, whereas the productions of some of those who had paid more attention to my affairs than their own were put up unfinished. When the festivities were over the duke, in addition to 400 crowns for the work, gave me 300 which were taken from those who had not finished their task according to the contract. With this money I married one of my sisters, and soon afterwards placed another in the Murate at Arezzo, giving the nunnery an Annunciation by my own hand, in addition to the dowry or alms, with a tabernacle for the Sacrament in it. This was placed in the choir where the offices are performed.

Being afterwards employed by the company of Corpus Domini of Arezzo to do the high-altar picture of S. Domenico, I did a Deposition from the Cross, and soon after I began a picture for the church of the company of S. Rocco in Florence. But while I was thus winning honour, fame and riches under the protection of Duke Alessandro, the poor prince was cruelly murdered, and I found myself deprived of all the hopes which I had based upon his favour. Since Clement, Ippolito and Alessandro had all died within a few years, I resolved, on the advice of M. Ottaviano, to follow art alone and not the favour of courts, although I might easily have settled under the new duke Cosimo. Accordingly I pushed on with the picture and façade of S. Rocco at Arezzo and was making arrangements to proceed to Rome.

But by the will of God, to whom I owe all I have, I was summoned to Camaldoli through the influence of M. Giovanni Pollastra, by the fathers there, to see what they wanted done in their church. On arriving there I was delighted with the eternal solitude and quiet of that holy place among the mountains. Although aware from the first that those venerable fathers were taken aback by my youth, I took courage and by my address I induced them to employ me on several paintings in oil and fresco for their church at Camaldoli. But whereas they desired me to do the high-altar picture before everything else, I urged that it would be better to do one of the minor ones first, for the transept, and then, if that pleased them, I could go on. Neither would I make any definite bargain with them, but told them that if they liked the work when it was done, they should pay me what they saw fit, and if not I would take it back. They agreed to these terms, which seemed almost too favourable to them. They told me that they wanted Our Lady holding the Child, with St. John the Baptist and St. Jerome, who were both hermits living in the wilds. Accordingly I left the hermitage and went down to their abbey of Camaldoli. There I soon had a design ready, which they liked, began the picture and completed it in two months. When it was set up the fathers seemed very pleased, and so was I. In this short space I had learned how helpful to study are peace and quiet as compared with the noise of the market-place and court, and I realised my mistake in basing my hopes on men and on the weathercocks of this world. When I had completed this picture the fathers immediately allotted to me the remainder of the transepts of the church, with scenes and other things in fresco, to be done in the coming summer, because it would hardly be possible to work in those altitudes in the winter.

In the meantime I returned to Arezzo and finished the picture of S. Rocco, doing Our Lady, six saints and a God the Father, holding arrows, to signify the plague, with whom St. Roch and other saints are pleading for the people. The wall contains other pictures, which are so so, like the picture. Then Frà Bartolommeo Graziani, an Augustinian friar of Monte Sansovino, sent for me to Val di Caprese and set me to do a large oil-painting for the high altar of the church of S. Agostino del Monte there. That arranged, I went to Florence to see M. Ottaviano de' Medici, and during a stay of some days I had a hard struggle to keep to my determination not to return to serve courts, as he proposed. However, I won the battle and decided to go to

Rome before doing anything else. But before this I made for M. Ottaviano a copy of the picture in which Raphael drew Pope Leo, Cardinal Giuliano de' Medici and the Cardinal de' Rossi, because the duke wanted the original, which was then in M. Ottaviano's possession. My copy is now in the house of his heirs. When I left for Rome he gave me a letter of exchange for 500 crowns on Giovanni Battista Puccini, to be paid at sight, saying, Make use of this so that you may attend to your studies. You can let me have it back either in cash or in pictures, whenever it is convenient.

I arrived in Rome in February 1538 and stayed there all June. I proposed, in company with my boy, Giovanni Battista Cangi of Borgo, to draw all that I had left on my previous visits, especially what was underground in the grottoes. There was nothing in architecture or sculpture which I did not draw or measure. I can say without exaggeration that I did more than 300 drawings in that period, and in after years they gave me much pleasure and served to refresh my memories of Rome. The value of these labours was proved on my return to Tuscany in the picture I did at Monte Sansovino, namely an Assumption, in an improved style, with St. Augustine and St. Romuald below, as well as the Apostles.

Proceeding to Camaldoli, in fulfilment of my promise to the fathers, I did a Nativity of Christ for the other side of the transept. The night is irradiated by the splendour of the Babe, who is surrounded by adoring shepherds. I imitated the sun's rays and drew the figures and other things from life, so as to approach reality as closely as possible. As the light could not proceed beyond the manger, I made the light outside come from the angels, who are singing *Gloria in Excelsis Deo*. Other parts are lighted by straw torches carried by the shepherds, by the moon, the stars and the angels appearing to the shepherds. For the buildings I introduced some antiquities with broken statues and such like. In short, I devoted all my powers to the work, and although my hand and brush did not nearly realise my aspirations, yet the work gave pleasure to many. Thus M. Fausto Sabeo, a very learned man and keeper of the Pope's library, as well as others, made Latin verses in honour of this picture, possibly moved rather by friendly feeling than by its excellence. However that may be, any merit it possesses was the gift of God. When the picture was finished the fathers decided that I should paint in fresco the scenes for the façade. Accordingly over the door I drew the hermitage, with St.

Romuald and a doge of Venice, who was a holy man, on one side, and on the other a vision of the saint at the place where he built his hermitage, with various fancies, grotesques, etc. When that was done they arranged that I should return in the summer of the following year to do the high-altar picture.

Meanwhile Don Miniato Pitti, who was then visitor of the congregation of Monte Oliveto, had seen my picture at Monte Sansovino and the works at Camaldoli. Meeting at Bologna Don Filippo Serragli, a Florentine, abbot of S. Michele in Bosco, he told him that for the painting to be done in their refectory there he ought to employ me and no one else. Thus they fetched me to Bologna, and although the work was great and important I undertook it, though first of all I wanted to see the famous paintings of the city by Bolognese and other artists. The work at the top of the refectory was divided into three pictures. The first was to be Abraham entertaining the angels in the plain of Mamre; the second Christ in the house of Mary Magdalene and Martha, telling the latter that Mary has chosen the better part, and the third St. Gregory feeding twelve poor men, one of whom he knew to be Christ. I began with the last, representing St. Gregory at table in a convent, served by white monks of the order, as the fathers desired. For the Pope I drew Clement VII. and among the ambassadors, princes, etc., looking on I drew Alessandro de' Medici, in memory of the favours received from him and for being what he was. I also drew many of my friends. Among those serving I drew some of the friars, such as the foresters who waited on me, the dispenser, the store-keeper and other such, as well as the Abbot Serraglio, the general Don Cipriano da Verona and Il Bentivoglio. I also represented the velvet, damask, cloth of gold, silk, etc., of the Pope's vestments. I gave the accessories, vases, animals, etc., to Cristofano dal Borgo, as related in his Life. In the second scene I endeavoured to make the heads, draperies, buildings, etc., different from the first. I also tried to bring out the feelings of Christ in instructing the Magdalene, and the love and diligence of Martha in preparing the meal and her complaint at her sister letting her do this unaided, not to mention the attention of the Apostles and many other circumstances of the picture. In the third scene I painted the three angels in a celestial light, an idea that came to me somehow. This seems to issue from them, while the rays of the sun surround them in a cloud. Abraham is adoring one of the angels, although he sees three; Sarah stands laughing at the idea of what has been promised

her, while Hagar is leading Ishmael away from the house. The same light illumines the servants, who are making ready, while some of them try to avoid it, shading their eyes. These things gave a special relief to this picture because the sharp contrast of light and shade imparts greater vigour. Moreover, a different colour scheme gave quite a different impression. I only wish I had been able to realise my conception, but I have always been making experiments in the difficulties of art. I completed the whole work, such as it was, in eight months, including a frieze in fresco, the architrave, inlay work, stalls, tables and other decoration of the refectory. I accepted 200 crowns for the whole, being more eager for glory than for gain. My close friend M. Andrea Alciati, then studying at Bologna, made this inscription for it: *Octonis mensibus opus ab Aretino Georgio pictum, non tam praetio quam amico obsequio et honoris voto, anno* 1539 *Ph. Seralius pon. curavit.*

About the same time I did two small pictures of a dead Christ and a Resurrection which were placed in the church of S. Maria di Barbiano outside S. Gimignano di Valdelsa by Abbot Don Miniato Pitti. These done I returned forthwith to Florence, because Trevisi, Maestro Biagio, and other Bolognese painters, thinking that I meant to settle at Bologna and deprive them of work, never ceased to vex me. But they did more harm to themselves, and some of their moods and tricks only served to amuse me. At Florence I copied a portrait of Cardinal Ippolito to the knees, and some other pictures for M. Ottaviano, devoting the trying part of the summer to this work. That done, I returned to the quiet and cool of Camaldoli to do the high-altar picture, a Deposition from the Cross. I devoted all my powers to this, and not being satisfied with the first sketch, I did it all over again as it now is. Delighting in the solitude I here did a youthful St. John, nude, among rocks like those about me. Scarcely had I completed this than M. Bindo Altoviti arrived at Camaldoli, to make a track from San Alberigo, a cell of the fathers, to Rome along the Tiber, for large firs, for the building of S. Pietro. He happened to see all the works I had done there, and fortunately admired them, so before he left he decided that I should do him a picture for his church of S. Apostolo at Florence. Accordingly, after finishing off at Camaldoli with the wall of the chapel, where I made the experiment of uniting oils with fresco, I proceeded to Florence and did this picture. I wished to give Florence a taste of my skill, as I had never done a work of this kind there, and having many

rivals and a desire to win fame, I determined to do my very best. To rid myself of all other preoccupations I first married my third sister and bought a house at Arezzo, with a fine site for gardens, in the Borgo di San Vito, in the best air of the town. Then, in October 1540, I began to paint a Conception of Our Lady for M. Bindo's chapel, that being the dedication. I found this no easy matter, and M. Bindo and I took the opinion of many mutual friends, men of letters and others. At length I did it thus. In the middle I represented the tree of original sin, at the foot of which, as the first sinners, I represented Adam and Eve, naked and bound. At the branches I represented bound by both hands Abraham, Isaac, Jacob, Moses, Aaron, Joshua, David and the other kings in their order, Samuel and St. John the Baptist having only one hand bound, as being sanctified in the womb. At the foot, with his tail wound round it, I made the serpent, of human form down to the middle, with his hands bound behind him. The glorious Virgin has one foot on his head, spurning his horns, and the other rests on the moon. She is clothed with the sun and crowned with twelve stars. She is supported in the air in a glory by a crowd of nude cherubs, illumined by rays issuing from her. The rays pass through the foliage of the tree and light on the captives, seeming to loose their bonds by the virtue and grace of their origin. In the sky at the top of the picture are two cherubs holding a cartel with the words: *Quos Evæ culpa damnavit Mariæ gratia solvit.* So far as I remember I had never before devoted myself so thoroughly to any other picture. But I did not satisfy myself, though I pleased others, well as I knew the labour I had expended, especially over the nudes and heads. M. Bindo gave me 300 gold crowns for my pains and in the following year showed me so much kindness in his house at Rome, where I did him a small miniature-like replica of this picture, that I shall always feel in his debt. While engaged upon this picture I did a Venus and a Leda for M. Ottaviano de' Medici from the cartoons of Michelagnolo, and a life-size St. Jerome in penitence, contemplating a crucifix and beating his breast, to drive away the lascivious thoughts which beset him even in the wilderness, as he himself relates. To indicate this I did Venus fleeing with Cupid in her arms and leading Play, the quiver and arrows strewing the ground. Cupid's arrows lie broken, and the doves of Venus pick up some with their beaks. I cannot say what I think of these paintings now, although they pleased me at the time and I put my best into them. But Art is difficult and

demands one's utmost. I may say this much, that I have always produced my paintings, inventions and designs with extraordinary ease, free from effort, even if I do not claim extreme speed. As evidence of this, as related elsewhere, is the large canvas I painted in S. Giovann at Florence in no more than six days, in 1542, for the christening of Don Francesco de' Medici, now prince of Florence and Siena.

Although after this I had intended to go to Rome, because of M. Bindo Altoviti, things did not fall out that way, for I was summoned to Venice by M. Pietro Aretino, then a poet of renown and my fast friend. As he greatly desired to see me I was obliged to go, and I was glad of the opportunity for seeing the works of Titian and others. In a few days I succeeded in seeing the works of Correggio in Parma and Modena, those of Giulio Romano at Mantua and the antiquities of Verona.

Reaching Venice with two pictures which I had painted from cartoons by Michelagnolo, I gave them to Don Diego de Mendozza, who sent me 200 gold ducats. I had not been long at Venice before, at the instance of Aretino, I did the decorations for the festival of the Signors of the Calza, assisted by Battista Cangi, Christofano Gherardi of Borgo San Sepolcro and Bastiano Flori of Arezzo, men of great skill, of which enough has been said elsewhere. I also did the nine pictures for the ceiling of a chamber of the palace of M. Giovanni Cornaro at San Benedetto. After doing these and other works of importance, I left Venice on 16 August, 1542, and returned to Tuscany, although I might have had my hands full of work. Before beginning anything else I painted the ceiling of a chamber I had built in my house with all the arts connected with design. In the middle Fame, seated on a globe, blows a golden trumpet and throws away one of fire, representing slander. About her are all the Arts with their attributes. Not having time to finish, I left eight ovals for portraits from life of our leading artists. At the same time I did a Nativity with life-size figures for a chapel in the garden of the nuns of St. Margarita in that town. After spending the remainder of the summer and part of the autumn in this way in my native town, I went to Rome, where M. Bindo gave me a cordial welcome. For him I did a life-size Deposition from the Cross, with Phœbus observing the face of the sun and Diana that of the moon. Rocky mountains break in pieces at the earthquake in the darkened landscape and dead saints rise from their graves. This picture, when finished, found favour with the greatest painter, sculptor and architect of our

own and perhaps of all time. It was shown by Giovio and
M. Bindo to Cardinal Farnese. For this prelate I did a painting
eight braccia by four, of Justice embracing an ostrich laden
with the twelve tables, holding a sceptre with a swan at the
end and wearing a helmet of iron and gold with three feathers
of divers colours, the device of the just judge. She was naked
from the middle upwards. At her girdle were the seven Vices
in golden chains, Corruption, Ignorance, Cruelty, Fear, Treason,
Falsehood and Slander. They carry on their bare backs a naked
Truth, offered to Time by Justice, with two doves, represent-
ing Innocence. Justice is putting an oaken crown, representing
Fortitude, on the head of Truth. I put all my powers into
this work.

In those days I courted Michelagnolo assiduously and con-
sulted him about all my affairs, and he was good enough to
show me great friendship. Having seen some of my designs, he
induced me to turn again to architecture and to study it in a
better manner. I might never have done this but for what he
said, which modesty will not permit me to repeat. As it was
very hot in Rome and I had spent all the summer of 1543 there,
I returned to Florence on St. Peter's day. There, in the house of
M. Ottaviano de' Medici, which I might call my own, I did a
picture for M. Biagio of Lucca, his friend, like the one I did for
M. Bindo in S. Apostolo, though I varied all the ideas. When
finished it was placed in his chapel in S. Piero Cigoli, Lucca.
I did another of the same size, i.e. seven braccia by four, of
Our Lady, St. Jerome, St. Luke, St. Cecilia, St. Martha, St.
Augustine and St. Guy the Hermit. This picture was placed in
the duomo at Pisa, which contains many other paintings by
great artists. No sooner was this done than the warden of the
duomo commissioned me to do another. As this also was to be
a Madonna, for the sake of variety I did Our Lady with the
dead Christ in her lap, at the foot of the cross, the thieves
hanging on crosses above, the Maries and Nicodemus standing
by; and introducing the titular saints of the chapels, forming
a pleasing composition. Returning to Rome again in 1544,
besides many pictures for friends, unnecessary to mention, I
did a Venus from a design of Michelagnolo for M. Bindo Alto-
viti, to whose house I returned. For Galeotto da Girona, a
Florentine merchant, I did a Deposition from the Cross, set up
in his chapel in S. Agostino, Rome. The more easily to deal with
this and other works, commissioned by Tiberio Crispo, castellan
of Castel S. Angelo, I betook myself to a palace built by Bishop

Adimari, near S. Onofrio, in Trastevere, afterwards occupied by Salviati. But feeling unwell and wearied by my labours, I was obliged to return to Florence. There I painted some pictures, one containing Dante, Petrarch, Guido Cavalcanti, Boccaccio, Cino da Pistoia and Guitone d'Arezzo, taken from authentic portraits, of which several copies have since been made.

That same year, 1544, I was sent for to Naples by Don Giammatteo of Antwerp, general of the monks of Monte Oliveto, to paint the refectory of their monastery, built by King Alfonso I. When I arrived I felt inclined to refuse the work, as the building is Gothic, low and dark, so that I feared the work could bring me little credit. However, constrained by Don Miniato Pitti and Don Ippolito da Milano, my warm friends and at that time visitors of the order, I ultimately accepted the task. Considering it hopeless without a great profusion of ornament, as numerous figures would confuse the spectator, I decided to cover the vaulting with stucco, and get rid of the old-fashioned awkward sections by making rich compartments in the modern style. The tufa stone used there in the walls gave me great assistance, since it is carved as easily as wood or rather like bricks not thoroughly baked. I was thus able to carve my squares, ovals and octagons in this tufa. This stucco-work was the first in the modern style to be made at Naples.

Having thus improved the proportions of the refectory, I did six oil-paintings, six braccia high, three for each end of the room. The three over the entry are: the Rain of Manna, with Moses and Aaron picking it up. I strove here to show the attitudes, dress and expression of the men, women and children who are gathering it and thanking God. At the top end is Christ dining in the house of Simon, with the repentant Magdalene washing His feet with her tears and drying them with her hair. The scene is divided into three. In the middle is the banquet. On the right a sideboard full of curious vessels of different shapes and on the left a carver distributing the viands. The vaulting was divided into three parts: one for Faith, the second for Religion and the third for Eternity. Each of these is accompanied by eight Virtues, to show the monks eating there what is required of them. I enriched the spaces of the vaulting with grotesques, forming a framework for the forty-eight celestial images. Under the windows along the sides I did a rich border of the Parables of Jesus Christ, appropriate to the place. The rich carving of the stalls was made to correspond with all these scenes and the general decoration. I after-

wards did the high-altar picture for the church, eight braccia high, of a Presentation in the Temple, done in an original way. It is an extraordinary thing that in that great and noble city no masters had done any painting of importance from the time of Giotto until then, although something had been done outside by Perugino and Raphael. I therefore exerted myself to the utmost in order to rouse the people of the country to great and honourable things. Whether from this or some other cause many fine works in stucco and painting have since been carried out there. In addition to these works I painted a life-size Christ bearing the cross on the vaulting of the guest-house of the monastery, and many saints doing the same, to show that whoever wishes to follow Him must bear adversity here below with patience. For the general of the order I did a large picture of Christ walking on the water and stretching a hand to Peter, who fears he will be drowned. I did another of the Resurrection for the Abbot Capeccia. On the completion of these I did a chapel for Don Pietro de Toledo, viceroy of Naples, in fresco, for his garden at Pozzuolo, and some very delicate stucco ornament. He also issued orders for two large loggias, but these were never carried out for the following reason. A difference had arisen between the viceroy and the monks, and so the constable with his attendants came to arrest the abbot and some of the monks, who in a procession had had a dispute about precedence with the black monks. But the monks defended themselves and, assisted by about fifteen youths who were helping with the stucco and the painting, they wounded some of the catchpoles. It was therefore necessary to get them away at night, and they were scattered in all directions.

Being thus left alone I was not only unable to do the loggias, but could not even do twenty-four scenes from the Old Testament and the life of St. John the Baptist. As I had no further wish to remain at Naples, I took these to Rome, and they were set up with the walnut-wood stalls and presses from my design in the sacristy of S. Giovanni Carbonaro, an Augustinian convent. For these hermit friars I had shortly before painted a Christ crucified in a chapel outside the church, surrounded by a rich stucco decoration, at the request of Seripando, then general and afterwards a cardinal. In the middle of the staircase of this convent I did a St. John the Evangelist gazing upon Our Lady, clothed with the sun, her foot on the moon and crowned with the twelve stars. In the same city I painted four

walls of a chamber in the house of M. Tommaso Cambi, a
Florentine merchant and my close friend, representing times
and seasons, and Sleep on a terrace, where I made a fountain.
For the Duke of Gravina I painted the Magi worshipping Christ,
which he took away with him. For Orsanca, the viceroy's
secretary, I did four figures about the cross and other pictures.
But although I was favoured by those lords, made money freely
and work multiplied, yet, as my men had gone, I thought I had
done enough in that city, and that it would be advisable to
return to Rome. I did so and my first work there was for Sig.
Ranuccio Farnese, the Archbishop of Naples, namely four very
large doors for the organ of the Piscopio of Naples, containing
five patron saints of the city, a Nativity of Christ with the
shepherds, and David playing the harp and singing *Dominus
dixit ad me*, etc., as well as the twenty-four pictures mentioned,
and some for M. Tommaso Cambi, which were all sent to
Naples. That done, I painted five pictures of the Passion for
Raffaello Acciaiuoli, who took them to Spain.

That same year Cardinal Farnese proposed to paint the hall
of the chancery in the palace of S. Giorgio; and Mons. Giovio,
who desired that I should do this, got me to prepare designs,
though they were never carried out. The cardinal finally decided
that it should be done in fresco, in a great hurry, by a certain
date. The room is more than a hundred palms long, with a
height and breadth of fifty. At each end a large scene was
done, and two scenes on one of the sides. It could not be managed
on the other because of the windows, and so a reflection was
made of the end wall opposite. To avoid making a dado in the
usual way for all the scenes, at nine palms at least from the
ground, I tried a new device of steps up from the ground, and
a scene in each, and from these I began to draw the figures,
putting them in gradually until the level of the scenes was
reached. It would be tedious to enter into all the minutiæ, and
I will confine myself to describing the principal things briefly.
The scenes represent the doings of Pope Paul III. and each
contains his portrait. The first represents the dispatches from
Rome, with numerous nationalities and embassies and many
portraits of persons coming to ask favours and to offer tribute
to the Pope. There are also two large figures above the door,
one on each side of the scene. One represents Eloquence, above
which are two Victories holding the head of Julius Cæsar. The
other is Justice and two other Victories hold the head of Alex-
ander the Great. Above, in the middle, are the Pope's arms

supported by Liberty and Reward. On the principal wall is the Pope rewarding merit, bestowing portions, knighthoods, benefices, pensions, bishoprics and red hats. Among those who receive them are Sadoleto, Pole, Bembo, Contarino, Giovio, Buonarotto and other great men, all portraits. In a niche stands a Grace with a cornucopia full of honours, which she is pouring out, and the Victories above her hold the head of the Emperor Trajan. Envy is there, eating vipers and apparently bursting with spite. Above are the arms of Cardinal Farnese, supported by Fame and Merit. In another scene Pope Paul is represented as intent upon his buildings, notably S. Pietro. Kneeling before the Pope are Painting, Sculpture and Architecture, who submit a plan of S. Pietro, and are receiving orders to carry it out. Beside these figures is a spirit pointing to his heart, next to Wealth and Plenty, in a niche, with two figures holding the effigy of Vespasian. The Christian Religion stands in a niche separating two scenes, with two victories above holding the head of Numa Pompilius. The arms above are those of Cardinal S. Giorgio, who built the palace. The other scene, opposite the dispatches of the Court, is Universal Peace in Christendom, achieved by this Pope, with portraits of the Emperor Charles V. and of Francis, King of France. Peace is burning arms, the Temple of Janus is closed and Fury is chained. The scene stands between two niches containing a Concord with two Victories above and the head of the Emperor Titus, and a Charity with numerous urchins. Two Victories above hold the head of the Emperor Augustus, and finally there are the arms of Charles V., supported by Victories and by Hilarity. The whole work is full of inscriptions and admirable mottoes, devised by Giovio. One in particular relates that the painting was done in a hundred days. I did this as a young man without a thought except to serve this magnate, who wanted it done by a certain time, as I have said. Although I worked hard in the planning and in making the cartoons, I confess that I did wrong in giving the work to apprentices, to save time, for it would have been better to have toiled for a hundred months and to have done it myself. Even if I had not done as much as I desired for the sake of the cardinal and my own honour, I should have had the satisfaction of having done it myself. But this mistake made me decide to finish everything myself, after the preparatory work of my assistants, done from my designs. The Spaniards Bizarra and Roviale acquired considerable skill at this work, as did Battista Bagnacavallo of Bologna, Bastian Flori of

Arezzo, Giovan Paolo of the Borgo, Frà Salvatore Foschi of Arezzo, and many other youths who helped me there.

At this time, at the end of the day, I often went to see the Cardinal Farnese dine in the evening. He was always entertained by the conversation of Molza, Annibale Caro, M. Gandolfo and M. Claudio Tolomei, M. Romolo Amaseo, Mons. Giovio and other gallants and men of letters of whom his court was always full. One evening they were talking of Giovio's museum and of his gallery of portraits of illustrious men with appropriate inscriptions. In the course of the conversation Mons. Giovio said that in addition to his museum and eulogies he would dearly like to have a treatise upon all famous artists from Cimabue to our own day. In developing this he showed great knowledge and judgment about our arts though it is true that, taking the matter as a whole, he lost sight of details and often confused the names of artists, their birthplaces and works. When Giovio had done the cardinal turned to me and said: What say you, Giorgio, would not this be a fine work? Admirable, I answered, if Giovio is assisted by someone of the profession to put things straight for him. I say this because in his admirable remarks he has confused many things. Urged by Giovio, Caro, Tolomei and others, the cardinal replied, You might make him a list of all the artists and their works in chronological order, and your arts will thus receive an additional benefit from you. I promised to do my best, and very gladly, although I knew it was beyond my powers. Accordingly I set to work to look up my notes and papers, which I had made as a pastime from my early youth, and because of my regard for artists. Selecting what I thought suitable I took it to Giovio. After praising freely what I had done he said: I wish you would undertake this task, Giorgio, and elaborate this, as I see you can do admirably. I do not feel equal to it, as I did not know the technicalities or many of the particulars, as you do. Besides, mine would more resemble a treatise like Pliny's. Do what I say, Vasari, for I see from what you have brought me here that it will prove a great success. To convince me he got Caro, Molza, Tolomei and other good friends of mine to say the same. Accordingly I made up my mind and set to work, intending to give it to one of them to revise and correct, and then issue it under some other name than mine. I left Rome in October 1546 and went to Florence, where I did a Last Supper in oils in the refectory of the famous nunnery of the Murate. This was commissioned and paid for by Pope Paul III., whose sister-in-law, formerly countess

of Pitigliano, was a nun there. I afterwards did another Madonna with the Child in her arms espousing St. Catherine, and two other saints. This was commissioned by M. Tommaso Cambi for a sister of his, abbess of the Bigallo nunnery, outside Florence. That done, I did two large oil-paintings for Mons. de' Rossi of the counts of S. Secondo and bishop of Pavia, one of St. Jerome and the other a Pietà. Both were sent to France. In 1547 I finished another picture for the duomo at Pisa at the instance of M. Bastiano della Seta the warden, and next did a large Madonna in oils for my great friend Simon Corsi.

Whilst engaged upon these works I had progressed so far with the *Lives of the Artists* that little remained but to make a fair copy. It so happened that I then met Don Gian Matteo Faetani of Rimini, a monk of Monte Oliveto, a learned man and a wit, to do some work for him in the church and monastery of S. Maria di Scolca, Rimini, where he was abbot. He promised to get a monk, a fine penman, to make a copy, and to revise it himself. So I went to Rimini to do the picture and high altar of this church, which is three miles out of the city. I represented the Magi adoring Christ, with a number of figures. I took great pains, trying to differentiate the men of the three courts, though mingled together. Some are white, some brown and some black, and they wear different costumes, thus adding distinction and charm. The picture is between two others, which contain the rest of the suite, horses, elephants and giraffes. About the chapel I scattered prophets, sibyls and evangelists in the act of writing. In the cupola or tribune I did four large figures dealing with the praises of Christ, his tree and the Virgin. There are Orpheus, Homer with some Greek mottoes, Virgil with the motto *Jam redit virgo*, etc., Dante with these lines:

> *Tu se' colei che l'umana natura*
> *Nobilitasti sì che il suo fattore*
> *Non si sdegnò di farsi sua fattura*[1]

with many other figures and inventions which I need not mention.

While the work of copying and revising my book was proceeding I did a large oil-painting for the high altar of S. Francesco Rimini of St. Francis receiving the stigmata, a portrait from life. As the landscape is full of rocks and stones and the St. Francis and his companions are in brown, I made a sun, in the

[1] Thou art the one who ennobled human nature so that the Creator did not abhor to make Himself thy creature.

Paradiso, Canto XXXIII. 4-6.

midst of which is Christ with a number of seraphim. This gave
variety, and the saint and other figures are illuminated by the
splendour of the sun, while the shadows in the landscape are of
various hues, much admired by some, notably Cardinal Capo-
diferro, legate of the Romagna. Proceeding from Rimini to
Ravenna I did a picture in the new church of the abbey of
Classe, of the Camaldoli order, representing a Deposition from
the Cross. At this same time I did a number of drawings,
pictures and other minor works for friends, which I have almost
forgotten, and which it might weary my readers to enumerate.

Meanwhile, as the building of my house at Arezzo was com-
pleted, I returned home and made the designs for painting the
hall, three rooms and façade, as a summer pastime. In these
designs I represented among other things all the provinces and
places where I had worked, as if they were bringing tribute to
my house. But, as it happened, I did no more than the ceiling
of the hall, where the woodwork is very rich, doing thirteen
large pictures, containing the gods of heaven, the four Seasons
in the corners, nude and regarding a large picture in the middle,
containing life-size paintings of Merit and Envy under her feet
and gripping Fortune by the hair, while she beats both. A cir-
cumstance that gave great pleasure at the time is that in going
round the room Fortune at one place seems above Envy and
Merit, and at another Merit is above Envy and Fortune, as is
often the case in reality. On the side walls are Plenty, Liberality,
Wisdom, Prudence, Toil, Honour, etc., and below them are
stories of the ancient painters, Apelles, Zeuxis, Parrasius, Proto-
genes, with other details which I omit. In the carved wooden
ceiling of a room I did God blessing the seed of Abraham in a
large round. In four squares about this I did Peace, Concord,
Merit, Modesty. As I always worshipped the memory and works
of the ancients and observed that the method of colouring in
tempera was going out, I tried to revive it and did the whole
work in that manner, which certainly ought not to be entirely
contemned or abandoned. At the entrance to the room I painted
as a sort of jest a bride holding a rake, indicating that she has
taken all she could from her father's house. As she enters the
house of her husband she holds forward a lighted torch to
indicate that she is bringing fire to consume everything.

While I was thus engaged in 1548, Don Giovan Benedetto
da Mantoa, abbot of S. Fiore e Lucilla, a house of the black
monks of Cassino, a great lover of painting and my close friend,
begged me to do a Last Supper or something similar at the top

of their refectory. I decided to oblige him and tried to think of
something out of the common. Finally I agreed with him to do
the wedding of Queen Esther and King Ahasuerus, in an oil-
painting fifteen braccia long, putting it in position and working
at it there. Having made the experiment I can assert that this
is the true way for anyone who wishes to have his picture in
the proper light, for to paint in some other position, lower
down or elsewhere makes a difference to the lights and shades
and other things. I exerted myself to produce something majestic
and grand, though it is not for me to say how far I succeeded.
I arranged the scene so as to show the various kinds of servants,
pages, squires, soldiers of the guard, buffet, sideboard, musicians,
a dwarf and all the other properties of a magnificent banquet.
Among other things the steward is having the food brought to
table, with a train of liveried pages and so forth. At the end
of the oval table are lords and other great personages and
courtiers, standing and looking on in the usual way. The king
is at table as one both dignified and in love. He leans his weight
on his left arm and offers a glass of wine to the queen with a
royal gesture. If I may believe what I heard at the time and
what I hear from everyone who sees the work, I might claim
some credit for the thought and labour I bestowed upon it.
Above is Christ offering a crown of flowers to the queen. This
is done in fresco and was intended to lay stress on the spiritual
signification of the story, namely that the ancient synagogue
was repudiated and Christ espoused the new church of faithful
Christians. At this same time I did a portrait of Luigi Guicciar-
dini, brother of M. Francesco, the historian, because he was my
very good friend and had given me that year, being commissary
of Arezzo, a very large holding of land called Frassineto in
Valdichiana, which will be the greatest benefit to my house and
to my successors also if, as I hope, they are true to themselves.
This portrait, now in possession of Luigi's heirs, is said to be
the best and most life-like of all that have been done. I will
make no mention of the numerous portraits I have painted,
as it would only be wearisome, and, to tell the truth, I have
avoided doing them whenever possible.

This work done, I painted for Frà Mariotto da Castiglione of
Arezzo, for the church of S. Francesco of the district, a picture
of Our Lady, St. Anne, St. Francis and St. Sylvester. At the same
time I laid out a large property for the cardinal of Monte, later
Pope Julius III., a great patron of mine and the legate of Bologna.
This was carried out at the foot of his native Monte S. Savino,

which I often visited by the instruction of that prelate, who was very fond of building. I then went to Florence, and that summer I did a processional banner for the company of S. Giovanni de' Peducci, Arezzo, representing the saint preaching to the crowd on one side, and on the other his baptising Christ. So soon as this was finished it was sent to my house at Arezzo, to be consigned to the men of the company. So it happened that Mons. Giorgio, Cardinal de Armagnac, a Frenchman, saw this banner when he came to my house upon other matters. He took a fancy to it and tried hard to get it, offering a good price, to send to the King of France. But I would not break faith with my patron. Many declared that I might have done another, but I cannot say if it would have succeeded so well or if I should have devoted so much care to it. Not long after, for M. Annibale Caro, in compliance with a request made long before, as shown in a published letter of his, I did an Adonis dying in the lap of Venus, as described by Theocritus. This work was subsequently taken to France, rather against my will, and given to M. Albizzo del Bene, together with a Psyche standing with a torch to admire a Cupid, who is aroused by being burned by a spark from the torch. All these nude life-size figures induced Alfonso di Tommaso Cambi, a very beautiful youth, learned and virtuous and of most agreeable manners, to have himself drawn nude and at full length as Endymion the huntsman, beloved by the moon, which illumines the landscape, otherwise dark as night. I took especial pains to imitate the peculiar yellow white of moonlight on the objects it illumines. I next did two pictures to send to Raugia, a Madonna and a Pietà, and for Francesco Botti a large canvas of the Virgin and Child with Joseph. This picture, to which I devoted all my powers, he took with him to Spain. On completing these works I went that same year to visit the Cardinal de' Monti at Bologna, where he was legate, remaining some days with him. Persuaded by the force of his arguments I decided to take a wife, a thing I had hitherto refused to do, and so espoused a daughter of Francesco Bacci, a noble citizen of Arezzo, as the cardinal wished.

Returning to Florence I did a large picture of the Virgin according to a new idea of my own, with several figures. M. Bindo Altoviti gave me 100 gold crowns for this, and took it to Rome, where it now is, in his house. At this same time I did many other pictures for M. Bernadetto de Medici, M. Bartollomeo Strada, an excellent physician, and other friends which I need not mention. At this period Gismondo Martelli died in

Florence, leaving instructions in his will that a picture of the Virgin and saints should be done for the family chapel in S. Lorenzo. Luigi and Pandolfo Martelli, with Cosimo Bartoli, my close friends, asked me to do this picture, and I consented, having obtained permission from Duke Cosimo, the patron and chief warden of the church, but on the condition of doing something I had thought of about St. Sigismund that being the testator's name. This being arranged, I remembered having learned that Filippo di ser Brunelleschi, the architect of the church, had constructed the chapels so that each should have one large picture filling the whole space, and not a little one. Wishing to respect Brunelleschi's idea and thinking more of honour than of the slight gain to be made from a small picture with few figures, I did the martyrdom of St. Sigismund, the king, ten braccia broad by thirteen high, when he, his wife and two children are thrown into a pit by another king or tyrant. I adapted the semicircular frame of the chapel as the space of the door of a large rustic palace opening on to a square courtyard, surrounded by doric pilasters and columns. In the middle is an octagonal pit with steps up to it, which the servants mount to throw the two naked children in. In the surrounding loggias I painted spectators regarding the horrid scene. On the left I represented ruffians who have roughly seized the king's wife and are carrying her to the pit to her death. At the main doorway I made a group of soldiers who are binding St. Sigismund. The saint is patiently prepared for his martyrdom and regards four angels in the air, who show him the palms and crowns of the martyrdom of himself and family, and this seems to afford him great consolation. I also endeavoured to represent the cruelty of the impious tyrant, who is standing in the courtyard to see his revenge and the death of St. Sigismund. I exerted all my powers to give the figures the appropriate expressions and attitudes. I must leave others to decide how far I have succeeded, but I can claim to have done my best.

Meanwhile Duke Cosimo desired that the book of the Lives, now practically completed with all the speed I could muster, should be printed. So I gave it to Lorenzo Torrentino, the ducal printer, who set to work. But the theory portion was not done when, owing to the death of Pope Paul III., I began to fear that I might have to leave Florence before the printing was completed. For when I went out of Florence to meet the Cardinal di Monte, on his way to the conclave, I had no sooner paid my respects and exchanged a few remarks, than he said: I am going

to Rome and shall assuredly be Pope. Get ahead with what you have in hand and as soon as you hear the news, set out for Rome at once, without waiting for a summons. This proved no vain prophecy, for during the carnival at Arezzo, where I was arranging some festivities and masquerades, news arrived that this cardinal had become Julius III. Accordingly I forthwith mounted and rode to Florence, whence, hastened by the duke, I proceeded to Rome to attend the coronation of the new Pope and to make some of the decorations. Reaching Rome and dismounting at the house of M. Bindo I went to kiss the foot of His Holiness. The first thing he did on this occasion was to remind me of his prophecy. When matters had quieted somewhat after the coronation the first thing he wished done was a tomb in S. Pietro a Montorio, in memory of Antonio, the first Cardinal di Monte. After the drawings had been prepared, this was carried out in marble, as related fully elsewhere. Meanwhile I painted the picture of the chapel, doing the Conversion of St. Paul. As a variation from that of Buonarotti in the Paolina I did Paul as a young man, such as he describes himself, dismounted and led blind by the soldiers to Ananias, receiving his sight by the laying on of hands, and baptised. Here, whether owing to the narrow space or some other cause, I did not entirely please myself, although others did not seem dissatisfied, notably Michelagnolo. For the same Pope I did another picture for the chapel of the palace, but for reasons which I have given elsewhere I took this afterwards to Arezzo and set it at the high altar of the Pieve. It is not astonishing if I failed entirely to satisfy myself or others in these works, as I was constantly at the Pope's beck and call and never at rest. If not I was engaged upon architectural designs, especially as I was the first to plan the villa Julia, which he had erected at incredible expense. Although this was afterwards carried out by others I was the one who made designs according to the Pope's ideas, and these were afterwards revised by Michelagnolo. Jacopo Barozzi di Vignola finished the apartments, halls and other ornaments, with numerous designs, but the groundwork was done by me and Ammannato. The latter remained there and did the loggia above the fountain. But it was impossible to display one's knowledge or do one's self credit in this work, because the Pope was always thinking of fresh schemes, which had to be carried out each day by order of M. Pier Aliotti, bishop of Forli. Meanwhile, as I had to go twice to Florence in 1550 upon other matters I contrived to finish the picture of St. Sigismund. The duke came to see this in the house

of M. Ottaviano de' Medici, where I was at work on it and liked
it so much that he said: Finish what you are doing at Rome and
come to serve me here where I will set you something to do.
Accordingly I returned to Rome and finished the works begun.
After finishing a picture for the high altar of the company of
the Misericordia in S. Giovanni Decollato very different from
the usual treatment, which was set up in 1553, I proposed to
leave. But I was constrained to do two large loggias in stucco
and fresco for M. Bindo Altoviti. I painted one of these at his
villa in a new style, and since the loggia was so large that it could
not be vaulted without danger, I roofed it with a wooden frame-
work filled in with laths, upon which I laid the stucco, and painted
in fresco as if it had been brick, and indeed it seems so to all
beholders. The roof was carried by numerous rare antique columns
of mixed marble. The other loggia on the ground floor of his
house in Ponte is full of scenes in fresco. Afterwards, for the
ceiling of an antechamber, I did the four Seasons of large size
in oils. That done I was constrained to paint the portrait of the
wife of my close friend Andrea della Fonte, and with it I gave
him a large painting of Christ bearing the cross. I had done this
for a relation of the Pope, to whom it did not suit me to give it.
For the bishop of Vaison I did a dead Christ supported by Nico-
demus and two angels, and for Pierantonio Bandini a Nativity
of Christ, with night illumination and other fancies.

While engaged upon these things and waiting to see what the
Pope intended to do, I came to perceive that little could be
expected of him and that it was waste of time to serve him.
So, although I had prepared the cartoons for painting in fresco
the loggia facing the fountain of his villa, I made up my mind
to go and serve the Duke of Florence, especially as M. Averardo
Serristori and the bishop of Ricasoli, his ambassadors at Rome
urged me to do so, and M. Sforza Almeni, his steward and chief
chamberlain wrote to the same effect. Reaching Arezzo on the
way to Florence, I was constrained to do a large Patience for
Mons. Minerbetti, the bishop there, as my lord and close friend,
which was afterwards adopted as a device and for the reverse
of his medals by Duke Ercole of Ferrara. That done, I went on
to kiss the hand of Duke Cosimo, who received me graciously.
While the work I was to undertake was under consideration
I got Cristoforo Gherardi of Borgo to do from my designs the
façade of M. Sforza Almeni, in chiaroscuro, as related fully else-
where. At that time I was one of the priors on the governing
body of Arezzo, and the duke in summoning me to serve him

absolved me from those duties. On reaching Florence I found that his excellency had that year begun to build the apartment of his palace facing the Piazza del Grano, under the direction of the carver Tasso, then architect of the palace. But the roof was made so low that all the rooms were stunted, ill-ventilated and dwarfed. As it would have taken a long time to raise the kingposts and the roof, I suggested making pyramidical spaces between the kingposts, two and a half braccia deep, with corbels to bear the uprights, forming a frieze about two braccia above the beams. His excellency highly approved and at once gave orders for it to be done, and that Tasso should make the woodwork and frames for the paintings of the genealogy of the gods and then go on to the other rooms.

While this work was proceeding I had leave from the duke to spend two months away between Arezzo and Cortona, partly on my own affairs and partly to complete a work in fresco begun at Cortona on the walls and vaulting of the company of the Gesù. There I did three scenes from the life of Christ and all the sacrifices made to God in the Old Testament, from Cain and Abel down to Nehemiah the prophet. Meanwhile I got out models and drawings from the Madonna Nuova outside the city.

On completing the work of the Gesù, I returned to Florence with all my household in 1555 to serve Duke Cosimo. I then began and finished the pictures, walls and ceiling of the room mentioned, called of the Elements, representing the castration of the Heaven by the Air. For a terrace adjacent to the room I did the acts of Saturn and Ops on the ceiling, and for the ceiling of another large room the story of Ceres and Proserpine. For the very rich ceiling of a larger room next this I did scenes of the goddess Berecynthia and Cybele with her triumph, and the four Seasons and the twelve Months on the walls. For the less ornate ceiling of another room I did the birth of Jove, the goat Amaltea rearing him, and other outstanding facts about him. Another terrace adjacent to this apartment and richly adorned with stones and stucco has other matter about Jupiter and Juno. The next chamber has the birth of Hercules with all his labours. All that would not go on to the ceiling has been put into the friezes or into the hangings which the duke had woven for each room after my designs, to correspond with the paintings on the walls. I will not speak of the arabesques, ornaments and paintings of the staircase or other details which I did for that decoration, as I hope to speak about them at

greater length elsewhere, and anyone who wishes can see them and pass his opinion.

While these rooms were being painted the others were building on the same level as the principal hall and in direct communication with it, with convenient public and private staircases from the top to the bottom of the palace. Meanwhile Tasso had died and the duke was very anxious to have the palace restored, for it had been built at haphazard in various ways and at different periods, and more for the use of officials than with any idea of arrangement. He decided that this should be done as far as possible, that the great hall should be painted in due course, and that Bandinello should go on with the audience-chamber. In order to co-ordinate the existing work with the alterations contemplated, he directed me to make various plans and designs, and finally a wooden model after those which he liked most, for the better arrangement of the rooms according to his desire; and to alter the old staircases, which he considered steep and ill-designed. I took up the work, although I realised its difficulty and felt it beyond my powers, producing a large model, which his excellency now has; rather from obedience than from hope of success. But when it was done, either my good fortune or my exceeding desire to please him rendered it most acceptable to him. So the building was begun and by gradual stages reached its present state.

While this was going on I decorated with rich stucco the first eight new rooms on the floor of the great hall, comprising salons, bedchambers and a chapel, and with paintings of historical scenes, beginning with Cosimo the elder, and calling each room by the name of one of his famous descendants. One contains the most notable actions of this Cosimo, his outstanding qualities and his leading friends and dependants, with portraits of his children, all from life. It is the same with the room of Lorenzo the elder, of Pope Leo, his son, of Pope Clement, of Sig. Giovanni, the duke's father, and of the duke himself. The chapel contains a fine large picture by Raphael, between SS. Cosimo and Damian by me, the tutelary saints. Similarly the four rooms painted for the Duchess Leonora contain the deeds of illustrious Greek, Hebrew, Latin and Tuscan women respectively. It would take too long to describe everything, and besides what has been said already the whole story will be told in a dialogue shortly to be published.

For these great and continuous labours the duke showed me the most magnificent liberality, and in addition to provisions

and liberal presents he gave me houses in Florence and in the country so that I might serve him with more comfort. In my native Arezzo he procured me the supreme magistracy of gonfaloniere and other offices, with power to appoint a deputy. To my brother Ser Piero he gave advantageous offices in Florence, and he has heaped favours on my relations at Arezzo, so that I can never say enough of my indebtedness to him.

To return to my work. The duke wished the great hall painted, a design worthy of his lofty spirit, which he had cherished for a long time. He may have been chaffing me when he said he felt sure I should get it off my hands and that he would see it finished in his time, or it may have been a secret of his showing his usual prudent judgment. The result was he bade me raise the king-posts and the roof thirteen braccia higher to make a wooden ceiling, gilded and painted with scenes in oils, a great and most important work, probably beyond my powers if not of my conception. However, the duke's confidence and habitual good fortune carried me beyond myself and either hope and the great opportunity enlarged my faculties, or God gave me strength, and I must put this before all else. So I took up the work and, contrary to the opinion of many, finished it not only in less time than I had promised and than the work itself deserved, but less than the duke or I expected. I certainly think he was astonished and highly pleased because it was done ready for the happiest occasion conceivable. To account for all this expedition I may explain that a marriage had been arranged between our prince and the daughter of the late emperor and sister of the present. I therefore thought it my duty to make every effort in order that they might be able to use the principal hall of the palace for the festivities. Not only artists, but those who are not of the profession, should excuse me if I have not always attained success, when they see the great variety of war-material by land and sea, sieges, attacks, skirmishes, the building of cities, public deliberations, ancient and modern ceremonies, triumphs, etc. All these took a very long time, with the sketches, designs and cartoons required, to say nothing of the nudes, in which the perfection of art rests, or the landscapes, which were all drawn on the spots concerned. I did the same with the numerous captains, generals and soldiers in my scenes. In fine, I venture to say that I had occasion to introduce into that ceiling practically all one can think of, namely forms, expressions, dresses, all kinds of armour, coiffures, horses, trappings, every sort of artillery, shipping, storms, rain, snow and so forth.

Those who see the work may imagine the labour and thought involved in about forty great scenes, some of them ten braccia square, with very large figures in every style. Although some of my young pupils helped me, it was not always an advantage, as I was occasionally obliged to do it all over again myself, as they know, so that it should all be in the same style. The scenes relate the history of Florence from its foundation to the present time: the division into quarters; the cities subdued, enemies overcome, and finally the beginning and end of the war of Pisa down one side; while the other has the beginning and end of that of Siena. The one conducted and finished by the popular Government in the space of fourteen years and the other by the duke in fourteen months. There are also fresco paintings for the ceiling and walls, which are eighty braccia long and thirty high, on which I am engaged, which will be described in the dialogue already mentioned. I have only said this much to show what labour I have devoted to art and what good excuse I have if I have failed, as on several occasions I think I have. I may add that about this very time I was instructed to design all the arches, to be shown to his excellency to determine the order and to have them put in hand, and also to get the preparations finished for the prince's wedding. I got out designs for ten pictures, fourteen braccia by eleven, of the piazzas of all the leading cities in the state, represented in perspective, with their founders and arms. At the same time I finished the end of the hall begun by Bandinello, doing a scene at the other end of the richest description, while I completed the rearrangement of the principal staircase of the palace, the landings, courtyard and columns in the way already described, with fifteen towns of the empire and the Tyrol in as many paintings. While all this was going on I devoted no small amount of time to the loggia and main building of the municipal building,[1] which faces the Arno, the most difficult and dangerous task I have ever attempted, from its being practically on the river and almost in the air. It was also necessary among other things to adapt to it the great passage-way connecting it with the Pitti palace and garden across the river. This was constructed in five months from my designs and under my direction, although it might well have taken five years. Further, for the same wedding it was my business to adapt for the large tribune of S. Spirito the new apparatus. This was done with complete success, avoiding the dangers which had previously been in-

[1] The Uffizi.

curred. I also had charge of the palace and church of the knights of St. Stephen, Pisa, and of the tribune or cupola of the Madonna dell' Umiltà, Pistoia, a very important work. With all the imperfections, which I fully realise, if I have achieved anything of worth, I thank God for it. I hope that He will enable me to see the end of the formidable undertaking of the façades of the hall to the complete satisfaction of my masters, for whom I have worked for thirteen years upon so many honourable and useful tasks, so that I may take my ease when tired, worn out and old. Although the works mentioned above have mostly been done hurriedly, for various reasons, I hope to do this one at my ease, since the duke is content that I shall not hurry but proceed leisurely, affording me all the rest and recreation that I can desire. This last year, when I was tired over the numerous works mentioned, he gave me leave to take a holiday of some months. Accordingly I travelled through nearly the whole of Italy, visiting friends and patrons and inspecting the works of various admirable artists, as related before in another connection. I visited Rome on my way back to Florence, and when I kissed the feet of Pope Pius V. he commissioned me to do a picture for him at Florence, to be sent to his convent and church of the Bosco, erected by him in his native place near Alessandria della Paglia. Accordingly I returned to Florence and did him an Adoration of the Magi. When the Pope heard that it was done he sent to intimate that I should take it to Rome, to please him and to discuss some of his plans with me, but above all to talk about S. Pietro, which he seemed to have most at heart. Equipping myself with 100 crowns which he sent to me for the purpose and sending on the picture, I set out for Rome. There I had many conversations with His Holiness, advising him not to allow any alterations in the arrangements for the building of S. Pietro. After I had done some designs, he directed me to make for the high altar of his church at Bosco, not a picture in the usual style, but a huge erection like a triumphal arch, with two large pictures, one in front and one behind, and about thirty smaller scenes, which were all successfully completed. At this time, by the Pope's favour, who sent the bulls for nothing, I obtained the erection of a chapel and deanery in the Pieve of Arezzo, which is the principal chapel there, the property of myself and my family and endowed by me. I painted this myself as a thank-offering to God, however small, for His infinite mercies to me. This picture is of much the same form

as the one just mentioned, and that is chiefly what reminded me of it. It is isolated and has pictures on both sides in the same way. The front one has been mentioned, the back is from the life of St. George, with pictures of saints at the sides and scenes from their lives in small sections below. Their bodies rest beneath in a handsome tomb, with other chief relics of the city. In the middle is a tabernacle for the Sacrament, conveniently arranged so as to serve either altar, adorned with scenes from the Old and New Testament relative to that mystery, as related elsewhere. I forgot to say that in the preceding year, when I went for the first time to kiss the feet, I travelled by Perugia to set up three large pictures done for the refectory of the black monks there. The middle one has the Marriage at Cana, when Christ turned the water into wine, the one on the right Elijah making whole the flour which the prophets did not eat because it had turned sour. The third is St. Benedict in time of famine, when his monks have nothing more to eat, telling a novice that some camels laden with flour have arrived at the gates, and angels appear conducting a very large quantity of flour miraculously. For Signora Gentilina, mother of Sig. Chiappino and of Sig. Paolo Vitelli, I painted in Florence and sent to Città di Castello a large Coronation of Our Lady. Above are angels dancing and below numerous figures larger than life. This picture was placed in S. Francesco. For the church of Poggio a Cajano, a villa of the duke, I did a Pietà with SS. Cosimo and Damian looking on and a weeping angel in the air holding the mysteries of the Passion. A picture of mine was placed in the chapel of my friends Matteo and Simone Botti in the Carmine at Florence, representing Christ on the Cross, Our Lady, St. John and the Magdalene weeping. Later on I did two large pictures for Jacopo Capponi to send to France. One is Spring and the other Autumn, with large figures and original ideas. Another large picture is a dead Christ supported by two angels, and God the Father above. About the same time or somewhat earlier I sent to the nuns of S. Maria Novella, Arezzo, an Annunciation, with saints at the sides, and for the Camaldoli nuns of Luco di Mugello I did a picture, now in their choir, of Christ crucified, Our Lady, St. John and St. Mary Magdalene. For my intimate friend Luca Torrigiani, who wanted a picture of mine for his collection, I did a large work of Venus and the Graces. One dresses her hair, another holds a mirror, and the third is pouring water for her to wash. I devoted the utmost pains to this, both for my own satisfaction

and because of my friend. For Antonio de' Nobili, storekeeper of his excellency and a friend of mine, besides a portrait, which was an effort. I did a head of Christ after the description of Lentulus, taking pains with both. For Sig. Mondragone, now primo to Don Francesco de' Medici, prince of Florence and Siena, I did a similar one, somewhat larger, which I gave to his wife, because he is a friend and admirer of our arts and as a token of my friendship. I also have in hand a large original work for Sig. Antonio Montalvo, lord of La Sassetta, first chamberlain and confidant of our duke, and a close friend as well as a superior of mine. If my skill suffices, I want this to be a pledge of my friendship to show how much I value him, and to preserve his memory for posterity, as he is a liberal patron of all artists and lovers of art. For Prince Don Francesco I have recently done two pictures which he has sent to Toledo, to a sister of the Duchess Leonora, his mother, and a small miniature like a picture, for himself, with forty figures, large and small, according to an original idea of his own. For Filippo Salviati I finished not long since a picture which is going to the sisters of S. Vicenzo at Prato. Above is the Virgin crowned, just arrived in heaven, with the Apostles about the tomb beneath. For the black monks of the Badia, Florence, I am also painting a picture, nearly finished, of an Assumption, the Apostles being larger than life, with other figures at the sides and scenes and ornaments in a new manner.

The duke, so admirable in every way, not only delights in building palaces, cities, fortresses, gates, loggias, squares, gardens, fountains, villas and other splendid and magnificent things, but also, as befits a Catholic prince, in restoring churches, like King Solomon. Thus recently he got me to remove the screen of S. Maria Novella, which spoilt all its beauty, and to make a new and handsome choir behind the high altar, removing the one that took up a great part of the middle of the church. This makes it indeed a handsome new church. As things lacking proportion cannot be perfectly beautiful, he has directed a rich decorative framework to be made round the columns of the side aisles, to form chapels with their altars, in one or two styles, to be furnished with pictures, seven braccia by five, at the pleasure of their owners. In one of these frameworks of my own design I did for Alessandro Strozzi, bishop of Volterra, my venerable and beloved patron, a Christ on the Cross, as seen by St. Anselm, with the seven Virtues, without which we cannot mount the seven steps to Jesus Christ, and other circumstances of the same

vision. In the same church, for Andrea Pasquali, the duke's physician, I did a Resurrection in a similar framework, as God inspired me, to please this good friend. Our great duke has wished the same thing to be done in the great church of S. Croce, Florence, namely to remove the screen and put the choir behind the high altar, drawing the altar slightly forward and setting over it a handsome tabernacle for the Most Holy Sacrament, richly gilded and decorated with scenes and figures, and further to make fourteen chapels along the walls, just as in S. Maria Novella, spending more on the decorations, as S. Croce is much larger. The pictures, including two by Salviati and Bronzino, are to represent all the chief mysteries of Our Saviour, from the beginning of His Passion to the sending of the Holy Spirit upon the Apostles. Having designed the chapels and the stone orna-mentation, I have in hand the picture of the Descent of the Holy Spirit, for M. Agnolo Biffoli, general treasurer of the Government and my good friend. Not long since I finished two large pictures which are in the offices of the Conservadoria, next S. Pier Scheraggio, one a head of Christ and the other a Madonna.

But it would take too long to describe in detail all the pictures, designs without number, models and masques that I have done. I have certainly said more than enough, and will only add that, important as are the things that I have kept putting before Duke Cosimo, I have never been able to attain to, much less surpass, the magnificence of his conceptions. There is, for example, a third sacristy which he wants to make near S. Lorenzo, like that of Michelagnolo, but with variegated marbles, to form a mauso-leum for his children, his father, mother, the Duchess Leonora and himself. I have already made a model from his instructions, to his satisfaction, and when carried out it will form a magnificent and truly royal structure. Let this suffice for myself. At the age of fifty-five I have completed these labours, in the hope that I may live so long as God wills, to His honour and in the service of friends, so far as my strength allows for the increase of our noble arts.

THE AUTHOR TO ARTISTS

Noble Sires, for whose benefit mainly I took up this lengthy task, I have now, by God's grace, reached for the second time the goal which I set for myself. For this I thank God first of all, and next my patrons, who have granted me every facility

and rest for my pen and mind. I shall take advantage of this so soon as I have touched upon certain matters. If I have seemed unduly longwinded and prolix in places, it is because I was particularly anxious to make myself clear without possible ambiguity. Repetitions are due to two causes, the nature of the subject and the interruption of my task for days and even months, by journeys or heavy work, painting designs and buildings, while I freely admit that it seems impossible to avoid errors entirely. If some think that I have given excessive praise to certain ancients or moderns, and that it is ridiculous to compare the ancients with the men of this age, my answer is that I have only praised the ancients after making every allowance for place, time and circumstances. For example, although Giotto was admirable in his own day, I do not know what we should say of him or of the other ancients if they had lived in the time of Buonarotto. Moreover, the men of this age would not have attained to the present pitch of perfection had it not been for their precursors. Thus the praise or blame awarded by me is justified and I have merely set down the truth as it appeared to me. But one cannot always hold the goldsmith's balance and those accustomed to the art of writing, especially where comparisons are concerned, which are by nature odious, or forming a judgment, will hold me blameless. I know too well the toil, trouble and expense which this has cost me for many years past, and I have encountered so many difficulties that frequently I have despaired. But for the assistance of many true friends, to whom I shall always feel indebted, I should never have had the courage to persevere with the collection of notes and materials upon various matters upon which I was in doubt. This help was so efficient that I was able to ascertain the truth and publish it, bringing back to life the memory of rare and pioneer spirits which was all but lost to sight, for the benefit of those who come after us. In this I have received no little assistance from the writings of Lorenzo Ghiberti, Domenico Grillandai and Raffaello of Urbino. Although I have confidence in them, I have always checked their remarks by inspecting the works, since long practice teaches careful painters to recognise the various styles of artists, just as a good secretary recognises the handwriting of his colleagues, and as everyone does that of his friends and relations. So, if I have achieved my purpose of instructing and pleasing at the same time, it will give me the utmost delight. If not, I shall have the satisfaction of having laboured in an honourable cause, which should earn

me the regard of good men if not their pardon. But to end a long story. I have written as a painter and in accordance with my lights, in the tongue I speak, be it Florentine or Tuscan, in the most natural and easy way known to me, leaving long and ornate periods, the choice of tenses and moods and other ornaments of speaking and writing to those who are not, like me, more accustomed to the brush than the pen, and more concerned with design than writing. If I have used many technical terms of our arts, which it might have been better to avoid, for the sake of being better understood, it is because I could hardly do otherwise, and I shall be understood by you artists, for whose sake chiefly I undertook this work. For the rest, as I have done my best, you must accept it in good part and not ask of me more than I can perform, at the same time giving me credit for my good intentions, for I am always desirous to help and to please others.

ADDITIONAL NOTES
BY THE EDITOR

VOLUME I

Page 1. It was a traditional practice to preface writings on art with a Technology. An Introduction in three parts headed respectively Architecture, Sculpture and Painting was originally prefixed to the work, containing practical directions about materials and processes. Being mainly of technical interest, it is not usual in modern editions to include this Introduction with the *Lives*. The student may be referred to *Vasari on Technique* (English translation by Louisa S. Maclehose), with commentary by Professor G. Baldwin Brown.

PREFACE TO THE LIVES

Page 1. Vasari expresses the prevailing view of his time that the arts originated in Egypt. Sixteenth-century scholars in Italy also showed an awakening interest in Egyptian archaeology.

Page 2. V. uses the Bible as a reference to the art of the earliest civilizations. The discovery of prehistoric art and research into Mesopotamian archaeology lay, of course, far in the future outside his ken!

Page 3. Sources for V.'s reference to ancient and classical art were Diodorus of Sicily (*Bibliotheca Historica*), Pliny the Elder (*Historia Naturalis*), Vitruvius (*De Re Architectura*) and Pausanias (*Periegesis* or Itinerary of Greece).

Page 4. Leone Battista Alberti (1404–72), architect, sculptor, painter and man of letters, author of the classic *De Re Aedificatoria*, was a critic and theorist of much influence in V.'s time. See also the Life.

Page 4. Porsena, King of the Etruscans, sixth century B.C. In his description of Etruscan art V. has in mind the family experience of restoring Etruscan vases.

Page 6. It will be seen that V. gives two separate reasons for the decay of classical art; loss of the sense of design and secondly the influx of barbarians.

Page 7. San Giovanni in Laterano, orginally the Basilica Constantiniana, had gone through many changes when V. wrote. It was modernized in the baroque style, *c.* 1560.

Page 8. Santa Croce in Gerusalemme, Rome, was rebuilt in 1144. San Lorenzo fuori le Mura, rebuilt 578, was again remodelled, 1216–27. Sant' Agnese fuori le Mura, founded by Constantine, retained the characteristics of the early Christian basilica though re-erected by Honorius I (625–38).

Page 8. Santa Maria Maggiore, basilica of the fourth century, re-erected by Sixtus III (432–40), was restored in the twelfth century.

Page 9. San Giovanni e Paolo, founded *c.* 400, was restored in the twelfth century.

Page 9. V. sees no redeeming feature in the barbarian invasions or any possibility of a revival of art outside Rome.

Page 10. Alaric, King of the Visigoths, captured and sacked Rome, 410.

Page 11. Totila, King of the Ostrogoths, captured Rome in 546.

Page 11. Narses (*c.* 475–573), Roman prefect of Justinian, destroyed the power of the Goths in Italy.

Page 11. Constantine II (*d.* 340), one of the three sons of Constantine the Great who partitioned the empire among them.

Page 11. Gregory I (*c.* 540–604).

Page 12. Lombards (Longobards), E. German folk who permanently settled N. Italy in the sixth century. V. uses the word elastically regarding date.

Page 12. It may be noted here that V. uses the terms 'barbarian', Greek, Gothic and German in a confusingly indiscriminate fashion.

Page 12. V. nowhere makes mention of the sixth-century mosaics of Ravenna, now regarded as great masterpieces of pictorial design.

Page 13. V. follows his friend Don Vincenzo Borghini, historian and antiquary, in his account of Lombard history and the early churches of Florence.

Page 17. St Silvester was Pope, 314–45.

PART I

Page 21. Among V.'s sources for the first part of his work were Machiavelli's *Florentine History*; Don Vincenzo Borghini's accounts of Florence and its churches and of Tuscan cities; the historical chronicles of Giovanni and Matteo Villani; Antico Libro dell'Opera del Duomo (Pisa); guild records of Florence; manuscript chronicles of Siena and Venice; Cennini's *Treatise on Painting*.

Page 21. Cimabue (Cenni di Pepi), *c.* 1240–*c.* 1302, though his fame in his own time is attested by Dante's reference to him, gains a prominence from V.'s account which has since been much contested. It may be added to the footnote on p. 21 that only four works can with some reason be attributed to him in whole or part: the mosaics of the cathedral at Pisa; the 'Madonna with Angels' of the Uffizi; the 'Madonna with Angels and St Francis' in the lower church of San Francesco, Assisi, and some frescoes in the upper church.

Page 27. It may be added to the footnote on p. 27 that the profile portrait V. refers to is a detail of a fresco now attributed to Andrea da Firenze, who worked in Florence, 1350–77.

Page 28. In his account of Arnolfo di Cambio (*b.* Colle di Val d'Elsa, 1232; *d.* Florence, 1302) V. tries to fill in a gap of two centuries between the architecture mentioned in his preface and that of the time of Arnolfo (and somewhat later) by brief reference to Romanesque and Gothic monuments of which he knew with exactness neither the date nor the architect, mostly ranging in time from *c.* 1150 to the end of the thirteenth century. Bonanno, Buono, Guglielmo, Marchionne of Arezzo, are architects of whom particulars are scanty. The range of date is indicated by the fact that the abbey of Monreale was built by the Normans (1174–82), the Certosa of Pavia is 1396–1481, the Duomo, Milan, was originally Romanesque (724–824) and then Gothic (1385–1435).

Page 29. Sant' Andrea at Pistoia was one of a number of churches built on the model of the twelfth-century cathedral of Pisa.

Page 33. Jacopo the German. There seems to be little authentic trace of this architect who became 'Lapo' and was erroneously described by V. as the 'father of Arnolfo'. Assisi, however, has the stamp of early German Gothic.

Page 34. Vescovado = the cathedral of Arezzo.

Page 37. Arnolfo stands out in V.'s estimation mainly as the architect of Santa Maria del Fiore, Santa Croce and the Palazzo Vecchio, Florence, and for a grandeur of proportion which he implies (p. 39) was classical as opposed to the 'great darkness' of Lombard Romanesque and Gothic.

Page 39. Niccola Pisano and Giovanni Pisano, father and son, are given especial importance by V. as revivers of the classical tradition in the plastic arts. The main sculptural works of Niccola (who is otherwise known as Niccola da Apulia) are the famous pulpits in the baptistery at Pisa and in Siena Cathedral. Giovanni, who was his assistant, was chief of works at Pisa Cathedral from *c.* 1299 to *c.* 1308.

Page 40. Fuccio. An unknown Florentine.

Page 40. V. gives no very exact idea of sculptural evolution and ignores the relation of the art of Niccola Pisano with that of southern Italy. Niccola, who was probably a native of Apulia in southern Italy, is believed to have received his early training there. He may well have been influenced by Sicilian as well as northern Gothic. As in dealing with architecture, V. takes no account of such unclassical forms as matters of style requiring serious consideration.

Page 45. Modern criticism doubts whether the sculptures for Orvieto Cathedral in which V. says Niccola Pisano 'surpassed the Germans' were actually his work.

Page 47. The Campo Santo, Pisa, was heavily damaged by a shell-hit and subsequent fire in 1944.

Page 53. The account of the thirteenth-century artist Andrea Tafi indicates a revival of the Byzantine style, in the form of mosaic, speading from Venice to Florence and Rome.

Page 56. Jacopo Torriti (*d.* 1284), an artist of Sienese origin, had more importance than V.'s (confused) statement suggests, apparently being considered the leading mosaicist in his day. He seems to have been influenced by ancient mosaics remaining in Rome rather than by Veneto-Byzantine art.

Page 57. Gaddo Gaddi, Florentine painter and mosaic worker, is not certainly the author of the mosaics inside the portal of the cathedral of Florence, but it is regarded as more probable that he executed the mosaics in the portico of Santa Maria Maggiore, Rome, relating to its legendary origin (p. 59).

Page 59. The mosaics of the original St Peter's no longer exist. There are no known paintings by Gaddi.

Page 62. Margaritone is V.'s name for the painter now usually referred to as Margarito of Arezzo. V. devotes considerable space to him as a fellow townsman. He lays his usual emphasis on the painter's 'Greek' manner, not distinguishing the Byzantine and Romanesque elements in his work (both of which appear in 'The Virgin and Child Enthroned' of the National Gallery), and sums him up as a somewhat old-fashioned painter in an age of innovation, commendable however for some improved points of technique.

Page 65. With dramatic emphasis V. describes Giotto as the first of the 'supermen' of art, giving the arts their true direction, tireless in production and exemplary in conduct and intelligence. He follows Ghiberti in legendary biographical detail, e.g. Cimabue's discovery of the young Giotto portraying a sheep. Most of the anecdotes, pleasant as they are, are without foundation. He follows Ghiberti, Filippo Villani and others in emphasizing the naturalism of the painter.

Page 66. Early influences on Giotto were Pietro Cavallini and the sculpture of the Pisani rather than Cimabue.

Page 67. The frescoes in Santa Croce, Florence (some time after 1317), have been much repainted but the conception can still be appreciated.

Page 69. Modern criticism doubts whether the frescoes in the upper church at Assisi are by Giotto.

Page 73. The paintings for St Peter's have disappeared.

Page 75. S. Chiara, Naples, was destroyed in the Second World War.

Page 80. The decoration of the Campanile has been attributed to Andrea Pisano.

Page 81. The Arena chapel, Padua, contains the greatest of Giotto's extant works.

Page 84. Pietro Laurati and Simon Memmi (Pietro Lorenzetti and Simone Martini) belong to the school of Siena and not of Florence. Pietro Cavallini (active between 1270 and 1334) was probably a precursor of Giotto and an influence on him rather than his pupil.

Page 86. Agostino and Agnolo of Siena. By means of these Christian names (which remain names only) V. indicates progress in architecture, and they enable him to consider together works at Siena not otherwise closely connected, part of the Palazzo Pubblico, the north front of the

cathedral and the church of the Convent of St Francis. He sees them also as inspiring influences in goldsmith work.

Page 92. Cione remains an unknown follower. Forzore di Spinello Aretino, a follower of Cione, is perhaps a composite product of V.'s deduction, possibly the Forzore of the fifteenth century and the Cola di Spinello of the fourteenth. In this study of evolution in goldsmith work, V., however, was a pioneer.

Page 93. The disciples of Agostino and Agnolo in architecture and sculpture represent for V. the diffusion of Pisan and Sienese influence which, (combined with that of northern Gothic) extends to Venice.

Page 94. It may be added to the footnote on p. 94 that writers before V. recognized the importance of a Stefano Fiorentino, though it is possible that he assembled under one name various painters so registered in the early fourteenth century. His admiration may have been excessive and imprecisely directed, but he was concerned to establish a new stage in the progress of naturalism after Giotto.

Page 96. The 'Transfiguration' and the fresco with a circle of saints at Assisi have disappeared.

Page 97. Ugolino Sanese = Ugolino di Nerio, a close follower of Duccio. His only authenticated work is the altar-piece of Santa Croce, Florence, now distributed.

V.'s anachronisms are to be noted here, and the development of the Sienese school is somewhat falsified in consequence. Duccio is considered much later on, and even after Lorenzetti and Simone Memmi. Ugolino is regarded by V. as a follower of Cimabue.

Page 98. Though Pietro Laurati = Pietro Lorenzetti (active *c.* 1306–45) was the brother of Ambrogio Lorenzetti, V. seems unaware of this relationship. V. miscopied the name of Pietro from the Latin signature 'Petrus Laurentii de Senis' on an altar-piece. Lorenzetti's art is related to that of Duccio rather than Giotto.

Page 99. The 'Lives of the Holy Fathers' of the Campo Santo, Pisa, is a work in fresco that modern criticism has ascribed to Orcagna or Traini rather than Lorenzetti.

Page 99. The fresco in the Pieve di Santa Maria, Arezzo, was painted in 1320. '1355' was later than Lorenzetti's presumed date of death.

Page 102. Andrea Pisano = Andrea da Pontedera (*b.* near Pisa, 1270; *d.* Orvieto, 1348) was not related to Niccola and Giovanni Pisano. He was architect in charge of Florence Cathedral, 1336, and of Orvieto Cathedral, 1347. V. links him with Giotto.

Page 109. Buonamico Buffalmacco (*b.* Florence, 1260) was a follower of Giotto. Tradition had kept his memory alive in V.'s time even more as a character than a painter, and V. here is expansively and amusingly anecdotal, though mingling with humour appreciation of the artist's vivacity in painting.

Page 111. The drawing in V.'s album has disappeared.

Page 117. The frescoes in the Campo Santo, Pisa, have been denied to Buffalmacco by modern criticism.

Page 122. Ambrogio Lorenzetti (active 1319–47) was the brother of Pietro Lorenzetti and probably his pupil. V., not realizing their connection, separates their lives but follows Ghiberti in attributing to Ambrogio some of Pietro's works. The famous 'Good and Bad Government' frescoes at Siena were his principal work.

Page 125. Pietro Cavallini (active *c.* 1270–*c.* 1334), Roman painter and mosaic worker, is placed by V. too late in chronological sequence. Instead of being a disciple of Giotto it is now accepted that he was the first to break with Byzantine influence and revive something of the classical spirit, influencing Giotto in this respect. The mosaics in the apse of Santa Maria di Trastevere (1291) and the remains of frescoes in Santa Cecilia, Rome, long covered with whitewash and disclosed in this century, are the only works still preserved.

Page 128. Simone Martini, an outstanding painter of the Sienese school,

is wrongly considered a pupil of Giotto by V., who as usual with him under-estimates or misunderstands Siena. His art stems from that of Duccio.

Page 128. Lippo Memmi (*d.* 1356) was the brother-in-law, not the brother, of Simone Martini (whom V. refers to as Simone Memmi), though he was influenced by him in his art.

Page 129. V. is not aware of the importance of Martini's stay at Avignon, where he occupied a position of great influence as an intermediary between French (or Gothic) and Italian painting and the centre of a group of painters, Italian and French.

Page 130. The portrait of Petrarch's Laura is now lost.

Page 132. Memmi collaborated with Martini in the 'Annunciation' now in the Uffizi.

Page 134. 'Simone did not excel greatly in design.' V. does not appreciate the exquisite linear quality of his art.

Page 134. Taddeo Gaddi (active 1334–66) is a Florentine painter to whom V. devotes especial attention as the most important follower of Giotto. He was probably the son of Gaddo Gaddi and was the father of Agnolo Gaddi. His best work is in the Baroncelli chapel of Santa Croce, mentioned by V.

Page 142. V. gave the date of Andrea di Cione's death wrongly as 1389. This Life has caused a good deal of controversy, as it describes the work of a group, the 'Orcagnesques', rather than that of one person. Andrea was the greatest of three brothers, the others being Nardo (Bernardo) and Jacope di Cione.

Page 143. Domenico Grillandai = Domenico Ghirlandaio.

Page 144. Francesco Traini (active first half of the fourteenth century) was a Pisan master to whom the 'Triumph of Death' in the Campo Santo, Pisa (destroyed in the Second World War), is now attributed. V., it will be noted, describes it at length as a work of Andrea.

Page 148. Orcagna directed the work on the stone tabernacle of Or San Michele, 1356–7.

Page 152. Many of the works mentioned have disappeared. There remain those in the chapel of St Sylvester in Santa Croce, some frescoes at Assisi, and the 'Deposition of San Romeo' has been identified with the painting in the Uffizi.

Page 156. Giovanni da Ponte is said to have come from Caversaccio (region of Como) and settled at Florence, *c.* 1350, becoming a Florentine citizen. It seems a question whether V. refers under this name to a minor painter, Giovanni di Lotto del Popolo di Santo Stefano, or to a group of artists. Most of the works mentioned have disappeared.

Page 157. Agnolo Gaddi (active 1369, *d.* 1396), Florentine painter, the son of Taddeo Gaddi, was last of the Giottesque line. His principal work is the 'Legend of the Holy Cross', frescoes in Santa Croce to which V. refers (p. 159).

Page 161. Antonio da Ferrara was one of the founders of the Ferrarese school.

Page 161. The work of Stefano da Verona = Stefano da Zevio (*d. c.* 1450) marks a transition to early Renaissance style.

Page 162. Cennino Cennini. No works are known to survive by the author of the famous *Treatise*, for which V. has a great respect.

Page 163. Berna = Barna da Siena (active mid fourteenth century) was a Sienese follower of Simone Martini and Lippo Memmi. His principal remaining work is the series of frescoes in the Collegiata of San Gimignano mentioned by V.

Page 165. Luca di Tomè (active second half of the fourteenth century) is the author of existing works at Pisa and Siena.

Page 165. Duccio = Duccio di Buoninsegna (dates now usually given as *c.* 1255–1319). V. includes this Life at far too late a point seeing that Duccio was the great founder of the Sienese school. He also wrongly states that Duccio was working *c.* 1350.

Page 166. V. mentions Duccio's great 'Majestà' for the high altar of Siena Cathedral, now in the cathedral museum, but is scanty in consideration

of his painting, placing undue stress on his marble pavement for the Duomo. He fails to realize the significance of the Byzantine renaissance of which Duccio was representative.

Page 167. Antonio Veneziano (*d.* Florence, *c.* 1383) is assumed by V. to have been a Venetian who came to Florence to learn painting from Agnolo Gaddi, though this would seem improbable, as Veneziano was much the elder of the two. Baldinucci described him as a native of Florence who acquired his surname from having worked in Venice.

Page 171. Jacopo di Casentino (active *c.* 1300, *d.*, it is now usual to state, 1358), was one of the founders of the painters' guild at Florence in 1339. Little remains of his work.

Page 174. Spinello Aretino (active 1373, *d.* 1410/11) was a painter of Arezzo who settled in Florence though he worked in other cities. He was possibly trained in Agnolo Gaddi's studio and continued the tradition of Giotto.

Page 178. The frescoes of the 'Life of St Benedict' are among the few extant by Spinello.

Page 180. Portions of the Monte Oliveto painting are in the Pinacoteca, Siena, the Fogg Museum, Cambridge, U.S.A., and at Budapest.

Page 184. Gherardo Starnina (active 1387–1413) was a link between the Giotto tradition and the art of the Quattrocento.

Page 184. Starnina was in Spain between 1398 and 1401 but the work of that time is unspecified.

Page 185. The frescoes (1404) for Santa Maria del Carmine, Florence, are now fragmentary.

Page 186. Lippo. Several painters of this name were members of the Guild of St Luke, and the identity of the first mentioned by V. is not clear.

Page 188. Lippo di Dalmasio (*c.* 1352–1410 +) was the son of a Bolognese painter, who worked at Pistoia and Bologna and by whom several signed works have survived.

Page 189. Lorenzo Monaco (date now usually given as before 1372–1422 +) = Piero di Giovanni of Siena. He took his monastic vows and the name of Lorenzo in 1391.

Page 190. The choirbooks from the monastery degli Angeli are preserved in the Biblioteca Mediceo-Laurenziana, Florence, but lack many miniatures.

Page 192. Taddeo Bartoli (*fl.* beginning of the fourteenth century) was a member of a Sienese family of painters. His father, Bartolo di Fredi, died in 1410. He and his nephew Domenico show the characteristic linear delicacy of the Sienese school.

Page 194. Lorenzo di Bicci, Bicci di Lorenzo, his son, and Neri di Bicci, his son-in-law, were Florentine painters who in the early fifteenth century still adhered to the tradition of Giotto.

PART II

Page 201. Among the works studied by Vasari for his account of the Quattrocento were the *Commentari* of Lorenzo Ghiberti; the *Libro di Ricordi e di spese* of Lorenzo and Vittorio Ghiberti; *Vita del Brunelleschi*; *De Re Aedificatoria*; *De Pictura*; *De Statua* of Alberti; *Trattato di Architettura* by Filarete; *Hypnerotomachia Poliphili*· various memoirs of artists, including the *Ricordi* of Alesso Baldovinetti, Squarcione and Ghirlandaio.

Page 210. Jacopo della Quercia (1374–1438) is represented by V. as, in sculpture, the pioneer of a new age. V. gives prominence to what are now regarded as principal works, the tomb of the wife of Paolo Guinigi, tyrant of Lucca; the Fonte Gaia in the square at Siena (1409–19) and the portal of San Petronio, Bologna.

Page 214. Matteo Civitali (1436–1501) was not, as dates show, a disciple of della Quercia, though he produced charming works in the Renaissance style.

Page 218. Dello = Dello di Niccolo Delli (dates now usually given as

c. 1404–71), Florentine painter who settled in Spain and worked mainly at Salamanca. Nothing of his work remains identifiable though his reputation as a decorative craftsman seems to have been considerable.

Page 221. Nanni d'Antonio di Banco was considerably older than Donatello and this has given rise to doubts of his being Donatello's disciple.

Page 224. Luca della Robbia may have studied also with Ghiberti.

Page 225. V. makes a celebrated comparison between the bas-reliefs of della Robbia for the Cantoria in Florence Cathedral and those of Donatello.

Page 227. It has been questioned whether Ottaviano and Agostino were Luca della Robbia's brothers.

Page 229. Andrea della Robbia (1435–1525) receives rather less than justice as one who continued Luca's work and further developed the terracotta technique. The continuation of the family industry is somewhat sketchily indicated, no work by Giovanni, Andrea's son, being mentioned.

Page 231. V. does justice to the complex and interesting character of Uccello though deprecating his too great attachment to theoretical perspective.

Page 234. V. cites a number of frescoes which have disappeared, e.g. those of San Miniato and the Carmine. Modern appreciation is based largely on a few panel pictures.

Page 236. Giovanni Acuto = Sir John Hawkwood was the celebrated English *condottiere* who after being at Crécy and Poitiers went to Italy as a mercenary and was given a retainer to fight on the side of Florence.

Page 239. Lorenzo Ghiberti (1378–1455), goldsmith, painter and sculptor, is the subject of a eulogistic Life which places him among the greatest Renaissance Florentines. V. approves—consistently with his main thesis—of Ghiberti's respect for classical art and likewise for nature. The Life is reinforced by detail derived from Ghiberti's own records.

Page 241. Ghiberti's earliest known work, the 'Sacrifice of Isaac', is in the Uffizi.

Page 255. Masolino di Panicale did not die so young as V. supposes. The work of this Florentine painter is more extensive than V. suggests by his concentration on the frescoes of the Brancacci chapel. V. makes no mention of Masaccio, though the latter's share in the works of the Brancacci chapel has since been the subject of much critical study.

Page 257. Parri Spinelli was the son of Spinello Aretino. He worked mainly at Arezzo, though little remains of his painting, which V. indicates was already decaying.

Page 262. Drawings by Spinelli are in the Uffizi.

Page 263. Masaccio was properly Tommaso di Giovanni di Simone Guidi —V. gives a reason for his nickname, 'Masaccio' (p. 264). He was probably a pupil of Mariotto di Cristofano, a painter at his native town of Valdarno, about thirty miles from Florence. V. fully recognizes his importance as a founder of the 'modern manner', i.e. of High Renaissance painting.

Page 265. The 'Madonna and St Anne' (Uffizi) is one of Masaccio's first known paintings. The altar-piece in the Chapel of the Carmine (central portion) is in the National Gallery.

Page 265. The Pisa altar-piece, 1426, exists in part in various galleries (National Gallery, London, Pisa, Vienna and Berlin).

Page 266. Some critics assign the most powerful of the remaining frescoes in the Brancacci chapel to Masaccio, the others to Masolino.

Page 266. The work in S. Maria Maggiore which V. attributes to Masaccio is now identified with the altar-piece by Masolino (part in National Gallery).

Page 269. Filippo Brunelleschi, Florentine sculptor and architect, is generally regarded as the founder of classical Renaissance architecture. V. drew extensively on the *Vita di Ser Brunellesco* for his Life.

Page 290. The crowning lantern of the cathedral dome was not finished until after Brunelleschi's death.

Page 294. The Pitti Palace was begun in 1435.

Page 301. Donato de Niccolo di Betto Bardi, or Donatello, is given his

full stature by V. as one of the great geniuses of the Renaissance and restorer of the glories of antiquity. His birth date was 1386, not 1383.

Page 301. The 'Annunciation' is considered a work of Donatello's maturity and not of his youth.

Page 302. The 'Crucifixion' of *c.* 1415 was Donatello's first carving of a nude figure.

Page 303. Until 1558 the statue of St John the Evangelist occupied a niche in the cathedral façade.

Page 305. Donatello's marble statues for the front of the Campanile are noted for their austere realism.

Page 305. The famous 'Judith' is a late work after Donatello's return to Florence from Padua.

Page 305. The 'David', *c.* 1440, was the first nude statue in the round of the Renaissance.

Page 307. The 'Gattamelata', Donatello's equestrian masterpiece, ranks with Verrocchio's 'Colleoni' as one of the supreme products of its kind.

Page 313. The 'bronze fight' by Bertoldo (*c.* 1420–91) is probably the Battle Relief now in the Museo Nazionale, Florence.

Page 314. Michelozzo Michelozzi, architect and sculptor, the youthful associate of Donatello, is considered in V.'s Life mainly as an architect.

Page 315. The Palazzo Medici-Riccardi (1444–59) was Michelozzo's principal work. V. suggests by his description the architect's practical concern with amenity and utility as well as architectural style.

Page 319. He reconstructed the church, cloister and library of San Marco between 1437 and 1471.

Page 324. Vincenzo Foppa (*c.* 1427–*c.* 1515), *b.* in Brescia, worked in Milan for the Sforza family.

Page 324. Antonio Filarete is treated with scant respect by V., though he is of some historical note as having introduced the early Renaissance style of sculpture into Milan.

Page 325. A considerable part of Filarete's Ospedale Maggiore was razed to the ground in 1943.

Page 325. It has been doubted whether Simone was Donatello's brother, though otherwise the artist remains unidentifiable.

Page 326. Though V. describes Filarete's *Trattato d'Architettura* as 'the most ridiculous and silly book' ever written, Milanesi has shown that he made use of it.

Page 328. Giuliano da Mariano is mainly noted for his method of inlaying in various woods.

Page 329. His brother Benedetto (1422–97), who is credited with the design of the Strozzi Palace, Florence, is further described in vol ii, p. 90.

Page 331. Piero della Francesca is treated with respect by V., though perhaps with less understanding of his greatness than might have been expected. The short Life does not convey the importance of this giant of the Renaissance as modern appreciation views Piero.

Page 331. He was trained in Florence, working with Domenico Veneziano, and evidently acquired his mastery of perspective and other technical advances of the time in Florence.

Page 332. V. does not mention the famous profile portraits of Federigo Montefeltro and his wife (Uffizi).

Page 332. The paintings for Pope Nicholas V. at Rome no longer exist.

Page 333. 'Our Lady of Mercy' = Madonna della Misericordia, 1445 (Palazzo Communale, Borgo).

Page 333. Luca da Cortona = Luca Signorelli.

Page 333. The Sant' Agostino altar-piece is now distributed, parts being in the National Gallery, London, the Frick Collection, New York, Milan and Lisbon.

Page 333. The frescoes of the 'Legend of the True Cross' at Arezzo, mainly inspired by the *Golden Legend* of Voragine, 1452–66, constitute Piero's master work.

Page 336. Pietro da Castel della Pieve = Pietro Perugino.

Page 336. Fra Angelico = Guido da Pietro, of Vicchio in the Mugello. V. lays stress on the gentle and angelic character of his art without, how-ever, following stylistically the modifications of its Gothic character and the effect of Fra Angelico's stay in Rome which introduced Renaissance elements, e.g. in the architectural backgrounds of the paintings. V. gives no detail of his training but it has been supposed that he was the pupil of Lorenzo Monaco. He worked at Fiesole, Florence and Rome, and carried on the Gothic tradition in Florentine painting.

Page 337. The frescoes of San Marco, Florence, 1436–45, were the principal work of Fra Angelico's Florentine period.

Page 338. The main panel of the altar-piece for San Domenico is still in the church. The ciborium mentioned by V. has been identified with a tabernacle now at Leningrad.

Page 339. The Madonna dei Linaiuoli, 1433, of the Fiesole period, with a number of other altar-pieces, is now in the San Marco Museum.

Page 343. Benozzo = Benozzo di Lese (Gozzoli).

Page 343. Attavante (late fifteenth century), also known as Vante, is recorded as having ornamented books for Matthias, King of Hungary, later collected in the Medicean and Estensean libraries.

Page 346. Leone Battista Alberti was trained as a lawyer. He travelled in France and Germany before taking to the study and practise of archi-tecture, *c.* 1435. V. is inclined to consider him as a Utopian theorist, though praising him as a writer and inventive spirit. Alberti was a pioneer of the Renaissance of Roman architecture.

Page 347. Known as the Tempio Malatestiano, the church of San Francesco, Rimini, was Alberti's first important building. It suffered serious war damage in 1943 though the façade remained intact.

Page 349. At Mantua Alberti designed San Sebastiano (1459) as well as Sant' Andrea (1472).

Page 350. Lazzaro Vasari. V. gives an interesting study of a provincial craftsman, treating Lazzaro, his ancestor, with perhaps excessive regard. It is hard to believe that his paintings were indistinguishable from those of Piero della Francesca.

Page 351. Pietro Borghese = Piero della Francesca.

Page 356. Antonello da Messina, the son of a sculptor at Messina, Sicily, was probably trained by Colantonio at Naples. Works by Jan van Eyck and Rogier van der Weyden also existed there at that time and may have influenced his style. There is no evidence that Antonello went to Flanders as V. states.

Page 357. The technique of oil-painting may have come to Venice by vari-ous routes and influences, but one influence certainly was that of Antonello.

Page 357. Fragments of the altar-piece for San Cassiano (1475–6) are preserved at Vienna.

Page 357. Maestro Domenico = Domenico Veneziano.

Page 358. Alesso Baldovinetti was enrolled in the Guild of St Luke in Florence, 1448 or 1449. He seems to have been influenced in style by Fra Angelico and worked exclusively in Florence.

Page 359. The frescoes in Santa Maria Nuova no longer exist.

Page 360. Fragments of fresco in Santa Trinità (1471) and the 'Nativity' in the Nunziata (1460–2) remain.

Page 360. V. justly remarks on his originality in landscape.

Page 364. Cardinal Bembo (1470–1547), Venetian scholar, secretary to Leo X and historian of the Venetian Republic, became cardinal in 1530.

VOLUME II

Page 1. Fra Filippo Lippi (who took his vows as a Carmelite in 1431) was a great influence on Florentine painting in the fifteenth century, V. notes his appreciation of the advances made by Masaccio, but Lippi also inherited and transmitted something of Fra Angelico's charm. The Life in human terms is highly picturesque.

ADDITIONAL NOTES

Page 1. Masaccio was painting in the Carmine, *c.* 1425–7.

Page 2. The account of Lippi's capture by Barbary pirates seems apocryphal.

Page 3. The 'Annunciation' has been identified with the painting in the National Gallery, Washington.

Page 4. Lippi was not relieved from religious vows and later was chaplain to the convent of San Giovannino, Florence, and rector (1457) of San Quirico, Legania.

Page 4. The frescoes in Prato Cathedral are the most important monumental works of Lippi.

Page 4. There seems no reason to dispute the circumstantial account of the seduction of Lucrezia Buti. Her portrait has been identified with a St Margaret in a picture in the gallery of Prato.

Page 4. Fra Diamante (1430–98 +), Carmelite monk of Florence, is mainly known as the assistant of Filippo Lippi.

Page 6. The painting for the church at Ventigliata is in the Metropolitan Museum, New York.

Page 8. Paolo Romano, Maestro Mino, Chimenti Camicia are minor figures. About the rival sculptors V. takes a few details from Filarete. The architect Camicia who spent most of his life in Hungary is entirely obscure.

Page 11. Andrea del Castagno and Domenico Veneziano are included in the same biographical chapter, partly to contrast the rough vigour of Castagno's art with that of Domenico and also to portray the (supposed) murderer and his 'victim' who, in fact, died years later).

Page 11. Andrea was not born at Castagno as V. says, but taken there at about the age of thirteen.

Page 12. The series of famous men and women is in the refectory of Sant' Apollonia, Florence (Castagno Museum), with other works, the most famous of which is the 'Last Supper', Castagno's masterpiece.

Page 13. The equestrian portrait of the military hero Niccolò da Tolentino was a parallel with that of Sir John Hawkwood by Uccello. It was influenced by Donatello's 'Gattamelata'.

Page 16. The 'Assumption' is now at Berlin.

Page 17. The frescoes for the Podestà are now lost.

Page 17. Little remains of Domenico's work. The frescoes for Santa Maria Nuova are now lost. His principal remaining work is the 'Madonna and Child with Saints' in the Uffizi, part of the predella being in the Fitzwilliam Museum, Cambridge.

Page 17. Gentile da Fabriano, Umbrian painter, and 'Vittore' (which should be Antonio)Pisanello (Pisano), Veronese painter, are placed together by V. because they worked together in Rome and Venice. Nowadays they would be more satisfactorily linked as Italian representatives of the International Gothic style.

Page 18. The beautiful and ornate 'Adoration of the Magi', now in the Uffizi, is one of Gentile's greatest works, in colour and detail conveying the essence of the Gothic style of painting as developed in Italy.

Page 19. Pisanello is famous chiefly as a medallist, his commissions taking him to a number of Italian cities.

Page 21. Francesco Pesellino (Francesco di Stefano), who is to be distinguished from his grandfather Giuliano Pesello, may, however, have been taught to paint by him.

Page 22. It may be noted that Pesellino collaborated with Uccello in the battle scenes for the Medici Palace.

Page 22. The 'Holy Trinity' painted for Pistoia, and now in the National Gallery, was completed after Pesellino's death by Fra Filippo Lippi.

Page 23. Benozzo = Benozzo di Lese. Gozzoli, as he is still often called, appears to be a printing error in the second edition of the *Lives*.

Page 23. The 'Journey of the Magi', begun in 1459, is Benozzo's most famous work, conceived in the style of Gentile da Fabriano.

Page 23. The frescoes for Santa Maria Maggiore (1483) are now lost.

Page 23. The twenty-five scenes from the Old Testament in the Campo Santo, Pisa, were destroyed or severely damaged in the Second World War.

Page 25. Melozzo da Forli was an Umbrian painter influenced by Piero da Francesca. In describing his most famous work, the 'Ascension' in the church of Santi Apostoli, Rome, V. notes the ceiling perspective of the kind later so much developed by painters of the Baroque age.

Page 26. Francesco di Giorgio Martini, Sienese architect, sculptor, painter and engineer, and L. Vecchietta = Vecchietta (Lorenzo di Pietro), Sienese architect, sculptor and painter, a pupil of Sassetta, are both considered primarily by V. as architects and craftsmen. He shows a characteristic indifference to Sienese painting.

Page 28. Galazzo is regarded by V. as a founder of the school of Ferrara, Cosimo Tura receiving little notice though he is now considered the first outstanding Ferrarese painter. V.'s statement that he 'cannot have painted much' is contradicted by the number of surviving works in public galleries.

Page 29. In this series of lives of sculptors no general trend of style and development is traced. Antonio Rossellino, his brother Bernardo, Desiderio da Settigano and Mino da Fiesole contributed to establish the characteristic form of the Renaissance tomb and its sculptural ornament.

Page 30. The masterpiece of Antonio Rossellino is the tomb of the Portuguese cardinal, *c.* 1460.

Page 34. The tomb of the Secretary of State, Marsuppini, in Santa Croce, Florence, is one of Settignano's masterpieces.

Page 36. Mino da Giovanni (Mino da Fiesole) was born at Poppi in the Casentino.

Page 38. The tomb of the Margrave Hugo (1481) is one of his principal works.

Page 39. V. assumes Lorenzo Costa to have been decisively influenced by Florentine art, though in fact he was the pupil of Francesco Cossa and Ercole de' Roberti at Ferrara and was much influenced by Venetian painting. A later period (which V. recognizes) at Bologna produced a Mannerist tendency.

Page 42. The central panel of the Griffoni altar-piece by Cossa is now in the National Gallery.

Page 43. The frescoes of the Garganelli Chapel are now represented by copies.

Page 44. In the second edition of the *Lives*, V., as the result of wider knowledge of Italy, dealt more fully with other regions than central Italy, especially Venice.

Page 44. Jacopo Bellini (the pupil of Gentile da Fabriano) is somewhat summarily treated. V. was not acquainted with the sketch-books (Louvre and British Museum) which show Jacopo's wide range of subject and observation.

Page 45. The portrait of Caterina Cornaro, Queen of Cyprus, would seem to be that of Gentile Bellini (Budapest).

Page 45. The paintings of the 'Miracle of the Holy Cross' (three of which are in the Accademia, Venice) were painted late in Gentile's career, dated 1496, 1500 and 1501.

Page 46. The portrait of Doge Loredano by Giovanni Bellini is in the National Gallery.

Page 46. The San Giobbe altar-piece (Venice, Accademia) was painted in the 1480's.

Page 47. Gentile Bellini was given charge of the paintings in the grand council chamber of the Doge's palace in 1474.

Page 47. The 'Procession in the Piazza San Marco' is in the Accademia, Venice.

Page 48. Alvise Vivarini, member of the famous Venetian family of painters, was influenced in style by Giovanni Bellini.

Page 49. The 'Madonna and Saints' of San Zaccaria (1505) marks the full development of Giovanni's art though V. does not trace this development

in detail. He does not mention the early influence of Mantegna or Antonello da Messina, or the relation of his later work with that of Titian.

Page 50. The portrait of the Sultan Mehmet II in the National Gallery is ascribed to Gentile Bellini.

Page 51. Gentile was in fact very active for many years subsequent to his return from Constantinople. The paintings of that period include, besides the 'Miracle of the Holy Cross', the 'Preaching of St Mark' (Milan, Brera), completed by Giovanni after his brother's death.

Page 52. Jacopo da Montagna = Jacopo da Montagnana, a Paduan artist.

Page 52. Niccolò Rondinello was a Venetian painter who worked at Ravenna when that city became a subsidiary of Venice.

Page 53. V. turns abruptly from Venice to the Florentine painter Cosimo Rosselli, a follower of Neri di Bicci and Benozzo di Lese, giving him moderate praise.

Page 54. Rosselli's employment in the Sistine Chapel left some influence on his style derived from his fellow workers which has been observed in the 'Miracle of the Sacrament' in Sant' Ambrogio, Florence, painted after his return from Rome.

Page 55. Fra Bartolommeo was also Rosselli's pupil.

Page 55. The artistic importance of the Florentine engineer Cecca consists in his having devised the apparatus which signalized the evolution of the mystery play towards the elaborate theatrical representations of the Renaissance period. It contributed to the dramatic and stage-like effects of much Renaissance painting.

Page 61. Though Italian authorities (Milanesi, Venturi) have held this painter to be a figment of V.'s imagination, records apparently now show that this abbot of San Clemente did in fact exist and was a painter—an authentic discovery on V.'s part, though his work remains obscure.

Page 63. The work by Matteo Lappoli has disappeared.

Page 66. As a miniaturist Don Bartolommeo leads V. to consider some minor practitioners of the art. Manuscripts illuminated by Attavante and Gherardo are in the National Library, Vienna, the Laurentian Library, Florence, and the Estense Library, Modena.

Page 68. Domenico Ghirlandaio, a prolific fresco painter, is regarded by V. as one of the great creators of the 'modern manner' showing an advance in realism. He was a pupil of Baldovinetti and Verrocchio. He had a busy workshop and was much patronized by the wealthy merchant and banking families of Florence.

Page 68. The 'Lamentation' in the Vespucci Chapel, church of the Ognissanti, Florence, was painted 1472–3.

Page 71. Ghirlandaio's most important contribution to the Sistine Chapel was the 'Vocation of Peter and Andrew'.

Page 71. The frescoes for Santa Maria Novella representing the 'Lives of the Virgin and St John the Baptist' were the artist's largest undertaking.

Page 73. Sebastiano Mainardi (*d.* 1513) has been credited with many products of Ghirlandaio's workshop.

Page 77. A predella panel from the altar-piece for St Justus is in the National Gallery, others in Detroit and New York. The main panel is in the Uffizi.

Page 79. Antonio Pollaiuolo and Piero Pollaiuolo were to an extent still regarded as uncertain collaborators in painting. V. was the first to stress Antonio's importance as a painter (as distinct from his work as a goldsmith).

Page 80. Maso Finiguerra (1410–75), the Italian sculptor and goldsmith, is celebrated in the history of engraving.

Page 81. The 'Martyrdom of St Sebastian' (National Gallery) is still ascribed to the brothers in collaboration, though main credit is customarily given to Antonio.

Page 84. Botticelli = Alessandro di Mariano di Filipepi is described by V. with some lack of appreciation of the qualities that now seem to single him out as a great and original figure in Florentine art, though the works

V. mentions include many well-known and existing masterpieces. He passes briefly over the 'Birth of Venus' and 'Primavera'. He attaches less than due importance to Botticelli's adherence to Savonarola and his religious disquiet. He finds him, however, 'excellent' in design, composition and portraiture.

Page 87. V.'s description of Sandro as 'a merry fellow' must be reconciled with the melancholy of many works and the mysticism of the 'Nativity' (National Gallery).

Page 92. The pulpit in Santa Croce, Florence, was one of Benedetto da Majano's principal works.

Page 92. The cornice of the Palazzo Strozzi was added by Cronaca.

Page 95. Andrea del Verrocchio is treated mainly as a sculptor though V. does not overlook his relation as a painter with Leonardo da Vinci. He conducted a busy workshop in which various arts and crafts had a place.

Page 96. The 'David' (1476) is in the Bargello, Florence.

Page 98. Leonardo painted the angel farthest to the left and part of the landscape in the 'Baptism of Christ' (Uffizi), begun in the 1470's.

Page 99. The Colleoni statue, Verrocchio's greatest work, follows the tradition of Donatello's 'Gattamelata'.

Page 102. Andrea Mantegna was born probably at Isola di Carturo between Vicenza and Padua. He worked mainly at Padua and Mantua. V. gives a full account of him, supported by material derived from Mantegna's master Squarcione. Mantegna's respect for classical antiquity was sure of his approval.

Page 103. The frescoes of the (thirteenth century) Eremitani Church, Padua, were mostly destroyed with the destruction of the church during the Second World War except for two sections previously removed.

Page 103. Mantegna was married to Nicolosia Bellini in 1454.

Page 105. The San Zeno altar-piece was painted in 1459, the main portion still being in the church and predella panels in the Louvre and at Tours.

Page 105. The 'Triumph of Caesar' cartoons were intended for the decoration of the theatre in the palace of the Gonzagas. They were bought for Charles I of England with other great works from the Gonzaga collection.

Page 106. The paintings for Pope Innocent VIII no longer exist.

Page 108. V. does not mention the 'Lamentation' (Brera, Milan), though he refers to Mantegna's skill in foreshortening; nor does he mention the 'Allegories' of the Louvre which show the later development of his style.

Page 108. Filippo Lippi = Filippino Lippi, trained by his father Fra Filippo, and an associate of Botticelli. He is praised highly by V. for invention and picturesque detail.

Page 110. In the work at Santa Maria Sopra Minerva, Filippino's graceful style is first clearly defined. The Strozzi Chapel frescoes were his last great work of decoration. V. makes much of their variety of detail.

Page 112. The 'Adoration of the Magi' (Uffizi) is typical of Filippino's art in its crowded and restless character.

Page 114. Bernardino (di Betto) Pinturicchio (or Pintoricchio), an Umbrian rather than 'painter of Florence', is probably more accurately described as a colleague of Perugino than as his pupil. V. judges him more severely than would seem warrantable. The suggestion that the paintings for the Siena Cathedral Library, 1502–8, were the conceptions of Raphael is not necessarily pejorative to Pinturicchio. He, Perugino and Raphael as the assistant of both would habitually work in close accord.

Page 115. V. does not specifically mention the collaboration of Perugino and Pinturicchio in the Sistine Chapel frescoes ('Moses in Egypt' and 'The Baptism of Christ').

Page 116. A reason for V.'s criticism is revealed in his dislike for paintings with ornament in relief.

Page 117. Benedette Bonfigli was possibly one of the masters of Perugino.

Page 118. Niccolò Alunno = Niccolò di Liberatore of Foligno worked

at Foligno and elsewhere in Umbria and has left many signed and dated works of considerable merit.

Page 118. Francesco Francia = Francesco Raibolini worked in the style of Lorenzo Costa, with whom he collaborated at Bologna. V. praises him at considerable length but indicates (p. 123) his distance from Raphael.

Page 124. Pietro Perugino = Pietro Vanucci was the foremost painter of the Umbrian school after Piero della Francesca. V. records his work at length though with comparatively little comment (though he duly records Michelangelo's adverse criticism). Most of the many works cited by V. have come down to us.

Page 125. Perugino may have worked in Verrocchio's studio but his style seems early to have been formed by contact with the Perugian, Fiorenzo di Lorenzo, and perhaps Bonfigli.

Page 130. V. ascribes the frescoes in the Sistine Chapel to Perugino alone, again without mention of Pinturrichio's collaboration.

Page 131. The 'Marriage of the Virgin', one of Perugino's most celebrated works, inspired Raphael's 'Lo Sposalizio', painted shortly afterwards.

Page 132. Cambio = the Exchange of Perugia.

Page 133. Apart from the great Raphael the pupils of Perugino are minor figures. Little is known of Rocco Zoppo, Roberto da Montevarchi and Baccio Ubertini.

Page 136. V. now sets himself to piece together the Venetian school and its relationships. The Life of Carpaccio begins with a somewhat shaky list of names. Stefano da Verona = Stefano da Zevio; Aldigieri = Altichiero da Zevio; Guariero da Padova = Guariento; Sebastiano and Lazzaro are to be separated from Scarpaccia and turned into one man = Lazzaro Bastiani; Giovan Battista of Conigliano = Cima da Conegliano. Bassarini and Bassiti = no doubt Marco Basaiti.

Page 136. Stefano da Zevio (c. 1375–c. 1450) represents a local development from Gothic to Renaissance style in painting.

Page 137. The 'Madonna and Child with St Catharine in a Rose Garden' (Verona Gallery) contains many of the characteristic features listed by V., e.g. the peacock.

Page 138. Aldigieri da Zevio = Altichiero (c. 1330–c. 1395) worked in Verona and Padua and was a leader of the early Veronese school.

Page 138. Jacopo Avanzi of Bologna is here confused with Jacopo Avanzo (of the same period—late fourteenth century), a painter of Verona. The latter was Altichiero's collaborator.

Page 139. Jacobello del Fiore (c. 1370–1439) was a Venetian painter, influenced in style by Gentile da Fabriano.

Page 139. Guariero = Guariento (active 1338–70) worked at Padua in a style influenced by the Giotto frescoes there. His fresco on the wall of the Presbytery survived the ruin of the Eremitani church in 1944.

Page 140. Scarpaccia = Carpaccio, Venetian contemporary of Gentile and Giovanni Bellini, is best known for the series of frescoes executed for the *scuole* or confraternities of Venice. V. singles him out for praise with discernment. He notes the 'skill' and 'resource' of the famous cycle, 'The Legend of St Ursula' (Venice, Accademia), though he makes no comment on its poetic feeling.

Page 140. V. does not mention the other great cycles, the 'St George' (1502–7), the 'St Stephen' (1511–20) and the 'Life of the Virgin', but is impressed by the 'History of the Martyrs' (Venice, Accademia) with its 300 figures. The famous painting known as 'The Courtesans' (Correr Museum, Venice) is also absent from his list.

Page 141. Vincenzo (di Biagio) Catena was a pupil of Giovanni Bellini.

Page 141. Giovan Battista of Conigliano = Cima da Conegliano, also a follower of Bellini, was the painter of many Madonnas in his style.

Page 141. Andrea Previtali (Cordeliaghi) was a painter at Bergamo, another Bellini follower.

Page 141. Marco Basarini = Marco Basaiti was a native of Venice or

Friuli assumed to have been of Greek origin and with some relation to Bellini in style.

Page 142. Bartolommeo Vivarini was a member of the famous Venetian artist family, the younger brother of Antonio Vivarini, with whom he collaborated. He worked in the style of Mantegna.

Page 142. Giovanni Mansueti, is between Bellini and Carpaccio in style.

Page 142. Bartolommeo Montagna was a leading master at Vicenza, influenced in style by both Mantegna and Giovanni Bellini.

Page 143. Leaving the Venetian school V. turns to Jacopo L' Indaco, little known, who seems to be introduced mainly by way of light relief, as the jolly friend of Michelangelo and as one 'who detested work'.

Page 145. Luca Signorelli is treated by V. as a great precursor of the Quinquecento, even foreshadowing the art of Michelangelo. He was probably Piero della Francesca's pupil but was influenced also by Florentine painting, like other Umbrian painters of the time.

Page 145. The frescoes for Sant' Agostino and San Francesco have disappeared.

Page 147. In the frescoes at Orvieto, the artist's greatest work, V. draws attention to Signorelli's mastery of the nude, as leading to the splendours of the sixteenth century.

Page 148. In Rome, 1482–3, Signorelli finished a fresco by Perugino in the Sistine Chapel. One of his own frescoes of the 'Life of Moses' remains.

Page 148. V. gives his first 'portrait from life' in his vivid description of the aged Signorelli. The story of his painting his dead son is a tribute to the artist's fortitude.

PART III

Page 151. For his account of the sixteenth century V. made use of historical works by Machiavelli, Guicciardini (description of the Netherlands), Bembo, Varchi, Borghini, Giovio, Adriani and Segni; treatises by various artists; Vincenzo Foppa, Butinone and Zenale; memoirs, account books and documents of Lotto, Pontormo, Bandinelli, Bellucci, Tribolo, Francesco da San Gallo, Michelangelo; Condivi, *Vita di M. A. Buonarotti*; Cellini, *La Vita scritta da lui medesimo*; the compilations of Antonio Billi and Magliabecchi; Francisco de Hollanda, *Tractato de Pintura Antigua*; Lampsonius, *Life of Lombardo Lamberti*; works on painting in Venice by Biondo, Doni and L. Dolce and books on cities and their works of art; Francesco Albertini on Rome and Florence, new and old (1510); Leandro Alberti, *Descrizione di tutta Italia* (1550); Ugolino Verino, *De Illustratione urbis Florentiae*; Marc Antonio Michel, *Notizie d' opere di disegno* (1516); De Falco, *Descrittione dei luoghi antichi di Napoli* (1535); Marliani, *Topographia Urbis Romae* (1544); Sansovino, *Dialogo di tutte le cose notabile che sono in Venezia* (1556); Pietro Lamo, *Graticola di Bologna* (1560); also letters from various contemporaries.

Page 156. Leonardo da Vinci is the subject of one of the most beautifully written and understanding of the *Lives*. The account might also be regarded as a grand poetic eulogy of the 'universal man' of the Renaissance.

Page 158. See note (to p. 98) on Verrocchio.

Page 158. V.'s description is the only record of Leonardo's 'Adam and Eve'.

Page 159. With literary art V. creates by his description a sense of Leonardo's imagination.

Page 160. The 'Adoration of the Magi' (Uffizi) was painted at the end of Leonardo's Florentine period.

Page 161. In 'The Last Supper' V. contrasts the precisely delineated expressions of the Apostles with the unfinished head of Christ to which Leonardo felt 'he could not give that celestial beauty it demanded'. The ill-fated equestrian statue of Francesco Sforza was the main reason for Leonardo's stay at Milan. It was there also that he painted the famous 'Madonna of the Rocks'.

Page 164. 'Mona' Lisa (Gherardini), born in Florence in 1479, married

Francesco del Giocondo in 1495. She would be about twenty-four when Leonardo painted the world-famous picture (Louvre).

Page 165. Nothing remains of the 'Battle of Anghiari' except contemporary copies and some drawings.

Page 166. The Madonna for Baldassare Turini da Pescia has disappeared.

Page 168. Giovanni Antonio Boltraffio was Leonardo's principal pupil at Milan.

Page 169. Giorgione is perceptively portrayed by V., though he mentions many works that have disappeared and does not mention the few masterpieces, e.g. 'The Tempest' (Venice, Accademia), by which he is now judged. Nevertheless he comes near in appreciation to the modern view of this great Venetian innovator. He compares his achievement in the mastery of light and shade to that of Leonardo.

Page 170. The portraits of Loredan, Giovanni da Castel Bolognese and others have disappeared.

Page 170. The frescoes of the Fondaco dei Tedeschi are only faintly indicated by the eighteenth-century etchings of Zanetti.

Page 170. The absence of an obvious story which puzzles V. is also a feature of the paintings. e.g. 'The Tempest', known to us.

Page 171. The Castelfranco altar-piece (c. 1504) is one of the four works ascribed with certainty to Giorgione.

Page 172. The actual date of Giorgione's death was October 1510.

Page 172. Titian was probably Giorgione's fellow pupil under Giovanni Bellini.

Page 172. Correggio = Antonio Allegri, who worked in Correggio and Parma, is placed on a level by V. with Leonardo and Giorgione as one of the great innovators of the 'modern' (High Renaissance) manner.

Page 172. V. assumes Correggio never visited Rome, though this has been questioned.

Page 172. The Duomo ceiling, a late work, is a masterpiece that foreshadows the triumphs of Baroque.

Page 176. In Piero di Cosimo = Piero di Lorenzo, a Florentine pupil of Cosimo Rosselli, V. depicts an eccentric character and stresses the fantastic nature of his imagination, in which he shows a certain likeness to Leonardo.

Page 183. Bramante is given his due as a great Renaissance architect though V. has little to say of his training and early career, and mentions none of the buildings produced during Bramante's stay at Milan, 1480–99, including Santa Maria presso San Satiro, 1482, the apse and sacristy of Pavia Cathedral, 1488, and the apse of Santa Marie delle Grazie, Milan, 1494.

Page 184. V. stresses the study of ancient Roman antiquities as the source of Bramante's inspiration.

Page 185. The cloister of Santa Maria della Pace, 1504.

Page 185. The fountains of Trastavere and Piazza di San Pietro no longer exist.

Page 185. The remodelling of the Vatican is described at length; the spiral staircase was the only part of his design for the Belvedere that he entirely completed.

Page 187. The 'Tempietto' of San Montorio belongs to Bramante's early years in Rome (1503). Bramante was largely occupied with the rebuilding of St Peter's from 1504.

Page 190. V. does not discuss the influence of Bramante on architecture generally. Ventura Vitoni was a minor craftsman rather than a notable architect.

Page 191. In Fra Bartolommeo (Baccio della Porta) V. depicts a mild and serious-minded artist, who passed through a religious crisis as the result of Savonarola's preaching; in art notable mainly for the light and shade (sfumato) in which he influenced Raphael.

Page 191. Mariotto Albertinelli (1474–1515), Bartolommeo's collaborator, was closely allied to him in style.

Page 192. The 'Last Judgment', finished by Albertinelli in 1500, has been transferred to canvas and taken to San Marco.

Page 193. Fra Bartolommeo seems to have died of a malarial fever rather than through eating figs.

Page 199. V. dramatically contrasts the temperament and career of Fra Bartolommeo and Albertinelli. Linked though they were in style (both pupils of Cosimo Rosselli) the one enters a convent, the other keeps a tavern!

Page 203. The 'oil painting of a sphere', V.'s obscure phrase, it has been suggested, indicates a picture painted on a mirror.

Page 203. The 'Tuscan cake' was *berlingozzo* = a species of puff pastry.

Page 204. V. was formerly accused of having confused three painters under the name of Raffaellino del Garbo, but it since appears that this was actually one Renaissance Florentine who signed himself in different ways. His work was related in style to that of Filippino Lippi. The date of his death is now assumed to be probably *c.* 1527.

Page 206. The 'master of the hospital' = Don Vincenzo Borghini.

Page 207. Agnolo Bronzino (1503–72), Florentine mannerist painter, to whom V. frequently refers.

Page 207. Pietro Torrigiano (Torrigiani) is duly castigated by V. for the 'proud and choleric' temper which caused him to break Michelangelo's nose and gains less than the appreciation accorded in England to his magnificent work in Westminster Abbey.

Page 208. V. perhaps exaggerates the role of Lorenzo de' Medici's garden as an 'academy' and training-ground.

Page 211. Giuliano da San Gallo and Antonio da San Gallo (1455–1517), who worked in collaboration, are described as having made considerable improvements in Tuscan architecture.

Page 212. The Villa Poggio at Cajano, 1483–5, is one of Giuliano's best works.

Page 213. Palazzo Gondi, *c.* 1490.

Page 215. Antonio's speciality was military architecture.

Page 219. Antonio's masterpiece is the church of San Biagio, Montepulciano.

Page 221. V. carefully distinguishes the greatness of Raphael from that of Michelangelo or Leonardo in one of the most magnificent of the *Lives*. As is usual in V.'s studies of great artists personal aspect and character are idealized.

Page 222. V. clearly defines the phases of Raphael's career: (I) At Perugia with Perugino (1500–4) culminating in the masterpiece 'Lo Sposalizio'.

Page 223. (II) At Florence, 1505–8, when he painted the portraits of Angelo Doni and his wife (Pitti) and a number of famous Madonnas.

Page 226. (III) At Rome, 1508–20. V. begins with an account of the 'Stanza della Segnatura' of the Vatican (1509–11)—with the confusion remarked on in the footnote to p. 227 of the two separate works, the 'Disputà' and 'The School of Athens'.

Page 235. The Madonna for Lionello da Carpi (? Naples or Leningrad).

Page 239. The frescoes in the Stanza del' Incendio were largely carried out by Raphael's assistants, 1517.

Page 240. The Loggie of the Vatican, 1517–19.

Page 241. The pope's villa = Villa Madama.

Page 243. The 'Transfiguration' (Vatican, *c.* 1519).

Page 243. V. added to the second edition of the *Lives* a reconsidered estimate of his greatness, bringing out more fully than before his individual excellences.

Page 250. Guglielmo da Marcilla, V.'s early master at Arezzo, is praised for his stained glass though not credited with great originality as a painter.

Page 256. Cronaca (Simone del Pollaiuolo) figures as an artist of the transitional period leading to the great Cinquecento. V.'s main comment concerns the Palazzo Strozzi, to which Cronaca added the famous cornice in 1491. He contrasts with it the poor imitation of Baccio d'Agnolo.

Page 259. V. notes the difficulties of restoring the Palazzo Vecchio.

Page 262. A brief comment by V. is a reminder of the powerful puritanical presence in Florence of Savonarola.

Page 263. Domenico Puligo gives rise to reflections on the triumph of natural gifts over lack of training. He was the pupil of Ridolfo Ghirlandaio though by V.'s system of chronology he comes first.

Page 263. Ridolfo Ghirlandaio had a large workshop in Florence and was official painter to the Signoria.

Page 266. Puligo was influenced by Andrea del Sarto, whose Life has still to appear.

Page 266. Andrea da Fiesole, a minor sculptor, introduces brief reference to other minor sculptors.

Page 270. Vincenzo da San Gimignano, 'whose portrait is given above' —i.e. in the edition of 1568.

Page 271. Timoteo Viti (1467–1523), born in Ferrara, settled in Urbino, 1501. It is not impossible that Timoteo was one of Raphael's masters.

Page 275. The life of Sansovino was added in the second edition. V. stresses his Tuscan education and represents him as one who brought a measure of architectural civilization to Venice. The same bias extends to Sansovino's work as a sculptor.

Page 277. Sansovino was summoned to Rome in 1505. His subsequent productions have been held to show a decline.

Page 281. The crisp personal portrait of Sansovino is to be noted.

Page 281. Benedetto da Rovezzano is represented above all as an expert craftsman.

Page 282. The Borgherini chimney-piece survives in damaged condition; that for Bindo Altoviti no longer exists.

Page 283. 'Service of the King', i.e. Henry VIII.

Page 285. V. gives importance to Raffaello as one who worked in the manner of the great Michelangelo.

Page 287. Lorenzo di Credi = Lorenzo d'Andrea d'Oderigo, a product of Verocchio's workshop, gains moderate praise from V. as a diligent craftsman.

Page 288. The 'Nativity' (Florence, Uffizi) has the finish and sweetness of his master Verrocchio. His portrait of the latter is in the Louvre.

Page 288. Fra Girolamo = Savonarola. Di Credi was one of those who burnt their secular paintings in Savonarola's Fire of Vanities, 1497.

Page 291. V. appends the lives of painters of Cremona to his account of the sculptor Lorenzetto. Boccaccio Boccaccino is criticized for his vilification of Michelangelo, though the frescoes for the chapel of Santa Maria Transpontina which exposed his pretensions have disappeared. Camillo finds more favour though briefly mentioned.

Page 292. Bernardo del Lupino = Bernardo Luini was a principal follower of Leonardo da Vinci at Milan.

Page 293. Baldassare Peruzzi, a pupil of Bramante, is noted for his combination of decorative painting with architecture. V. stresses the scenic aspect of his work.

Page 299. Sebastiano Serlio (1475–1554), architect and writer on architecture, became Peruzzi's assistant in Rome and accompanied him to Venice in 1527. His treatise on architecture was published there in 1537.

Page 300. Drawings by Peruzzi of stage scenery are in the Uffizi and the Turin Library.

Page 300. Giovanni Penni finds brief mention as the assistant of Raphael.

Page 301. The 'Baptism of Constantine' in the Vatican is attributed to him.

Page 303. V. gives Andrea del Sarto high praise, stressing the influence of Michelangelo (who was also a great admirer of del Sarto's painting), and referring with approval to the artist's achievement in the treatment of light and shade.

Page 311. The Madonna for the King of France is the 'Holy Family' now in the Louvre.

Page 325. With the woman sculptor Properzia, V. takes the opportunity of noting two women painters, the best known being Sophonisba

Anguisciola (1527–1623), celebrated principally for her portraits. V. gives a further account of her later in the *Lives*.

Page 328. Alfonso Lombardi (Ferrarese) enables V. to deal together with other sculptors and other artists of Ferrara.

Page 329. V. is in error in stating that Alfonso was the first good portrait medallist (he has forgotten Pisanello).

Page 333. Dosso Dossi (*c.* 1480–1542) (Giovanni Luteri), originally from Trento, was a friend of Titian, with whom he had some affinity in landscape painting. He was known as 'the Ariosto of painting' and painted scenes from the poet's *Orlando Furioso* (in which he is mentioned).

Page 334. Mirozzo = Melozzo da Forli. The frescoes in the Villa Imperiale and those at Ferrara, in which Battista Dossi (*d.* 1548), Giovanni's younger brother, collaborated no longer exist.

Page 335. It is not certain whether V. visited the province of Friuli, but he would no doubt see examples of the painters' work at Venice.

Page 336. Pellegrino di San Daniele (*c.* 1467–1547) worked mainly at Udine, where Giovanni Martini was his contemporary.

Page 338. Pordenone was probably the pupil of Alvise Vivarini. His real name was Giovanni Antonio Sacchi. V. calls him Licinio in error. He is assumed to have visited Rome though V. makes no mention of this.

Page 340. The frescoes at Venice have mostly disappeared.

Page 341. Pomponio Amalteo (1505–88) was painter, sculptor, architect and engraver.

Page 342. Giovanni Antonio Sogliani painted in the full-blown Renaissance style. The 'Legend of St Dominic' (San Marco, Florence), 1536, is his principal work.

Page 347. Girolamo da Treviso's age at death was given as forty-six in the first edition of the *Lives*, as thirty-six in the second. The San Petronio frescoes were executed, 1525–6.

Page 348. He became military engineer to Henry VIII in 1508.

Page 349. Polidoro da Caravaggio (Polidoro Caldara) was a pupil and follower of Raphael, celebrated in his own time for his exterior frescoes.

Page 349. Weather has mainly demolished the paintings on façades executed with Maturino.

Page 350. Records of perished frescoes, on the piazza of Capranica, the Triumph of Camillus and Story of Perillus exist in sixteenth-century engravings by Cavaliere and others.

Page 351. Fra Mariano = Fra Mariano Fetti.

Page 351. At S. Silvestro, Cappella Fetti, two scenes of the Life of the Magdalen are *in situ*.

Page 352. Fragments of the Niobe fresco remain at the Palazzo Milesi, Rome.

Page 355. Rosso = Giovanni Battista dei Rossi, also known as Rosso Florentino, was a Florentine Mannerist painter, noted for his exaggerations of Michelangelo's style, and as a founder of the school of Fontainebleau in France. An extravagance of personal character comes out in V.'s account.

Page 361. Gallery at Fontainebleau—V. refers to the decorations in the Salle François Premier.

Page 362. Designs for masques by Rosso, *c.* 1537, are in the Louvre.

Page 363. The Pietà for the Constable de Montmorency is in the Louvre.

Page 364. V. finds no great talents among the painters of Romagna. Bagnacavallo (Bartolommeo Ramenghi) is the best of them. He worked mainly in Bologna.

Page 365. 'The Holy Family with Saints' is in the Accademia, Bologna.

Page 365. Amico Bolognese = Amico Aspertini (*c.* 1474–1552) provides one of V.'s entertaining studies in eccentricity.

Page 366. Francesco Guicciardini (1483–1540), was the Florentine historian and statesman of whose *Storia d'Italia* V. made considerable use.

Page 367. Girolamo da Cotignuola (*c.* 1480–1550) and Innocenzo da Imola (p. 368) were both pupils of Francia, who worked at Bologna.

ADDITIONAL NOTES 311

Page 367. The panel for S. Giuseppe, 'La Sposalizio di Maria,' is now in the Pinacoteca, Bologna.

Page 368. Franciabigio (Francesco Giudini) has already found mention in the Life of his friend Andrea del Sarto, with whom he collaborated.

VOLUME III

Page 1. The Lives of the Venetian painter Morto da Feltre, who worked in Rome. and the Florentine, Andrea Feltrini, constitute a brief history of the revival of antique decorative motives ('Grotesques').

Page 5. V. gives a somewhat cursory glance at the sixteenth-century Neapolitan school, singling out Marco Calavrese (Calabrese) = Marco Cardisco, his pupil, Giovanni Battista Crescione and Lionardo Castellani, but giving no general observations on style in southern Italy.

Page 6. From his Calabrian excursion V. quickly returns to the north and Francesco Mazzuoli = Parmigianino, a follower of Correggio, in whom the Mannerist tendency to exaggeration of form is clearly seen. V. emphasizes his charm.

Page 7. The 'Baptism of Christ' is in the Berlin Gallery..

Page 8. The 'Circumcision' no longer exists.

Page 12. The 'Lucretia' is in the Pinacoteca, Naples.

Page 15. V. now turns to Venetians, related in style to Giovanni Bellini, Giorgione and Titian. Jacopo Palma (Palma Vecchio) = Jacopo Negretti, born near Bergamo, and Lorenzo Lotto, born in Venice of a Bergamese family. He does not give to Lorenzo Lotto the importance now attached to his work.

Page 15. Lotto's portraits are among his greatest achievements.

Page 15. The altar-piece at Santa Maria Formosa, Venice, is now considered to represent especially well the individuality of his style.

Page 19. Niccolò Rondinellini and his pupil Francesco da Cotignuola were minor painters who continued the tradition of Giovanni Bellini.

Page 19. V. now considers some artists of Verona, beginning with Fra Giocondo, architect, engineer, philosopher and antiquary. He went to France in 1495.

Page 22. V. refers to the Brenta Canal between Verona and Venice.

Page 24. Liberale da Verona = Liberale di Jacopo della Biava began as a miniaturist at Verona. He probably owed something of his style to Mantegna and the Vivarini as well as Bellini.

Page 25. V. stresses the miniaturist character of his art. The Piccolomini Library, Siena, retains excellent examples.

Page 27. Giovanni Francesco Caroto is considered the best of Liberale's pupils.

Page 27. The 'Circumcision' and 'Flight into Egypt' are now in the Louvre.

Page 31. Giovanni Caroto was personally known to V.

Page 32. Torbido was influenced by Giorgione and the Venetians but later (for the worse in Berenson's view) by Giulio Romano.

Page 36. Monsignori = Francesco Bonsignori was an assistant of Mantegna at Mantua. He is noted mainly as portrait painter, and it is in this light that V. views him.

Page 35. Danese Carrara = Danese Cattaneo (*b.* Carrara 1509, *d.* Padua, 1573).

Page 37. Bonsignori's 'St Sebastian' is at Berlin.

Page 39. Domenico Morone was born in Albino near Bergamo and was a pupil of Moretto da Brescia. He imitated the style of Mantegna.

Page 40. His son, Giovanni Francesco Morone, often collaborated with him.

Page 42. The school of Morone was of considerable importance. The most talented of his followers was Girolamo dai Libri, but Paolo Cavazzuola (Morone) was notable both in portraiture and landscape background.

Page 44. Stefano of Verona = Stefano da Zevio.

Page 44. Giovanni Maria Falconetto is singled out as the first to bring 'good' (i.e. classically inspired) architecture to Verona.

Page 48. Girolamo dei Libri ('of the books') was a distinguished pupil of Domenico Morone, celebrated mainly as a manuscript illuminator. In painting he was influenced by Mantegna.

Page 49. The Cartieri altar-piece is now in the Metropolitan Museum, New York.

Page 49. Miniatures by Girolamo are in the Museo Civico, Verona, the Morgan Library, New York, and the Victoria and Albert Museum.

Page 52. Francesco Granacci, a minor Florentine painter and pupil of Ghirlandaio, is represented by V. as wholly submissive to Michelangelo.

Page 55. Baccio d'Agnolo was a Florentine wood-carver, sculptor and architect whom V. judges fairly, despite Michelangelo's contempt (p. 57), though allowing him less proficiency in architecture than in sculpture.

Page 56. Columns like those criticized by the Florentines in the palace for Giovanni Bartolini were previously confined to the façades of churches.

Page 60. This series of *Lives* draws attention to the artistic importance of engraved gems in Renaissance Italy, where there were many collectors of ancient classic examples and a consequent revival of gem-cutting.

Page 61. Domenico de' Cammei = Domenico of the Cameos. V. is the sole source of information about this craftsman. Giovanni delle Corniole = Giovanni di Lorenzo delle Opere (*c*. 1470–1506).

Page 61. Examples of Giovanni da Castel Bolognese's intaglios are in the Vatican and Metropolitan Museum, New York.

Page 62. The 'Cassetta Farnese' is in the Museo Nazionale, Naples.

Page 62. The 'Turkish War' crystal is in the Metropolitan Museum, New York.

Page 66. Examples of Alessandro Cesati's medals are in the British Museum.

Page 67. The 'Head of Phocion' is identified with the Zanetti cameo in the British Museum; the vase of heliotrope as one of the treasures of the Pitti Palace.

Page 68. The Lives of Marcantonio (*d*. 1534) and other engravers constitute an important early study of the history of engraving. V. pays attention to Martin Schongauer and Albrecht Dürer mainly for their technical skill and its influence in Italy.

Page 74. V. considers Marcantonio as an interpretative rather than original artist-engraver.

Page 82. V. mentions books recently published with engravings: Serlio's *Antiquities of Rome*, the treatises on architecture of Labacco and Vignola, the treatise on perspective by Jean Cousin, etc.

Page 87. V. gives Antonio da San Gallo (the Younger), nephew of Antonio the Elder, a principal place between Bramante and Michelangelo in the development of Italian architecture.

Page 88. The Palazzo Farnese, his masterpiece, was begun in 1513, completed by Michelangelo.

Page 90. Adrian VI, reforming Pope (1522–3) met with much opposition during his short pontificate.

Page 95. The model for St Peter's is now in the Petriano Museum of the Vatican.

Page 95. V. seems to have suspected a form of 'Gothic revival' in the 'projections' and members which 'approached the German style'.

Page 95. Palma = *c*. 9 in.

Page 95. Canna = 4 braccia.

Page 97. Giulio Romano (Giulio Pippi), born in Rome, was influenced not only by Raphael but by Michelangelo and Venetian painters in Rome. He was the friend of V., who accompanied him to Mantua and admired his work as a continuation of that of the supreme Renaissance masters.

Page 98. 'Burning of the Borgo' in the Stanza dell' Incendio of the Vatican.

ADDITIONAL NOTES

Page 105. The 'Sala dei Giganti' is a famous work for which V. shows evident enthusiasm in his lengthy description.

Page 106. Decoration of the Palazzo Ducale, 1532–8.

Page 112. Sebastiano del Piombo (Sebastiano Luciani) was a link between the Renaissance art of Rome and Venice.

Page 112. Some critics have even attributed to him the 'Fête Champêtre' of the Louvre, usually ascribed to Giorgione. V. lays stress on his colour.

Page 118. V. underlines the decay of an artist who ceased to bother.

Page 120. Perino (or Pierino) del Vaga (Pietro Buonaccorsi), the pupil of Ridolfo Ghirlandaio and Florentine decorative artist, greatly esteemed in his own time, is placed by V. among the most representative Roman artists of his time.

Page 125. Nicodemus = often V.'s name for incidental male figures in a 'Deposition'.

Page 140. Domenico Beccafumi (Domenico Meccherino or Macarino) was a Mannerist painter of Siena (born in delli Cortine, the son of a peasant). He was influenced by Raphael and Michelangelo, whose works he studied in Rome.

Page 150. Giovanni Antonio Lappoli was a minor painter of Arezzo, which in the sixteenth century remained somewhat apart from the main current of painting.

Page 150. 'Clemente' = Don Bartolommeo della Gatta, Abbot of S. Clemente.

Page 155. The fate of Bartolommeo Torri throws its light on the ambitions of a competitive age and the tragedy of failure.

Page 156. In Niccolò Soggi V. again portrays a minor painter, irresolute and poverty-stricken in the backwaters of Renaissance art.

Page 162. The statue in memory of Domenico's liberality still exists in the Council Chamber.

Page 162. The growth of mannerism in sculpture signalized by exaggerations in the style of Michelangelo, far-fetched allegories and a sense of theatre extending to garden design and theatrical scenery, is traced in V.'s lives of Niccoló Tribolo and Pierino da Vinci.

Page 162. The nickname 'tribolo' = teasel.

Page 186. The 'Sampson and Philistine' of Pierino is in the courtyard of the Palazzo Vecchio, Florence.

Page 188. Baccio Bandinelli is portrayed as a sculptor obsessed with colossal conceptions and the desire to surpass Michelangelo. V. finds, however, a good word to say for the 'Hercules and Cacus' (Florence, Piazza della Signoria). The portrait of Bandinelli, however, brings out his jealous and destructive character.

Page 206. The reliefs of the choir screen in the cathedral at Florence show Baccio at his best.

Page 209. Benvenuto Cellini (1500–71). V. subdues resentment at Cellini's attacks on him to give unbiased praise. The famous 'Perseus', suggested as a subject for Cellini by Cosimo de' Medici, is in the Loggia dei Lanzi, Florence.

Page 213. Giovanni da Bologna (1524–1608), born at Douai, was attached to the court of the Medici in 1558. He married at Bologna and then took the name by which he is known.

Page 215. Giuliano Bugiardini, a minor Florentine painter, assisted Albertinelli in completing unfinished works by Fra Bartolommeo.

Page 218. The portrait of Michelangelo is identified with that in the Louvre.

Page 219. Cristofano Gherardi (Doceno) was V.'s principal assistant, noted for his technical skill in fresco and his stucco decoration. V. portrays with humour a picaresque and Bohemian character.

Page 226. Lattanzio's panel is in the Pinacoteca, Perugia.

Page 234. The inscription should read: 'Obiit Die iiii. April MDLVI. Vixit An. XLVII. Men. iiii. Dies X.'

Page 234. Jacopo da Pontormo (Jacopo Carrucci) was a leading painter

among the Florentine Mannerists. V. studies with care and penetration his restless changes of style and the various influences on his art, as far apart as Dürer and Michelangelo. In character he appears as an independent and solitary spirit.

Page 244. The frescoes for the Certosa di Val d' Ema survive in a damaged condition.

Page 247. The 'Deposition' of Santa Felicità, Florence, painted in 1525, is Pontormo's principal work.

Page 251. The Medici villas at Correggi and Castello are both destroyed.

Page 255. Simone Mosca was a contemporary of V. noted for his decorative carving rather than the plastic qualities of his sculpture, a talent roughly criticized by Michelangelo (see p. 260).

Page 256. Macigno = grey sandstone.

Page 261. Girolamo Genga of Urbino, painter, sculptor and architect, appears as a courtly figure and the exponent of a modern style of architecture. Among his principal works as architect were the church of San Giovanni, Pesaro, finished by his son, and the façade of Mantua Cathedral (c. 1528).

Page 261. The 'Diana and Actaeon' is in the Museo di Bargello.

Page 262. The frescoes for Petrucci exist, two in the Pinacoteca, Siena, one in the National Gallery.

Page 265. Parmigiano = Palmezzano.

Page 271. Michele Sanmichele was member of an architect family at Verona. His principal works are in that city and at Venice, notable especially being the Palazzo Grimani. The Porta Nova and Porta Palio at Verona, c. 1535, are singled out by V. for their classic strength and simplicity.

Page 281. Brusasorci (1516–67) was a pupil of Caroto, a follower of the Venetians in style and a protégé of Cardinal Gonzaga.

Page 283. Paolino = Paolo Caliari (Veronese), V.'s great contemporary, suddenly and almost anonymously emerges from references to minor artists.

Page 283. The frescoes of the Doge's Palace were partly destroyed in 1577.

Page 284. The 'Supper in the House of Levi' and the 'Triumph of Venice' in the Doge's Palace were masterpieces as yet unpainted when V. wrote.

Page 285. Sodoma = Giovanni Antonio Bazzi, Lombard Mannerist mainly working in Siena. He studied in his native Vercelli and was influenced in style by a number of masters, especially Leonardo and Raphael. V., prejudiced against him personally, writes in a tone of ethical disapproval.

Page 289. St Sebastian (Uffizi).

Page 290. The paintings in the chapel of Santa Caterina are Sodoma's masterpieces.

Page 293. Bastiano da San Gallo was one of the pupils of Perugino, who is portrayed mainly as a scene painter in V.'s account.

Page 303. Francesco Ubertini, another of Perugino's many pupils and the friend of Andrea del Sarto, was a painter of considerable charm. The obscure Jacone is the occasion for one of V.'s Bohemian portraits.

Page 304. V. in the second edition of the *Lives* collected this series of notes on painting in Lombardy, Emilia and Romagna ranged around Benvenuto (Tisi da) Garofalo, a devotee of Raphael and Michelangelo.

Page 307. 'St. Nicholas of Tolentino reviving a Child' (from S. Andrea) is in the Metropolitan Museum, New York.

Page 309. Girolamo da Carpi (d. c. 1556), Garofalo's pupil, is portrayed as a provincial painter regretting not having visited Rome in his younger days. V. has a good word for his portraits.

Page 313. Niccolo = Niccolò dell' Abbate, one of the founders of the school of Fontainebleau, went to France in 1552.

Page 314. Il Modana = Antonio Begarelli.

Page 315. Bernardo (or Bernardino) Gatti was a Cremonese painter who worked at Parma and Piacenza as well as Cremona. He was a follower of Correggio.

Page 315. Domenico Brusciasorzi = Brusasorci (see note to p. 281).

Page 316. Giulio Campo (*d.* 1572) worked at Cremona.

Page 319. Sofonisba's self-portrait is in the Kunsthistorisches Museum, Vienna.

Page 320. Geremia is actually mentioned in the Life of Brunelleschi.

Page 321. A group of painters at Brescia follows the Cremonese Girolamo Romanino, who worked in the Venetian style. He employed a number of assistants.

Page 321. Alessandro Moretto = Alessandro Bonvicino was a painter in the Venetian style, noted for his portraits.

Page 321. Lattanzio Gambara is said by other writers to have been the son-in-law and pupil of Romanino.

Page 321. Gian Girolamo Bresciano = Giovanni Girolamo Savoldo worked at Brescia, Venice, Florence and elsewhere. V. takes note of his originality.

Page 321. Girolamo Muziano was a pupil of Romanino.

Page 322. V. now adds particulars about Milan in addition to those given in the Life of Bramante.

Page 322. Bramantino = Suardi was a pupil of the Milanese painter Butinone. He became court painter to Francesco Sforza at Milan.

Page 323. S. Ambrogio, Milan (twelfth century), suffered serious war damage in 1943, the cloister by Bramante being destroyed.

Page 325. Paintings of Salome by Cesare da Sesto are in the National Gallery and at Vienna.

VOLUME IV

Page 1. Davide Ghirlandaio and his brother, Benedetto, were close collaborators of the more famous Domenico.

Page 2. Ridolfo Ghirlandaio, though able and soundly trained, belonged in style to the fifteenth rather than the sixteenth century, which may account for some lack of enthusiasm on V.'s part.

Page 5. Ridolfo's Florentine pupils are of little note.

Page 8. Giovanni da Udine (dei Ricamatori = Embroiderers), painter and architect, is noted mainly as the inventor of the decorative style (described at length by V.) and adapted from the decoration of the then newly discovered Baths of Titus at Rome.

Page 9. The Loggie of the Vatican, 1517–19.

Page 11. Decoration of the Medici Palace, 1520.

Page 15. Battista Franco, despite his imitation of Michelangelo, is critically viewed by V. and appreciated mainly as scene painter and designer.

Page 23. Again a great Venetian suddenly appears in the account of a minor painter. Tintoretto (Jacopo Robusti) is recognized by V. as an artist of extraordinary ability, though V. deplores his 'vagaries'. A number of early works mentioned have not survived.

Page 26. The 'Apotheosis of San Rocco' was the only painting by Tintoretto yet finished in the Scuola di San Rocco when V. wrote. He did not live to see the great works the artist later added.

Page 27. Andrea Schiavone = Andrea Meldolla was a Slav painter, born probably at Zara, who worked in Venice and was influenced by Tintoretto.

Page 27. Giovan Francisco Rustico = Giovanni Francesco Rustici (1474– *d.* Tours, 1554). In the Life of the sculptor, V. gives vivid sidelights on sixteenth-century modes, manners and banquets.

Page 28. Rustici was not old enough to have met Leonardo in Verrocchio's studio.

Page 29. The Mercury has been identified with a figure exhibited Victoria and Albert Museum, 1961, now in a private collection.

Page 29. The 'St John the Baptist' has been identified with a tomb in the Bargello Museum, Florence.

Page 31. The 'Noli me tangere' has been identified with a relief in the Bargello.

Page 31. 'His gown over his shoulder'—V. refers to the *lucco*—the long Florentine gown for ceremonial occasions.

Page 32. Company of the Cauldron (Paiuolo).

Page 32. 'Spillo the painter' was Francesco d'Angelo Lanfranchi.

Page 33. 'A book made of pastry,' i.e. of *lasagne*, broad strips of macaroni.

Page 34. Company of the Trowel (Cazzuola.)

Page 35. 'Luia' is properly Aia = threshing-floor.

Page 39. V.'s detailed account of the sculptor Montorsoli, a disciple of Michelangelo, brings out the growing elaboration of sixteenth-century sculpture and its attempts to rival painting in allegorical subject-matter.

Page 39. The tomb of Raffaello Maffei is by Silvio Cosini. Montorsole, however, designed the tomb of Mauro Maffei in the Duomo, Volterra.

Page 40. 'King of Bossina' = Mattia Hunyadi, King of Bosnia. The Signor of Piombino = Giacomo Appiani.

Page 48. Both the Fountain of Orion (1547–53) and Neptune (1557) exist.

Page 53. 'Died on 31 August, 1563.' The actual date was in December 1562.

Page 53. Francesco Salviati (Francesco di' Rossi), V.'s close friend, is the subject of a long and appreciative study, Salviati's Mannerist style, formed on Michelangelo and Raphael, entirely conforming to V.'s criterion. Many of the works mentioned, however, have now disappeared.

Page 59. 'The opportunity which God had given them'. V.'s term is 'Messer Domeneddio' = a quaint and untranslatable form of reference to the Deity.

Page 63. Of 'Charity', versions exist in the Uffizi, Corsini Gallery and National Gallery.

Page 65. The 'Adam and Eve' is in the Colonna Gallery, Rome.

Page 73. Daniello Ricciarelli (Daniele da Volterra), painter, sculptor and architect, much influenced by Michelangelo, and perhaps the most powerful of Michelangelo's followers, was more gifted than V.'s comparison of him with Salviati suggests.

Page 74. The 'Descent from the Cross', 1541, in the Orsini Chapel, Santa Trinità de' Monti, was a celebrated work in the artist's own time and is one of his principal achievements.

Page 77. The painted version of the 'David' is in the Louvre, the 'Dead Christ' (Prado), the 'St John' (Munich).

Page 81. Taddeo Zucchero (Zuccari) and his younger brother Federigo (1542–1609), prolific painters, influential in the spread of Roman Mannerist style, are given disproportionately long biographies (they occupy more space than that devoted to Raphael and Leonardo). V. perhaps was anxious to show no prejudice against a personal rival such as Taddeo and also to defend him and Federigo as representative academicians.

Page 89. The 'Christ' for the Cardinal Farnese is now in the Borghese Gallery, Rome.

Page 92. The hunting scene for the Queen of Austria (1565) is in the Uffizi.

Page 108. The Life of Michelangelo comes belatedly as far as aesthetic exposition is concerned, a host of followers having been previously dealt with, though it was originally intended that he should conclude the *Lives* with a burst of final glory. V. builds up an impressive verbal portrait, physical and psychological, of the great Florentine, who for him was more than what Dr Johnson was to Boswell. The only flaw in this splendid Life is the lack of relation between the work and personality of the great man— his technical skill being overemphasized.

Page 113. The 'Angel with the Candlestick' is in S. Domenico, Bologna.

Page 116. Wax models for the 'David' are in the Museo Buonaroti.

Page 117. A replica of the 'David' is in front of the Palazzo Vecchio.

Page 118. Drawings for the Cascina composition are in the Ashmolean, Albertina, British Museum, Museo Buonaroti and Louvre.

Page 119. The Tomb of Pope Julius is a famous tragedy. The work dragged on from 1505 to 1545.

Page 120. The 'Moses' was finished in 1516.

Page 134. The Medici tomb in San Lorenzo, Florence, was executed 1524-34.

Page 179. 'Founding of the academy.' V. believed that in his time Florence was regaining that supremacy in art which it had yielded to Rome. The Florentine Academy founded in 1561 under the patronage of Cosimo de' Medici was its organized expression. Its function was to glorify the Medicean court, not only with painting and sculpture but in preparing decoration for its festivals and ceremonies.

Page 188. Alessandro Allori (1535-1607), a follower of Bronzino, much influenced also by Michelangelo.

Page 192. After the Life of Michelangelo V. in the second edition of the *Lives* added a number of artists still living in 1566.

Page 192. Francesco Primaticcio, who was born in Bologna and died in Paris, is famous principally for his decorative work at Fontainebleau which V. knew only by report.

Page 193. Niccolo da Modena = Niccolò dell' Abbate.

Page 195. Prospero Fontana (1512-97), born in Bologna, was an eminent Mannerist painter.

Page 195. Pellegrino Bolognese = Pellegrino Tibaldi, painter, sculptor and architect who worked in Rome, Bologna and Spain, was noted for his perspective decorations.

Page 197. Orazio Fumaccini = Sammacchini.

Page 197. In Romagna V. mentions some minor artists working mainly at Rome.

Page 199. Some of V.'s prejudice against Venetian art appears in the Life of Titian (whose date of birth is now somewhat doubtfully given as between 1474 and 1484), though V. recognizes him as a man of genius.

Page 199. The gentleman of the Barberigo family has been speculatively identified with the 'Portrait of a Man' by Titian in the National Gallery.

Page 208. The 'Rape of Europa' is in the Gardner Museum, Boston.

Page 212. V. makes Bordone a student of Titian and follower of Giorgione, which seems probable. The overpowering competition of Titian may well account for the time he spent away from Venice, in north Italy, France and Germany.

Page 213. The painting of the 'luxurious (*lasciviosa*) lady' has disappeared.

Page 213. Bathsheba (Cologne).

Page 215. Jacopo Sansovino (Jacopo Tatti) is regarded by V. as in sculpture and architecture the one great artist of orginality to vie with Michelangelo. After his death in 1570 V. published a separate and extended Life. The personal portrait he gives is a triumph of exact description.

Page 218. The 'Bacchus' is in the Museo Nazionale, Florence.

Page 233. The figure of the Sun (Apollo) is now in the courtyard of Ca Pesaro, Venice.

Page 233. Andrea Palladio (1518-80), architect of Vicenza, greatly influential through his writings on architecture. His last great work, Il Redentore at Venice, was later (1576) than V.'s Life.

Page 236. Colossal proportions and the free use of allegories and symbols characterize the work of the sixteenth-century sculptors in this section of the *Lives*. V. regards with approval their 'invention.' Leone Lioni, *b.* Arezzo, *c.* 1509, *d.* Milan, 1590.

Page 244. Giulio Clovio = Jurai Glovicich, *b.* Croatia, 1498, came to Italy in 1516, was the principal manuscript illuminator of V.'s time—praised as a 'Michelangelo in little', also by Annibale Caro and Francisco de Hollanda.

Page 245. The 'Lucretia' has disappeared. The 'Office of the Virgin' for Cardinal Grimani is in the British Museum. The St Paul epistolary is in the Soane Museum, London.

Page 252. Niccolo dalle Pomerance = Niccolò Circignani (1517–96). Ludovico is an unknown sculptor.

Page 252. V.'s knowledge of art in the Netherlands was inevitably fragmentary. He makes no distinction of style between the 'primitive' and later period of Netherlandish painting, but the chapter is of interest as showing what came to the notice of a sixteenth-century Italian.

Page 253. To the revised list of names may be added John Cornelis = Jan Cornelisz Vermeyen, John Schoorel = Jan Scorel, John Bellagamba = Jean Bellegambe, Francis Mostaeret = Franz Mostaert.

Page 257. Alessandro de' Medici (1510–37) governed Florence as Duke from 1530.

Page 257. Ippolito de' Medici, (1511–35).

Page 258. The painting for S. Piero d'Arezzo has disappeared.

Page 260. 'Venus and the Graces' is possibly the painting in the Budapest Gallery.

Page 260. Cosimo I (1519–74), Grand Duke of Tuscany from 1569.

Page 260. Clement VII = Giulio de' Medici (Pope, 1523–34).

Page 261. The portrait of Duke Alexander is in the Museo Mediceo.

Page 261. The portrait of Lorenzo de' Medici is in the Uffizi, Florence.

Page 265. 'Christ in the House of Martha' *in situ*, 'St Gregory' (Bologna, Pinacoteca). 'Abraham entertaining the angels' has disappeared.

Page 267. The copy of 'The Conception' is in the Uffizi.

Page 267. 'Leda' possibly painting in the Borghese Gallery, Rome.

Page 267. 'St Jerome in Penitence', Pitti.

Page 268. Pietro Aretino (1492–1556), poet and playwright, was a fellow townsman of V.

Page 268. The 'Deposition' is in the Doria Gallery, Rome.

Page 269. The painting for S. Piero Cigoli is now in the Pinacoteca, Lucca.

Page 270. 'Christ in the House of Simon' (Naples, Museo Nazionale).

Page 274. Cardinal Alessandro Farnese (1520–89).

Page 274. Paolo Giovio (1483–1552), the historian and biographer, kept his collection of portraits of famous men (now dispersed) at his villa on the lake of Como.

Page 274. The 'Last Supper' is in the Museo di Santa Croce, Florence.

Page 275. The 'Madonna' for Simon Corsi. Versions at Dresden, Grenoble, Monaco, Vienna and in the Prado, Madrid.

Page 276. The 'Deposition' is in the Museo di Ravenna

Page 278. 'Adonis dying in the lap of Venus' (Berlin).

Page 281. 'Nativity' (for Bondini), Pitti Gallery, version also in the Borghese Gallery.

Page 283. The 'fine picture by Raphael' = 'Madonna dell' Impannata' (Pitti).

Page 283. 'The dialogue' = *I Ragionamenti*, dialogue account of the paintings in the Palazzo Vecchio, published after Vasari's death (1588).

Page 284. The wall and ceiling paintings in the great hall of the Palazzo Vecchio were Vasari's principal work as a painter.

Page 287. 'The Annunciation', given to the nuns of Arezzo when V.'s sister took the veil, is now in the Louvre.

Page 288. Pictures sent to Spain, ? 'Madonna and Child' and 'Charity' in the Prado, Madrid.

Page 291. In the seven years remaining to him after the second edition of the *Lives* was published, V. completed his work in the Palazzo Vecchio and the Sala Regia of the Vatican. He also began the paintings for the cupola of the cathedral at Florence finished by Federigo Zuccari.

INDEX

319